AMERICAN MUSE
Anthropological Excursions into Art and Aesthetics

Richard L. Anderson
Kansas City Art Institute

Prentice Hall, Upper Saddle River, New Jersey 07458

Library of Congress Cataloging-in-Publication Data

Anderson, Richard L.
　　American muse : anthropological excursions into art and aesthetics
／ Richard L. Anderson.
　　　p.　cm.
　　Includes bibliographical references and index.
　　ISBN 0–13–084313–X
　　1. Arts, American.　2. Arts, Modern—20th century—United States.
　3. Aesthetics, American.　I. Title.
NX504.A585　2000
700′.973′0904—dc21
　　　　　　　　　　　　　　　　　　　99–35355
　　　　　　　　　　　　　　　　　　　CIP

Editorial director: Charlyce Jones-Owen
Editor-in-chief: Nancy Roberts
Managing editor: Sharon Chambliss
Production liaison: Fran Russello
Editorial/production supervision: Bruce Hobart (Pine Tree Composition)
Prepress and manufacturing buyer: Ben Smith
Marketing manager: Christopher DeJohn
Cover designer: Richard L. Anderson
Cover image: Chief's gate. Source: Kansas City Art Institute

This book was set in 11/13 Perpetua by Pine Tree Composition, Inc.,
and was printed and bound by R. R. Donnelley & Sons Company.
The cover was printed by Phoenix Color Corp.

For permission to use copyrighted material please refer
to p. xi that is hereby made part of this copyright page.

Prentice-Hall International (UK) Limited, *London*
Prentice-Hall of Australia Pty. Limited, *Sydney*
Prentice-Hall Canada, Inc., *Toronto*
Prentice-Hall Hispanoamericana, S.A., *Mexico*
Prentice-Hall of India Private Limited, *New Delhi*
Prentice-Hall of Japan, Ltd., *Tokyo*
Pearson Education Asia Pte. Ltd., *Singapore*
Editora Prentice-Hall do Brasil, Ltda., *Rio de Janeiro*

To the memory of
Mary Alyce Anderson and
Donald L. Anderson
Good and generous souls, both

Contents

List of Illustrations

Credits

Harold Arlen and Truman Capote, excerpt from "I Never Has Seen Snow" (MPL Communications, Inc.). Reprinted with the permission of Hal Leonard Corporation. All rights reserved.

"Beauty and the Beast" lyrics by Howard Ashman. Music by Alan Menken. Copyright © 1991 by Walt Disney Music Co. and Wonderland Music Company, Inc. All rights reserved. Reprinted by permission.

Kirth Anthony Atkins and Jalil Hutchins, excerpt from "I'm Def (Jump Back and Kiss Myself)." Copyright © 1987 by Willesden Music, Inc., Zomba Music Publishers, Ltd., Roy Cormier d.b.a. Cosjoy Publishing. Reprinted with the permission of the Zomba Music Group. All rights reserved.

Irving Berlin, excerpts from "Cheek to Cheek," "Easter Parade," "The Girl That I Marry," "Puttin' on the Ritz," "Let's Face the Music and Dance," and "Alexander's Ragtime Band." (Williamson Music Company). Reprinted with the permission of Williamson Music Company. All rights reserved.

Rick Bowles and Rob Crosby, excerpt from "She's a Natural." Copyright © 1991 by Maypop Music/Songs of the Grand Coalition. All rights reserved. Used by permission.

Jackson Browne and David Garofalo, excerpt from "The Load-Out." Copyright © 1977, 1978 by Swallow Turn Music & Gianni Music. Reprinted with the permission of Warner Bros Publications U.S. Inc., Miami, FL 33014. All rights reserved.

Gary S. Burr, excerpt from "That's My Job." Copyright © 1986, 1987 by Garwin Music, Shenandoah Music, a division of Terrace Entertainment Corporation. Reprinted by permission. All rights reserved.

John Cale and Lou Reed, excerpts from "Open House," "Smalltown," and "Style It Takes" from *Songs for Drella*. Copyright © 1990 by Metal Machine Music and John Cale Music, Inc. Used by permission.

John Denver, excerpts from "This Old Guitar" (Cherry Lane Music Publishing). Copyright © 1974 by Cherry Lane Music Publishing. Reprinted with the permission of Hal Leonard Corporation. All rights reserved.

Dion Di Mucci and Ernest Maresca, excerpt from "Donna, the Prima Donna" (Bronx Soul Music, Inc.). Reprinted by permission. All rights reserved.

"Seventh Son" written by Willie Dixon. Copyright © 1965, 1993 by HOOCHIE COOCHIE MUSIC (BMI)/Administered by Bug Music. All rights reserved. Used by permission.

Bobby Gene Emmons and Chips Moman, excerpt from "Luckenbach, Texas" (Songs of Polygram International/Sony/ATV Songs LLC). (Songs of Polygram International/Sony/ATV Songs LLC). Reprinted with the permission of Sony/ATV Tunes LLC. All rights reserved.

Ira and George Gershwin, excerpt from "I Got Rhythm." Copyright 1930, © 1958. Reprinted with the permission of Warner Bros Publications U.S. Inc., Miami, FL 33014. All rights reserved.

Gerald Goffin and Barry Mann, excerpt from "Who Put the Bomp" Copyright © 1961 and renewed 1989 by Gerald Goffin and Barry Mann. Reprinted with the permission of Hal Leonard Corporation. All rights reserved.

Gerald Goffin and Carole King, excerpt from "Loco Motion." Copyright © by Screen Gems-EMI Music, Inc. Reprinted with the permission of Hal Leonard Corporation. All rights reserved.

Woody Harris, excerpt from "Queen of the Hop" (Ellipsis Music Corp./Anna Teresa Music Ltd.). Copyright © 1958 and renewed 1986 by Florence Herwitz. Reprinted by permission. All rights reserved.

Robert Blaine Honey, Richard Belmont Powell, Jr., and Daniel Thomas Truman, excerpt from "Norma Jean Riley." Copyright © 1990 by Warner-Tamerlane Publishing Corporation, Resaca Beach Music, Music Corporation of America, Inc., Dan Truman Music, Mountain Green Music. Reprinted with the permission of Warner Bros Publications U.S. Inc., Miami, FL 33014. All rights reserved.

Charles Ives, excerpts from "Berceuse," "The New River," and "The Things Our Fathers Loved." Reprinted with the permission of Peer International Corporation. All rights reserved.

Oscar Jerome Jackson, excerpt from "Break the Grip of Shame." Reprinted with the permission of T-Boy Music LLC. All rights reserved.

Oliver J. Lieber, excerpt from "Romeo and Juliet" (EMI Virgin Music, Inc.). Copyright © by EMI Virgin Music, Inc. Reprinted by permission. All rights reserved worldwide.

Lizzy Borden, excerpt from "Master of Disguise" (Greg Harges). Copyright © 1989 by Forty Whacks Music. Reprinted by permission.

Joe Maphis, excerpt from "Me and Ol' Merle." Copyright © Red River Songs, Inc. Reprinted with the permission of Warner Bros Publications U.S. Inc., Miami, FL 33014. All rights reserved.

Dolly Parton, excerpt from "Why'd You Come In Here Lookin' Like That?" Copyright © Velvet Apple Music & Warner-Tamerlane Publishing Corporation. Reprinted with the permission of Warner Bros Publications U.S. Inc., Miami, FL 33014. All rights reserved.

Dean Pitchford and Thomas Righter Snow, excerpt from "Let's Hear It For the Boy." Copyright © 1984 by Ensign Music Corporation. Reprinted by permission.

Righteous Brothers, excerpt from "Rock-n-Roll Heaven" (Lynn Paul & Aaron Collins). Copyright © 1961 and renewed 1989 by Lynn Paul & Aaron Collins. Reprinted by permission.

Edward T. Riley and Mohandas DeWese, excerpt from "How Ya Like Me Now?" Copyright © 1987 by Willesden Music, Inc., Mohandas DeWese (p.k.a. Kool Moe Dee d.b.a. Kool Moe Dee Music), Zomba Enterprises, Inc., & Edward T. Riley (p.k.a. Teddy Riley d.b.a. Donril Music). Reprinted with the permission of the Zomba Music Group. All rights reserved.

William Robinson, Jr. and Berry Gordy, Jr., excerpt from "Shop Around." Copyright © 1960 and renewed 1988 by William Robinson, Jr. and Berry Gordy, Jr. Reprinted with the permission of Jobete Music Company, Inc./EMI Music Publishing. All rights reserved.

John Benson Sebastian, excerpts from "Do You Believe in Magic?" Copyright © by Alley Music Corp./Trio Music Company, Inc. Reprinted by permission. All rights reserved.

Bob Seger, excerpt from "Rock 'n' Roll Never Forgets." Copyright © 1976 by Gear Publishing Company. Reprinted by permission.

John Martin Sommers, excerpt from "Thank God I'm a Country Boy." Copyright © 1979 by Cherry Lane Music Publishing Company. Reprinted with the permission of Hal Leonard Corporation. All rights reserved.

Ken Spooner and Kim Williams, excerpt from "If the Devil Danced (in Empty Pockets)." Copyright © by Texas Wedge Music, Cross Keys Publishing, Windswept Music. Reprinted with the permission of Warner Bros Publications U.S. Inc., Miami, FL 33014.

Steady B, excerpt from "Bring the Beat Back" (Warren McGlone). Copyright © 1986 by Zomba Productions, Ltd. Reprinted with the permission of the Zomba Music Group. All rights reserved.

Randy Bruce Traywick and Alan Eugene Jackson, excerpt [5 lines] from "Better Class of Losers." Copyright © 1991 by Sometimes You Win Music & Seventh Son Music. Reprinted with the permission of Warner Bros Publications U.S. Inc., Miami, FL 33014.

Jimmy Van Heusen and Phil Silvers, excerpt from "Nancy with the Laughing Face." Copyright © by Barton Music Corporation. Reprinted by permission.

Preface

I am a cultural anthropologist, and throughout my professional career, my central interest has been art. A previous book, *Calliope's Sisters,* took its title from the first of the muses, the mythic beings that the ancient Greeks associated with the arts. The book was an anthropological study of philosophies of art in several non-Western cultures. Writing the book consumed more than ten years, so as it neared completion and I began consciously (and, no doubt, unconsciously) mulling over ideas about what I might do next, I was certain only that I did not want another decadelong project. Beyond that, the only thing I was certain of was that I wanted to pursue further the study of aesthetics that had so engaged me in the past.

Also relevant is the fact that I teach in the Liberal Arts Department of a college of art and design, the Kansas City Art Institute; and as the sole social scientist on the faculty, I am in the fortunate position of being able to pursue almost any line of research without encroaching on other colleagues' academic turf. Although the school encourages professional development, unlike many universities, it does not require faculty members to turn out a steady stream of specialized monographs and articles for peer-reviewed journals.

As I was making the final changes to the page proofs for *Calliope's Sisters,* my wife and I had a child. He was my first, and one cool and sunny Saturday morning in the spring of 1989, still euphoric from the excitement of recent parenthood, I went out for a run. For me, running is insufferably boring. My sole reason for doing it (and not, for that matter, in large doses) is that with

my otherwise sedentary lifestyle, it is the only way I can indulge my love of desserts and not court an early death. To cope with the tedium of running, I wear a portable radio headset, usually tuned to a National Public Radio news broadcast. On the Saturday morning in question, however, the local station was having its spring fund drive, so I was listening instead to music on another station. I enjoy many kinds of music, but as my morning run took me into a park dappled with spring flowers, the song that happened to come on the radio was the Barry Mann oldie that asks, "Who put the 'bomp' in the 'bomp, bomp, bomp'? Who put the rhyme in the 'ranga-danga-ding-dang'?" Later, Mann continues, "Who was that man? I'd like to shake his hand. He made my baby fall in love with me!"

It was a revelatory moment for me! Like most other American adults, I had heard (and dismissed) the song often before; but this time, probably because circumstances both intellectual and personal had opened the door to vast new opportunities, I actually paid attention to the lyrics. In claiming that "bomp" (i.e., music, i.e., *art*) can cause a person to fall in love, the lyrics were making an *aesthetic assertion,* attributing a significant emotional power to bomp/music/art. In non-Western cultures, such remarks are the raw material of aesthetic systems; and in less time than it took me to finish the remaining mile and a half of my Saturday morning run, I knew what my next project would be: I would examine art in America but would do so from the unique perspective of cultural anthropology.

I discuss the ramifications of my approach to American art in various contexts in the chapters that follow; but to put my proverbial cards on the table at the outset, here are the defining principles that underlie this project:

- Unlike most others who write about art, such as art historians, art critics, and aestheticians, I look not only at the fine arts but also at the popular arts. *Of course* there are differences between the two; but inasmuch as both are significant sites for artistic production and consumption in our current environment, to ignore one at the expense of the other is to produce an incomplete account of art in America.
- I do not take my job to be passing judgment on artworks, artists, art styles, or aesthetic paradigms. *Of course* I have my own preferences; and as a "native" of the culture in question, many of them coincide with the views of the people whom I talk about in this book. Following the principle of cultural relativism, however, I find it easier to understand cultural practices by taking them on their own terms rather than by measuring them according to the yardstick of my own personal value system.
- If my own judgments are irrelevant, the judgments of other Americans themselves (as well as the reasons they give for their judgments, the behaviors through which they act out those judgments, and so on) provide the raw

material on which my analysis is built. *Of course* not all Americans have identical views on every subject, any more than do the hundreds of thousands of Navajos in the American Southwest agree with each other, or the millions of Yoruba in Nigeria agree with each other. But how could such vastly populous societies continue to exist without some degree of integration and coherence in their belief systems? My job, obviously a challenging one, is to discover and document such artistic integration and coherence that does exist.

A final point may be obvious but ought to be stated explicitly at the outset: *Of course* American art is too diverse and complex to be surveyed exhaustively in a single book. (Indeed, my use of *America* when I mean to refer only to the United States reminds us of the great diversity and complexity of the American continents that we share with so many other cultures and nations.) I have done as much as I can; and in the subtitle of this book, I concede the incompleteness of my efforts: This book comprises a collection of

Figure 0–1 *Chief's gate—in context. Driving down Nicholson Street in the "East Bottoms" neighborhood of Kansas City, Missouri, some people might not notice the things around Chief Korzinowski house, and others might see only a yard full of "junk." But the artistry of Chief's work is apparent to anyone who takes a closer look at objects such as his fence gate, which, visually isolated from its environment, appears on the cover of this book.*

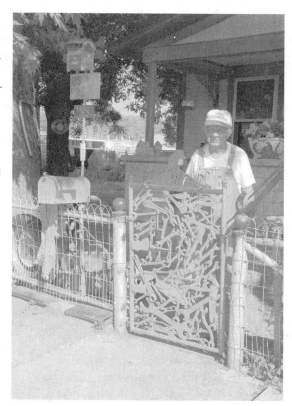

"excursions" into American art and aesthetics. I believe that the forays described in the chapters that follow reveal the principle attractions, the must-sees; but many side roads have yet to be explored.

After all, I started with the intention of carrying out a project that would not stretch on for as long a time as did *Calliope's Sisters,* and although this has been perhaps the most enjoyable book I have written, the fact is that my son William, whose birth may have indirectly sparked the idea that led to it, will be ten years old when this book sees the light of day. Time *does* fly when you're having fun!

Throughout the duration of this project, I have been helped by many people in many ways. I wish to thank Joann Keali'inohomoku, who, in her review of a late draft of *Calliope's Sisters,* planted (perhaps unintentionally) some seeds in my mind that find fruition in this book. I stand in debt to all of the individuals I interviewed, photographed, videotaped, and otherwise received information from for Chapters Two, Three, and Six through Ten. For Chapter Two, they include Kim Anderson, Dick Jobe, and Carmen Servin Tamayo; for Chapter Three, Kim Crenshaw, Pete Fosselman, Baila Goldstein, Francy Bedford Johnson, Larry Johnson, Milton Katz, and Patricia Stewart; and for Chapters Six through Ten, Dielle Alexandre, Donna Allen, Kim Anderson, Ed Bartozsek, Lee Berkowitz, Susan C. Berkowitz, Michael Christie, Jack Cox, Liz Craig, Steve Cromwell, Bill Desmone, Debra Di Blasi, Joe Egle, Arnold Epley, "Eve," "Frankie," Michele Fricke, Ted Gardner, Larry "Fats"Goldberg, Lester Goldman, Teddy Graham, Jimmy Green, Joyce Halford, Chris Harris, Rev. Wallace Hartsfield, Donna Hobbs, Roger Hurst, Nancy Jenkins, Dick Jobe, Linette Johnson, Steve Johnson, Jan Jones, Marya Jones, East Coast Al Kimber, Kim Kircher, John "Chief" Korzinowski, Renée Lindberg, Celeste Lindell, Linda Lindell, Gene Lowry, Rev. Bo Mason, Theresa Maybrier, Carol Mickett, Lawless Morgan, Arielle Thomas Newman, Robyn Nichols, Jane Overesch, Gail Owens, Karin Page, Jim Perucca, Jack Rees, Loretta Rivard, Nick Rivard, John Schaefer, Jim Schindelbeck, Marvin Snyder, Lou Sondern, Boyde Stone, Maria Vasquez-Boyd, Sally Von Werlhof-Uhlmann, Dr. Ken Walker, Tracy Warren, Bill Whitener, Bonnie Winston, and Doug Wylie.

Also, numerous people have read and commented on part or all of the manuscript at one time or another. They include Kim Crenshaw, Debra Di Blasi, Holly Dilbeck, Susan Feagin, Jeane Fortune, Baila Goldstein, Chuck Haddox, Harvey Hix, Milton Katz, John Mariarty, Lea McChesney, Bill Schurk, Tom Trillin, and Nancy Yoffie. In ways great and small, all of them have contributed to the clarity and coherence of what I have written.

The wedding photographs that illustrate Chapter Three were taken by Minneapolis photographer Kathleen Day-Coen, who has generously allowed

me to use them here. My colleague Steven J. Cromwell gave invaluable assistance with numerous computer-related challenges; another colleague, Paul Mazzucca, helped me with the cover graphic; and my pal from high school, Jim Dawson, made several useful suggestions regarding my remarks about popular music in Chapter Five.

Substantive suggestions for the text also came from John Dilworth, Denis Dutton, and a third anonymous reviewer who, at the request of Prentice Hall, invested substantial time and thought into constructively criticizing the manuscript as it neared completion.

At Prentice Hall, I give great thanks to Nancy Roberts, with whom I have worked for many years. Her unflagging support of this project, from inception to completion, made it possible for me to pursue my work, confident that it would see its way to publication. At Pine Tree Composition, Bruce Hobart greatly facilitated production of the book; and copy editor Carolyn Ingalls not only spotted and corrected countless stylistic snafus but suggested changes that greatly clarified myriad muddled phrasings. To both of them I give sincere thanks.

As always, the greatest help came from my family. My wife, Kim Anderson, conceived the book's cover, made sharp-eyed suggestions for the book's illustrations, and gave me countless editorial suggestions, ranging from minor stylistic points to major conceptual analysis, thereby improving the text significantly. She and my son, William Archer Anderson, have taught me more about life and about art than I could have learned in any library.

Richard Anderson

1

Introduction

PROLOGUE

During the last two decades of my career as a cultural anthropologist, I have been involved primarily with art in other societies, and my conclusions in that domain are unequivocally clear: In the dozen or so cultures that I have studied in depth, art is an absolute necessity.[1] Consider, for instance, the following evidence from three non-Western societies.

The arts of sculpture, body decoration, music, dance, and song helped the aboriginal peoples of Australia survive in the semiarid vastness of their traditional homeland. Without the elaborate rituals of initiation and the requisite graphic and performing arts, successive generations of aboriginal youths could not have attained the status of adulthood and so have become heirs to the rich repertoire of their elders' culture; nor would they have received many kinds of vital information, from courtship techniques to lessons in local geography (Berndt 1976). Moreover, the varied methods of aboriginal body decoration aided in the formation and maintenance of social networks. Needless to say, these art-contingent benefits could well have made the difference between life and death; and before dismissing the aboriginal claim for the necessity of art, one should reflect on the fact that without the

[1]See especially R. Anderson 1990a; see also R. Anderson 1979; 1989; and R. Anderson and Field 1993.

1

niceties of Western technology, most of us urban-dwelling Americans[2] would probably perish in the Australian environment.

To cite a second example, art so permeates the daily lives of traditional Navajos that one scholar, Gary Witherspoon, who has spent much of his adult life living with them, says that Navajos "don't admonish one 'to be beautiful' or 'to see beauty' but to 'walk (live) in beauty' and to 'radiate beauty'" (Witherspoon 1977:32). Indeed, the Navajo people exist in a world where many women weave, where most men compose songs, and where beauty is thought to pervade virtually all things, as reflected in this Navajo prayer:

> With beauty before me, I walk
> With beauty behind me, I walk
> With beauty above me, I walk
> With beauty below me, I walk. (Witherspoon 1977:153)[3]

A final example, taken from another point of the compass, is provided by the people of the Yoruba kingdoms of Nigeria, West Africa. Yoruba sculpture is world-famous for its power and grace; the sophisticated canon of criticism used by Yoruba connoisseurs of visual art has been made available to Westerners (see, for example, Thompson 1973); and Yoruba ceramics, textiles, and performing arts are also highly developed. But aesthetic merit aside, art also plays a vital role in sustaining fundamental beliefs and values in Yoruba culture. Yoruba arts embody, and thus validate, important ethical principles: Just as a "beautiful" wooden statuette should portray its subject as being full of vital energy while simultaneously being balanced and grounded, a "good" Yoruba person is powerful and at the same time is expected to live in harmony with Yoruba society and tradition.

Art plays a crucial role in Yoruba speculative thought, too. One passage of Yoruba divination poetry tells of Olodumare, the high (but remote) Yoruba god, sending his superenergized power to earth via three seminal entities, which are known collectively as *Ọrọ̀*. On earth this same *Ọrọ̀* is equated with divination proverbs themselves, and it extends metaphorically "to the communicative properties of sculpture, . . . dance, drama, song, chant, poetry, [and] incantations" (Abiodun 1987:255). That is, thoughtful Yoruba conceive art to be an earthly manifestation of Olodumare's divine energy.

With these three non-Western cases in mind, imagine a community in America being visited by a researcher from another culture, a perceptive individual with a newly arrived foreigner's innocence. At the end of a year or two's

[2]With apologies to our neighbors to the north and south, I follow the common convention of using "America" and "Americans" in preference to the more unwieldy "United States" and "residents of the United States."

[3]I have been told of highway signs along the roads in the Navajo Reservation that admonish, "Buckle Up/Drive in Beauty" (Elizabeth Anderson: personal communication).

fieldwork with us "natives," what conclusions would the person have drawn with regard to art in America?[4] Would he or she see our lives (and minds) as being full of concerns about business, recreation, and technological gadgetry, but as being very little involved with art; or would the picture be on a par with that of Australian Aborigines, with their spiritually potent art, with the beauty that pervades the Navajo universe, or with the Yoruba and their art that encodes fundamental ethical and metaphysical principles? Moreover, how would the foreign researcher arrive at these conclusions? What data would be pertinent, and what assumptions and definitions would undergird the analysis?

Given these questions as prologue, I can now state the two propositions that the following chapters will develop—and that will, I believe, be convincingly supported by extensive evidence and reasoned argument. First, I propose that *there is an enormous amount of art in America today*—far more than is generally recognized by most people, scholar and nonspecialist alike.[5] Second, I propose not only that art is remarkably ubiquitous (after all, one could broaden the definition of art so as to encompass everything and then conclude that everything is art!) but also that *art plays an extremely important role in the lives of many individual Americans* and that by addressing several fundamental human concerns, *art looms large in our civilization as a whole*. Subsequent chapters will show that although the significance of art is muted in most public discourse, there is compelling evidence for art's having considerable power and influence in the day-to-day lives of Americans. The remainder of this chapter will address necessary questions of theory, laying out assumptions and definitions and defending their usefulness for the purpose at hand.

EMPIRICAL STUDIES OF THE ARTS

Like the other "-ologies," anthropology was founded on the model of the physical and biological sciences; but because some writers in recent years have questioned the viability of anthropology as an empirical science,

[4]The success of this "mind experiment" is clearly contingent on our hypothetical non-Western anthropologist's possessing a cultural category that parallels our category, *art*. For the moment, I can only ask the reader to imagine that such is the case and promise that subsequent pages of this chapter will offer a definition of *art* that is not tied to the conventions of Western fine art.

[5]I myself, in the "Epilogue" of *Calliope's Sisters*, concluded that by comparison with the non-Western societies whose aesthetic systems had been described in preceding chapters, we Westerners "do not live particularly aesthetic lives" (R. Anderson 1990a:288); and that our contemporary philosophies of art make little contribution to the spiritual and ethical dimensions of culture.

However, in two footnotes (prompted by a prescient remark by Joann Keali'inohomoku), I recorded the reservation that such an estimate applied only to the fine arts and that a quite different conclusion might result if the popular arts were to be included in the analysis.

especially with regard to such an ephemeral and nuanced phenomenon as art, I must begin with a brief justification for the approach that I am taking.[6]

Postmodern critics of the scientific paradigm in anthropology have called attention to the influence of two types of subjective factors in the execution of the anthropological endeavor. First, it has been argued that because much (or, by some accounts, all) of the primary data of cultural anthropology derives from the thoughts and feelings of others, an empirically grounded anthropology is impossible because such information is abstract, changeable, and remote, and thus not knowable with certainty. Second, say the critics, even if such data could be gathered, the researcher's own subjectivity inevitably influences the descriptions, the explanations, and the predictions that the data are used to support.[7] Specifically, because conflicting accounts have been given of some cultural phenomena, it has been claimed that unlike the natural sciences, anthropological propositions cannot be refuted by the presentation of contradictory evidence. If accurate description is unlikely and if unbiased explanation impossible (the argument goes), anthropology can yield not science but only *interpretations*, conveying humanistically the multiple meanings and the intuitive "feel" of the symbolic acts that constitute cultural life.

But I (and others—e.g., O'Meara 1989; D'Andrade 1995) believe that there are several compelling reasons why the interpretivist critique does not rule out the possibility and usefulness of pursuing an empirical anthropology. For one thing, not all anthropological data must be sought in the minds of others, since behavior is relevant too; and behavior itself, especially speech behavior, does provide some access to cognitive and affective data. That is not to say that access to the inner realm is easy—but then neither is access to the behavior of, say, subatomic particles; and nuclear physicists have demonstrated an impressive measure of success in determining the particles' unlikely nature. Obviously, human observational skills, including the ability to ask questions and understand answers, are imperfect tools for studying other peoples' thoughts and feelings; but even the most

[6]In the following remarks, I accept O'Meara's use of "empirical science" to mean "the systematic description and classification of objects, events, and processes, and the explanation of those events and processes by theories that employ lawful regularities, all of the descriptive and explanatory statements employed being testable against publicly observable data" (O'Meara 1989:354).

Of course, many things fall under the rubric of "publicly observable data," from the chemists' laboratory findings to, in the following chapters, such things as brides' accounts of their preferences in wedding gowns. All such data require interpretation, but the scientist's striving objectively to interpret empirical data is distinguishable from the humanist's creative interpretation of, say, a literary text.

[7]See, for example, Geertz 1973; 1983; Tyler 1986; Clifford 1988; Ruby 1982; Taylor 1979; and a long series of articles and letters that appeared in the *Anthropology Newsletter* during 1996 and 1997.

cynical must admit that *some* relationship exists between actions and words, beliefs and affects, and that *sometimes* the relationship can be plausibly determined.

Also, seemingly contradictory findings do not nullify empirical efforts and should not thwart the search for explanatory patterns. Rather, they constitute problems that call out for solutions. Consistent differences between sectors of a given culture; changes within a culture that occur over time; and individuals' varying reactions in varied contexts—all are interesting and important subjects for inquiry.

In sum, in the following chapters, I assume that art and aesthetics in America have an objective reality, one that can be empirically studied. Obviously, some data, such as the attendance at fine arts museums or the readership of gothic romances, can be determined with a fair degree of certainty; others, such as the way that a museum-visitor or romance-reader responds to a given work, are also determinable—albeit with a greater degree of doubt. To assert otherwise, I believe, runs contrary to our daily experience and common observational and conversational faculties: We can seldom say *exactly* what a smile or frown means, and we cannot always trust the verbal accounts that accompany them; but the fact that we function at all in our articulated, social lives is testament to our knowing something about such deeds and words.

At the same time, I have no illusions regarding the *level* of science that my undertaking involves. If the goals of science are, successively, to describe, to explain, to predict, and finally to control; then little of what follows rises above description; and even my descriptive accounts will be on a fairly rudimentary level inasmuch as none of my substantial findings lend themselves to sophisticated statistical analysis. Thus, my first general thesis, that America is remarkably rich in art, can be accepted only in general terms. Art's significance cannot be placed precisely on the proverbial "scale of from one to ten." But when all of my evidence and argument is complete, I expect to have supported my premise convincingly and to have done so in an empirical fashion.

DEFINITIONS, PART I: ART AND AESTHETICS

Like a chameleon, the word *art* takes on differing colors, depending on the verbal foliage in which it is found. Thus, it makes no more sense to speak of an eternally and universally "true" meaning of the word than it does to assert that if virtually anything has the potential to be transformed into art, then *art* must be everything. Avoiding the extremes of dogmatic proclamation and

undiscriminating relativism, I think that for present purposes, the best way to define *art* is to follow a strategy proposed some time ago by the philosopher Morris Weitz (1957; see also Kennick 1958; Gallie 1964; Davies 1991; Graves 1998). Weitz pointed out that although there have been countless efforts to narrowly specify a trait (or a list of traits) that is necessary and sufficient to determine unequivocally, now and forever, whether or not something is art, all attempts have foundered on the craggy reality of ever-changing cultural understandings of what *art* refers to.

Following Ludwig Wittgenstein's dictum, "Don't say: 'There *must* be something in common'—but *look and see!*" (quoted in Weitz 1957:31), Weitz claimed that when we actually examine the way *art* is used, the best anyone can do is to generate a list of traits (or "recognition criteria"), most (or all) of which are present in most (or all) of the things that are considered to be clear instances of *artworks* at a given time in a particular speech community. Conversely, things that the same people agree to be *not art* lack most or all of these traits. Between *art* and *not art*, there exists a gray area, where things are accepted as being art to the degree that they possess the recognition criteria that characterize artworks. Furthermore, as the passage of time brings about different usages of *art*, or as one moves into different speech communities, the list of similarities must be altered as little or as much as is required by current, local custom.[8]

Weitz himself offers a list of recognition criteria for *art*, which is based on the way he (and other thoughtful Westerners) use the word. He says, "Thus, mostly, when we describe something as a work of art, we do so under the conditions of there being present some sort of artifact, made by human skill, ingenuity, and imagination, which embodies in its sensuous, public medium—stone, wood, sounds, words, etc.—certain distinguishable elements and relations" (1957:33). Several of the items in Weitz's list deserve comment.[9]

First, it is clear that most artworks are things—material or behavioral **artifacts**—that have been **produced by humans** (hence, earlier English writers' tendency to contrast art with nature). Moreover, we generally expect artworks to be made by **skillful** humans. In fact, *artem*, the Latin root of *art*, meant "skill of any kind"; and for the first four hundred years after its thirteenth-century introduction into English, that remained its principal

[8]In previous writing (R. Anderson 1989; 1990a), I also followed Weitz's approach, but subsequent discussions with Susan Feagin further clarified my understanding of Weitz's seminal article.

[9]The following discussion of *art* also draws on Raymond Williams's (1976) useful essays on the histories and contemporary usages of these words.

meaning in English, a usage that still occurs in such phrases as "the martial arts" and "the art of persuasion."

By the late seventeenth century, however, as we ourselves became more specialized in our daily lives and occupations, a more specialized meaning of *art* began to appear. With increasing frequency, *art* referred to the exceptional skills associated with painting, drawing, engraving, and sculpture; and by the late nineteenth century, that was the dominant use of the word. This change was the historical source of three more of the recognition criteria that Weitz associates with art: First, arts such as painting and sculpture usually involve the skillful manipulation of media that are **public** in nature. (As Weitz points out, a work that exists only in its creator's mind *might* be considered to be art, but this possibility is much more the exception than the rule.)

Second, we generally expect artists to give serious consideration to the **sensuous** potentialities of their media—hence the distinction between art and science. (Here, and throughout this book, by "sensuous," I mean "of or relating to any of the senses," not to be confused with "sensual," which tends to be restricted to the more carnal of the senses.) As Weitz's comment suggests (". . . stone, wood, sounds, words. . ."), the senses to which the arts appeal include not only those of vision and hearing but also the kinesthetic sense (for dance); and the senses of taste and smell can be excluded only arbitrarily. (I am not the first to point out that we have no name for the "sense" to which literature appeals. For oral literature, the sense of hearing is called into play, and vision is required for reading; but there is no sensory organ that is stimulated by narrative.)

Third, we now usually take for granted that the artist's skills necessarily include an intellectual, creative dimension, so that an artisan (that is, a "skilled manual worker" [R. Williams 1976:33]) is distinguished from an artist—prompting Weitz's reference to **ingenuity and imagination** as being common features of art. (Ellen Dissanayake's insightful *Homo Aestheticus* [1992] pursues the countless ways in which the artist "makes special" by use of his or her exceptional skills. Similarly, Denis Dutton has noted that the arts everywhere are "bracketed off from ordinary life, made a special and dramatic focus of experience" [1998:17].)

Weitz's fourth, and final, criterion, that art embodies "certain **distinguishable elements and relations**" (ibid.), could be interpreted parochially to imply that when we call something an artwork, we expect it to manifest specifiable formal features, such as (in the visual arts) certain canonical principles of composition as form, line, color, and so on. Given the demise of formalism and inasmuch as Weitz's prime concern was to free art

from the constraints of dogmatic aesthetic theorizing, I take the phrase instead to refer to a much more generalized principle, namely, that typically a thing that we call an artwork demonstrably shares stylistic features with other works, usually those produced in a not-too-distant time and place.[10]

Thus, in the following chapters, things will be considered to be art to the extent to which they are

- Artifacts of human creation;
- Created through the exercise of exceptional physical, conceptual, or imaginative skill;
- Produced in a public medium;
- Intended to affect the senses; and
- Seen to share stylistic conventions with similar works.[11]

To apply such a definition to things in the real world requires only that we are able to *recognize* these criteria when we encounter them: There is no presumption that one criterion takes precedence over another or that, for example, art whose production requires great conceptual skill is better or worse than one demanding exceptional physical skill. That said, I believe that Weitz

[10]In an earlier book [1990a], I offered a list of traits that are typically found in most of the things we consider to be art not only in the West but in other cultures as well. That list is consistent with the one being developed here, albeit with one exception: Most of the makers of the art discussed in that book expected it to convey a quality that I glossed as "significant cultural meaning," Western art being the most problematic case for this generalization to apply to. I exclude cultural significance from the present discussion of the meaning of *art* for two reasons. First, my understanding of contemporary American society is that most of us do not overtly expect art in America to convey culturally significant meaning; and this interpretation is supported by the fact that neither of the sources I am here using, namely Weitz and Williams, includes this quality in his discussion of our usage of *art*. Second, the cultural significance of art in America is one of the central questions under investigation.

[11]Aestheticians Denis Dutton and John Dilworth have noted (personal communications) that the concept of "aesthetic attitude" is absent from this discussion. Several seminal philosophers of art (e.g., John Hospers, Jerome Stolnitz, and Edward Bullock) and some anthropologists (e.g., George Mills and Jacques Maquet) have sought to avoid some of the difficulties of defining artworks in terms of their intrinsic properties by focusing instead on what they take to be a distinctive attitude (described in negative terms as being "non-practical," "non-cognitive," and "non-personal" by Hospers [1969:3]) of the properly attuned person's response to art. Such an approach can be illuminating with regard to Western fine art, although George Dickie (1964) has called even that particular application into question, and Richard Shusterman has written of "the end of aesthetic experience" (1997).

Some years ago, however (Anderson 1979:14-18; 1989:14–16), I made the case that in non-Western settings, problems of cross-cultural translation of psychological states make this approach considerably more trouble than it is worth. Moreover, for some things that many people would unequivocally consider to be artworks, be they drawn from non-Western societies or from American popular culture, we might well have to wait a *very* long time before finding an instance of someone from the art-producing culture apprehending it with a purely "aesthetic attitude."

Thus, rather than defining the subject of study as the things that the attuned percipient appreciates via an aesthetic attitude, I use the preceding list of recognition criteria to demarcate the domain of art and then ask, "What attitudes do people have regarding them?"

has provided the only viable approach for distinguishing art from nonart, to say nothing of the important, albeit fuzzy, category of semi-art.[12] Nonetheless, several related problems remain to be addressed.

First, like most other anthropologists, I seek a methodology untainted by the ethnocentrism and elitism that have been attributed, often correctly, to the efforts of many white, male, American scholars. In this particular instance, it could be claimed that when all is said and done, the foregoing characterization of *art* will necessarily lead to uncritically demarcating the domain of art in such a way as to exclude popular art and to include only things that are found in fine art museums and galleries, that are listed on the programs of symphony orchestra concerts, and that constitute the Great Literature (pronounced "li-ter-a-tyure," not "litter-chr") of the West, together with all other art forms whose primary constituency is the American upper class and upper-middle class.

But such a procedure is not dictated by the way in which I am construing *art*, and it will certainly not determine my use of the term. In fact, although the following pages give serious consideration to the arts whose chief patrons and audience are the American socioeconomic elite, I devote much more attention to American popular art. There are both habitual and theoretical reasons for doing so. First, as an anthropologist, I am interested in the *total* artistic output of societies, and if the society happens to contain distinct social strata, I am interested in the output of *all* of the strata.[13]

Second, and more important, the traits previously listed are clearly present not only in most American fine arts but also in American popular arts. For example, it goes without saying that a customized low-rider automobile, a rhythm-and-blues favorite, and a gothic romance are aesthetically (and, for that matter, ideologically) different from a museum sculpture, a classical symphony, and a Shakespearean play. Nevertheless, the car, the song, and the romance all unambiguously manifest the features that are commonly associated with art: Each was produced by individuals whose exceptional imaginative and

[12]With regard to the gray area between art and nonart, Graves notes, for example, the perennial "transgressive tradition" in Western art, whereby individuals create works that "subvert or undermine prevailing artistic conventions and practices" (1998:43). I think that in the larger picture of things, the vast majority of art (both Western and non-Western) is not transgressive in this sense. However, when such works do appear and are accepted into the canon at a later time, the process of cooptation changes their status from semiart to art while simultaneously effecting an evolution of conventional thinking about what is, and what is not, art.

[13]If much Western scholarship has overemphasized the culture of the elite, anthropological studies of complex cultures have often had the opposite bias, focusing on mass culture and ignoring the culture of the aristocracy. I have tried to strike a middle course. For example, of the sixty-four people I interviewed for Chapters Six through Ten, eleven, or 15 percent are primarily involved in the fine arts.

technical skills are recognized by informed others; each is executed in a sensuous, public medium; and each embodies the diverse stylistic conventions that characterize their respective genres; that is, *they are art*. Individuals undeniably differ in their perception and evaluation of skill, imagination, sensuousness, and so on. Thus, the connoisseur of Jackson Pollock's paintings and the custom car aficionado may have trouble seeing, much less responding to, the mastery, creativity, and beauty of each others' favorite pieces. Predictably, however, they both critically analyze and articulately discuss the artistry of the works that appeal to their respective tastes. Thus, although the recognition criteria of art listed earlier were first discussed within elite-supported academe, things that meet the criteria are by no means limited to elite art.

Another difficulty with the Weitzian approach (at least, as I am using it here) concerns semi-art, that is, material that falls somewhere between art and nonart, a sizable and unwieldy borderland for anyone who expands the domain of art to include popular art. One person who has done so is John Forrest, whose book *Lord I'm Coming Home: Everyday Aesthetics in Tidewater North Carolina* (1988) attempts empirically and exhaustively to document the artistic components of common people's lives. Following Forrest's lead, I will use the word *artistic* to refer to things that have some, but not all, of the qualities commonly associated with art.[14]

There is a third problem with the Weitzian approach as I use it here: It can include some things that few, if any, contemporary Americans would otherwise consider to be art. Take, for example, the method by which water is fluoridated in most American cities. The process is carried out by a small number of individuals who possess the exceptional skill of being able to produce fluoride compounds and to introduce them into water supplies in the minute amount that is needed for therapeutic results, a technique that reflects the considerable creativity and ingenuity of twentieth-century American chemical engineering and technology. Moreover, hardly anything is a more "public medium" than water; and water is fluoridated for ultimately sensuous reasons, in that water containing about one part per million of hydrofluosilicic acid leads to a 60 percent reduction in dental cavities, which in turn improves personal appearance and decreases the likelihood of (sensuously unpleasant) toothaches and dental work. (On the other hand, more than one-and-a-half

[14]For his part, Forrest uses *aesthetic* rather than *artistic*. I have adopted the latter because I am using *aesthetic* to refer to "philosophy of art."

Forrest focused on things such as duck decoys, which are considered to be art by the people he lived with but not by the conventional fine art community. In that respect, my approach parallels Forrest's. But his definition also includes sunsets (which I do not include), and it leaves open the possibility of there being things that are "potentially aesthetic" (p. 24), such as fishermen's boats, that is, things that we might think of as artworks but that, in fact, never are considered as such by the people who build and use them.

parts per million of the same chemical can cause unsightly mottling of the teeth.) One could further argue that fluoridation is accomplished in an identifiable "stylistic tradition," in that the procedure began in the 1930s, rapidly spread to almost all cities in America and several other countries, and at present is performed by use of similar (but not identical) techniques throughout the land.

But although it arguably meets the recognition criteria of "art," who would call water fluoridation an art form? Perhaps within the small circle of fluoridation experts, a few individuals are known for their exemplary performance; and their colleagues might sometimes call them the "true artists" in the field. Such a usage returns *art* to its broader, pre-seventeenth-century meaning of an exceptional human skill in *any* endeavor.

The only way that I see to close this loophole is by narrowing the recognition criteria of art in such a way that "false positives" such as water fluoridation do not meet them but that activities we conventionally think of as being fine and popular art forms do meet them. Thus, in keeping with contemporary usage, I would suggest that when Americans use the term *art*, as in "fine art" or "popular art," in most instances they implicitly limit it to skills that have a **direct and immediate** sensuous effect. Thus, painting a picture or singing a song may be considered to be art; but art (in this sense) is not involved in manufacturing fluoride compounds in a chemical factory and adding one part per million of them to public drinking water supplies, so that at some unspecifiable time and place in the future, the people who drink the water will have teeth that generally look and feel better.

But what of photography and the composition of New Age electronic music? Either activity clearly could be an art form, despite the fact that the artist is far removed from the audience by time, place, and technology, much in the same way as the industrial chemist is removed from people with better teeth.

Dilemmas such as this make me glad to be an anthropologist, rather than a philosopher! Some sorts of consistency are typically present in traditional cultural constructs, as Lévi-Strauss and other structuralists were at pains to show; but perfect consistency is far from inevitable in all cultural realms. That being the case, I will proceed by accepting the Weitzian approach to delimiting art, while admitting that it leaves some problems unresolved.

One final component of my adaptation of Weitz's approach must be noted. Weitz distinguishes two uses of the word *art*. The first, which he calls "descriptive," has been, and shall remain, my own primary concern in the following account of art in America, an undertaking that is essentially ethnographic in nature. But Weitz also notes a second usage of *art* that he calls

"evaluative." It is based on "the view according to which to say of something that it is a work of art is to imply that it is a *successful* harmonization of elements" (Weitz 1957:34, emphasis in original). From such a perspective, to call something art is to identify it as *excellent* art, causing such phrases as "mediocre art," "amateur art," or "second-rate art" to be self-contradictory. It is also worth noting that evaluative criteria are as omnipresent in the popular arts as in the fine arts. (Denis Dutton [1998:16] has observed that "indigenous critical language of judgment and appreciation" is also typically present in tribal societies.)

In the following chapters, I avoid using *art* evaluatively, except when quoting the evaluative views of others.[15] However, using *art* in a purely descriptive fashion will lead me to include in the category some things that are, by virtually any standard, of a very second-rate artistic nature. To use myself as an example (and thus avoid offending others), consider my own singing. Although I have never had any formal vocal training, and despite the fact that even the most charitable of listeners would find it difficult to say anything better about my singing than to call it enthusiastic, I nevertheless consider it to be music—that is, to be art. By so categorizing it, I do not mean to suggest that the quality of my voice is particularly sonorous (it is not), that my sense of pitch is well developed (no, again), or that my repertoire is exactly sophisticated (far from it!). Rather, for current purposes, I consider my singing to be music because despite its considerable limitations, it clearly has more in common with performances by expert singers than it does with my own everyday, nonsinging verbal behavior. Thus, after my fashion, I do attempt, albeit often unsuccessfully, to produce an aurally sensuous effect; I have enough skill to get most of the notes and words approximately right; my performance generally conforms to Western vocal music traditions; and sometimes I even have the temerity to perform within the earshot of others, notably with a circle of friends, all more proficient than I, who occasionally spend evenings playing and singing bluegrass music together. Therefore, for purposes of analysis I classify my singing (and other such efforts, by myself and by any other amateur, in music or in any other sensuous medium) as art.

I close this discussion of definitions of *art* and *aesthetics* with some comments about approaches to vernacular aesthetics that I will *not* adopt, although others have used them successfully for their own purposes.

[15]Although I use the preceding recognition criteria in a descriptive way, one could easily convert them into standards for evaluation, asserting, for example, that being executed with exceptional skill confers aesthetic value on an artwork. Describing such ideas that Americans have about art is part of my aesthetic/ethnographic project, but doing so requires persistent relativism on my part. That is, I do not assume that exceptional skill is intrinsically good or bad; but I do find it interesting and significant that many Americans expect superior art of most media and styles to be produced with great skill.

The claim that art could not be defined in a simple and lasting fashion, as argued by Weitz and others in the 1950s, was not the last word on the subject (cf. Carroll 1986:57–58). A decade later, the "institutional" approach was forged, growing out of the work of such writers as George Dickey, Howard Becker, and Arthur Danto. According to this approach, an object is considered to be art if, and only if, it is accorded that status by members of the "Artworld," which, in turn, is defined as "a loosely organized, but nevertheless related, set of persons including artists. . . , producers, museum directors, museum-goers, theater-goers, reporters for newspapers, critics for publications of all sorts, art historians, art theorists, philosophers of art, and others" (Dickie 1974:35–36). Such an approach is appealing because of its sociological, potentially nonelitist perspective, but it is of limited usefulness to my own purposes because of its emphasis on social relations (described, for example, by Becker as "the sociology of occupations applied to artistic work," 1982:xi). Links between the creators, purveyors, and consumers of art are fascinating, but they are tangential to art itself. Thus, Chapters Six through Ten present an ethnographic account of people who are seriously involved in the arts, although they are not sufficiently connected with each other to constitute an "Artworld."

On the other hand, *pre*-Weitzian assumptions still hold sway in some circles, especially outside the domain of philosophy. For example, Kris Hardin, an anthropologist, has suggested that previous work by her and others provides "models for avoiding the dilemma of Euro-American categories" of art (Hardin 1991:120). For example, an earlier paper by Hardin (1988) avoids difficulties in art by focusing instead on aesthetics. In doing so, she follows a suggestion made by d'Azevedo thirty years earlier (1958) and utilized more recently by Maquet (1986). Namely, she assumes that the "aesthetic response" is the definitive trait of interest and believes that such a response can be unequivocally identified in non-Western cultures. But as I have pointed out (Anderson 1979:14–18; 1989:14–17; see also Dickie 1964; Carroll 1986), although some researchers write as if they are unequivocally able to recognize the objects and activities in other societies that have the potential to provoke an aesthetic response, they have not defined the response itself, nor have they presented evidence that such a response is experienced by (some or all) individuals in (some or all) other societies.

In summary, in the following chapters, I will use *art* to refer to things that have all, or most, of the qualities of being made by humans whose elevated intellectual, creative, or bodily skills are recognized by others in their group; of being imaginatively created in an immediately, and directly sensuous, public medium; and of sharing stylistic commonalities with other works

produced in proximate times and places. Things lacking most or all of these qualities are not considered to be art; and those between the two may be said to be "artistic." Finally, the word *aesthetics* refers to ideas about the meaning and role of art.

DEFINITIONS, PART II: *CULTURE* AND *POPULAR CULTURE*

Culture rivals *art* as a difficult term to define—indeed, Raymond Williams has claimed it to be one of the most complicated words in our language (1976:76). More than a century ago E. B. Tylor provided the nascent discipline of anthropology with the classic definition when he identified *culture* as "that complex whole which includes knowledge, belief, art, law, morals, custom and any other capabilities and habits acquired by man as a member of society" (Tylor 1958 [orig. 1871]: 51). By 1950 over two hundred refinements of *culture* had been offered (cf. Kroeber and Kluckhohn 1952), and the debate continues up to the present (cf. Shweder and Levine 1984; Freilich 1989).

As with art, we can perhaps best treat culture as an open concept, most incarnations of which, although not being identical, possess the following traits.

First, culture is not so much the observable behavior of flesh-and-blood human beings, nor is it the artifacts that such people make and use. Rather, culture is composed of abstractions—the implicit and explicit rules and values on which behavior and artifacts are based. Second, culture is not biologically inherited; rather, individuals *learn* culture by virtue of growing up in a particular society.

A third point requires more extensive consideration. Some usages of the word *culture* are meant to suggest "cultivation," or "civility," and in particular a familiarity with the fine arts. This meaning is clearly at odds with that of Tylor and subsequent anthropologists, which holds that people in *every* enduring society, and in *every sector within* such societies, have their respective values, behavioral strategies, and institutions—that is, they have their own cultures. Patrons of American fine arts assuredly possess a culture, one that cannot be ignored in any broad study of art in America. However, other people have their own art-related values, strategies, and so on; and inasmuch as they constitute a numerical majority within American society, I find their culture is at least as deserving of study as the culture of fine arts aficionados.

But once we accept the inevitable plurality of American culture, other questions immediately arise: How many cultures are there in America? Obviously, many. How much do they overlap each other? Some, a little; some, a lot. If we are to examine, not "art in America," but rather "arts in America,"

how many must we observe? There is no simple answer. Consider the possibilities in the visual arts alone. Each of the following not only is "American" in some plausible sense of the word, but also, I believe, meets the criteria of recognition for art stated previously: A painting by Robert Rauschenburg; a photolithograph by Andy Warhol; a poster that reproduces a scenic photograph by Ansel Adams; a billboard advertising a current model of automobile; a teenage boy's T-shirt, imprinted with an image of his favorite musician; a young Chicana beauty queen's appearance; a competitive bodybuilder's physique; a painted ceramic bowl, owned by a Hopi woman, made by her mother, and occupying a place of honor among the family heirlooms; and a colorful apron, designed and sewn by a Hmong woman, who recently migrated to the United States, to supplement her limited income in her new homeland.

This enormous diversity of American arts rules out certain research issues. Obviously, one could never expect to document every genre, every artist, every art appreciator. But other questions can, I believe, be profitably pursued. For one thing, it is reasonable and feasible to inquire into the importance of art in the more sizable American subcultures. It is equally interesting to ascertain the widely held assumptions about art's fundamental nature, as well as beliefs regarding the role of art in one's day-to-day life. It is these two questions that will engage us for the remainder of this book.

2

The Role of Art in Americans' Lives: Three Vignettes

In the course of a day, to what extent does one interact with art, as creator, as active audience-member, or simply by being exposed to art, or to things with distinctly artistic dimensions? I contend that, like fish unaware of the water they swim through, most of us, during most of our waking hours, are surrounded by art and artistic things. The goal of this chapter is to illustrate the pervasiveness of art in our daily lives.[1]

One way of accomplishing this goal is to consider the following vignettes from the lives of three people. The data were collected in November 1991 by videotaping each person's surroundings and activities for five minutes.[2] I had known each of the people for two or more years and I had asked, about an hour previously, if he or she would object to the videotaping. Each knew that I was an anthropologist and that I had written previous books on non-Western art; and each was told, very briefly, that I was now studying art in America—"not just the things that are in museums, but the things that people like you and me have around us all of the time."

[1]Two other extensive and excellent accounts of the arts of the American home are David Halle's *Inside Culture* (1993) and Colleen McDannell's *Material Christianity* (1995).

[2]Although some time has passed since this information was collected and even though details of the informants' lives and environments have changed, for the purposes of this chapter, the three cases remain fundamentally the same. Therefore, I have used the ethnographic present tense throughout the chapter.

No claim can be made that these accounts represent statistically random samples with regard either to the three people who were videotaped or to the extent to which the five-minute episodes are representative of their broader day-to-day lives. However, I would argue that they are not *atypical* in either of these regards. In the first setting, a private residence, a great many things are art, pure and simple, or at least they have a distinctly artistic dimension. Nonetheless, some other people's homes (e.g., that of Susan C. Berkowitz, whom I refer to in Chapters Six through Ten) have even more art in them. At the other extreme, the auto repair shop described later has relatively less art; but again, other places—even other auto repair shops—doubtless have even less.

What about the representativeness of the specific five-minute time periods that were videotaped? The amount of art in one's surroundings obviously varies from moment to moment and hour to hour, as the activities of the days, weeks, months, and years unfold; but I, as well as the people I videotaped, believe that the five minutes I recorded are fairly typical of their lives.[3]

KIM, A PAINTER

Kim Anderson, the first person videotaped, is an artist, the author's wife; and as might be expected, the record of her activities reveals a very high presence of art in her environment. But, as will be seen, the other two individuals, neither of whom is an artist, have only slightly less art around them; and of all the art in Kim's surroundings, only a very small portion falls into the traditional category of "fine art."

[3]Collecting ethnographic information by documenting the events in part or all of a not atypical day has a long precedent. Oscar Lewis's first study of a family in Tepoztlan (1951) includes a log (pp. 63–71) of each family member's activities, recorded at half-hour intervals. In *Five Families* (1959), the same author used day-in-the-life accounts as one component of his ethnographic descriptions (see, esp., pp. 18–20); and this technique became his primary organizing device in *La Vida* (1965, see, esp., pp. xxi–xxii). Meanwhile, Barker and Wright (1951) published an account of the activities of a seven-year-old boy during the course of one day; and Roberts (1965) recorded five days' events in a Zuni family's life. Such efforts, though interesting and useful, have proven to be ultimately Sisyphean: The more closely one examines the stream of behavior, the more there is to record—hence, the more than four hundred pages generated by Barker and Wright's team of researchers. The most extreme instance is a nearly two-hundred-page transcription of only five minutes of the interaction between a psychiatrist and his patient, even though the authors examined only the sound recording of the interview, omitting the visual and kinesthetic interaction, as well as all aspects of the setting in which the exchange took place (Pittenger, Hocket, and Denehy 1960).

Therefore, in the pages that follow, my goal will not be to record everything in an individual's environment but merely to record the things that are art, or are artistic, in the person's orbit during that period of time.

Kim is a middle-class woman in her late thirties in 1991, who paints in a studio in her home. During the videotaping, she is preparing to go to a photocopy shop to have postcards made to announce a current exhibition of her paintings. The first noteworthy artistic factor, one that is visible throughout the five-minute videotape, is the house in which she lives in Kansas City, Missouri. Many features of residences are determined by practical considerations, such as protection from the elements, availability of materials, cost of construction, and so on, but many other aspects are distinctly artistic in nature. In case there is any doubt that architecture is an art form, one should consider the extent to which architecture, including "vernacular architecture" (Kemp 1987) possesses the recognition criteria of art listed in Chapter One: Residences such as Kim's reflect the exceptional skill and ingenuity of the architect who planned it and the craftsmen who built it; they were designed in such a way as to enhance the sensuous—especially the visual—appeal of the dwelling; and they reflect a particular style, in this case the "airplane bungalow" dating from the 1920s, that may be found in other times and places, particularly in Florida and California, but also elsewhere in Kansas City. In fact, one of the houses next door to Kim's has a nearly identical floor plan, except that it is a mirror image of Kim's, and a previous owner claimed that the correspondence is a result of both houses' being the work of the same builder, a man who constructed them for his two daughters upon their marriage.

The artistry of the house (perhaps due in part to the builder's personal reasons for making the house) is particularly apparent in its architectural details: Although the house is far from grand in scale, it sports not only oak flooring throughout its main floor but also wide, golden oak moldings as ceiling coves and around the ten windows in the front rooms of the house, as well as oak wainscotting in the dining room. The importance of the artistic dimension of the house is revealed in the circumstances under which the house was purchased five years ago. Kim and I happened to see it on the second day that the house was on the market, and we made an offer to buy it almost immediately. Admittedly, we were satisfied by the house's practical features (floor plan, mechanical systems, cost), but it was the oak woodwork, which had never been painted, that made us so eager to buy it. (After moving in, Kim's feelings about the woodwork have become more complicated: As an artist, she wants ample, natural lighting, but the oak flooring and woodwork cause the house to be darker than she would like. Nevertheless, the oak remains unpainted, at least in part because Kim and I hope that we, too, will be able quickly to find a buyer for the house should we ever decide to move.)

Kim's house is not the only architectural structure that she is exposed to during the five minutes we are examining: As she walks by the windows in her bedroom, she can see another house, recently painted; and out of the

dining room windows, she can clearly see a third house, along with a perennial flower garden that was created and lovingly cared for by that house's previous owner. (Indeed, one cannot look out *any* of the windows of Kim's house without seeing both landscaping and building structures that were created and maintained with at least some artistic considerations in mind.)

But within Kim's house, still more architectural features reflect artistic considerations. Walls and ceilings are painted in colors that, in at least some instances, were selected by Kim herself with extreme care. The ceiling light in the dining room, although far from gaudy, is fancy enough undoubtedly to reflect an artistic choice on the part of a previous owner of the house, as do the styles of ceramic tile used on the floor and walls of the bathroom.

But architecture is only one of several artistic media observable in the videotape. Another important medium involves body decoration and personal appearance. Again, from the perspective outlined in Chapter One, there is no question that these things have an artistic dimension. Although writers on Western fashion have not always termed it an art form, when anthropologists document the arts of non-Western cultures, body decoration is often identified as a major avenue of artistic expression.[4] (The plausibility of considering body decoration an art form in non-Western societies lies in its being a human creation, executed in a sensuous, public medium, conforming to stylistic conventions. Also, some measure of skill is often apparent, and this is certainly the case in the West, where the relative expertise of the practitioners of "body art" is commonly evaluated, both formally in "beauty pageants" and informally by other people in everyday situations (see, e.g., Hatfield and Sprecher 1986).

Thus, at the beginning of the videotaping, Kim prepares to leave her house by combing and blow-drying her recently washed hair, and by wearing stylish jeans, a black sleeveless top, a colorful sweater, and ankle-high black lace-up boots. The video record gives additional evidence of the importance of body decoration and personal appearance: In her bedroom can be seen five additional pairs of black leather boots, as well as another pair of black, low-cut shoes; a belt and a colorful silk scarf; numerous strings of beads; many earrings; and two purses—one red and white, woven in Mexico, and another fashioned from a lidded basket. Also in evidence are a woolen hat and a black scarf, both belonging to me, and a mail-order catalog of women's clothing. Finally, in addition to these articles of adornment, there are visible in the bathroom a bottle of special facial cleanser, as well as a vanity containing

[4]See, for example, Faris's analysis (1972) of Nuba body painting, as well as various accounts of the San in southwestern Africa and the Sepik River tribes of Papua New Guinea (R. Anderson 1990a:11–33, 72–94).

numerous other preparations for skin, teeth, and hair, many used daily by Kim and me. More elementally still, Kim maintains her figure through exercise and careful control of her diet.

If one were to take out of context this considerable array of items associated with body decoration and personal appearance, as Horace Miner did in his classic paper "Body Rituals of the Nacirema" (1956), the time, money, and effort that Kim puts into maintaining her appearance may seem aberrant. In fact, however, Kim's attention to these matters is far less consuming than for many people of similar age and socioeconomic level in the United States today.

For most people, the word *art* probably brings to mind not the architecture and body decoration just discussed, but rather oil paintings and other works created by artists—that is, by individuals with special talent and training in the fine arts who devote much of their lives to working in their chosen medium. And, indeed, the videotape of Kim does reveal some such art, in this very narrow sense of the term. One oil painting of Kim's may be seen, but all of her other recent work (except for the one painting, a four-year-old collage, and a small, mixed-media construction) is in her current show.

But even in the absence of much original fine art, many other types of two-dimensional art are in evidence in Kim's surroundings. On the bedroom wall may be seen two reproductions of Persian miniature paintings, and Kim's cosmopolitan taste in art is also evidenced by several textile pieces that easily qualify as "folk art": On the bedroom wall are two colorful, hand-woven textiles, one from Ecuador and one from Mexico; and another textile, from Guatemala, covers a bedside table. Also hanging decoratively on the wall are a crocheted woolen hat from Peru, with human figures worked into its geometric design; and on another wall is an *arpillera,* also from Peru. On the same wall is a handmade, appliquéd Pakistani shirt and a small Mexican handbag.

I, for one, have no reservations about including such items as these in the inventory of art, or artistic things, in Kim's surroundings. More problematic, however, is a four-by-five-inch paper rectangle that Kim has stuck under the edge of a mirror on her vanity. On it are several red, roughly concentric circles, bisected by numerous yellow, energetically executed marks. At first glance, the rectangle appears to be the work of a child, as, in fact, it is, having been made by Kim's and my son Will, who is two-and-a-half-years-old at the time of videotaping.

Despite the drawing's charm and the specialness that Kim and I feel for it (and for other such works by Will that are around the house), it is difficult to determine the degree to which it meets most of the criteria of art listed in

Chapter One. The drawing is executed in a public medium, albeit inadvertently; I see no way to establish how much its sensuous quality was purposefully created; and I am equally uncertain regarding the level of skill possessed by its young maker. I confess to being truly agnostic on these questions. Perhaps the qualities involved—special skill and purposeful sensuousness—are present in some meaningful way, perhaps not: I see no realistic means of learning the answer.

The criterion of traditional style in the child's drawing is also problematic. Presumably, its design was not altogether spontaneous because both of its elements—concentric circle and kinetic, back-and-forth markings—are seen in many of Will's recent drawings; and he himself has a name for his style, calling it "scribble-bibble-babble." Rhoda Kellog (1969) once claimed to have documented a universal pattern whereby children in all cultures pass through distinct phases of drawing, although subsequent scholars, using more systematic methodologies, have questioned this conclusion and maintain that only the most general similarities are to be found cross-culturally (cf., e.g., Goodnow 1979:141–145; Alland 1983; Gardner 1980).

In any case, insofar as universal patterns do exist, they are presumably instinctive artifacts of psychomotor development, not the result of an individual's utilizing and adapting cultural conventions to attain personal artistic ends, which I take to be the distinctive trait of style.

But whether young Will's drawing is artistic or not, the videotape of Kim's surroundings reveals many—a dozen, at least—two-dimensional works that range from those (such as an original oil painting) that unequivocally meet the criteria of art; through others (such as the textile wall-hangings) that, though not customarily included in the category of fine art, nevertheless clearly meet the recognition criteria of art; to, finally, a piece (the child's drawing) that is, at most, only marginally artistic, in the sense in which that word is being used here.

The preceding discussion of the two-dimensional visual art that may be seen in the videotape of Kim's activities omitted one important category—namely, photographs—and a populous category it is, too. A hundred or so color slides of Kim's paintings may be seen on a desk in Kim's dining room; and an even larger number of wallet-size color prints reside inside the same desk, as do two photo albums. These prints, surely numbering several hundred, all have as their subjects family members and activities, as is the case with the four photographs that may be seen on display in Kim's bedroom. The latter are framed and include photos of Kim's mother and grandmother; a photo of Kim standing beneath a dramatically wide-branched tree in a churchyard in Lafayette,

Louisiana, taken when Kim and I were on vacation; and a final one of a tiger at a zoo.

But as with the child's drawing just discussed, the question of the artistry of these photos is complex. Admittedly, all are executed in a public medium, and some certainly meet the other recognition criteria of art. The photo of Kim's grandmother, for example, appears to have been taken in a commercial studio by a professional photographer. Thus, it probably was created by a skilled individual and represents an effort to create a sensuous end product, at least insofar as the subject is portrayed in a visually arresting manner by virtue of her placement in an artificial setting, her pose when the photograph was taken, and, finally, the photograph's current display in a brass frame.

Art is also clearly involved in some of the other photographs, albeit in a secondhand fashion: The slides of Kim's paintings provide a medium whereby the artworks are made accessible to other viewers.

But these photographs, as well as many of the others, owe their existence less to their sensuous use of the photographic medium or to the skill

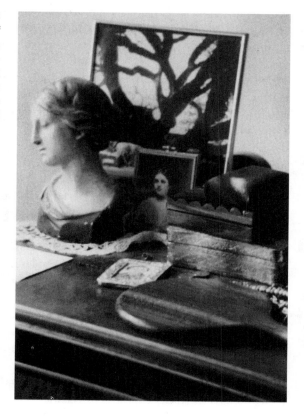

Figure 2–1 Kim's house is filled with art. On this corner of a dresser alone can be seen a reproduction of a bust by Raphael (sitting on a crocheted doily), two thoughtfully chosen family photos, three decorative boxes, and a mahogany hand mirror.

with which they were made, and more to the nature of their respective sub-
ject matter—Will's first birthday, a trip to the zoo, and so on.

On the other hand, some of these photos *do* possess a measure of
artistry. For one thing, given the technology of amateur photography in the
late twentieth century, most of the photos stored in the desk have been se-
lected from a much larger number of photos. Out of the twenty-four or
thirty-six pictures on a roll of thirty-five millimeter film, Kim and I usually
keep out only the best ones, relegating the others, of identical subject matter,
to a lower drawer of the desk. In most cases, the decision for special treat-
ment reflects two of the criteria that we have repeatedly used in identifying
art: The most artful photos were created with greater (albeit ephemeral)
skill, and they render their subjects in a more attractive light, or at least in
more visually arresting light, as is true of one particular photograph that Kim
was actively involved with during the videotaping. As noted, at the time of
the taping, she was preparing to leave the house to have postcards made to
announce a current exhibition of her paintings. For the postcards, Kim had
used a photograph of herself as a child, wearing a winter coat and making a
somewhat pugilistic gesture with her right hand and arm. The figure, cut out
of its photographic context and photocopied to increase its size and contrast,
now provides a black background for the gallery show announcement. This
manipulation makes the original snapshot even more distinctly artistic. (Kim's
creation of the card also brings to play other art forms. Around the card's
margin is information about the location of the art exhibit and the time of a
reception for the artist, set in three different typefaces, each undoubtedly cre-
ated by individuals with considerable skill in graphic design. Furthermore, on
the dining room table, along with scissors, scraps of paper, and other detri-
tus, sits a bottle of rubber cement, with an eye-catching label.)

Even snapshots, however, conform to stylistic conventions that are as
broadly influential in determining a traditional style of vernacular art as they
are in being tacit in the understanding of most amateur photographers, who
inevitably expect their subject to face the camera, to stand still, and to smile
("Say cheese!"). An examination of photos made in other times and places re-
veals the more implicit conventions of popular photography (cf. Geary 1988):
the amount of emphasis on human subjects, the selection of proper back-
grounds, the direction of the subject's gaze, and so on. These and other more
subtle desiderata tend to determine when the camera's shutter is released;
and after the film is processed, the same criteria play a large part in determin-
ing which photos go into the album and which do not, both in Kim's home
and in most other American households as well.

Thus, of the hundreds of photos that may be seen in the videotape,
many possess the traits that are typically associated with art.

In the preceding discussion of two-dimensional objects, a continuum was found to exist, ranging from the unequivocal artwork to the vaguely artistic. The same is true of the three-dimensional decorative items that are visible in the videotape of Kim and her surroundings. In Kim's dining room is a small, low-relief sculpture that Kim made when she was in art school; and in the bedroom is a clay pot with relief decorations that Kim made two years ago, as well as a reproduction of a plaster bust by Raphael.

Again, though, such objects are far outnumbered by a wide array of pieces from outside the Euro-American fine art tradition: two pots made by contemporary Pueblo ceramicists; a brightly colored wooden fish, an equally colorful terra cotta candlestick, and a black terra cotta pot, with two small figures, all from Mexico; a hand-painted, antique Japanese tea service; four fancy dolls, one Japanese and three Spanish, dating from Kim's own childhood and now located on the highest shelf of a bookcase and on the top of a chest of drawers; a large, colorful terra-cotta censer, made in Spain; and a painted Ukrainian Easter egg. All of these meet the recognition criteria of art.

Many of the other objects on display in Kim's house also unquestionably meet these criteria, although they probably would not find their way into most fine art museums. Stemware and china sit in a china cabinet; a cut glass vase stands on the high shelf of a bookcase; and two items, both associated with body decoration, are also to be seen—a hand-carved vanity mirror and a decorative ceramic soap dish.

Still other items, although machine-made, reflect exceptional skill in their design. Two decorative baskets are displayed, and a third is used as a wastebasket; two vases—one glass and the other ceramic, filled with dried flowers—may be seen; and a cigar box, holding personal memorabilia, has a lid and side panels that bear ornate decorations.

Several artistic items reveal unexceptional skill on the parts of their makers: a wooden bird, carved by Kim's father-in-law, is one of only two such items its maker ever produced; a ceramic bowl, made by a friend of Kim's, was also the result of a passing interest in pottery; and a Christmas tree ornament, cast in plaster of Paris and painted red, now lying broken on the desk in the dining room, came from Kim's (and my) son, although it is unclear which steps in its execution were carried out by the child. These are, at most, only marginally artistic.

Finally, several three-dimensional decorative items fall short of several of the criteria of art: Four special, attractive rocks, a large scallop shell, and another decorative shell are all visible in the videotape. Although their use as home decorations reflect Kim's judgment about their sensuous qualities, the only human skill involved is the act of Kim's selection and placement of them. (The same is true of the nine decorative houseplants that may be seen.)

Some of the furniture visible in the videotape has very little that can be called artistic by any stretch of the imagination. The bed, for example, sits on a simple frame—no headboard or footboard—whose sole purpose is to elevate the box springs and mattress off the floor and allow them to be moved more easily. Most of the other furniture, however, is not only utilitarian but artistic as well. A china cabinet, side-board, dresser, chest of drawers, and cedar chest are all handsomely designed older pieces; and an oak dining-room table and cane-bottom chairs (with floral cushions), as well as a rolltop desk, all reflect widely occurring styles. Furthermore, it is interesting to note that besides being artistic in themselves, each one of these serves a purpose that is itself artistic in some degree: The china cabinet both stores and displays Kim's best dishes; the cedar chest holds her linens; the sideboard, dresser, and chest of drawers are all filled with the clothing that Kim and I decorate our bodies with; and the dining-room table serves, obviously, for not only everyday meals but also the more elaborate meals that Kim and I occasionally create—which is also true of the attractive placemats that may be seen on the table.

This double artistry is apparent also in a sewing machine and a small, handheld vacuum cleaner. Not only are both designed with some attention to their appearance (the sewing machine is an older model, in a mahogany cabinet), but also they are "artistic tools," items whose purpose it is to create or enhance the visual attractiveness of other things—clothing, in the case of the sewing machine, and the household, in the case of the vacuum cleaner.

Other home furnishings also have artistic dimensions: All three of the rooms that are visible in the videotape have decorative rugs on their floors. In the bedroom, the bedspread and the sheets are patterned, and a telephone, which is dark brown and contemporary in design, sits on Kim's vanity. In the bathroom, three towels appear in attractive plain colors, a fourth has a floral design, the shower curtain has a repeating pattern of geese and water plants, ceramic tile covers the floor and part of the wall, and among the brightly colored children's bathtub toys is a plastic bucket whose side is decorated with a cartoon duck in low relief. Finally, every window visible in the videotape is bordered by its gauze curtain.

There remain a few other items in Kim's orbit that have visual artistic aspects. Postage stamps, which can be seen in the desk, on closer inspection reveal a scenic view of Vermont; also, the playing cards in the desk have ornate decorations on their backs, and the face cards have equally imaginative portrayals of the jack, queen, king, and joker.

Thus far, all of the art described in Kim's house has been visual, but Chapter One's discussion of the recognition criteria of art does not limit it to the visual medium. Obviously, literature qualifies, and several items in the

videotape fit easily within that category. On Kim's bedroom dressing table is a paperbound copy of Dostoyevsky's *Brothers Karamazov*, lying open to the page where she put it down while rereading it recently; and a novel by Allen Appel, a high school friend of mine, may be seen on the rolltop desk, along with two recent issues of *Harper's*, a magazine that typically contains short fiction, as well as essays and writings in other literary genres. Finally, four hardbound, coffee-table books, each with an attractively designed dust jacket, are stacked on the cedar chest.

Music is another art form well represented in Kim's household. In the dining room is a stereo receiver, turntable, tape deck, and speaker, along with several hundred long-playing recordings and tape cassettes. Kim and her family listen to a very wide range of music, from opera and classical instrumental music, through various popular styles, especially blues, to African music.

Other items seen in the videotape also relate to music. In a corner of the dining room stands a guitar. Not only is it and its colorful strap attractive, but also Kim and I occasionally play it, sometimes with friends but more often to accompany songs we sing with our son. (Also, on Kim's dressing table is a jewelry box that plays music when its lid is opened; beside the bed is a clock radio, set to go off to music; and also visible is a personal stereo, or "walkman," on which I sometime listen to music. Finally, a local biweekly newspaper lies on the desk, saved because it provides the most comprehensive listing of live music performances in Kansas City; and the bookcase in the dining room, which houses the stereo components, also holds several books related to music in one way or another.

A final medium that should be explored for its artistic potential is food. Here, too, a range of artistry is evident. For holidays and dinner parties, dining meets all the recognition criteria of art: Dishes are prepared with studied skill and inventiveness, according to local custom, for a public "audience" in an effort to create an experience for diners that is gustatorily and visually sensuous. Other meals deviate from this level of artistry in varying degrees, by being less imaginative, less skillfully executed, or intended for more private audiences.

Although Kim did not go into her kitchen during the videotaping, evidence of food arts is nonetheless visible. On the dining-room table lies the food section of the midweek edition of the local daily newspaper; and, of course, most of the contents of the china cabinet are intended to be used in artistic eating.

Five minutes' observation of the painter Kim and of her surroundings reveals well over a hundred things that are either art or that at least have

distinctly artistic dimensions. As noted earlier, a few of these are the direct result of Kim's profession as an artist, but a far greater number reflect Kim's general artistic sensibility and her desire to live and work in a setting that is beautiful and artistically interesting.

But as we shall see, most other contemporary Americans share this value to one degree or another. At least, that is the conclusion suggested by the remaining two case studies.

CARMEN, A RETIRED GARMENT INDUSTRY WORKER

The second videotape records five minutes of a weekday afternoon in the home of a retired woman, Carmen Servin Temayo. The Spanish associations that one might have with Carmen's name correctly reflect her background: Carmen's parents moved to the United States from Mexico before she was born; her first language was Spanish; and Carmen began learning English systematically only when she was nearing school age. During her adult life, Carmen worked in a garment factory, and she has lived for over twenty years in her current house in Kansas City, Missouri, which she purchased with her former husband. Carmen's daughter, now an adult who lives about fifteen minutes away, regularly visits Carmen and often talks to her on the telephone. Carmen does not own a car but lives within walking distance of a shopping area, a Catholic church, and other necessities. Although retired, she remains very busy with frequent baby-sitting jobs and activities with her friends.

In fact, at the time of the videotaping, Carmen had visitors, another retired couple, longtime friends of Carmen who had come to help the vigorous but diminutive Carmen move a large chair from one room to another. Carmen was also packing for a ten-day trip that she was about to take with the same couple.[5]

As a garment worker, Carmen played an active role in the important art medium of body decoration; but unlike Kim the painter, Carmen minimizes

[5]So much was going on, in fact, that after greeting the author at her front door and reaffirming that he was welcome to videotape her home and activities, she moved quickly through her living room, dining room, and into her kitchen, where the man of the visiting couple was now working on Carmen's sink. After chatting there a moment, Carmen disappeared into her bedroom to do more packing, with occasional forays into other rooms. In fact, she moved so rapidly that I decided to spend my time making a thorough record of the first rooms she was in—the living room, dining room, and kitchen (with adjoining breakfast nook)—rather than superficially videotaping all of the half-dozen rooms that Carmen quickly passed through during my visit.

her involvement with art. When I first telephoned her to describe my project and to ask whether I could videotape her and her home, she immediately assented, but she expressly denied having very much art around her house. To the contrary, she said, her preference is to have everything neat, tidy, and simple in her home—nothing fancy. Later, near the end of the actual videotaping, she walked by me as I was recording an elaborate display of items arranged in front of a wall mirror in her dining room; I told her that I was looking at the "decorative art" in her house, but Carmen said, "Oh, there's no art here!"

We were, of course, adopting two different meanings of the word *art*, with Carmen's using the word to refer solely to *fine* art—a not unreasonable assumption, inasmuch as she knows that I teach in the Liberal Arts Department of an art college, that I have written previous books on art, and that my wife is a painter. But under the broader conception of what is and what is not art that I am using here, the video record of Carmen's home reveals many

Figure 2–2 Carmen says, "For me, the only art in the house is my arches; they're pretty."

artistic things.[6] Indeed, the three rooms of Carmen's house that were observed have nearly as much art in them as do the three previously described rooms of Kim, the professional artist.[7] The following inventory of Carmen's art is somewhat shorter than the corresponding account of art in Kim's home largely because, with the exception of the comments regarding television, there is no need to repeat here the preceding explanations as to why certain media such as architecture qualify as art.

Like others in her neighborhood, Carmen lives in an attractive house—a bungalow, built in the 1920s. Many of its interior details also add to the house's artistry. The plaster on the interior walls is textured, and the walls and woodwork are painted in pleasant colors, except for the dining room, which has wallpaper with a pattern of muted diagonal lines and small red strawberries and flowers.

The list of interior architectural features and furnishings that are simultaneously practical and artistic is lengthy. One door boasts a glass doorknob and a brass plate, and there are decorative switchplates around the wall switches in all three rooms. The ceiling lamps in the dining room and kitchen are both brass, the former having five flame-shaped lightbulbs. Both the living-room fireplace and the kitchen wall behind the stove sport attractive ceramic tile, and the fireplace has an elaborate screen with brass pulls. Light brown carpeting covers all of the floors except the kitchen, which has vinyl flooring with a simulated hardwood design, and all windows are covered by sheer drapes. The doorbell chime, inconspicuously mounted high on a kitchen wall, is ivory colored and bears a decorative gold star on its front. Even the steel security bars on the outside of the back door are designed in an attractive geometric pattern.

Of the furniture seen in the videotape, every piece has artistic dimensions. In the living room, a long couch is covered with floral fabric, and an easy

[6]Despite her disclaimer that "there's no art here," even the no-nonsense Carmen betrayed some ambivalence. After reading an early draft of my account of the art in her house, she added, "No, I don't have any art in my house—just odds and ends." But she continued, saying, "For me, the only art in the house is my arches; they're pretty," referring to the two arched doorways in her living room.

[7]After repeated viewings of the videotape of Kim, I listed 136 items that qualify as art; in the videotape of Carmen, 96. I believe that these figures approximate the relative amounts of art in the two videotapes, but as absolute figures, they substantially underrepresent the actual amount of art at the two sites because many of the entries in my lists include more than one item. For example, for Kim I have as a single entry, "jewelry, including perhaps a dozen strings of beads and many earrings"; for Carmen, "small dining table, four chairs, each with cushions covered with a fabric printed with old-fashioned newspaper illustrations" counted as a single art work.

chair in the same room was recently reupholstered in material with a complementary patterned design. A spindle-back rocking chair with a floral cushion and a cane-back chair are also in the living room. Other furnishings in the living room are an octagonal oak coffee table with a glass top, and three small tables, one with a marble top, another made of dark wood, perhaps mahogany, and a third with decorative wooden inlay; two of the tables hold table lamps with light rose-colored bases and ivory shades. A dining table and six matching upholstered chairs share the dining room with a blond wooden sideboard. In a breakfast nook off the kitchen is a smaller dining table at which Carmen has most of her meals, plus four straight-back chairs, each with a cushion covered in a fabric printed with old-fashioned newspaper illustrations.

Furniture and architectural details aside, a cursory look around the living and dining rooms of Carmen's house would probably lead most visitors to accept her account of herself as a person who prefers to keep her home decorations plain and unostentatious. However, this perception results from one's eye *expecting* to find many artistic objects displayed in residences. Despite the apparent sparseness, when all of the wall decorations in Carmen's living room, dining room, and kitchen are brought together in a list, their number is impressive. In the living and dining rooms there are two medium-sized prints of landscape paintings; two matched prints of floral bouquets in oval frames; another pair of prints, in diamond-shaped frames, with neoclassical subjects; a print of two birds perched on a flowering branch; and a largish framed print that depicts a peasant woman holding potted flowers outside a humble house. Also, next to the telephone in the kitchen is a calendar, which Carmen uses to schedule her baby-sitting jobs, with an attractive print of flowers on its upper half.

Besides art prints, the walls display three ceramic plaques, each with a homey prayer. One in the kitchen says, for example, "Thank you for the food we eat; thank you for the friends we bring; thank you, Lord, for everything." (Inconspicuously attached to the plaque by the front door is a dried palm leaf from a previous Easter season, folded into a decorative design.) The walls of the kitchen and dining room also display several artistic items, including a pair of flowers that are fashioned out of enameled metal or hard plastic and another pair of ceramic wall ornaments depicting bananas and other fruit; a diamond-shaped wall decoration with a floral motif; a figure with a ceramic face and a knitted or crocheted body; another high-relief ceramic face; three devices, two depicting birds and the other painted with a teddy-bear figure, intended to hold pot holders or kitchen towels; and a plastic saucer and cup, the latter with a small floral design, meant to be used as a wall decoration. Hanging in the dining-room window is a stained-glass ornament in the shape of a bird.

Some of the "wall art" is more elaborate in nature:

- Above the sideboard in the dining room is a wide mirror, the frame of which incorporates several shelves for the display of items—in this case, seventeen small ceramic figures, including ballerinas, dogs, seashells, and a castle.
- On a kitchen wall is a shallow box patterned after those that printers once stored type in, whose many small compartments and shelves now hold thirty-five small ceramic dogs, each one different—as well as one plastic fire hydrant.
- A third wall hanging, in the shape of a rustic house, also contains several knick-knacks, including a miniature rocking horse.
- The door of Carmen's refrigerator holds seven small, magnetized objects that range from the abstract (a sparkling piece of hematite) to the figurative (a teddy bear).

In addition, there are wall clocks in both the dining room and the kitchen—one with a colorful sunburst design on its face, the other without decoration but embodying the unmistakable style of the small appliances of the 1950s.

If the "parietal art" on the walls of Carmen's home matches in quantity that of the most profusely painted prehistoric European caves, the "mobiliary art" is equally numerous. The three-dimensional art consisting of miniature dogs, ballerinas, and whatnot in the shadow boxes has already been mentioned; and a napkin ring in the shape of a tiger sits on the lower shelf of one of the small living-room tables. The videotape also records a cut glass bowl and two candlesticks; two brass candlesticks; another candle holder; a lidded glass jar, with brightly colored beads inside; and a glass bowl containing colorful dried flowers. Ceramic pieces include a vase, a dog, an ashtray in the shape of a San Francisco trolley car, and, finally, a ceramic figurine depicting a young man surrounded by several miniature musical instruments—the only music-associated item that I observed on the videotape. A large flowerpot from Mexico, painted with a rooster and flowers, was also unique in being the only item displayed in her home that reflects her ethnic heritage. As a centerpiece on the dining-room table, Carmen uses a flaring brass bowl with a candle in the middle, surrounded by dried flowers. Two houseplants may also be seen, one in a brass flowerpot, the other on a wooden plant stand. Many of the three-dimensional items, such as the dining-room centerpiece, have been placed on doilies, crocheted in bright colors, with floral motifs.

Besides her home and its permanent decorations, several other sorts of art are also in evidence in the videotape. Some are visual in nature: a shopping bag, whose plaid design, on closer inspection, turns out to be a repeating pattern of the American Express logo[8]; a flier from the purchase of new luggage

[8]In the analysis of the next videotape, I will discuss the artistic status of commercial logos.

that includes its manufacturer's logo; an envelope bearing canceled postage stamps; grocery store coupons with eye-catching graphic designs; a card holder, which is attached to the kitchen wall near Carmen's telephone, with eight small business cards, some of which display company logos; and several items that are mundane in nature but that nevertheless reveal an effort to create an attractive design, such as several ballpoint pens, a letter opener, and two telephones.

Body decoration is also in evidence, both in the clothing that Carmen wears during the videotaping and in the pair of earrings that casually lie on her dining-room table (virtually the only things that are not in their proper place) and a knitted woolen hat that lies on a hassock in the dining room.

Also, in the small dining area off the kitchen is a television, along with its remote control device. Carmen does not watch a great deal of television, but one could plausibly argue that *all* television broadcasts contain artistic elements. Televised dramas, which are public by their very natures, obviously require both technical and artistic skills on the part of their makers; they are created within definable stylistic traditions; and they are visually sensuous and can appeal to one's narrative sense in the same way as does all popular literature. (Except for this latter narrative element, the same traits are to be found in *all* types of television programs.) Because the high financial stakes and the competitive nature of the broadcast media, it is well known that much effort goes into such undeniably artistic concerns as color rendition, musical accompaniment, and dramatic presentation even in such seemingly nonartistic programs as news broadcasts. Therefore, although Carmen's television was not turned on during the videotaping, it is significant that at the touch of a button on a remote control, Carmen's television can provide six broadcast channels (and many more channels, if Carmen were on cable) of performing and literary arts, twenty-four hours a day.

Finally, the videotape reveals several artistic items associated with food. In the kitchen are stored bowls, plates, silverware, and kitchen utensils—all of simple but handsome design. Also, a tray and a white tablecloth are, in themselves, attractive items. Carmen fixes elaborate meals only occasionally, but the stove, refrigerator, microwave oven, and other appliances in the kitchen all give her the option of pursuing that particular art medium.

The quantity of art in Americans' surroundings ranges from a few people with a lot of art, through many people with a middling amount, to a few others who have relatively less art around themselves. Given Carmen's age, her ethnic background, and other unique features of her past, she cannot be said to be average, but I believe that Carmen's home does fall somewhere near the middle of the distribution: I consider her home to have an amount of

art that is typical of the majority of Americans today. Obviously, that amount is sizable indeed.

DICK, AN AUTO REPAIR SPECIALIST

The third and last videotape of a not-atypical five minutes in a not-atypical person's day was made at Downtown Import Service, a small auto repair garage in Kansas City, Missouri. Dick Jobe, its owner, began working on other people's cars in the garage of his own home as a young man, and with passing years, he increasingly specialized in Volvo repair. His business grew, as word-of-mouth advertising brought Dick a reputation for being fair, adept at fixing Volvos, less expensive than the Volvo dealership, and, not least, a raconteur whose affable, easygoing manner could take some of the sting out of repair bills that were still higher than owners often hoped. Having outgrown his home garage, five years ago Dick moved into the site that was used for the videotaping, which is in an older building large enough to accommodate four or five cars.[9] In his thirties when I videotaped him, Dick currently delegates most of the shop's mechanical work to his four employees, while he himself supervises his technicians, deals with customers, orders parts, and so on.

Like Kim and Carmen, Dick lives in a home that has a substantial amount of decorative art in it, but the videotape was made not in his home but at his work setting. A large portion of many Americans' waking hours are spent at a job, of course, so it is interesting to examine the amount and kinds of art that are found in a specific work environment. One might expect art to be highly visible in, for example, department stores and corporate boardrooms, but an auto repair shop seems less promising. However, Dick's five years' residence in the building has given it an artistic patina so that a surprisingly large amount of art may be seen in the three areas that were videotaped—a small public space where customers wait while their cars are repaired; an area where spare parts are stored and where Dick himself spends most of his time, speaking over one counter to his customers and over another counter to the technicians in the garage (this multipurpose room will from now on be referred to as "Dick's area"); and the portion of the garage itself that is adjacent to Dick's area.

Some of the art in these places parallels that found in the home environments of both Kim and Carmen. Thus, although the building appears to have

[9]We will meet Dick again in Chapters Six through Ten, by which time he will have outgrown the building described here and moved into an even larger building in a better location.

been designed originally with practical considerations foremost in mind, several interior details added by Dick are distinctly artistic in nature. This characteristic is particularly true of the customer waiting room, where one finds wood paneling covering the walls, two stained glass windows with automotive designs, and a wooden door with relief carving on its lower portion and, above, an etched glass pane that includes "Downtown Import Service," a silhouette rendering of a downtown skyline, and a design similar to the familiar Volvo logo.

Also, although some furniture, such as the tall stools behind the counter, serve purely practical purposes, other pieces have additional artistic dimensions. Two desk lamps and one wall lamp not only give light but also provide decorative touches to the areas that are visible to customers. Some of Dick's paperwork is stored in the cubbyholes of an impressive old oak desk, and Dick keeps customers' keys in an antique-looking wooden cabinet with a glass door, on which is an etched decoration that, again, resembles the Volvo logo.

The Volvo logo's status as art deserves comment. No doubt it was created by graphic designers with a great deal of experience and skill in producing images that catch the eye. The logo's visual appeal derives in part from its linkage with two stylistic traditions—its embodiment of the clean, uncluttered appearance that characterizes modern Scandinavian design and also its similarity to the astrological sign for Mars, which is sometimes used to symbolize the male of a species.

The value of the Volvo logo is attested by events that occurred several years ago. Although it is now called Downtown Import Service, when Dick opened his shop at this location he took the name Downtown Volvo Service and hired a painter to make a sign for the building's front, which would display that name and the actual Volvo logo. Soon afterward a lawyer representing the Volvo company paid an unexpected visit, informing Dick that unless the business's name were changed and the Volvo logo removed from the sign, from advertising fliers, and from everything else in the shop, Dick could expect to be sued, with no hope of winning. Dick capitulated, so that now in the garage one sees the real Volvo logo only on items purchased directly from the Volvo company: All other logos are different enough to prevent the threatened lawsuit.

The artistic Volvo logo and Dick's adaptations of it occur repeatedly in the videotape, where one sees not only Volvo automobiles themselves and the packaging for genuine Volvo parts but also a coffee mug bearing a Volvo logo; a large Volvo-like sign on the wall of the waiting room as well as a photograph, pinned on the wall of Dick's area, that shows him standing proudly beneath the sign; a custom-made sign, designed to resemble a city street sign,

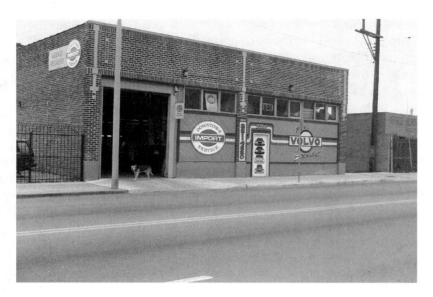

Figure 2–3 Downtown Import Service (1992 location), with Dick's adaptation of the Volvo logo.

saying "Volvo Parking Only"; and a fancy automobile license-plate holder with "Dr. Volvo" written across its top edge.

Other company logos and commercial designs are even more numerous in Dick's garage. Some of them are predictable: Of the hundreds, perhaps thousands, of auto parts stored in the garage, virtually all are packaged in some fashion, and most of their wrappings bear at least the maker's name, often the company logo, and sometimes a more elaborate illustration. Each of several packages of windshield wiper blades, for example, features a drawing of the blades' cross-section, dramatically depicting their effectiveness in sweeping water off inundated windshields. Furthermore, a few of the auto-motive logos and advertising designs are visible even in the absence of the products they represent. For example, on Dick's desk is a file of perhaps three hundred business cards, most bearing some sort of graphic design.

Taken together, the number of such automobile-related designs in the garage is staggering, but there are others that are not automotive in nature. For example, sitting on a high shelf in Dick's area are three boxes containing new Bosch coffeemakers, each with a photograph of cups of brewed coffee, coffee cake, and flower arrangements. (When asked about the coffeemakers, Dick laughingly says only, "Yeah, we're gettin' to be a regular Bosch boutique.") On another shelf in the same room sits a three-pound can of ground coffee, bearing its maker's familiar label. Also in Dick's area are five

successive years' business licenses, each with the official city emblem, a design that was adopted in 1976 as a part of the municipal celebration of the United States bicentennial year.[10]

Commercial designs play a role even in the clothing worn by Dick and his employees, each of whose shirts displays a patch that says "ASA" in large red letters, indicating that the wearer is approved by the Automotive Service Association. (Three stacks of extra patches—for ASA, Bosch, and the American Automobile Association—are stored in Dick's area, and yet another ASA patch is attached to the wall beside the counter, in easy view of customers, as are four wall plaques that attest, in ornate script, to successful completion of training programs in automotive repair.) Also, both Dick and his technicians, three men and one woman, are dressed in a manner that is partly practical—dark blue pants—and partly determined by considerations of appearance—white work shirts. Furthermore, a catalog of mail-order clothing lies in Dick's area, suggesting an ongoing concern with personal appearance.

Of course, body decoration is not limited to those who work in the garage. During the videotaping Dick spoke with a woman customer who had an attractive coat, leather purse, earrings, and a hairdo that suggested a recent trip to the beauty parlor. Her companion, a man, was also nattily dressed and sported a carefully trimmed beard.

The artistic items in Dick's garage range from the commercial, through the decorative, to the purely personal, as is demonstrated by the many photographs to be seen in the videotape. Thus, a calendar in the garage displays, perhaps predictably, a pinup girl and an advertisement for Snap-On Tools; and the cover illustrations of magazines in the customer area are similarly sales-oriented. Other photos are of a more personal nature, such as the stack of pictures of friends that is visible in Dick's desk and the two photos that are thumbtacked to the desk, one of a young woman and another of an old English sports car that Dick has restored to running order. Finally, photographs that combine the personal and the public may also be seen, both in a newspaper photo pinned up in the garage area that enigmatically shows the black funnel cloud of a tornado as it approaches a city, as well as an elaborate display of perhaps 150 picture postcards that Dick has received from friends and customers.

[10]Like almost all the logos in Dick's garage, this one reveals numerous artistic decisions. Its red, white, and blue colors convey an obvious patriotic message; and its design—two long, round-cornered rectangles, diagonally crossing and intertwined with each other—suggests a theme that civic leaders probably hoped to promulgate, namely integration, both between different sectors of the community and between the city and the nation as a whole. (It is interesting that the design closely resembles a pattern found in some traditional Native American groups and has a more remote similarity to the interlaced "knots" that appear in medieval manuscript illustrations.)

Other wall decorations are equally diverse. In the garage a decal advertises a radio station; and a very large painting, done directly on the wall and executed in a naive style, shows an older model Volvo with a smiling driver waving out of the car's window. The same kitsch sensibility is found in Dick's office, where a small painted wooden duck sits atop a door frame, a carved wooden horse hangs on a string from the ceiling, and a black sea horse is pinned to Dick's desk, not far from a headline clipped from a tabloid newspaper that announces, "Man's Heart Started by Jumper Cables!" The walls of the customer area are more decorously adorned with five large, framed prints with automotive themes, all executed in light, pastel tones. A glass jar, holding colorful hard candies, sits on the counter in easy reach of customers and employees alike.

Finally, Dick's environment includes numerous items that, although functional in purpose, betray artistic factors in their design. This characteristic is true of the various pieces of office equipment in Dick's area—a computer with three printers, a microfiche reader, a calculator, a telephone, a pen holder, and miscellaneous additional ballpoint pens. But the most significant objects at Dick's garage that are simultaneously artistic and practical are the automobiles themselves, which are, of course, the very reason for the garage's existence. At the time of my visit, five Volvos were being worked on in the garage, and several others were parked in the lot outside. Even though each one was undoubtedly purchased and maintained by its owner to provide a safe, reliable means of transportation, we cannot ignore the components of the cars that serve largely as decoration, such as chrome trim and attractive paint, both outside and in; stylish body design, from the hood ornament in front to the nameplate on the back; and so on. And if their makers are like the manufacturers of American cars, even Volvo engines are designed to appeal to the buyer's eye. (In Dick's shop, the carefully engineered "look" of Volvo automobiles extends beyond the confines of the garage area. In a display case beneath the customer counter sit four toy model Volvos, and two more are to be found in Dick's area.)

In Dick's shop, as in the other two videotaped settings, the most obvious and numerous arts are visual; but other media are represented as well. A shelf in Dick's area holds perhaps two hundred books, mostly automotive manuals and parts catalogs, but there are also instruction books for computer software and a catalog of art supplies.

More noticeable is the music that plays in the garage, emanating from a stereo system installed in the first mechanic's bay just outside Dick's area. Its FM radio is tuned to a popular music station, and although the busy garage is rarely free of the noise of car engines, pneumatic wrenches, or other equipment, Dick's regular customers know music to be perennially present in his shop.

One might not expect an auto repair garage to be a fertile setting for art and artistic things; and by my reckoning, Dick's Downtown Import Service does indeed contain less art than do the homes of both Kim and Carmen.[11] Furthermore, many of the artistic items at Dick's garage exist for thoroughly nonartistic reasons, primarily for Dick's company and other companies to make money. Nevertheless, the amount of art in the garage is impressive indeed.

CONCLUSION

Not everything seen in the videotapes of Kim, Carmen, and Dick is art. For example, the bed frame in Kim's bedroom is not intended to be displayed (i.e., is not in a "public medium"), very little about its appearance suggests a concern on the part of its makers with its visual appearance (i.e., it is only minimally sensuous), and practical efficacy, not style, determines its construction. For exactly the same reasons, the sound of the motors in Carmen's refrigerator is not music; the movement of Dick's technicians as they repair Volvos is not dance; and Dick's conversation with a customer regarding the relative costs of parts and labor is not oral literature, even though each of these things does possess one or more of the traits associated with art.[12]

But such things are the exception rather than the rule; and most of the objects and actions recorded on the videotapes have distinctly artistic dimensions. The next chapter uses a different approach to take the measure of the role of art in American civilization. (Moreover, in Chapters Six through Ten, Kim and Dick will be among the interviewees who talk about their involvements with the arts.) Nonetheless, the analysis of the three videotapes suggests just how evident is art's presence in our personal, day-to-day lives.

[11]As noted earlier, the initial lists I made on viewing the videotapes contained 136 items for Kim and 96 for Carmen. By contrast, 54 were listed for Dick's garage. The earlier cautions about the general incomparability of these figures still apply, however, and they are amplified by the fact that art is only one aspect of so many of the items in Dick's garage.

[12]The bed frame was, of course, designed with skill, and it has been painted a deep, rich brown; sensory, as well as practical, considerations no doubt led the engineers who designed Carmen's refrigerator to use compressor and fan motors that make as little sound as feasible; some experienced mechanics, whether they intend to or not, move with an economy and a grace that seems almost choreographed; and Dick does have a distinct flare for language use, as shown in his alliterative remark that his garage is becoming a "Bosch boutique."

3

Weddings:
Art in an American Rite of Passage

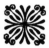

Anthropologists possess no foolproof formula for finding and analyzing art in small-scale societies, but some techniques have frequently proven to be useful in carrying out their research. While acknowledging that obvious differences of size, heterogeneity, and technology exist between contemporary America and small-scale societies, we might find it worthwhile to adapt to our present needs some of the methods that have withstood the test of time in the field. For instance, rites of passage have often proven to be productive sites for study, dramatically revealing numerous cultural values and social norms that otherwise might go unnoticed in normal daily life.

In America, weddings are one rite of passage that follow this pattern. Rather than following the casual way in which most transitions are observed in the lives of Americans, many couples begin their union with ceremonies that conform to Van Gannep's classic paradigm for rites of passage (1961): After elaborate preliminaries, the principle actors, the bride and the groom, are dressed in special clothes that are in marked contrast to the normal dress of others and to their own premarried status; during the ceremony itself, they are the focus of attention, existing in a special, virtually sacralized, state; and after a period of "seclusion," the honeymoon, they are reincorporated into their old milieus but are vested with their new identity as partners in a married couple.

$20,000, AND MOST OF IT FOR ART

Like all other things American, marriages come in a variety of sizes and styles; but art plays a crucial and pervasive role in the vast majority of them. We can take the measure of art's significance for weddings in several ways. First, there is the sheer economic importance of the decorative arts that accompany weddings. Consider, for example, the data gathered in reader surveys by the magazines *Modern Bride* and *Bride's* (Anonymous 1990, 1991a; see also Powell 1991). Fifty-nine percent of the former's readers were planning a formal, black-tie wedding; and both surveys indicate that respondents spend an average of about $20,000 for weddings, honeymoons included, a figure that is roughly 40 percent of the average annual income for the survey respondents. The breakdown of wedding expenses is particularly interesting, as shown in Table 3–1.

Table 3-1 Wedding expenditures by readers of bridal magazines (in dollars).

	MAGAZINE TITLE	
ITEM	Bride's	Modern Bride
Bride's wedding dress and veil	$ 963	$ 900
Groom's suit (rented)[a]	82	100
Bridal attendants' dresses	745	587
Bride's mother's dress	236	n.a.
Best man's and ushers' suits	333	400
Wedding rings	1,004	961
Engagement ring	2,285	2,206
Trousseau, honeymoon clothes	936	n.a.
Music	882	1,500
Photographs, video	908	971
Clergy, church or synagogue fee	166	186
Bouquet and other flowers	478	616
Invitations, announcements	286	304
Reception	5,900	7,200
Attendants' gifts	238	505
Limousine	201	222
Rehearsal dinner	501	n.a.
TOTAL	$16,144	$16,658[b]
Honeymoon	3,200	n.a.
TOTAL, with honeymoon	$19,344	$22,267 (est.)[c]

[a]The tenfold difference between the cost of providing a dress for the bride versus a suit for the groom is indicative of gender differences found in American weddings generally. Wedding magazines' titles (*Bride's*, *Modern Bride*, *Bridal Guide*, and so on) correctly suggest that women are central to the ritual, men peripheral.

Some ambiguities remain in these figures[1] (what, for example, is included in the contemporary American bride's trousseau?), but they do indicate the enormous significance of art and artistic things in American middle-

[*continuation of table footnote a*]

Advertising in the magazines tells the same story. For example, the "Directory of Advertisers" in *Modern Bride* (Feb. 1992:801f) lists 72 companies selling "bridal apparel," and only four for "men's formalwear"—a category that is missing altogether from the index for *Bride's* (Feb. 1992:1039f). Virtually all of the advertisements in bridal magazines feature women and sell items of primary use to women. In the few advertisements in which men appear, they are relegated to the same subordinate status that Goffman (1974) has identified for women in most other advertising: Men are literally in the background, often out of focus, their gaze is averted, and they are removed from the action. Some advertisements for men's formalwear show men in dominant positions, but in others the men appear to be quite remote. For example, in one tuxedo ad (*Modern Bride*, Feb. 1992:142), the otherwise well-lit male model is positioned so that his face is largely in shadow; and in another (ibid.:380), a tux with no man inside it appears to sit by itself in a chair.

[b]The closeness of the two totals is slightly deceptive: The *Modern Bride* survey does not contain figures for several costly items—trousseau, honeymoon clothes, the bride's mother's dress, and the reception rehearsal dinner—that are included in the *Bride's* survey. If these items are removed from the *Bride's* data, the resultant total is $14,471. The difference between this and the comparable *Modern Bride* figure of $16,698 may be the result of differences between the two magazines' readerships, sampling errors, or undetermined differences in methods of categorizing the data.

[c]This estimate was arrived at as follows: For the 14 items listed in both surveys, *Modern Bride* respondents appear to have spent approximately 1.15 times as much as *Bride's* respondents. To make up for the omissions from the *Modern Bride* data, I have multiplied the *Bride's* total, $19,344, by the same factor, yielding $22,267. In round figures, these surveys suggest that respondents spent about $20,000 for their weddings, honeymoons included.

Other accounts in the popular press give figures that are more or less in line with this one. For example, an article in *Good Housekeeping*, disarmingly entitled "Weddings: Big Dreams on Small Budgets," describes the weddings of four young, middle-class couples whose expenses, including honeymoons, averaged $14,750 (Gage 1991). Far less costly marriages are common, but much more expensive weddings also are found. One article in *Money* magazine describes a $60,000 wedding between a head flight attendant and a graduate student-cum-entrepreneur; and a 1997 article in the *New York Times* reported that "in New York City, a wedding can cost $1 million. Nuptials costing $100,000 are common enough that caterers consider them—take a breath—mid-range; the lower end is around $25,000" (White 1997).

[1]Data from bridal magazines are clearly unrepresentative of Americans as a whole in that the publications admittedly seek a middle- and upper-class readership. (The 1991 *Modern Bride* survey, for example, found that nearly 50 percent of the survey respondents have a combined household income of $50,000, and a similar figure is reported by *Bride's*.) Also, information provided by the magazines based on surveys of their readers could be intentionally or unintentionally skewed even further in the same direction: Like most mass media, wedding magazines derive more of their income from selling advertising than from selling magazines, and publishers seek statistics to convince advertisers of the lucrative market to which their magazine provides access. Furthermore, like most other popular magazines in the United States, wedding magazines accept (and perpetuate) an image of how people in the bridal industry *wish* weddings to be, rather than how they really are. The figures in the surveys do, however, receive some corroboration from a 1994 *New York Times* article that says

and upper-class weddings.[2] Using the more complete data from the *Bride's* survey, items that in a small-scale society would be classified as "body decoration"—elaborate clothing and other adornments—probably cost the survey respondents over $6,000.[3]

Other expensive necessities, at least for the respondents to these surveys, are also clearly forms of popular art, such as music and professionally (or semi-professionally) made photos or videotapes of the ceremonies. Other items in the budget have distinctly artistic components, such as the reception, whose cost includes a wedding cake (the price of which ranges from $250 to $500), as well as flowers and special food. Finally, some things in the list serve nonartistic and artistic purposes simultaneously: The architectural structure in which the wedding takes place gives protection from possible inclement weather, but in most cases it also provides a setting of beauty, indeed grandeur, for the proceedings. The same can be said of the invitations, attendants' gifts,[4] the limousine, and, perhaps, the honeymoon. Even the remarks by the officiant who performs the ceremony may include an element of artistic rhetoric. Indeed, given the staging, the costumes, the prepared lines spoken by the principals before the assembled audience, to call a wedding a "theater" event does not stretch the word's common meaning, even though it is intended that there be only one performance that is preceded by only one rehearsal.

that $2 billion (or an average of $833 per bride) is spent annually on wedding gowns and $30 billion ($12,500 per wedding) on "rings, receptions, honeymoons and such" (Diesenhouse 1994), numbers roughly in line with the bridal magazines' reader surveys.

In any case, when field anthropologists are given information by individuals in small-scale societies, they realize that no one is free of biases and personal interests, a fact that makes the data-gathering process difficult but not impossible: In the absence of totally objective and omniscient informants, one seeks to identify the factors that might color specific comments and seek corroboration from other sources. In a complex, mass-media-oriented society, the same methodology leads to the cautious use of information derived from popular magazines, as I do here. Certainly such publications cannot be ignored, given their considerable circulation. For example, over 360,000 copies of *Modern Bride* are distributed bimonthly. Thus, over two million copies are distributed each year—and there are only about two-and-a-half million marriages per year in America.

[2]Niel Shister (1998) has aptly observed that in contemporary America, weddings on *all* socioeconomic levels include things that are believed to be characteristic trappings of aristocratic revelry.

[3]The sum of the first seven items in the preceding list, plus half of the eighth, is $6,166.

[4]An indication of the role of artistic factors in ostensibly nonartistic components of the wedding is indicated by a suggestion regarding small gifts from the bride to the wedding guests: "Choose a favor that's both pretty and practical" (*Bride's*, Feb. 1992:778). The author continues, "Food is a traditional wedding favor. It can be a delicious groom's cake, which is cut into small pieces and packed in white boxes for guests to take home. (According to legend, single women who sleep with a slice of wedding cake under their pillow will dream of their future husband)" (ibid.). The artistic aspects of this suggestion are clear: The cake is special—"delicious"—and even the color of the box in which it is presented is specified. Finally, a legend is cited to situate the practice in a long-standing tradition.

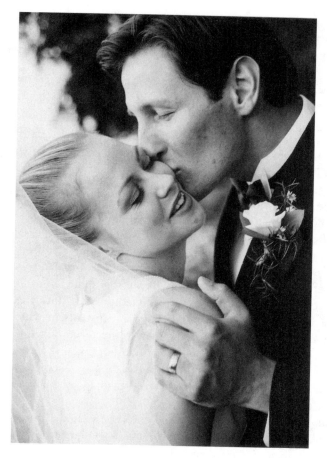

Figure 3–1 What anthropologists might blandly refer to as "body decoration" can rise to spectacular heights in weddings. Bridal gowns are a particular focus of interest (and expense) at most weddings; but the groom's appearance, from his tux, boutonniere, and wedding ring, to his carefully cut hair, should not be overlooked. (Photo by Kathleen Day-Coen)

Admittedly, if something that happens to be art also happens to be highly valued, it does not necessarily follow that it is valued *because it is art*.[5] Consider, for example, wedding photos. Published accounts testify to the importance of wedding photos: An article in *Money* magazine, intending to give shrewd advice on matters of personal finance, advises, "Know when to cut corners"—on alcohol for the reception, they suggest—"and when not to. It pays to get the best photography you can" (Cook 1990:126). The significance

[5]This tangential discussion was prompted by insightful comments by John Dilworth.

of photography seems to lie in its ability to evoke memories. Thus, a bridal magazine advertisement for leather photo albums says, "Remember . . . It's not a thousand words each picture's worth. It's a thousand memories" (*Modern Bride,* February, 1992:24).

But are wedding photos anything more than "memories"? Certainly, many of them are highly valued as mementos—as visual records of important personal events in the past. Whether or not they are art (and whether or not they are valued as art) depends on several factors, not the least of which concern the photographs themselves. At one extreme, consider any one of those by Kathleen Day-Coen, which are included in this chapter. It was taken by a professional photographer who has had formal education in both photography and art in general, who has specialized in wedding photography for several years and who gets many jobs by showing people her portfolio of photos that she is proud of for their artistic value (and which, for strangers, would carry no value as mementos). Such images fit into a long-standing tradition of American wedding photography in which bride, groom, and wedding party pose for carefully composed and evenly lit photographic exposures—or, as in Day-Coen's case, in the photojournalistic tradition of capturing crucial moments of the action on a couple's wedding day, instants in which the formal composition and lighting convey to the viewer the ceremony at hand.

At the opposite extreme would be a snapshot taken at the same wedding ceremony, which is similar only in that it has the same subject matter as the previously described photographs—that is, an image that meets few of the criteria for art.

Although both kinds of photograph could be valued as mementos, many Americans place great value on the former—as evidenced by their spending (according to the surveys cited previously) nearly a thousand dollars to have such professionally produced photos (or videos) of their wedding. In the same way, in the following chapters, time and again, things that happen to be art works also happen to be highly valued. It is as if being art is to cultural artifact what the *italic* style of font is to the printed word, bringing a penumbra of significance to things and actions. Various of the recognition criteria of art can elevate the value of the artistic wedding photograph beyond that of a snapshot momento of a wedding—the demonstrably greater skill in technique and imagination of the professional photographer who creates the photograph, the increased sensuousness (i.e., the beauty) of the photograph itself, the fact that it is conceived and created to be "suitable for framing" (i.e., executed in a public medium), and its conforming to the well-established stylistic conventions that define the sub-genre of wedding photography.

Admittedly, a few wedding expenses are void of artistic impulse (e.g., fees for blood tests), and there are others for which artistry is only incidental

to their role in the ritual (e.g., the designs on the postage stamps that are used to mail wedding invitations). But when weddings are viewed in purely economic terms, a pervasive, indeed prevailing, factor is the artistic dimension of the event.

PERSONAL ACCOUNTS: WHAT COUNTS AS "A REAL WEDDING CEREMONY"?

Individual accounts of weddings also reflect the importance of art in the ritual, as revealed in interviews with several just married, and about to be married, couples. The planning of larger weddings seems virtually to compel people to address artistic issues. When my friends Patricia Stewart and Pete Fosselman spoke to me about their recent wedding, they both repeatedly stressed that, unlike other weddings, "where the emphasis is on the party," they themselves placed highest importance on the actual ceremony in the church. Nevertheless, the arts played a crucial role in their wedding. Having good music during the service, they said, was "a really high priority"; and when they realized that the date they had first chosen for the wedding fell during Advent, when a large, "beautiful" triptych in the front of the church would be covered, they selected another date. Moreover, Pete's only retrospective reservation about the wedding was that the church's usual beauty was marred by a "hideous display" that featured bales of hay and canned food, created by the church staff to remind parishioners that during the traditional harvest season, they should make donations to the church's food pantry for the needy. (Pete recognized the difficulties of balancing humanitarian and aesthetic goals, saying, "It bothers me that it bothered me . . . Our guests at the wedding should think about [the hungry and the homeless], but I think it could have been done more tastefully.") And despite their placing greatest emphasis on the matrimonial ceremony, Patricia and Pete, in part to please the bride's mother, did ultimately incorporate most of the usual artistic concomitants into their wedding, including attractive wedding invitations, formal attire, and rings; and after the ceremony, they had a reception (with wedding cake, cookies, and punch, but no dinner or band), plus a later dinner for their closest friends and relatives.

Perhaps the most convincing evidence for the importance of artistic factors in weddings on the individual level comes from ceremonies that are comparatively simple affairs, including those in which the bride or the groom has previously been married. For example, a colleague's daughter, Francy Bedford Johnson, who was planning to remarry in four months, responded to one of my questions with, "Oh gosh, music for the wedding! I don't know, maybe

none. I hadn't even thought of that. I'd better put it on my list"—which she proceeded to do. That is, after rhetorically considering having a ceremony without music (music for the reception having already been arranged), she dutifully added it to the two-page list of things that she felt had to be done in planning the wedding, an event that she repeatedly described as being atypical for its simplicity and informality.

In keeping with her desire for a wedding that was simpler than her first, Francy intended to hold the wedding in the backyard of the groom's house. But as in her first marriage, when she decided between two possible churches by choosing "the bigger one—because it was more brilliant," she hoped to have as attractive a setting as possible for her upcoming wedding. The backyard, she said, "has a wooden privacy fence, so it's not a lovely area. But he [the groom] is going to fix it up. He's going to plant a certain kind of grass that comes up real quickly and be there for a couple weeks . . . and then it will die! So, he's really going to make an effort to do what he can for the yard." She had already contacted a rental company to reserve a white trellis to install in the yard for the occasion, and flowers had been ordered to decorate the trellis, as well as the backyard in general.

Kim Crenshaw, a friend who had recently remarried, told me, "I was so sort of lackadaisical about the whole thing that I didn't even have plans to get flowers." But, perhaps predictably, at the last moment, a friend "got a little basket of rose petals for [my daughter] Ashley, and she, like, walked in front and dropped rose petals, and it was real cute. And she brought me a real pretty little bouquet, and then she brought [the groom] a little rose for his lapel." Implicitly confirming the significance of the nearly forgotten flowers, Kim remarked that they had saved the groom's rose after the wedding, and, in fact, they still have it.

Asked why they did not simply go to the office of a justice of the peace to get married, people gave particularly interesting responses. Kim Crenshaw, who is a successful commercial photographer, said, "Visually, things for me are important. And mood and atmosphere make things romantic . . . There was just something about just going down to the Justice of the Peace that was just a cold, sterile office."[6]

[6]The Quakers (or Society of Friends), with their de-emphasis on ceremony and artifice in their regular meetings, provide an interesting test of the extent to which the arts can be dispensed with for weddings. Evidence, albeit only anecdotal, suggests that many of the art media that adorn non-Quaker weddings are found in Quaker weddings, as well: A colleague, Bess Reed, who married into a Quaker family, had, she says, "a Quaker wedding." Although the ceremony was simple, she wore a special dress, purchased for the occasion, and the wedding took place in Northern California on a bluff with a spectacular view of the Pacific Ocean.

A cursory check of the Internet, using the search engine, HotBot, found twenty-eight sites on the World Wide Web containing the phrase "Quaker wedding." They include a personal page for Maryland and Sean Reilly (http://mail.med.upenn.edu/~crosson/quaker.html) that, among other things, includes photographs showing members of the wedding party in traditional, formal wedding attire (including a white, floor-length gown for the

Kim's wedding took place in Memphis, shortly before she and her new husband moved to another city. Kim went on to make a telling remark about the merits of having an artistically elaborate rite of passage: After describing her relatively unostentatious June wedding, Kim said, "We had thought that we might come back [to Memphis] in September and do a *real* ceremony in the church and have all the friends and family—but it never happened." In a subsequent conversation, Kim elaborated on what, in her mind, would have turned the first ceremony into a "real" wedding: On the one hand, only a few friends and no family members (except for the bride's daughter) were invited to the wedding; but also, because she and her husband were about to move to another city, they had been forced to rush their plans for their first wedding. Given more time, she said, they would have "put a little more thought into it—like telling the flutist what music to play, and picking out some better things to say in our vows." That is, they would have included *more and better art* in the wedding.

Art is only one of the components of weddings, as was made clear by the individuals I spoke to. For some, the solemnness of religious ritual is important; for others, sharing the event with friends and family members takes first priority; and still others emphasize the festive element, as did the aforementioned Francy Bedford Johnson, who in planning her wedding had made arrangements to have musicians for the reception but for whom music during the ceremony was almost overlooked. But even this most secular of motives—having a memorable party—draws on art for much of its appeal. Consider this exchange between Francy and me:

R.A.: What's the most important thing about the wedding?

F.J.: Probably, the aspect of the celebration, because [the groom] kept saying, "Why don't we just go to the Justice of the Peace and then just be around with the family?" But I felt that wouldn't really be celebrating...

R.A.: But you can celebrate just by getting a couple kegs of beer.

F.J.: I can do that anytime. But that doesn't make it special, though. What makes it special to me is to get family together. I think that if you have

bride and tails for the groom), as well as flowers. Other sites make reference to wedding rings (http://www.angelfire.com/pa/jofrancis/) and "late 17th-century Quaker wedding feasts" (http://www.libertynet.org/pensbury/).

Also, a site for Snowolff Designs (http://home.att.net/~snowolff/) advertises (and provides photographs of) marriage certificates for Quaker weddings designed by Jennifer Snow Wolff. The site says, "Since there was no priest or minister to witness the [Quaker] wedding, U.S. law historically did not recognize the marriages, so Quakers created a certificate with their written vows . . . In the past, Quakers had no art or mirrors in the home, so often the plain, calligraphed certificate was the home's only decoration. Today, certificates may be illustrated, a new practice," and some of the certificates that Wolff sells via her website do indeed include handsome colored ink drawings of flowers and other decorative subjects.

something small, it doesn't give people the incentive to . . . [trails off] Like, I have a grandfather in Arkansas and if I was just going to do just a little tiny thing, it wouldn't draw the family together.

R.A.: So all the decorating, all the things you're going through is. . . ?

F.N.: To please the guests, in addition to, I guess . . . to make it a festive atmosphere.

OTHER FACTORS IN "WEDDING ARTS"

Like most other culturally significant performances, weddings require elaborate preparations, with magazines commonly providing timetables for things that should be done as much as two years before the actual wedding. Predictably, many such chores are related to art. For example, a bridal magazine quotes a woman's letter to members of her wedding party, in which she makes this plea regarding dancing: "PLEASE, PLEASE, practice now! Suggestion: Go take dancing lessons!! That's what we have to do!!" (Anonymous 1991b:36). (The writer goes on to make another interesting aesthetic remark: Although there will be "some polkas, the Charleston, jitterbug, and

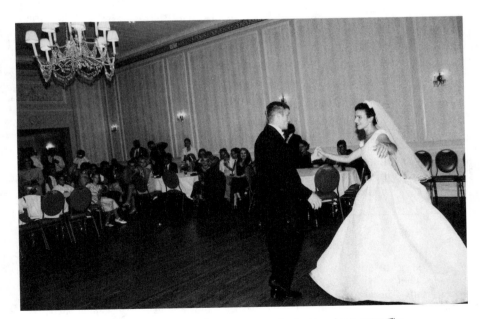

Figure 3–2 The wedding reception has its own set of attendant arts: The guests are well dressed, of course, and the setting is a special place, as indicated by the chandelier. But the main attraction at this point in the proceedings is dance. (Photo by Kathleen Day-Coen.)

others . . . there will not be any up-to-date dances. I personally dislike them and think they look terrible—they simply are not dances, in my estimation" [ibid.].)

Individuals' published remarks about details of the wedding ceremony likewise emphasize artistic concerns. An account of a wedding between "Teri and Larry" includes the observation that they "exchanged *rings*[7]—'symbol of eternity'—designed by Teri's father, a *jeweler*" (Gage 1991:208). Later, the couple "posed outside the *church* in front of the *elegant* 1954 Bentley that Larry had rented for the day. A chauffeur sped the couple to their reception at the Shaefer Mansion, one of the most *picturesque* Victorian bed and break- fasts on Seattle's Capitol Hill" (ibid.). For another couple, "Finding just the right church was high on Renata's priority list. 'I think the centuries-old Eu- ropean cathedrals are *so beautiful*,' she explains. 'I wanted *that feeling* in my wedding ceremony'" (ibid.:212). Remarks such as these, which consistently stress the artistic factors behind wedding decisions, are the rule rather than the exception.

Predictably, merchants capitalize on the same sentiments: One wedding magazine advertisement says, "A plain gold band says we're married. A dia- mond says forever" (Anonymous 1992c:31). And Vincent Piccione, "presi- dent of Alfred Angelo, the country's largest bridalwear manufacturers," re- marks, "A bride might stint on the reception, but the dress is critical. [The bride] wants a gorgeous picture to point to" (Wise 1991:189).

An interesting insight into "wedding arts" is given by the "Gift Registry Checklists" provided by both *Modern Bride* and *Bride's*. Again, the majority of items on such lists are artistically created, and often they serve distinctly artistic purposes. Several of the general categories of gifts are related to stylish dining: dinnerware, flatware, fine crystal and casual glassware, bar and cooking equip- ment, and kitchenware. Home decoration is implied by two other broad gift categories, linens and "decorative accessories" (e.g., picture frames, decanters with glasses, and desk sets). All of the things in the "electrical appliances" cate- gory are related to food preparation, and often for especially fancy dishes, such as homemade pasta. The "home electronics" items all involve music or broad- cast media, with the exception of "telephone/answering machine"; and (with the exception of the smoke alarm) all of the "home care" gifts are intended to aid in maintaining tidy clothes and a clean house. Thus, of the 202 items listed, only 2—the telephone and the smoke detector—do not overtly or potentially serve artistic purposes (Anonymous 1992d:232). (One can imagine a gift- buying store customer reading "smoke alarm" on a gift registry list and think- ing, "Nah—that wouldn't be an appropriate wedding gift.")

[7]Emphasis is added throughout this paragraph.

In Western culture, with its elaborate division of labor and complex occupational specialization, art forms spawn technical and media-specific vocabularies and criteria for criticism, and predictably such is the case with "wedding arts." Consider, for example, the wedding gown, an item that is central to the ceremony. After more than a thousand pages, in which advertisements for wedding dresses hold a primary position, *Bride's* (Anonymous 1992e:1038) gives readers a one-page reference guide entitled "Your Wedding Dress . . . Defined," which provides clear distinctions between eight styles of necklines, six sorts of sleeves, four types of lace, seven varieties of veils, five "silhouettes," eight "lengths and trains," eight fabrics, and eight "headpieces." Each style is named (in order of increasing length, and trains are called "sweep," "court," "chapel," and "cathedral"), and the designations seem to be fairly widely accepted through the industry (cf. Anonymous 1992f:530).

In part, selection of gowns reflects personal taste, but tradition also comes to bear on the choice. A complex table provided by *Modern Bride* makes distinctions along several different dimensions, including degree of formality (formal, semiformal, and informal), time of day ("six o'clock is the hour that

Figure 3–3 The bride's appearance must be just right for her "special day." The wedding gown is the subject of an elaborate vocabulary. (Photo by Kathleen Day-Coen.)

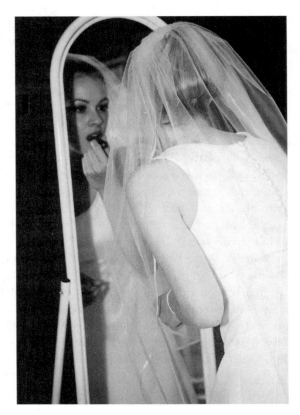

separates the formal evening wedding from the formal day wedding" [Anonymous 1992g:440]), and, for men, traditional versus contemporary. For each, the appropriate clothes are specified for the bride, the bridesmaids, the bride's and groom's mothers, and the men in the wedding party. Thus, formal weddings during the day require mothers to wear street-length dresses, whereas floor-length or ankle-length dresses are recommended for formal weddings in the evening.

It is difficult to determine the extent to which such ideal prescriptions are used in reality; but there is little doubt that some people give considerable attention to such details. For example, one bride-to-be's letter to her bridal party, after explaining that "black tie" means "tuxedo," goes on to say, "If you do not wish to wear a tux, or do not wish to take on the expense of renting one, it will be perfectly fine to wear a 'black' suit, white shirt with French cuffs, black silk socks, black shoes, and a black-and-silver tie." (Anonymous 1991b:38). She goes on to admonish, "I hope this doesn't inconvenience too many, but I would hate to look at color pictures of the head table and see some men in black tails and others in brown or blue suits!!" (ibid.). (The writer of the letter apologizes for "being a real fusspot" but adds, "I'm doing this for my friends and relatives, for all of us to have a good time, but since there are only so many hours in the day, and *I already have three jobs,* and I am not a Vanderbilt, some lines must be drawn, and I hope everyone understands" [ibid., emphasis added].)

Guidelines are available for music, too. For example, one magazine advises that "for a [reception] party of approximately 100 people, hire a three- or four-piece band; four or five pieces for 150 people; and six or seven pieces for any number over 150" (Anonymous 1992a:466). Another article steers readers away from Wagner's *Lohengrin* for use during the ceremony and toward Pachelbel's *Canon in D Minor* and Vivaldi's *The Four Seasons.* The same author also gives other art-related tips, such as, "Some Baptist churches don't allow *Ave Maria,* [and] synagogues may restrict secular selections" (Anonymous 1992b:250).

Such rules are often formulaic (as in the preceding suggestions regarding the size of a band for the reception) or formalistic. For instance, one article (N. Davis 1992:594) suggests that in looking for the "best" wedding photographer, the bride should examine candidates' portfolios for "proper background lighting that creates a three-dimensional feeling" (ibid.).

These formulaic and formalistic guidelines make sense, inasmuch as exceptional skill of execution is a common trait of art. Elaborate weddings tend to be planned by couples who have not been married before,[8] that is, by

[8]The *Modern Bride* survey found that 95 percent of its respondents were planning their first wedding.

individuals who have had little or no opportunity to acquire the requisite skills. Besides following prescribed formulas to the letter, other means of simulating skill may be found: An article in *Bride's* (Kimple 1992:648) gives advice on "Writing Your Own Vows." The author comments, "For those who appreciate poetry but don't write it, another's words may just as effectively express the sentiments felt," and then the author provides seven passages from Kahlil Gibran, Elizabeth Barrett Browning, and others. Along similar lines, *Modern Bride* (Anonymous 1992h:376b) suggests that if the best man is nervous about creating a toast for the reception, he should take a tip from "Susan Polis Schutz, America's best-selling love poet"—such as, "Pick one message for the toast: love, commitment, relationships, friendship, etc." Or, to take another case of simulated skill: Although wedding invitations and announcements are professionally printed, etiquette once dictated that envelopes had to be addressed by hand, usually by the bride. Now, however, several companies advertise computer services to print addresses on envelopes in a script that looks as if it has been hand-lettered by a professional calligrapher. Finally, quite a few couples (12 percent of *Bride's* survey respondents) hire wedding consultants—individuals who claim to bring genuine skill, knowledge, and experience to planning a wedding ceremony—and who, according to the survey, receive an average fee of $225 for their services.

Discussions with individuals who are about to be, or who have recently gotten, married reveal several channels through which information about wedding arts is acquired. For instance, Patricia and Pete laughingly told me that during their engagement, they "had been to two or three other weddings and had consciously gone to get ideas or to see what other people did." The printed word gives others information and guidelines, some of which they take with a grain of salt. (Pete said, "We read all those books, the things the jewelers say about what fraction of your annual income you should spend on the ring. It's such a joke!")

However, a vague notion of "tradition" is the most mentioned source of wedding decisions. When I asked Kim Crenshaw why her first wedding had been such a grand affair, she said, "Oh, probably because that was the tradition. And the romantic kind of thing." Francy Bedford Johnson, as she was planning her second marriage, said of the wedding gown, "I don't know that white's particularly appropriate, since I've been married before. But white's a better color on me than off-white." Thus, Francy had to decide between two different cultural ideals, one calling for her to look her best, the other restricting the use of white gowns to women who have not previously been married.

Family precedents, in addition to societal customs, influence decisions about wedding arts. Patricia Stewart's experience with her gown was particularly illuminating. After trying on several gowns and looking at many more, none of which satisfied her, she found a gown that she liked very much, only to realize after purchasing it that it bore "a striking resemblance to my mother's wedding dress." Moreover, Patricia told me that she was going to have her own dress "preserved" so that others in her family could use it if they wished to.[9]

An artwork may affect us because of its immediate sensuousness, but often there is more to the story. Symbolic or iconographic associations may be superadded to its manifest appearance; and references to other art forms can also enrich the experience. The multifarious arts of American weddings illustrate these mechanisms.

First, overt symbolism ranges from the well-known (the bride's white dress indicating her putative virginity), through the arcane (according to some, orange roses mean desire), to the idiosyncratic and creative: According to the magazine account of one wedding, "Although neither Marilyn nor Paul is Jewish, Marilyn wanted to be married under their version of a *chuppah,* a canopy covered with flowers . . . To make their *chuppah* even more distinctive, the florist decorated the frame and canopy with satin ribbons, and grapevines from California's wine country, where Marilyn's father lives" (Gage 1991:211).

Some symbolism may simultaneously provide a link with history and a rationale for the complexities of formal weddings. *Bride's,* for example, provides a page of "wedding customs and their origins" (Katz 1992:782). Predictably, of the thirty-nine items listed, twenty-eight involve some form of art. They include beliefs about the personal adornments ("It is lucky to have the groom's birthstone set in an engagement ring" [ibid.]), the cake ("Romans broke the cake over the bride's head for good luck" [ibid.]), or other subjects, such as a set of rhymes that associate the month of marriage with particular outcomes ("The month of roses—June—life will be one long honeymoon" [ibid.]).

But more interesting are the cases in which wedding arts evoke other art forms or art activities that are only remotely related to weddings. Consider one bridal magazine's admonition regarding the gown: "A woman shouldn't look like a cookie-cutter bride. Instead, she should make a statement!"

[9]In discussing this "archetypal wedding dress" (as she called it), Patricia said that clothes had always played a powerful role in her memories. When she was five or six, in fact, she had been given her mother's wedding dress to play with, and it got extensive use, even after her brother ran over its train with a lawn mower!

(Anonymous 1992f:530). The implication is that the bride-to-be, like a modern fine artist, ought actively to "make a statement" rather than passively to resemble a product of the more mundane and domestic popular art form, cookie decoration. Indeed, because class consciousness plays such an important role in many weddings, allusions to the fine arts are common. For example, one magazine refers to elaborate flower arrangements as "neoclassic, lavish designs" (ibid.:494), and another magazine article about extraordinarily complex wedding cakes describes the work of Kevin Pauline, who "spent untold hours sculpting flowers, tier separators—even the cake plate—from sugar. 'Any medium an artist would use, such as clay or paint, I can replicate with sugar,'" the article quoted Pauline as saying (ibid.:706).

Some tie-ins between diverse art media are quite complex. For instance, in 1992, *Bride's* published an article (Anonymous 1992i), the theme of which was a then-showing movie, *Father of the Bride*. In the magazine, the film's female lead, Kimberly Williams, is shown on the movie set modeling several wedding dresses. One inset photo, taken from the movie itself, shows

Figure 3–4 *The wedding cake: ritual food as sculpture. (Photo by Kathleen Day-Coen.)*

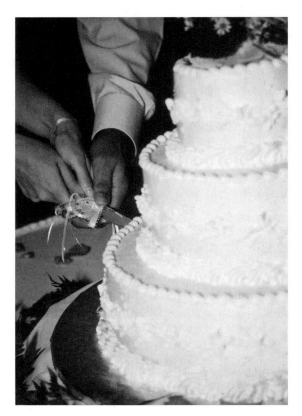

Williams holding a previous issue of *Bride's* magazine. To complicate the self-referentiality of wedding arts still further, one bride-to-be whom I interviewed cited the movie in question as a source of her own information about weddings.

Individual popular artworks rarely exist in artistic isolation. Rather, they tend to be linked in complex and sometimes unexpected ways to other art forms. Weddings illustrate this pattern quite well. Both published sources and most of the individuals whom I questioned emphasized the importance of coordinating the colors that were used in wedding decorations. For example, Francy Bedford Johnson said,

> Normally you choose colors, right, for your wedding. In most cases it's like two colors. Pink and blue, or something like that. Then everything's decorated in those colors—your plates, your napkins, all of that, you know? Then normally, your dress would be white and your bridesmaids and your maid of honor would have coordinating colors that went along with that, in addition to having your groomsmen and all that.

Larry Johnson, a professional wedding-cake maker, told me that although his own critical standards differ somewhat from those of his clients, the matching of colors is nevertheless a major concern for both him and those at the wedding reception.

The artistic integration of wedding ceremonies goes well beyond color schemes. One couple was especially pleased with the candles they bought for use in their ceremony because, like the church in which the ceremony was held, the candles were in a "Gothic style." More important, and as noted earlier, is that an effort is usually made to maintain a consistent degree of formality throughout the proceedings. As Patricia Stewart put it, "I know one thing I was really conscious of after Pete gave me the engagement ring was, here he was giving me this really nice ring and I have to have a really nice dress to go with it."

CODA

At this point, it should be abundantly clear that most American weddings, even those of relatively modest scale, involve a great deal of art. Indeed, for most weddings, virtually all art media come to play in some way: architecture, body decoration, music, theater, oratory, and, if there is a reception, probably dance. In American ceremonial and institutional life, however, weddings are far from unique for their artistic richness. For example, funerals, like weddings, are rites of passage in contemporary society; and they, too,

often necessitate a broad spectrum of art media.[10] Besides being embalmed, the corpse is typically dressed in appropriate clothes (selected from the deceased's wardrobe or perhaps purchased from a Texas company that specializes in "deathware" [J. Anderson 1990:110]); and hair and skin are treated to create an attractive appearance. According to one report (McManus 1991), even the simplest coffins have crepe interiors, and the most expensive ones are constructed of polished solid oak. Viewing of the deceased and the funeral ceremony itself typically occur in the relatively opulent setting of a funeral home, complete with elaborate flower arrangements and soft background music. And, finally, grave markers or stones range from the sculpturally simple to the truly monumental. Even those who are cremated, estimated to be between 15 and 20 percent of those dying (ibid.), may have their ashes stored in an urn that is specifically designed for the purpose and perhaps kept in an elaborate mausoleum.

Consider also that most distinctive of American annual holidays, Christmas. As is well known, the rate of consumer spending reaches its peak in the period between Thanksgiving and New Year's Day; and as with weddings, most expenditures are for art—or, at least, things that are artistic: decorations for the home and the Christmas tree; wrapping paper and ribbons for gifts—many of which themselves serve to decorate the home or the body; the fancy food and drink of the season; and greeting cards. Christmas also brings with it characteristic music, from the simplest of carols, whose melodies even the most irreligious of Americans typically know, to Tchaikovsky's *Nutcracker Suite* and Handel's *Messiah*. A round of special television programs (both newly created programs as well as "classics" ranging from the film version of Dicken's *A Christmas Carol* to *The Grinch Who Stole Christmas*) is inevitably broadcast; and virtually all shop windows feature elaborate displays—indeed, whole buildings and shopping districts may be embellished with colored lights and seasonal two- and three-dimensional decorations.

Similarly, the Jewish holiday of Hanukkah has numerous artistic concomitants. Some, such as the eight-candled menorah, dreidels (decorated toy tops), and children's Hanukkah songs, are remembered from the childhoods of present-day adults. Others—crepe-paper decorations that announce "Happy Hanukkah," Hanukkah cards, and gift-wrapping paper in the national colors of Israel, blue and white—have become popular only in recent years.

Christmas and Hanukkah are, in part, commercial events, and for some people, these holidays retain a strong religious significance. But for most contemporary Americans, these festivities, like weddings, are also accompanied by arts that are as diverse as they are abundant.

[10]I am indebted to Kelly Kievit for suggesting this line of inquiry.

4

Art's Cultural Significance

As the preceding chapters have demonstrated, it is fairly easy to show that art plays an enormously important role in the day-to-day lives of most Americans. But a second question is more difficult to answer: What do the arts of America *do*? That is, why do we put such vast amounts of time and effort, money and material, into the arts? In non-Western cultures, a recurring theme is that art conveys culturally significant meaning. Our concern here centers on the cultural meaningfulness of art in America, but before pursuing that question, it will be helpful to examine philosophies of art in two non-Western societies, namely, those of traditional Eskimo and Aztec cultures. Doing so will give some idea of the nature of full-blown aesthetic systems, and it will provide clues regarding methodology, suggesting where and how to look for the concepts that constitute an aesthetic system.

With regard to the multifarious arts of the traditional (say, pre-1950) Eskimos, or Inuit,[1] it is noteworthy that although some Inuit art was produced for supernatural purposes—shamans in some groups did own special masks—much of it was, without doubt, secular in conception and use. Thus, if many of their beautifully carved ivory figures were amulets with supernatural powers, others doubtless were children's toys or adult gaming devices, which were used to while away the long winter months of Arctic darkness.

[1]People in some regions of the Arctic wish to be called "Inuit," their name for themselves in their own language, and others prefer "Eskimo." In the absence of a consensus among the people involved, I use both terms.

Similarly, whereas some songs and dances were ritualistic, others were performed purely for pleasure or were used to settle disputes. Likewise, some Inuit tattoos served religious purposes—those on a woman's chest, for example, were thought to increase a nursing mother's production of milk—whereas others, such as those on a woman's face, were created solely to make the wearer more beautiful in the eyes of others (Birket-Smith 1933:69; Rasmussen 1932; Jenness 1946:54; Ray 1977:23; Hrdlicka 1975:45).

But whatever its use, Eskimos traditionally saw art as an active force in their world. In eastern Greenland, for example, it was believed that if a boy wore inside his parka a doll carved from a straight willow trunk, he would grow up to have a strong, straight back (Meldgaard 1960:7). But in addition to the power of sympathetic magic with which such amulets were endowed, Inuit seem to have believed that art can provide a channel through which things can move between three distinct levels of reality, namely, the supernatural, the human world, and the world of nature—a remarkable feat indeed.

For instance, an Inuit creation story recorded nearly a century ago includes an episode in which a mythic being, Raven, encounters First Man, who has just emerged spontaneously from a pea pod. Seeing First Man, Raven "raised one of its wings, pushed up its beak, like a mask, to the top of its head, and changed at once into a man" (Nelson 1899:451). That is, the act of removing an artwork—a mask—transformed a supernatural spirit into a mortal. In a later passage, Raven took some clay and fashioned "an image very much like [First Man himself]. Then he fastened a lot of fine water grass on the back of the head for hair, and after the image had dried in his hand, he waved his wings over it . . . and a beautiful young woman arose and stood beside Man" (Nelson 1899:454). Here a different artistic process, figurative modeling, turns inert clay into living flesh and blood.

Lacking full-time philosophers, small-scale societies vest much of their speculative thought in the implicit assumptions that underlie their mythology; and this story, in conjunction with several other tales and songs containing the same theme, suggests an Eskimo belief in the transformational, alchemical, power of art. Over fifty years ago, a Netsilik Eskimo named Orpingalik told Knut Rasmussen why one of the songs he had written was called "My Breath": "It is just as necessary to me to sing as it is to breathe" (Rasmussen 1932:321).

Traditional Aztec culture provides another, albeit a contrasting, example of a non-Western aesthetic system. Before the Mesoamerican empire of the Aztecs fell to the Spanish conquistadors in the early 1520s, their culture produced art of remarkable quantity and grandeur, not only the well-known pyramids and other monumental structures whose ruins impress visitors still today, but also relief sculpture and frescoes that adorned the exteriors of the

religious edifices, plus smaller, mobiliary sculptures fashioned out of gold, shell, turquoise, and other semiprecious stones, as well as intricately painted and subtly shaped ceramics, illustrated manuscripts, fine textiles, and an impressive body of music, dance, and poetry.

The Aztecs had what they believed to be very good reasons for producing their arts. Commoners saw much art as a necessary component of elaborate annual rituals, and art was a means whereby the Aztec aristocracy displayed their wealth and power. But another set of notions was developed by a group of wise men in the Aztec priestly class, individuals called *tlamatinime*. These thinkers derived their ideas from Aztec cosmological myths, which claimed that the world would be created and destroyed five times, that four such cycles had already occurred, and that the fifth and final destruction was imminent. Aztec popular thought was pervaded by a fear of the cataclysmic end of the earth, but Aztec intellectuals agonized over more abstract problems. They asked, Are all humans and all human creations inevitably ephemeral, destined soon to disappear into nothingness?

These Aztec thinkers believed that one thing was indeed genuine and lasting, namely, "flower and song," a figure of speech that referred to *art*. The *tlamatinime* concluded that by giving the deities the finest art and the blood of human sacrifice, the final destruction of the world might be temporarily forestalled. Thus one Aztec poet exclaimed,

> Finally my heart understands it:
> I hear a song,
> I see a flower.
> Behold, they will not wither!
> (Ms. *Romances de los señores de la
> Nueva España*, fol. 19v) (cited in León-Portilla [1966:35])

Thanks primarily to the research of Miguel León-Portilla (1963; 1966; 1971), we know that the *tlamatinime* speculated at considerable length about the basis of art's power to postpone the destruction of the world. Some of the Aztec priests suggested that the pleasure that flower and song give to mortals would also affect the gods; and, being pleased, the supernaturals would postpone the inevitable cataclysm. Others noted that the essence of art transcends the material world and rises to the level of the abstract and eternal; and this being the case, the production of art brings the maker into intimate contact with immortality. Still others argued that all sense of time is lost for one who is thoroughly engaged by art and that this state is a sort of immortality itself. These are highly ingenious and intriguing arguments, indicative of sustained and serious reflection on the part of Aztec aestheticians (see also, R. Anderson 1990a:34–54, 140–156).

What lessons can we learn from this brief recounting of Inuit and Aztec aesthetics? First, both peoples believed that art fills needs that are multiple and significant. Although the two systems differed generally in details, in both of them, art was a source of entertainment, facilitated social relations, provided a channel of communication with the supernatural, and served profound meta-physical purposes. Also, art in Inuit culture, in the form of children's toys, was an instrument of socialization; and Aztec art conveyed important class distinctions. Similarly, in each of the other non-Western peoples that I have looked at in depth—the San, Aboriginal Australians, groups living in New Guinea's Sepik River area, the Navajo, the Yoruba, Hindus of classical India, and pre-1867 Japan—art serves numerous significant purposes.

Western civilization is admittedly unique in some respects, but in this regard, I suspect that we are very much like others: It is less productive to ask, What is *the* meaning of art in America? and instead to pursue the question, What are the meanings of art in America? As with other complex institutions and beliefs, such as religion or the family, we should expect to find art in America doing several things, ranging from the individual and psychological to the societal and cultural.

Cross-cultural studies of aesthetics also suggest ways out of a serious methodological problem. As numerous studies in anthropological epistemology have revealed (e.g., Fernandez 1965; Keesing 1982; G. Lewis 1980), it is not altogether clear what sorts of procedures lead to the production and testing of such statements. In an important paper on the anthropological interpretation of Scottish wedding cakes and associated practices, Simon Charsley (1987a,b) situates this debate in a context that is useful for our present inquiry into American arts. He sees several possible meanings in the rituals associated with the wedding cake: The bride and groom cut the cake together, thus affirming their newly forged union; and their sharing of the cake with guests allows them to make the ceremony their own, despite the bride's parents' having traditionally played an important role in determining most components of the ceremony. Further, Charsley notes that the shape and color of the cake parallels that of the bride in her gown; and "plunging the knife into the centre of the cake breaks through the 'virginal white' outer shell" of the cake (1987a:106).

But where do these interpretations come from, and how is their validity to be determined? When Charsley and his assistants asked newlyweds in Glasgow about the meaning of wedding cakes, most of the answers they received shed very little light on the matter, as exemplified by the following exchange:

Interviewer. Do you think the cake means anything?
P., a recently married woman. I don't think so. No, really. Do you?

R., her husband. I don't know where it came from but there's a lot centres around it: cutting the cake, toast to the bride and groom . . .
P. It seems to be an important bit, but I don't know . . . (Charsley 1987a:93)

On rare occasions, some of the researcher's respondents did suggest interpretations of wedding cake practices. One couple chose to omit a cake from their reception altogether because the bride had been told previously that "married people knew that the cutting of the cake meant the bride losing her virginity . . . A horrible idea, she thought" (Charsley 1987b:12). Thus, at the same time that this couple's remarks suggest a meaning for the practice of cutting the cake, their interpretation led them to reject the practice, although none of Charsley's other respondents seem to have volunteered a sexual reading of the cake-cutting ritual. Charsley remarks, "Indigenous exegesis should not be treated as a guide to any 'true meaning' . . . It is, rather, an integral part of the phenomenon for study" (1987a:94). In fact, he says, "Tendentious and unwarranted interpretations can as well be made by those whose societies and cultures are under study as by those studying them" (ibid.:102).

How indeed are we to avoid "tendentious and unwarranted interpretations" in looking for the meaning of not just a narrowly defined practice such as the cutting of wedding cakes but for a far broader issue, the meaning of art in America? First, I think, we must accept Charsley's own conclusion (1987a:107) that there are no "real meanings," only various constructions of meaning that spring from diverse sources. But that does not necessarily lead to the conclusion that all interpretations are equally satisfactory.

The criterion suggested by Charsley himself is that a given theory of meaning be "appropriate and acceptable to all" (1987b:13).[2] But, one immediately asks, "All of whom?" One obvious place to look for aesthetic theories is in the writings of aestheticians. During the two-and-a-half millennia of written Western history, a vast congeries of individuals have thought long and hard about the meaning of art; and these efforts continue up to the present day. Western aestheticians have spoken with a multitude of voices; but diverse as they are, the result has not been cacophony. Instead, by several accounts (e.g., Abrams 1953; Stolnitz 1960; Pepper 1945), most theories fall into four fundamental categories. Moreover, with regard to each other, these four positions can be seen as being complementary, not contradictory. Chapter Eleven will examine these paradigms at some length.

[2]Similarly, David et al. (1988:366) remark, "Natives' acceptance or rejection of rationales for their symbolic behaviour constitutes neither proof nor disproof of analyses that must be judged on their ability to reveal meaningful patterning and coherence in superficially disparate observations."

But of course, professional aestheticians are not the only ones in our culture who have ideas about the meaning of art. A second group is made up of people without formal training in aesthetics. Such people range from those whose professions center around the arts, who predictably have quite a lot to .say on the subject, to those whose relationship to art is purely amateur. Chapters Six through Ten will attempt to discern the coherent aesthetic themes among a number of people who, in one way or the other, are very actively involved in the arts.

A third source of ideas about art is to be found in artworks themselves. I am thinking not of the deep meanings posited by structuralists and psychoanalytically inclined theorists. Rather, contained within the narrative arts, such as vocal music, there are many statements about the nature of art, some spelled out explicitly, others expressed somewhat elliptically. An examination of this corpus of aesthetic principles is the focus of the next chapter, Chapter Five.

My conception of a society's aesthetic system, and of how to go about discovering it, might be conveyed by means of an extended analogy. Imagine a large construction site, one that occupies an entire city block. For safety's sake, a high wooden fence has been built around the entire operation, but in deference to the curiosity of passersby, holes have been cut in the wall to provide a means of seeing what is going on behind it. But the holes are fairly small—indeed, so small that when a person looks through any one hole, only a portion of the building activity can be seen. There are only six holes, with each hole providing a view that is unique but that only partially overlaps the views given by the others. Anyone can look through the holes, although few passersby take time for more than an occasional glance through them. But a person so inclined could locate all of the holes and, with some imagination, obtain a relatively accurate and complete idea of the structures being created inside the fence.

The following six chapters—the six peepholes, if you will—reveal, I believe, not the structure of a building under construction but the structure of a set of aesthetic concepts for Western art, a system that (as Chapter Eleven will show) displays a pleasing interrelationship between its component parts. The sources of information that I utilize have their limitations; but taken together, they reveal a pattern of ideas and beliefs about art in America that is fairly coherent, and this outcome is perhaps the most we can ask. Since all methodologies are flawed, one can only hope to develop techniques whose shortcomings are such that minimal salient information is missed. At the conclusion of this book, the reader must determine whether my argument is convincing—that is, whether the peepholes that I use are sufficient to reveal the structure of American vernacular aesthetics, a conceptual edifice that perhaps can *never* be seen directly or in its totality.

5

Who Put the "Bomp" in the "Bomp, Bomp, Bomp"?

WHAT AMERICAN MUSIC SAYS ABOUT AMERICAN ARTS

A popular song of the 1960s asked, "Who put the 'bomp' in the 'bomp, bomp, bomp?' Who put the rhyme in the 'ranga-danga-ding-dang'?" The song continues, "Who was that man? I'd like to shake his hand. He made my baby fall in love with me!" These lyrics, written by Barry Mann, simplistic though they might seem, contain an assertion that is fundamentally aesthetic in nature, claiming, as they do, that "bomp"—that is, art—can "make" people fall in love. Taken literally, the words credit art with the compulsive power to dramatically influence people's emotions.

Although academic philosophers might dismiss a doo-whop song as an unlikely place to find aesthetic speculation, there is ample cross-cultural precedent for it. While collecting data for *Calliope's Sisters,* I often discovered aesthetic principles "hiding," as it were, within art forms themselves. Thus, for example, a San song praises a girl's "lovely legs" (Kirby 1936:431)—that is, the lyric reveals one standard of feminine beauty among the San. And if folktales are accepted as art forms—and I see no reason to exclude oral literature from the realm of "art"—then some Inuit stories assert that art can transform reality.[1]

Listening to the song "Who Put the 'Bomp'?" from this perspective led me to look seriously at the content of American musical lyrics in search of

[1]See also the previous discussion of Inuit aesthetics in Chapter Four, as well as R. Anderson 1990a:49–52.

statements about the arts; and the results provide the basis for the present chapter. Because of their verbal, yet succinct, nature, songs are an extremely productive source of information about aesthetics—more so, perhaps, than the visual arts, dance, or other forms of music or oral literature.[2] Indeed, as the remainder of this chapter shows, American songwriters and singers have articulated a wide range of aesthetic principles; and later, in the concluding chapter, these principles will be an important part of a broader synthesis of American vernacular aesthetics.

METHODOLOGY

During the summer of 1992, I listened carefully to 850 recorded songs in an effort to discover assertions and assumptions about aesthetics conveyed in the songs' lyrics. Admittedly, it would be impossible to obtain a statistically random sample of the music that Americans hear and know; but I believe that the songs I listened to are a plausible approximation of such a sample. They are highly diverse and include the most popular musical genres in American culture, falling into ten categories, each containing at least 40 songs. Those groupings, whose names correspond to labels commonly used in the contemporary music industry in the early 1990s, are shown in Table 5–1.

Table 5–1 Categories of musical genres sampled, in alphabetical order, with the number of examples included in each category.

GENRE	NUMBER OF EXAMPLES
Blues, both traditional and urban	62
Bluegrass, traditional, folk, and hillbilly	98
Classical	48
Country and western	96
Metal	53
Oldies	147
Pop, broadway, and jazz	114
Rap	41
Top-40, including alternative rock, but not metal or rap	83
Urban contemporary and older rhythm and blues	108

[2]Aesthetic maxims are to be found in other media. Thus, for example, in the original film version of *The Wizard of Oz,* Dorothy is told, "Only bad witches are ugly." That is, an equivalence is made between evil and ugliness, and implicitly, between goodness and beauty, a belief that parallels ideas found in other cultures, such as Yoruba. (Cf., e.g., R. Anderson 1990a:133–137.)

Most of the songs I listened to were either audiotape recordings of radio broadcasts (primarily nationally syndicated broadcasts or weekly "countdown" programs) or were from the LP and CD collections of the Kansas City (Missouri) Public Library.[3] By drawing on these sources, I was assured that the songs had some currency in American culture. Metal and rap music were nearly absent from these sources, however, so for these genres, I bought a few tapes, LPs, and CDs, mostly compilations, and I borrowed others from friends. Thanks to the use of audiotapes and CDs, I could listen repeatedly to songs when necessary, and the number of undecipherable lyrics was very small, amounting to a few random words scattered through a small number of the songs. Ranging from Philip Glass to Woody Guthrie and from Ice-T to Lawrence Welk, the songs would seem to be broadly representative of late-twentieth-century American vocal music.[4]

The 850 songs in the sample contain a rich lode of assertions about the nature of art, the role of the arts in human affairs, and the relations of various art forms to each other. By my count, 276—nearly one-third—of the songs I listened to make references to art in some way. Furthermore, that proportion lies within a relatively limited range, from 23 percent for metal songs to 40 percent for classical music songs.[5]

The types of art that are mentioned in the songs are highly varied, as Table 5–2 indicates. Thus, whereas many (41.5 percent) of the lyrics' references to the arts allude to music, the majority comment on a variety of other art media. Many of the 276 songs that had explicit references to the arts made more than one assertion, resulting in a corpus of 481 propositions regarding

[3]Using "countdown" programs provided song titles and artists' names, information not consistently provided on most other radio broadcasts. LPs were recorded onto audiotape to facilitate repeated listenings to lyrics that were not easy to understand.

[4]The sample of 850 songs is somewhat unrepresentative in two ways. First, some viable, albeit relatively small, musical idioms are omitted—in particular, regional and ethnic styles (e.g., zydeco and salsa) as well as the more esoteric varieties of pop music (e.g., techno and oi). Second, I see no satisfactory way to ensure that the song styles included in the sample are present in numbers that correspond to their actual currency in American culture.

Having made these concessions, however, I believe that my corpus of data is sufficient to permit a first approximation of the broadest aesthetic principles found in modern American songs.

[5]The only style that falls outside this range is rap music, with 66 percent of the rap songs making reference to art. In part this is because most rap songs contain more words than do songs in other styles. But also, rap is unique for its frequent inclusion of artistic braggadocio, with many rappers claiming superiority over other performers. Amy Linden has observed (*New York Times*, June 20, 1993) that "One-upmanship . . . is at the core of hip-hop." Presumably, this convention evolved from "the dozens," a traditional form of competitive boasting practiced for decades by urban African-American youths.

Table 5–2 Types of arts mentioned in the corpus of songs, with number (N) of lyrics that mention each medium and percentage (%) of total references to media.[a]

MEDIUM	N	%
Music, including references to lyrics and rhythm	218	41.5
Personal appearance, including clothing and adornment but excluding natural traits not purposefully enhanced for sensuous effect	105	20.0
Dance	69	13.1
Artists and performers	52	9.9
Fine arts, including the visual, literary, and performing arts	17	3.2
Cuisine, that is, skillfully prepared food that is valued in part for its sensuous qualities	12	2.3
Flower arrangements	11	2.1
Beauty, as a general quality	11	2.1
Oral literature	9	1.7
Interior decoration, including photographs	6	1.1
Architecture, with emphasis on a structure's appearance or style, rather than on the protection it affords from the elements	5	1.0
Perfume and other purposefully sensuous scents	4	.8
Radio and television, as entertainment media	4	.8
Movies	2	.4

[a]Many songs in the corpus refer to more than one type of art, so that the sum of the frequency numbers in this table (525) is greater than the total number of songs that make reference to any form of art (276).

art.[6] As one might expect, although each lyric is unique, certain themes are heard again and again, appearing in widely varying settings and genres.

THE SALIENCE OF LYRICS

In this chapter, I assume that the aesthetic principles repeatedly articulated in American song lyrics correspond to beliefs commonly held by Americans regarding art. Is this assumption valid? In recent years it has become popular to emphasize the analysis of texts for their own sakes, ignoring meanings intended by the texts' creators or perceived by nonacademic listeners. This deconstructive approach notwithstanding, we should not forget the accumulated evi-

[6]It should be noted that these propositions represent fairly literal readings of the lyrics at hand. Double entendre, veiled meanings, and so on, are of course common in popular music. I ignore them here for the very reason that their interpretation is so indeterminate. Here I am primarily concerned with overt, rather than covert, messages.

dence, derived from many disciplines, that art reflects society. Archaeologists, for example, have long found information in pottery designs about the potters' culture; students of non-Western art have frequently shown that stylistic traits of the visual arts provide maps of cultural principles; and analysts of folklore, mythology, and other forms of oral literature have used the same approach. Similarly, those who study mass media have generated a vast corpus of literature on "effects," that is, consumers' reactions to mass media.

More directly relevant are studies of American music that see song lyrics as an index of American culture. For example, Zullow (1991) has offered evidence that "pessimistic rumination" in the words of popular songs is statistically correlated with widespread negativism about the national economy, making it a reasonably accurate predictor of economic recession. The many extant content analyses of song lyrics are based on the assumption of a correspondence between the things songs say and the things listeners believe or feel. For example, a seminal study by Shirley Seltzer (1976) catalogs the ways in which popular music lyrics reflect the values of American adolescents. The most sustained subject of research concerns the ways in which teenagers' ideas about love and romance are articulated in the lyrics of popular song, ideas that for several decades have evolved in their details but have remained constant in their essence (Horton 1957; Carey 1969; Bridges and Denisoff 1986). Along similar lines, Chesebro et al. (1986) looked at song lyrics to find changing attitudes regarding human relationships; and, more narrowly, Chandler et al. (1984) examined country music for themes of marital infidelity, and Bleich et al. (1991) for adolescent rebelliousness. More ambitious is James F. Harris's (1993) study, *Philosophy at 33-1/3,* which isolates themes in "classic" rock music that correspond to social and political beliefs that were popular among that genre's audience between 1962 and 1974. Also, the aesthetician Crispin Sartwell (1995) has produced a brief but penetrating analysis of blues music in light of the philosophy of John Dewey and also has looked at parallels between ideas found in country music and in Confucius.

Although many studies (e.g., Lull 1987; Cole 1971; Frith 1981; Carey 1969) have examined the thematic content of popular music, work by others reveals the problematic nature of the relationship between lyrics and cultural premises. For example, several researchers (e.g., Rosenbaum and Prinsky 1987; Lull 1982) have found that few people report that they listen to songs to hear their lyrics—or even *know* the lyrics (e.g., Robinson and Hirsch 1972; Denisoff and Levine 1972).[7] But whereas some researchers have discovered

[7]A journalistic study of "Louie Louie" (Marsh 1993) claims that of the many recordings of the song, the most famous one, performed in 1963 by The Kingsmen, owed much of its popularity to the very fact that its words could *not* be understood, thus leading to widespread rumors that they were obscene.

that many people do not understand the "true" meaning of songs' lyrics, their data also reveal that many listeners do derive meaning from their favorite songs' words. For example, 9 percent of Rosenbaum and Prinsky's respondents said that wanting to listen to songs' words was their primary reason for listening to music, and an additional 20 percent said that their primary motivation for listening to music lay in the fact that the "words express how I feel" (Rosenbaum and Prinsky 1987:85). Also, it must be born in mind that the authors asked only for listeners' *primary* motivation for liking music, ignoring the likely possibility that songs' words are one of several reasons that people listen to music. And although Robinson and Hirsch's claim that 10 percent to 30 percent of their subjects did not know songs' lyrics with complete accuracy, many (up to 67 percent) gave interpretations that the authors classified not as "wrong" but merely as "inadequate" (Robinson and Hirsch 1972:226). (Significantly, those giving correct answers tended to be older individuals and better students, and they were likely to listen to more music.)

The case in favor of giving credence to song lyrics is strengthened even more by a reappraisal of Rosenbaum and Prinsky's data. Although the authors emphasize the large number of respondents whose interpretations differ from their own, they tellingly remark that "descriptions of songs given in this study, as in 'Stairway to Heaven,' show that respondents tended to interpret songs quite literally" (Rosenbaum and Prinsky 1987:86).[8] For present purposes, it is very significant that among Rosenbaum and Prinsky's subjects, many listeners were aware of the literal meanings of the lyrics of the songs that they heard frequently, and I suspect that the same is true for most genres and audiences of American music.

Thus, just because a particular song makes a particular assertion, we cannot assume that everyone who listens to the song understands—much less, agrees with—the idea put forth in its lyrics. On the other hand, *some* listeners, *some* of the time, clearly do attend to song's words, an outcome that surely must jibe with most people's personal experience: Whenever one sings a song to oneself or recognizes lyrics such as those that appear in the following pages, the sizable repertoire of lyrics lodged in memory becomes apparent.

The lyrics in the 850 pieces of music that I listened to have a great deal to say about art. Like people, each song is unique in its message; nevertheless,

[8]Rosenbaum and Prinsky shed further light on this in remarking, "It may be that a complete understanding of popular music lyrics requires a degree of sophistication in literary analysis that is lacking in most young people" (Rosenbaum and Prinsky 1987:86). Also, there has been little study of the way texts are interpreted by nonacademic, readers. One scholar did, however, find that college freshmen tended to understand poetry in terms that are more literal than interpretations given by a trained literary critic (DeBeaugrande 1985:17).

certain themes do recur in the corpus of lyrics. Thus, the following sections of this chapter will look at assertions about art as a spiritual, metaphysical, cultural, and societal entity.

ART AND THE SUPERNATURAL: "THE MAGIC'S IN THE MUSIC..."

Although most contemporary American music is secular, references to the sacred do occur in American vocal music. Of the songs in the sample, 29 link the arts with some aspect of the supernatural—most often, "heaven," "the devil," or "magic." Of these, almost all fall into two categories. One recurrent theme is that the realm of the supernatural has a distinctly artistic dimension. Images of singing angels, of heavenly music, of spotless robes and bright crowns, and of pearly-gated cities are common in musical references to "heaven." It is not surprising to find such allusions in spirituals and gospel songs, but the same idea occurs in other music styles as well. Thus the rap song, "P-Funk" (performed by Digital Underground) includes the lines "Somebody says, 'Is there funk after death?' I say, 'Is Seven Up?'" Similarly, a 1973 oldie asserts,

> If there's a rock and roll heaven,
> Well you know they got a helluva band.
> (Righteous Brothers, "Rock and Roll Heaven")

The choice of words in these last lyrics—divine music played by a "helluva" band—introduces a related concept by placing the arts not only in "heaven" but also in "hell." Thus, "the devil" is a good dancer, is well dressed, and (in one song) performs to the accompaniment of

> A nine-foot grand,
> A ten piece band,
> And a twelve-girl chorus line.
> (Joe Diffie, "If the Devil Danced in Empty Pockets")

In the preceding lyrics, the arts are manifest in heaven or in hell; but a second, and distinctly different, theme is also apparent: Some songs describe art as a means by which the supernatural is effectively manifest on earth. Thus, in the old standard, "Cheek to Cheek," the singer claims to be "in heaven, when we're out together, dancin' cheek to cheek." Doubtless, in writing these lyrics, Irving Berlin did not literally mean that close dancing could transport a person to heaven; and any transcendent effect must be at least as much due to the particular dancing partner as to the act of dancing itself. But having factored out these considerations, we should not ignore the idea that

art has an alchemical power to transform the mundane into the sacred, because it occurs in so many other songs, such as

> The magic's in the music,
> And the music's in me.
> (Lovin' Spoonful, "Do You Believe in Magic?")[9]

When the supernatural is made manifest through art, it usually works through humans, but sometimes art is portrayed as an independent, virtually animistic, force in itself. For example, in Ronnie Milsap's song "Lost in the Fifties Tonight," an even older song, "In the Still of the Night," transports the singer to another time and place.

Art can even give life to inanimate objects. For instance, musical instruments positively *want* to perform: In the Stampeeders' song, "Sweet City Woman," a banjo wishes to sing,[10] and when "Bubba Shot the Jukebox," it was (according to singer Mark Chestnut) "a case of justifiable homicide." That is, Bubba's shots destroyed not just a mechanical device but something arguably human, a notion that also provides the central trope for another country-and-western song, "Brother Jukebox, Sister Wine." And through the artistic process of ceramic modeling, Gene McDaniels claimed that God made a woman from only a "Hundred Pounds of Clay").[11]

How seriously should we take these associations between art and the supernatural? In cases in which secular art appears to provide a means to transcendence—for example, when dancing "cheek to cheek" puts one "in heaven"—the linkage may serve merely poetic purposes. In "Cheek to

[9]Performers are not just in a enchanted state; some also have the ability to affect the world through their preternatural artistic powers. For example, blues singer Jimmy Johnson (in "Country Preacher") says,

> When it comes to raisin' souls,
> You know, I've got the magic touch.

In other settings, performers claim to have extraordinary abilities to spread the gospel or, in the extreme, to control life and death, as in

> I can insure
> Life or death with my breath.
> My voice is a cure . . .
> I make a sick man rock on his death bed.
> (Kool Moe Dee, "How Ya Like Me Now?").

[10]David Berliner's excellent account of South African *mbira* players shows that they, too, attribute human qualities to their instruments. See Berliner 1978:127–135; also, R. Anderson and Field 1993:179–186.

[11]This rock 'n' roll retelling of a creation story closely parallels an Inuit folktale mentioned previously in which Raven creates First Woman by means of sculpting clay. See Nelson 1899:451; also, R. Anderson 1990a:50.

Cheek," one could replace "heaven" with "a state of blissful happiness" and perhaps not alter the lyricist's intended meaning.

But in other cases—when gospel songs assert that angels sing, and say so with the same certainty as when they claim that heaven itself exists; when performers assert that their artistry gives them mysterious, awesome power; or when the means of music production are personified as having spirits of their own—in all of these cases, the association between art and the supernatural should not be dismissed. If one were straightforwardly to ask lyricists, performers, and audience members, "Do you believe that art literally has divine, diabolical, or magical powers?" the answer might be "No." But if the question were, "Do you feel that the arts sometimes have incredible power, a force beyond anything that science can explain?" then many people, even the empirically minded, might well answer "Yes."

Although some people believe that art in small-scale societies is inevitably linked to religion, in fact many cultures (such as those of the San and the Inuit) create predominantly secular art. But even among those peoples, art is thought to have a supernatural warrant, with people tacitly acknowledging that art plays a powerful role in day-to-day life because of its awesome capacity to affect people, things, and events. This chapter will have much more to say about the ways in which American music portrays American art; but already it is clear that, like the San and the Inuit, Americans sometimes attribute divine power to art.

METAPHYSICAL THEMES: POWER, ENERGY, AND TRUTH

Whether or not art has a spiritual dimension, it is unequivocally referred to in American music as having a potent metaphysical significance in the world. In song after song, the arts are portrayed as embodying compulsive power and as exercising unmistakable influence. Art's cultural function is founded on two broad ideas: First, *art gives value or meaning to one's life;* and, second, *art embodies potent energy in the world*—for good or, occasionally, for ill. After giving examples of these two concepts, we shall look at three explanations that songs posit as the basis for the significance of art: the relationship art has with truth, with nature, and with the elite sector of society.

Art, Meaning, and Energy

Lyrics sometimes characterize the arts as making life itself worth living. For singers and songwriters, their own medium of music predictably fills this role. Thus, country performers Waylon Jennings and Willie Nelson say, "The

only two things in life that make it worth livin' / Is guitars tuned good and firm feelin' women" ("Luchenbach Texas").[12]

The idea that music gives musicians a reason to live seems to be taken seriously by some performers. Perhaps the most compelling testament to art's preeminent importance in the performer's life occurs in Jackson Browne's "Stay / The Loadout": Despite the boredom of a touring band's life on the road, when the show finally begins, "we hear that crowd, and we re-member why we came." (Then the plea is made to the audience, "Oh, won't you stay / Just a little bit longer?")

If music is seen as a potent symbolic force for those who create it, it is portrayed as being equally influential in the world at large. This idea occurs across the spectrum of musical genres, from the classical composer Elliott Carter ("Where is the music coming from, the energy?"[13]), to the rapper Paris, who says that his music is "a power so strong you can't stop it now" ("Break the Grip of Shame"). Less abstract but more frequent is the claim that music possesses the power to make people dance. Thus, rap can "make you move your butt" (Whodini, "Jump Back and Kiss Myself").

Just as lyrical allusions to the supernatural link the arts not only with heaven but also with the devil, references to the secular power of the arts also recognize a darker potential. Thus, in "It Ain't Over 'Till the Fat Lady Sings," the group En Vogue claims to have "vocal lethal weapons."

All of these songs speak only of music; but other media are also some-times mentioned as having diabolical potential, as when the metal group Lizzy Borden claims (in "Master of Disguise") to be "dressed to kill." Painting and the fine arts get the same treatment in words that Lou Reed and John Cale at-tribute to Andy Warhol:

> You scared yourself with music;
> I scared myself with paint.
> I drew 550 different shoes today,
> It almost made me faint.
> ("Open House")

[12]Similarly, the introduction to the old standard "I Got Rhythm," as remade in the 1970s by The Happenings, says,

> In this vast and troubled world
> We sometimes lose our way.
> But I am never lost—
> I feel this way because . . .
> I got rhythm
> I got music,
> I got my girl,
> Who could ask for anything more?

[13]From *Anaphora*, performed by Speculum Musicae.

Where Is the Energy Coming From?

Although several songs acknowledge art's power, others admit how difficult it is to isolate the source of that power. For example, after the Lovin' Spoonful (in "Do You Believe in Magic?") makes the promise to tell "'bout the music/And it'll free your soul," the very next lines say,

> But it's like tryin' to tell a stranger
> 'Bout rock 'n' roll.

Some lyricists may be resigned to the futility of explaining art's efficacy, but a number of songs postulate several possible sources of "art power."

Some songs suggest that art's influence in the world derives from its containing manifest **truth.** Thus, rappers repeatedly declare the verity of their words, as in

> Now I'm ready to rap,
> Strong fax I swing.
> (Public Enemy, "Move!")[14]

A second possible explanation for art's power is found in several other songs that imply that art's significance derives from its being an intrinsic part of **nature.** This idea appears in a pastoral song by Charles Ives:

> O'er the mountain towards the west,
> As the children go to rest,
> Faintly comes a sound, a song of nature hovers round,
> 'Tis the beauty of the night;
> Sleep thee well till morning light.
> ("Berceuse")

But the relationship posited between art and nature is complex. In the previously mentioned "Cheek to Cheek," the pleasures of nature take a distinct second place to the satisfactions of dancing:

> Oh, I'd love to climb a mountain,
> And to reach the highest peak,
> But it doesn't thrill me half as much as
> Dancin' cheek to cheek.

Other songs express the opposite view, that art is a lesser entity than nature. Thus, Charles Ives's "The New River" contains the lines

[14]The claim to authority is not confined to rap music. For example, a popular 1992 song entitled "Beauty and the Beast," from the score for an animated movie by the same name and based on the traditional story, contains the lines

> Tale as old as time
> True as it can be . . .
> "Beauty and the Beast."
> (Celine Dion and Peabo Bryson, "Beauty and the Beast")

> It's only the sounds of man,
> Phonographs and gasoline, dancing halls and tambourine;
> Killed is the blare of the hunting horn.
> The River Gods are gone.

And singer Rob Crosby, in a song with the telling title "She's a Natural," praises a woman for not using cosmetics to alter her appearance:

> She's got just a touch of gray in her hair.
> That's OK. She knows I don't care.
> And the little lines around her eyes,
> She don't need to disguise.

Taken together, these four lyrics both contrast art and nature and equate them. This pattern of presenting both thesis and antithesis occurs often in American vernacular aesthetics and will be discussed later at length; but a closer reading of these particular lyrics suggests that an additional point is also being made. The songs actually say that what is inferior to nature are the arts of crass social artifice, such as dance halls and cosmetics. Such things are of lesser merit than the simple sound of a hunting horn and the natural beauty of a woman's face.

The relationship of art to the natural world is less ambiguous when the focus shifts to the talents of the artist. These talents, American song makes clear, spring directly from nature. Thus: Steady B says he has "Got the knack, for I'm a natural" ("Bring the Beat Back"). The "natural" quality of artistic talent, in contrast to culturally acquired skills such as literacy, is perhaps best seen in the case of "Johnny B. Goode" (in this case sung by Jim and Jesse), a musician who,

> . . . never ever learned to
> Read and write so well,
> But he could play a guitar
> Just like a-playin' a bell.

(A corollary of the premise that art is natural is that it is easy or simple. Thus, Little Eva says that the "brand new dance" that she describes in her song, "Locomotion" is "easier than learnin' your ABC's.")

A final theme, found only three times in the corpus of data, also has to do with the power of art. Consider these lyrics:

> We've got a chance
> For a story-book romance, . . .
> Just like Romeo and Juliet.
> (Stacy Earle, "Romeo and Juliet")

> Where did Picasso come from
> There's no Michelangelo coming from Pittsburgh.
> (Lou Reed and John Cale, "Smalltown"[15])

[15]The punctuation used here duplicates that which appears in the liner notes for the recording.

And,

> I've got the style it takes,
> And money is all that it takes.
> (Lou Reed and John Cale, "Style It Takes")

In all three cases, some form of excellence is associated with the **socioeconomic elite** of Western culture. In the play *Romeo and Juliet*, the love affair of Shakespeare's protagonists is equated with an exemplary romance; and the two Lou Reed/John Cale songs suggest that successful fine art originates only in cosmopolitan, affluent settings. From these statements, it is not a great leap to conclude that art is powerful because members of the most influential sector of society both identify and possess the "best" works of art. It is interesting to note, however, that whereas some songs praised the simpler arts by equating them with nature, these three lyrics seem to do the opposite by elevating to prominence the most aristocratic arts. Although the evidence is sparse, perhaps what is going on in these contexts is not a debate about the relative merits of elite versus folk art, but rather the claim that *both* elite and folk art are superior to the great mass of popular, commercial art that lies between these two extremes. Needless to say, this is a fairly grand hypothesis to rest on the mere assertions that a "hunting horn" is preferable to a tambourine and that Michelangelos do not come from Pittsburgh. And perhaps more important, the relevant lyrics come from sources that are closely related to the fine arts—the classical composer Charles Ives, in the first case, and in the second, Lou Reed, whose first success was with the Velvet Underground, a seminal art rock group of the 1960s, and who (with John Cale) wrote the album *Songs for Drella—A Fiction* as a memorial to Andy Warhol. Voices from this quarter have long praised the supposedly untutored, naive "noble savage" and simultaneously disdained the bourgeoisie—all the while formulating a rationale for producing fine art for an elite audience. (American opinions regarding the relative merits of folk, popular, and fine art will concern us several times in the chapter also.)

ART AND EMOTIONS

The song lyrics that were cited in the previous section situated the arts in the symbolic system of values and beliefs that constitutes American culture; and those in the section following this one examine art's role in the social interactions of Americans. But more common than references to either culture or society are lyrics that focus on psychological issues, especially the complex

area of human emotions. As we shall see, music not only soothes the savage breast but profoundly affects it in numerous other ways as well.

Art and Affection

Many songs suggest in one way or another that the arts can foster positive feelings between people. Some songs describe how art can spawn friendships, as when John Denver sings that his guitar "introduced me to some friends of mine, who brightened up some days" ("This Old Guitar").

Art leads not just to friendships; often it brings romance. Examples of this possibility come from diverse genres of music. Thus, besides having given him friends, John Denver's previously mentioned guitar also "gave me my lovely lady; it opened up her eyes and ears to me, yes it did." Or, to cite another example,

> Gonna write a song;
> Sing about her hair, her lips, and her eyes.
> Bring her to tears with my heartfelt honesty.
> Norma Jean Riley's gonna fall for me.
> (Diamond Rio, "Norma Jean Riley")

In this case, art in the form of a flattering song becomes a purposeful instrument for attaining love, an idea akin to the previously discussed notion that the arts have a preternatural ability to make things happen.

These examples depict the romantic potential of song and dance, but other art media are also said to have aphrodisiac qualities. For example, a country group proposes to enhance romance with music, while also advising,

> Champagne and a box of candy,
> A dozen roses might come in handy.
> (Shenandoah, "Rock My Baby")

Art and Romance: Antitheses

The most intriguing variation on the linkage between art and romance is found in songs that call into question art's romantic affect. In its weaker form, this position asserts that love can flourish even in the absence of artistic accomplishment:

> Maybe he sings off-key,
> But that's all right by me.
> 'Cause every time he pulls me near,
> I just wanna cheer.
> (Deniece Williams, "Let's Hear It For the Boy")

This idea is carried further by a number of songs in which the arts are portrayed as being positively untrustworthy as a means of guaranteeing "true love." Thus,

Handsome boys come a dime a dozen.
Try to find one who's gonna give you true lovin'.
(Mary Wells, "Shop Around")

The indictment of art in such songs is serious indeed, the suggestion being that beauty can mask people's true purposes or identities, as in the case of "Donna," who has recently broken the heart of Dion and the Del-Satins:

She always wears charms, diamonds, pearls galore.
She buys them at the five and ten cent store.
She wants to be just like Zsa Zsa Gabor,
Even though she's the girl next door.
They call her Donna, Donna, the prima donna.
(Dion and the Del-Satins, "Prima Donna")

Art and Conceptions of Personal Beauty

Dictionary definitions of the word *aesthetics* typically begin by identifying it as "a branch of philosophy dealing with the nature of beauty" (*Merriam Webster's Collegiate Dictionary* 1993:19). As used by most philosophers, however, *aesthetics* encompasses broader questions regarding (as the same dictionary goes on to say) "the nature of art." Nevertheless, ideas about beauty are subsumed into the aesthetician's larger project, and quite a few of the songs in the corpus make a connection between a person's beauty and his or her desirability as a lover. The most common theme is the claim that one's own lover—or, perhaps, the person conceived to be the *ideal* lover—is beautiful. A succinct statement of this idea occurs in the Broadway song, "I Never Has Seen Snow," performed by Liza Minelli:

Nothin' will ever be
Beautiful like my love is, . . .

In this case, as in many others, the lyrics do not say how or why the lover is beautiful—or, indeed, if the lover's beauty is an objective quality vested in the person or an artifact of the singer's subjective perception, a possibility suggested by the next line in the song:

Like my love is, to me.

Although American men tend to be more concerned about a woman's physical appearance than American women are about a man's (cf., e.g., Strong and DeVault 1994:351–352), in the lyrics under study, women are sometimes vocal on the subject, too[16]—as in

[16]Of course, the situation is complicated by the fact that although a woman performs a particular song, the lyricist, the producer, and ultimately the consumer, may all be men.

Why'd you come in here lookin' like that
In your cowboy boots and your faded old jeans,
When you could stop traffic in a gunny sack?
You're almost givin' me a heart attack.
Why'd you come in here lookin' like that?
(Dolly Parton, "Why'd You Come In Here Lookin' Like That?")

Whereas it is not uncommon for American men to seek women who, first of all, are attractive and, secondarily, who have some promise of being good mothers and domestic workers, many American women want men who are good providers—and, secondarily, who are attractive and sensitive. American songs tend to support such a picture, as illustrated by these contrasting lyrics:

The girl that I marry will have to be
As soft and pink as a nursery.
(Billy Eckstine, "The Girl That I Marry")

and

My friend says he's real cute . . .
He's got plenty money
And he's fun to be with.
He dresses in the finest clothes.
(Deniece Williams, "Blind Dating")

In other cases, the reason for calling a lover beautiful lies not in bodily appearance but rather in the decorations worn by the person. Such is the case in the song, "Easter Parade," in which a woman is praised for her "Easter bonnet, with all the frills upon it" (Sarah Vaughan and Billy Eckstein). And in some instances, fashion accoutrements overcome features that some might view as deficits of physical appearance:

Picture a tomboy in lace,
That's Nancy with the laughing face.
(Frank Sinatra, "Nancy")

Finally, some mention must be made of the one trait of physical appearance that receives recurrent mention: In four songs (Buddy and the Juniors' "Hoochie-Koochie Man," Howlin' Wolf's "Hidden Charms," Heavy D/Third World's "Now That We Found Love," and William Clarke's "Must Be Jelly") male singers praise women for being fat.[17] The obvious commonality is the African-American culture. (The first three singers are black, and from an early age William Clarke modeled his musical style after black performers, such as Big Joe Turner and Big Mama Thornton.) Black male performers, just

[17]Since the late 1980s, "fat" (or "phat") has been used as an all-purpose adjective of approval in rap music. In fact, one of the sources of rap songs for this study was a compilation entitled *Fat Cassette* (Tommy Boy, #TB 1036).

like their white counterparts, praise women for their attractiveness; and in their songs, they express a desire for such women, although the specific traits that the two communities find attractive differ.

Most songs that link artistry to affection emphasize romance, but several go a step further, portraying art as a sexual aphrodisiac. In some instances, the reference is somewhat veiled:

> I can talk these words
> That sound so sweet.
> I can make your little heart
> Skip a beat.
> (Willie Dixon, "Seventh Son")

(A variant of this theme occurs when lyricists use one or another form of art as a metaphorical referent to sexual relations. Long before the term, *rock 'n' roll* was a style of music, in black English the phrase referred to sexual intercourse [Dawson and Propes 1992:135]; and *funk,* now the name of a style of music, but which once referred to sexual relations and to a malodorous condition, probably has an even longer history.)

In the extreme, and doubtless incorporating considerable hyperbole, the passion engendered by art can push a person beyond the bounds of sanity:

> My baby drives me crazy
> When she does The Stroll.
> (Bobby Darin, "Queen of the Hop"[18])

Art and Expression

Several songs assert, either explicitly or implicitly, that art provides a vehicle through which the singer can express nonromantic psychological states. Thus, John Denver sings,

> This old guitar taught me to sing a love song,
> Showed me how to laugh and how to cry.
> (John Denver, "This Old Guitar")

Although music may teach one "how to laugh," the more common idea is that music provides a means of expressing feelings. Sometimes unrequited love is the source of the demoralization; but other emotions can equally well be expressed through music, as when Jeanie and Jimmy Cheatum recount how acutely they miss a deceased musician in "Buddy Bolden's Blues."

[18]Again, it is as important to avoid taking this hyperbole ("drives me crazy") literally as it is to ignore the other songs in the corpus that likewise suggest that the arts can affect a person's emotions so powerfully as to temporarily challenge one's reason.

Besides expressing feelings, art can positively *affect* one's spirits. A wide range of evoked feelings are described, ranging from laughter, through crying, to anguish, as in Joe Maphis's tribute to fellow performer Merle Travis:

Well, I've never seen a guy
Like ol' Trav'.
He could make you cry,
He could make you laugh.
(Joe Maphis, "Me and Ol' Merle")

By far the most common idea, however, is that the arts possess the ability to elevate a person's mood and make one happy. Several songs make the bold claim that the arts can transform sadness into happiness, as in this:

The cares that hung around
Through the week
Seem to vanish like a
Gambler's lucky streak,
When we're out together
Dancin' cheek to cheek.
(Ella Fitzgerald and Louis Armstrong, "Cheek to Cheek")

Memories as a Source of Art's Psychological Power

One source of art's psychological impact lies in its ability to connect the present with the past. In 17 songs, the singer makes a poignant reference to his or her personal history, using an artwork to evoke a nostalgic feeling about a bygone time. In some cases, present exposure to a particular song powerfully brings to mind past, and often idyllic, days. A thoughtful treatment of this concept is found in a song by Charles Ives:

I think there must be a place in the soul of all
Made of tunes,
Of tunes of long ago . . .
Now!
Hear the songs!
I know not what are the words
But they sing in my soul of the things our Fathers loved.
(Charles Ives, "The Things Our Fathers Loved")

In the line, "I know not what are the words," Ives points out what many of us have experienced: Even if we cannot consciously recall the words of a familiar song, its melody still can evoke thoughts and feelings from the past.[19]

[19]Hansen and Hansen (1991) have experimentally demonstrated that listeners typically comprehend a song's theme, regardless of how many of the song's words they comprehended; and such "schematic information processing" must account for the phenomenon to which Ives refers.

Another example of memories revivified by art also contain the previously discussed idea of artworks as having a consciousness of their own:

> All you gotta do is
> Get with the mix,
> If you want a fix.
> Ooh, rock 'n' roll never forgets.
> (Bob Seeger, "Rock 'n' Roll Never Forgets")

ART IN SOCIETY

American songs talk about the arts not only in metaphysical, cultural, and psychological contexts but also in the social lives of living, breathing people. Song lyrics address a wide spectrum of sociological issues, from describing the role of artists to proposing a tentative genealogy of the arts.

The Artist's Role

Many Americans believe that artists' talents and skills surpass those of nonartists, but just as there is no consensus among world cultures regarding the source of the artist's special abilities (cf. R. Anderson 1989:88–91), we also find disagreement in American song lyrics about the origin of individual artistry, variously attributing artistic ability to God (M. C. Hammer, in "Can't Touch This"), family (John Denver, "Thank God, I'm a Country Boy"), and nature (Jim and Jesse, "Johnny B. Goode").

But whatever the source of artistic talent, American songs speak with certainty regarding the role of the mature artist. One prevalent theme in these passages is the concept of "art as work." Thus, Conway Twitty (in "That's My Job") says, "I make a livin' with words and rhymes"; and John Denver avers that "This Old Guitar" "gave me . . . my living."

Some singers do, however, evince ambivalence about the material rewards of success and complain about their seemingly privileged lives. For example, in a song with the highly ironic title of "Life's Been Good," Joe Walsh jauntily describes the rigors of living his life in hotel rooms rather than in the luxurious house that he owns but has never seen, of losing his driver's license so he cannot drive his fast and sexy Italian sports car, of using a limousine more as a fortress for protection against overzealous fans than as an elegant means of transportation, and most of all, of always fearing that the extravagant praise he receives is mere flattery.

This love/hate pattern regarding the material rewards of art-making, a dialectic tension that turns up in so many contexts, is also seen in artists' opinions regarding their audience and the attendant phenomenon of fame. To be sure, several singers desire and expect acclaim:

> Many people comin' from miles around,
> To hear you play your music till the sun goes down.
> And maybe your name will be in lights, sayin'
> "Johnny B. Goode Tonight."
> (Jim and Jesse, "Johnny B. Goode")

But along with the artist's need for recognition also comes vulnerability:

> Mother, do you think they'll like this song?
> Mother, do you think they'll try to break my balls?
> (Pink Floyd, "Mother")

Thus emerges a fragmentary portrait of the artist in America: His or her talents, of uncertain source but apparent from an early age, lead to a professional career that is a mixed blessing. It is rightfully a source of sustenance and fame, but success can also bring real or apparent decadence and isolation from meaningful human contact.

Art and Social Identity

Art is sometimes said to be "nonutilitarian," and the value of producing art does indeed seem to be a different matter than, say, producing food. Nonetheless, cultural anthropological studies of art in non-Western cultures (e.g., R. Anderson 1989:28–45) have consistently and overwhelmingly confirmed that art fills extremely important functions in society. (In anthropological contexts, *function* does not simply mean "use" but refers to the contribution that a traditional belief, institution, or practice makes to the maintenance of human life or to the cultural stability of the society in which it occurs.)

Despite our egalitarian ideology, Americans are quite aware of social status; and as elsewhere in the world, one of American art's common functions is to indicate a person's class. Some instances are blatant, as in "Puttin' on the Ritz," in which the rich are identified by their "High hats and Arrow collars, white spats and lots of dollars" (Fred Astaire, "Puttin' on the Ritz").

But contemporary popular music lyrics generally say more about the lives of common people than the aristocracy, and the corpus of songs makes correspondingly more references to more proletarian body decorations. For example, rap artists present themselves in a style of fashion that is as distinctive as it is elaborate: "There's B-boy's hat and B-boy's rap" (Shoolly D, "Coqui 900"). Rappers, however, are certainly not the first to use dress as a code for a particular subculture. Older songs, with their more frequent reference to rural life, did the same, singing of, for example, a J. B. Stetson hat in "Muleskinner Blues."

By the same token that body decorations can effectively convey information, they can also deceive. Thus, for example, Public Enemy warns, "Now the KKK wears three-piece suits" (Public Enemy, "Rebirth"). Still other songs

accept the equation between style and status, and they use it as a tool of resistance and rebellion. For example,

> I need friends who don't pay their bills on home computers
> And they buy their coffee beans already ground.
> If you think it's disgraceful
> That they drink three-dollar wine,
> A better class of loser suits me fine.
> (Randy Travis, "Better Class of Losers")

The Social Settings of Art Production

A previous chapter discussed the role of art in weddings as rites of passage. Among the lyrics in the corpus, rites of passage attendant to death and dying are mentioned more often than any other: Woody Guthrie's "1913 Massacre," mentions a funeral tune; the traditional "Jimmy Grove and Barbara Ellen" describes grave decorations, as does the cowboy song "Streets of Laredo"; and even the death of the family pet is memorialized in Charles Ives' "Slow March," which was written following the death of a dog. But art also makes an appearance at weddings, in the form of ringing bells (Manfred Mann, "Ooh-Wah Ditty Ditty") and festive songs and dances (Charles Ives, "Waltz").

Arts used in rites of passage quickly blend into arts used for less formalized occasions, however. Artistic concomitants of military activities, for example, are mentioned in three songs; and Christmas songs are noted in another. Carried one step further, the arts are often portrayed as being a common accompaniment to festive good times. For example,

> When the works all done
> And the sun sets low,
> Pull out the fiddle and we'll
> Rosin up the bow.
> (John Denver, "Thank God, I'm a Country Boy")

The preceding song is particularly clear in presenting the arts as the necessary ingredient in setting apart work and play; and a more extreme contrast appears in "Let's Face the Music and Dance," where the special state associated with the performing arts is contrasted to the harsh reality of having to pay one's bill:

> Before the fiddlers have fled,
> Before they ask us to pay the bill,
> And while we still have a chance,
> Let's face the music and dance.
> (Ella Fitzgerald, "Let's Face the Music and Dance")

Thus, the message is unequivocally clear: American songs present music and dance as a necessary part of good times. As we have seen previously, the

arts are often attributed a supernatural capacity to transform both the world about us and the world within us. If that is the theory, the practice follows immediately: To convert mundane proceedings into a special event, add art!

Relationships Between the Arts

In the same way that some cultures personify the art as deities, the relations between whom parallel the relations between art forms, American song lyrics provide, in at least a fragmentary fashion, a family tree for the arts. Thus, rap performer Art Kelly's "Born Into the Nineties" acknowledges miscellaneous sources of rap music; and Jeanie and Jimmy Cheatum devote a song to the memory of early jazz performer Buddy Bolden ("Buddy Bolden's Blues").

Competitive evaluation of groups is a recurrent theme in rap music— one of the very few instances of a theme's being so closely linked to a particular style of music. In four different rap pieces, performers brag that they are superior to other rappers. (The only other occurrence of this theme is found in "Alexander's Ragtime Band," as performed by Liza Minelli: "It's just the best-est band what am, my honey-lamb.")

Such lyrics merely give placement to one performer or group in relation to others; they are more sociological than philosophical. A few songs make more abstract claims, however: Two lyrics present "beat" as the precursor of a later musical style; and a third claims that rap was once just a "cool dance." Although this is sparse evidence from which to derive a hypothesis, these songs concur on a very interesting point: All imply that the kinesthetic instinct for rhythm is more primitive than the melodic and harmonic components of music. The prehistoric origins of music is such a speculative question that few ethnomusicologists or social scientists today address it directly; but a century ago, in more intrepid intellectual times, the German economist Carl Buecher argued that music did indeed evolve out of rhythmic movement—specifically, the movements necessitated by repetitive work activities (cf. Nettl 1983:165). Even contemporary philosophers of art generally abjure theories of origin, but song lyricists, writing for a popular audience, have made some suggestions in this area, ones that parallel those put forward by earlier scholars.

If some lyrics suggest a hierarchy between the arts, several others emphasize the complementarity between diverse art forms. A number of songs imply that certain styles and certain art forms tend to go hand in hand. The association between music and dance is the most frequent example of this; however, two other songs also make a linkage between musical genres and the visual arts of

interior design and body decoration. The most comprehensive assemblage of arts is found in a performer name Ruby, renowned for her good looks, tight dresses, and style of dance (Clinton Gregory, "Play, Ruby, Play").[20]

CONCLUSION

We began with 850 songs, taken from ten diverse musical styles, and discovered that nearly a third of them make one or more references to art. In all, 481 lyric passages alluded directly to an art form—41.5 percent of them dealing with music itself, but the others mentioning a wide variety of performing, visual, and literary arts. From this body of raw material, what general inferences may be drawn?

Taken as a group, the song lyrics generate a broad theoretical characterization of the arts: On the philosophical level, art is portrayed as having a supernatural warrant in two different ways: Numerous lyrics assert that the domain of art extends into the supernatural dimension, and others suggest that art provides a vehicle through which the supernatural affects the human realm. Moreover, American song lyrics attribute the qualities of power, truth, and energy to the arts, both in individual artists' lives and in the world at large. Various theories are adduced to account for art's potency; but whatever the source, its existence seems generally to be agreed on.

Furthermore, many songs proclaim the psychological potency of art. Again and again art is alleged to spawn romance, and other lyrics shed light on ideas about beauty, sexuality, and erotic passion. Art, the lyrics say, can also affect nonromantic feelings and may even influence one's physical well-being.

Finally, numerous lyrics place art in a societal setting, offering views on the artist's role in society and social affairs: art, the lyrics tell us, is a necessary component of various institutional activities, such as rites of passage. And, last of all, some songs chart a few of the linkages among diverse art forms.

In this chapter, I treat this set of ideas as an isolate—a closed system composed of concepts that exhibit a structure of their own. But, of course, song lyricists are not the only people with thoughtfully considered opinions about the arts. Many nonphilosophers who have a passionate interest in one or another particular art form also have opinions about the "true" nature of

[20]Lou Reed and John Cale concatenate fine art painting and Hollywood in a song entitled "Starlight"; and although the two seem like strange bedfellows, Andy Warhol did indeed utilize both media.

artists, artworks, and art in general; and since the time of the ancient Greeks, professional philosophers have proffered thoughtful views on the same subjects. The remaining chapters will examine these two groups of people, attempting to map the aesthetic values they articulate, and to compare and contrast these values with those we have found in American song lyrics.

6

The Artist's World

Ah, the romance of the cultural anthropologist of yore! After a long and harrowing journey by ship, boat, and dugout canoe, the intrepid adventurer would arrive at "his" village; after many dangerous or farcical setbacks, he would be slowly accepted by "the natives," gradually mastering their complex language and learning their exotic customs, increasingly seeing the world through their eyes; and after a year or two in the bush, he would return to "civilization," bent on enlightening his countrymen on the wisdom and nobility of "his people."

Today that image of the "anthropologist as hero" (cf. Hayes and Hayes, 1970) has been shattered. As the number of unexplored lands has diminished to the vanishing point, anthropological interest in emerging nations and complex cultures has flourished; and with the disappearance or radical modification of indigenous lifeways, theoretical interest has shifted to issues such as hegemony and resistance that were rarely of interest in the past (Brown 1996). Furthermore, the social scientist's supposed attitude of aloof detachment has been called into question by postmodern theorists who problematize the distinction between subject and object, often revelling in the anthropologist's personal and political engagement with the people and ideas he works with. And this hypothetical "he," of course, is now likely to be a "she" or a collaborative "they."

Some of these changes were inevitable; most of the others, in my view, are desirable. But all of them notwithstanding, there is still a place for a

fundamental component of the classic cultural anthropological project, namely, discovering (with as much empirical rigor as possible) the beliefs and behaviors of people who are different from oneself and then describing these things to others who are unaware of them. Through this ethnographic undertaking, greater interpersonal understanding is promoted; and in a world where ethnic tensions can quickly escalate into mass slaughter, such understanding can only be a good thing.

This chapter strives for that goal, going directly to the people who have firsthand experience—specifically, to sixty-four committed producers and serious consumers of thirteen diverse art forms. Before looking at those interviews in depth, however, something must be said about the sources of the information.[1]

THE ART FORMS

As noted in Chapter One, *art* once referred to any human skill; but a narrowing of meaning began in the Renaissance, and by the mid-nineteenth century, it usually referred to literature, music, painting, sculpture, and theater (cf. Williams 1958:xiv;1976). Often a qualitative evaluation was implied: Only the *best* literature, music, and so on, were true works of art (Weitz 1957). They were the product of Genius, and they conveyed Truth. Anything less was craft, the work of a mere artisan.

But the final decades of the twentieth century have witnessed a marked reversal of this trend. Perhaps it was the popular movements of the 1960s that started the pendulum swinging in the other direction, but the people interviewed for this chapter have a far broader definition of art than merely literature, music, and the like. Indeed, the meaning seems almost to have regained its older usage meaning of "any human skill."

The remarks of Chris Harris, who makes his living by doing body piercing in a tattoo studio and whose back and upper arms bear several large tattoos, are typical of several others I spoke with: "I can't really think of anything that doesn't have an artistic value, can you? For a while I built racing yachts, and you'd think something like that wasn't very artistic, but it was. It was extremely artistic. It was mechanical, but when it was finally built, then it was of very flowing design and pleasing. So it is artistic."

It is significant that Chris was not undiscriminating in his conception of art:

[1]One of the few rigorously empirical studies of fine artists is by Karen Field [1979], who used the technique of symbolic interactionism to study artists' marginality, both in self-conception and in the views of others.

R.L.A.: Do you think everything *is* artistic, or that everything *can be* artistic?

C.H.: Everything *can be* artistic. It's the approach that's more important than anything else . . .

R.L.A.: What is it about a particular perspective that makes it art?

C.H.: I think it's the ability to envision something. Envisioning it in your mind, and then making something that looks like that vision that you had in your mind.

R.L.A.: So it's creating.

C.H.: Creating from something. Yeah. I think that there's a lot of mechanical ability that's involved in things, but the mechanics are just a function of your artistic ability.

For Chris Harris, imagination and creativity are defining criteria of art; and later we shall examine this and other theories about the definitive features of art that emerged from the interviews. For now, the important point is that for their part, the people I talked to considered their activities to be art forms.

If anything can be an art form, how can the researcher hope to develop a comprehensive and accurate picture of art in America? One would have to look at every art form pursued by every artist in America—obviously, an impossibility. The solution to the problem lies in sampling. Thus, I have restricted myself to a manageable number of highly diverse art forms that, taken together, more or less span the breadth of most American art. If consistent patterns emerge for them, then those patterns are also likely to be found in the larger universe of art in America generally.

Structured interviews were conducted with sixty-four people, eight of whom were actively involved in more than one art form, producing a corpus of information on seventy-two topics. The informants came from many walks of life and socioeconomic levels; about half were women.[2] All lived in the Greater Kansas City metropolitan area.[3] Because I sought people who had been involved with an art form for many years, the age distribution of the group is somewhat skewed toward older people.[4] Some I had known for

[2]Whereas thirty-one of the sixty-four (or 46 percent) of the individuals I interviewed were women, all but one of the eight people whom I interviewed about two art forms were women, so that thirty-eight of the seventy-two (or 53 percent) of the art forms included in the total corpus of data are pursued by women.

[3]Besides being conveniently near my own residence, this sample represents an effort to redress the imbalance of art studies in the United States. With few exceptions (e.g., Plattner 1996), Midwestern art has received far less study than the major American art centers, especially, *the* American art center, New York City—or, in reality, a very small portion of the art culture of New York City, namely that of the most exclusive fine art galleries of Manhattan.

[4]I did not explicitly ask most people's ages, but from appearances and offhand biographical remarks, I believe that only two informants were under twenty-five years of age, whereas fourteen were probably over sixty.

Chris Harris: A Piercist with Tattoos

Chris Harris says that during their many generations of living in the hills of southern Missouri, members of his family were known for their ability to play any musical instrument (and, Chris says, for getting drunk). Chris did not take up music, but a musician's manual dexterity is apparent in the jobs Chris has held, from building racing yachts to working as a professional piercist.

Another readily apparent trait is Chris's inquiring mind. For example, at an early age, he wondered why some people feel that it is perfectly all right to tattoo pictures on their bodies, whereas he was severely reprimanded every time he painted pictures on the walls of his parents' house. Because of his analytic bent, Chris is cited several times in this chapter; in particular, his theory about tattoos being outer representations of the wearer's inner self will be discussed in later pages.

Another fascinating thesis of Chris's concerns the relationship of tattoos to the passage of time and the permanence of things. Chris is highly sensitive to the transience of most material possessions. He says, "I've always believed that everything I have was only temporary, that it was just on loan to me. Even the things that I buy are just temporary; because when I go on, they're not going with me, except for maybe the tattoo [emphasis added]."

In Chris's thinking, the enduring nature of tattoos has a practical dimension: "I like artwork, and it's nice to carry [my tattoo] and not have to worry about getting hard-up for money and having to sell it . . . or having it burn up in a house." But Chris, who has read extensively about tattoos, recognizes another, more metaphysical, value in the permanence of tattoos: "Orientals believe that . . . every time the pigment is inserted in your skin it also is reflected upon your soul. So basically, if you take that concept, then I'll carry it [my tattoo] through eternity . . . If you're in the Netherworld and your spirit is wandering around, then along with the spirit is that tattoo. It stays with you."

Thus, the lasting nature of tattoos, a reason why many other people do not get a tattoo, is a central reason why Chris Harris is tattooed.

years, others were casual acquaintances; some were friends of friends, others I actively sought out in an effort to attain the desired degree of diversity. But regardless of gender, age, or class, informants all shared a vital characteristic: Every one had a very high level of involvement with an art form, as well as a facility for talking about it. (Both common sense and empirical studies [e.g., Child 1962] tell us that individuals with an intense involvement in art are

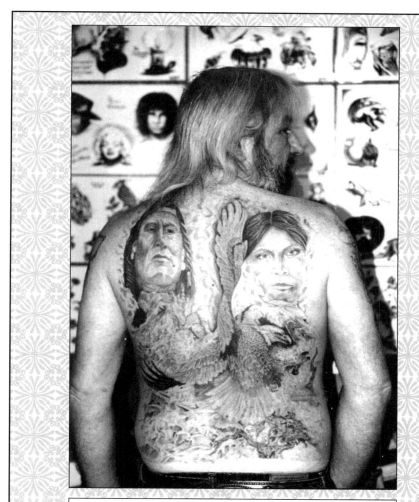

Figure 6–1 Chris's "backpiece," created by East Coast Al Kimber, has won international tattoo competitions.

likely to give more thoughtful and articulate analyses than are people who have only a tepid interest in the same arts.)

Finding such people was easier than might be expected. For example, early in the project, I decided that one category of the arts that I wanted to include was dance, but nobody I knew sprung immediately to mind as a dancer. During a discussion about my research with a colleague, however, he

happened to remember that his next-door neighbor, Arielle Thomas Newman, had been a professional performer and choreographer of modern dance. He agreed to mention my interests to her and, if she consented, to give me her phone number. I later spent two hours talking with Arielle about dance, and two weeks later she facilitated my interviewing her acquaintance William Whitener, the director of the State Ballet of Missouri.[5] Then I recalled that a former student, Dielle Alexandre, had once mentioned in class that she had worked for more than a year as a topless dancer. I interviewed Dielle, and she introduced me to a woman who danced under the name of "Frankie,"[6] with whom she had shared a locker at The Club, and who had danced (both in topless clubs and, under a different name, on the stage) for many years. Then at a health club, I happened to see a woman with a T-shirt that said "Dance or Die." After some conversation, I learned that she was Liz Craig, a professional copywriter who loved ballroom dancing. A week later, I interviewed her, and so it went.

The relatively easy availability of people who are highly involved in the arts is one more confirmation of a thesis developed in earlier chapters, namely, that America has an extremely rich and pervasive art culture. The situation parallels Robert Farris Thompson's findings among the Yoruba of Nigeria, West Africa: Seeking to identify Yoruba standards of art criticism, Thompson would drive into a town or village, unload from his car a collection of Yoruba wood carvings, and then ask, "Was someone willing to rank the carvings for a minimal fee and explain why he liked one piece over another? . . . Almost without fail someone would step forward and immediately begin to criticize the sculpture" (Thompson 1973:26). But whereas the Yoruba are proverbial for the richness of their visual and performing arts, no published literature attributes a comparable reputation to Kansas City, the Midwest, or the United States in general. However, as the following analysis shows, when *art* is defined broadly and when thoughtful people are asked pertinent questions, a rich storehouse of aesthetic information is readily available nearly everywhere one looks.

[5]The "friend-of-a-friend," or "snowball," method of sampling has well-documented strengths and weaknesses. It is commonly used in ethnographic fieldwork, where it is not possible to list exhaustively all members of the population under study, and also because it facilitates entrée and helps the outsider find people whom insiders believe to be truly expert. On the other hand, the technique can increase the homogeneity of the voices one hears because Informant One's biases probably affect the person he or she recommends as Informant Two. There is also the possibility that the first person interviewed is somewhat aberrant and will introduce the researcher only to others on the fringe, although this problem usually becomes apparent—and correctable—if enough people are interviewed.

[6]"Frankie" is a stage name—hence, the quotation marks.

THE INTERVIEWEES AND THEIR ARTS

Several considerations influenced my choice of art forms to focus on and of individuals to interview. Chief among these factors was diversity. By the time the interviews were completed, I had gathered information about **visual** arts (46 percent of the informants), **performing** arts (43 percent), and **literary** arts (14 percent). (The total is more than 100 percent because although the visual/performing/literary distinction works for the fine arts, it fails for some popular arts: Comic books, for example, undeniably fall into both literary and visual categories.)

Many (but far from all) of the arts of small-scale societies are produced for overtly religious purposes, so in like manner I included some straightforwardly sacred arts in the research, talking with two music directors and one paid chorister in the Episcopal church and with four preachers (three of them African-American) known for the artistry of their sermons. Thus, the corpus of information includes both **secular** (87 percent) and overtly **sacred** (13 percent) art forms.

Again, some instances did not fit unequivocally into one of the two categories. For example, when I asked my gardener friend Nick Rivard what he gets back from all the effort he puts into growing flowers, he said,

> I've thought about it from a lot of perspectives. I think it's church for me. I think it's real spiritual. It's like, I don't cause plants to grow, but I can do things that help them grow and make them look pretty . . .
>
> [Working in the greenhouse] is heaven; that's heaven to me. Especially if I'm there by myself on Sunday morning, maybe listening to Public Radio and . . . growing plants.

Nevertheless, for purposes of analysis, I classified my interview with Nick as looking at a secular art form: He did go on to discuss "a lot of perspectives" that were thoroughly nonreligious.

The case of Nick's greenhouse raises another problem of categorization: commercial versus non-commercial. Although Nick had been a total amateur for years, starting his seedlings under grow-lights in his basement, when I interviewed him, he had become part owner of a small greenhouse. Then two years after I interviewed him, Nick and his wife Loretta became sole owners of the business, and Nick resigned from his professional management position in a social service agency and started working full-time in the greenhouse.

The absence of a clear boundary between amateur and commercial is best illustrated by the four painters I talked with: One has sold very little work in recent years, although she works almost daily in her studio; another

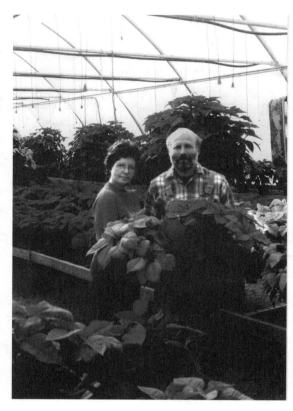

Figure 6–2 Nick and Loretta Rivard, at Nick's Greenleaf Nursery.

had a large solo show two years before I talked to him, but he derives most of his income from his position as a college art teacher; a third shows often, sells quite a few paintings, but is fortunate in having a spouse with enough income to support her and her family; and the fourth works daily from 8 A.M. to 5 P.M. to produce the six hundred paintings that he sells at art fairs each summer. By most definitions, the last painter is commercial, the first one is not. For purposes of enumeration, I also count the second and third as being commercial, although they both would continue painting even if they knew they would never sell another piece. By such reckoning, 51 percent of my informants are **"commercial,"** 49 percent **amateur.**

Another dimension of variation in the sample has to do with the size and nature of the community in which the art is produced and consumed. Consider, for example, the contrast between interior design and tattoo. Almost everyone in America is involved with interior design to one degree or another. Few of us are as dedicated to interior design (or, arguably, as talented in it) as are the four people I interviewed, but we all live and work in spaces

that are decorated; and at one time or another, most of us have been involved in the process of decorating.

Tattoo is different. Long confined to a few small sectors of society—principally, sailors, bikers, and convicts—tattoos began to appear in mainstream America in the 1980s. For example, during my interview with Celeste Lindell (who works as a copywriter and editor) about her singing in an alternative music band, I mentioned that tattoo was another art form I wanted to interview people about. Celeste laughingly said that she seemed to be the only one in her circle of young professionals without at least a small tattoo. But on the other hand, she continued, nobody took them very seriously: It was just a passing fad.

But if for some people, tattoos are only a fashion, albeit a popular one, they retain their role as serious expressive media for others—usually people whose occupations or lifestyles place them at the edge of the mainstream. I interviewed four people with large tattoos that had been acquired over a number of years, individuals for whom tattoos have great personal significance. Their ages ranged from the midtwenties to the late forties; and they all talked at length about the importance of tattoos in their lives. Each person struck me as intelligent and thoughtful, but each was pursuing a fairly unconventional lifestyle: Besides the aforementioned Chris Harris, with his large backpiece and other tattoos and who works as a professional body piercist, there was East Coast Al Kimber, owner of one of Kansas City's oldest and most successful tattoo studios, and a serious biker; Dielle Alexandre, an art student (now graduated) who used part of her income from working as a topless dancer to pay for a dragon tattoo that extends from her right wrist to the back of her neck; and Jim Schindelbeck, a young bartender, who had spent two years (and $3,700) planning and having executed the large tattoo that was nearly complete on his back when I interviewed him.

As with the other dichotomies, this one is not clear-cut; but of the seventy-two art forms about which I gathered information, 12 percent could be considered to be **outside mainstream culture.** Besides tattooed people, I include topless dancers, African-American preachers, a writer and director of experimental theater, an adult trader (and reader) of comic books, and four people who decorate their lawns in elaborate and unconventional ways.[7]

Although most of the people I interviewed are active producers of art, I also included in the sample some committed art consumers. For example, music has been an important part of Steve Cromwell's life since his adolescence

[7]*Mainstream* is obviously a relative concept. Not only does a gray area lie between mainstream and periphery, but also art forms that are peripheral to me, as a middle-aged, male WASP, would not be for others. For example, black preachers, whom I categorize as nonmainstream, are unquestionably central to the African-American community.

in Rockford, Illinois, in the 1950s. Although he played in his high school's band for a few years and briefly considered a career in music, most of his efforts have gone toward listening to music. Steve's musical tastes are broad:

> I'm into soul, seventies soul, not contemporary Black music. I'm into blues, but probably not what you'd call "roots blues." I'm into country, but probably not traditional country. I'm into new groups that might do traditional country. I'm into folk. I'm into rock-n-roll, which is too broad of a definition right now. I'm into rock, earlier rock. (Now a group has to really grab me, they have to be closer to something I liked before.) I'm into gospel; I'm heavily into gospel. So I'd have to say my mainstays are blues, country, gospel, and big band jazz or jazz that is not fusion or acid jazz.

To justify including Steve among my informants, one could reason by analogy with the fine arts, where competent critics and collectors not only possesses a wealth of information but also have a perceptiveness and sensibility that allows them to speak with insight about the fine arts, despite having had little or no firsthand experience at painting, composing symphonies, or whatever. Similarly, Steve's knowledge and critical ability make him a thoughtful commentator on popular music; and his remarks during our interview make a valuable contribution to this chapter. The same can be said of the other nine informants (making a total of 14 percent) who are more **consumers** than **producers** of art.[8]

A final distinction can be made between **fine** and **popular** art in the sample. Of the seventy-two art forms that I gathered information on, I would consider eleven (or 15 percent) to fall in the category of fine art. They are modern dance, ballet, Episcopal church music, paintings that are shown in galleries, poetry, and experimental fiction and theater.

[8]On examination, even the distinction between art producer and art consumer shifts from an either/or dichotomy to a continuum. Among the car enthusiasts, for example, Jan Jones has a strong commitment to buying and driving cars that appeal to her aesthetically: She is purely a consumer. Joe Egle shares Jan's appreciation for cars, but he also sometimes works on them. The extent to which he is a "producer" is limited, however. He says, "I love working on cars when I see progress and improvements. I hate it when it turns into something that I can't master—which is when I go get some help." And then there is Roger Hurst, who, the morning I met him at his foreign car garage, had his head under the hood of a customer's sports car, creating an elegant solution to a wiring problem that had to be fixed before the car could be raced again. (A serious treatment of automobiles as artworks is Hickey 1997:61–72.)

Denis Dutton (personal communication) has usefully pointed out that the similarities and differences between art producers and art consumers remains to be determined. The same, of course, could be said about all of the distinctions made in this section—between amateur and commercial artist, mainstream and fringe, and so on.

Given those parameters, the thirteen art media that informants spoke about at length, along with the number of informants for each one and miscellaneous comments for clarification, are shown in Table 6–1.

Table 6–1 Informants' media, numbers, and special interests.

ART FORM	NUMBER OF INFORMANTS	COMMENTS
Cars-as-art	4	Two are men who own auto repair shops and who also take great pleasure in looking at, owning, driving, and working on cars; another is a dealer in rare cars, now semiretired, who has owned hundreds of classic cars in his lifetime; and the fourth is a woman who has long owned and driven stylish cars made between the mid-1960s and the mid-1980s.
Dance	7	Types of dance represented by this group include ballet and modern (choreography, direction, and performance), club dancing, and topless dancing.
Decoration of the body	4	Three are women who give exceptional attention to their clothes and makeup; the fourth is a successful silversmith whose designs include very expensive, nationally marketed silver jewelry.
Food	4	Included are an amateur gourmet cook; a restauranteur and chef; a caterer and food consultant; and the founder of a chain of pizzerias, locally known for his reviews of restaurants on radio.
Gardening	8	Each has had flower gardens for years; six are amateurs, and two own a medium-size commercial greenhouse; three of the eight are active in garden clubs.
Interior design	4	One is a former officeholder in the Association of Interior Designers, now semiretired; another is the owner of a home furnishings shop; and two individuals put great thought and effort into decorating their own homes.
Music	11	One is a professor of choral music; two are Episcopal church music directors; another is a paid member of an Episcopal church choir

(table continues on the next page)

ART FORM	NUMBER OF INFORMANTS	COMMENTS
		and a musical theater performer; one is a musical theater performer; two are former members of a touring rock band; another is a singer in an alternative music band; two are amateur music performers; and the last is a record collector and avid fan of several musical genres.
Painting	4	Three are painters who show their work in galleries, two of whom also teach painting. Another painter supports himself by selling his acrylic paintings at summer art fairs.
Sermons	4	All are ordained ministers who preach regularly; three are African-Americans; two are professors (of preaching and homiletics) at a United Methodist seminary.
Tattoo	4	All have worn large or numerous tattoos for a number of years, and three may get more (the fourth will get no more tattoos because he has become diabetic); one owns a tattoo studio.
Television	4	All identify themselves as people who watch a great deal of television; one works as a graphic designer for a television station.
Theater	4	All act on stage, two also direct, and one writes plays. Three are involved with community theater.
Written word	6	Two are published writers of poetry and experimental fiction; one is an advertising copywriter; two are as yet unpublished fiction writers; another is a lifelong comic book fan and owner of a comic book store.
Yard art	4	Three are retired men; one is a younger woman. All continually acquire, or make decorations for their yards. Decorations include antique tools and farm implements, stuffed toys, and bowling balls. All four are self-taught in the visual arts.

Two questions are prompted by this information. First, in what sense are things such as cars and television art forms? This issue has been raised in previous chapters, and little more can be done here than to reiterate the previous answer: For people who are avidly involved with them, the things and activities listed in Table 6–1 possess most or all of the following traits: They are human creations that are produced with extraordinary skill; and they are executed in sensuous, public media and in accordance with a style of broad geographic and temporal distribution.[9] Some artists and art forms may fit this pattern more closely than others, but it is interesting (and as I shall discuss later) that the degree of fit does not vary consistently between fine and popular art.

The second question is, How adequate is the sample? Compared with techniques common in the physical sciences, or even in other social sciences such as sociology and psychology, I concede that my sample looks hopelessly haphazard. The people whom I interviewed were not chosen at random, and the congruence between the sample and the universe that it is intended to represent is questionable. Is American art exactly 51 percent commercial, 13 percent religious, 43 percent performing, 46 percent visual, 14 percent literary, 78 percent mainstream, and 85 percent popular? Only an empiricist run amok could make such laughable claims to precision! But are commercial and amateur art both richly represented in America; does secular art overshadow religious art in most communities; do many of us spend less time reading poetry and fiction than we do watching television comedies and dramas and seeing advertising; is the majority of American art mainstream and popular? I think so. (On the other hand, the proportion of committed art producers, as opposed to art consumers, in the sample is surely much higher than in American society at large.)

If, as Ralph Waldo Emerson said, "a foolish consistency is the hobgoblin of little minds," surely the same can be said of "foolish scientism," a scientism that would seek to quantify the unquantifiable or to attain absolute objectivity. But having abjured such folly, I submit that a useful purpose is served by attempting to be as rigorous, as "scientific," as possible, seeking the best empirical grounding that resources permit. That is what I have tried to do. (A few of the data-based conclusions that I arrive at in this chapter can be presented numerically, but in most cases, a small but significant gray area between white and black renders statistical treatment unrealistic. In such cases, I have used such adjectives as "few," "several," "many," and "most" with care in an effort to portray my findings as accurately as possible.)

[9]Using a similar line of argument, Judith Lynn Hanna, a seminal student of the anthropology of dance, testified for the defense in a 1997 obscenity trial involving a Roanoke, Virginia, strip club. The performances, she said, "include the 4 criteria that make dance artistic: skill, creativity, aesthetics, and message" (*Anthropology Newsletter,* February 1998).

Rejecting a relativism that cannot adjudicate rival interpretations, I believe that the portrait of American art and aesthetics presented in this chapter is subject to two sorts of validation. First, one must ask, Is there a sound relationship between data and conclusions? That is, are my conclusions, and no others, supported by the interviews I conducted? The body of this chapter attempts to establish that this is so; and obviously others are welcome to collect data homologous to mine to test the replicability of my conclusions. Second, do the conclusions, if sound, apply to the larger universe of American art and aesthetics? Again, I argue that they do. This is a first effort, and I expect future studies by other scholars to bring changes in the paradigm I construct. Needless to say, I hope the changes are minor refinements, but only time will answer that question.

A few final notes on methodology: The interviews lasted from one hour to two-and-a-half hours; most were at least an hour-and-a-half long. When scheduling the interviews, and again as they got underway, I explained my background and current project, emphasizing that I was especially interested in the informants' theories about the arts that they were involved with. (Many initially said something along the lines of, "Gosh, I don't know if I can help you much in that department." Nevertheless, all found that they were able to respond at great length to my questions.)

Questions that I consistently pursued, usually in this order, were the following:

- What was your earliest involvement with the art form? What initially attracted you to it?
- Do you consider yourself talented; where do you think your talents come from; are others in your family artistic?
- What is the nature of your involvement in art at the present time?
- What do you get from the art that you are actively involved with; why do you invest so much time and energy in it; what would life be like if art were not in your life?
- What do you think society gets from your art of choice; is the world a better place because it exists—and why?

Additional questions were determined by the art form and the personal history and interests of the informant. For example, for an activity that some people might be reluctant to call an "art," I often asked the informant's views on the issue. If the subject matter and medium of the art form allowed, I also asked about issues of truth, integrity, and realism.

Why did I begin my inquiry with these questions and not others? The query, "What is the nature of your involvement in art?" is merely a census question, a means of gaining necessary background information. Other ques-

tions have a more complex motivation, however. Some were chosen because they have proven themselves useful in my own previous studies of non-Western art and aesthetics; and more broadly, they have an honorable history in the anthropological analysis of a wide range of sociocultural topics. Thus, "What do you get from art?" reflects a particular strain of functionalism that reaches back several generations to the writings of Bronislaw Malinowski; and "What do you think society gets out of art?" embodies concerns that can be traced through the structural-functionalism of A. R. Radcliffe-Brown all the way back to turn-of-the-century writings by Émile Durkheim and Ferdinand de Saussure. On the other hand, "What was your earliest involvement?" echoes a long-standing interest among both anthropologists and psychologists in the developmental stages of mental processes, issues that have been productively pursued with regard to art by such scholars as Howard Gardner and that ultimately derive from the work of Jean Piaget. Still other questions (e.g., "Where does talent come from?") are not only staples of academic debate but also of popular curiosity, as I have learned through twenty-five years' teaching in a college of art and design.

In any case, however, these were merely *starting* questions. My approach in gathering and analyzing the information for this chapter has been thoroughly inductive, rather than deductive; and like the sociologists who follow the methodology of Grounded Theory,[10] the questions I began with were refined and added to, both within individual interviews and from one interview to the next as research proceeded.

All interviews were tape-recorded and transcribed, resulting in approximately one thousand single-spaced pages of text. Every informant had a singular personal history in the arts; and as creative individuals, they all gave me unique insights into their own particular media, and about art and aesthetics in general. But out of this welter of information, certain motifs emerged repeatedly. On closer examination, these themes can be seen as fitting fairly comfortably into four broad topics that I am labeling The Artist, Art and the Inner World, Art and Society, and Vernacular Aesthetic Theory. The following chapters deal with each of these subjects. The result, I feel, is a complex and compelling conception of art in contemporary America.

[10]Grounded Theory grew out of Interactionist sociology in the mid-1960s under the guidance of Barney Glaser and Anselm Strauss (cf. Glaser and Strauss 1967; Strauss and Corbin 1990). The theory combines naturalistic observation and data collection with inductive theory-building.

7

The Artist

Like most other Americans, artists enjoy their individuality, but the sixty-four people I interviewed about their long-standing engagement with the arts tended to share certain traits. By definition, they all have a high degree of involvement in one or more art media. Besides that commonality, however, they tend to share similar notions about artistic talent. The roots of their interest in the arts typically reach back to their childhood and are best understood in the broader context of their families of origin; and in many cases, they experience a profound identification between their selves and their art of choice. We shall look at these themes in turn.

DEGREE OF INVOLVEMENT IN THE ARTS

If body decoration, food, and cars can be art, then all of our daily lives bring constant contact with art media. But for many people, including those whom I interviewed, commitment to such media rises to levels that can amaze the mere dilettante. For one thing, the sheer duration of the involvement is remarkable.

Consider, for example, the passion that now-retired Joe Egle has felt since childhood for classic cars. The first car to capture his imagination was his father's elegant Windsor, the talk of his neighborhood when Joe was a youth. For his own earliest car, purchased when he was thirteen, Joe had to

settle for a 1926 Model-T Coupe, but in later years, when only about half a dozen of the rare Windsor's were known to exist, Joe owned two of the best of them. Over the course of five decades of collecting (and not counting the many cars that passed through the classic and foreign car dealerships he owned), Joe has had hundreds of showy, elegant, or rare automobiles, including several racing Jaguars.

Joe now owns only a handful of cars, including a beautifully restored 1950 Dodge Roadster that he drives around town and a thirty-year-old Austin-Healy Sprite that has been driven only four thousand miles: "It's a lovely little thing just to walk past and look at once in a while," Joe told me. But the walls of several rooms in his home are covered with photographs of the cars Joe has owned, and his enthusiasm for cars lives on. "Sometimes," he said, "I lie awake at night, thinking about the next car I want to buy."

Joe Egle's enduring obsession with cars is as atypical of most other Americans as it is typical of the other people I interviewed. The majority trace their first involvement back to their youth, a topic that will interest us shortly when we look more closely at the sources of artists' interests in the arts.

The only informants who have not had a lifelong involvement in art are the four individuals who have filled their yards with work that would be called "installations" in the fine art world, but, given the lack of formal art training of their creators, are typically referred to as "folk" or "outsider" art. Like many in this genre, three of the four are older men who began decorating their yards after they retired from jobs that were not art related. But even for these people, art is not a brief fancy: John Korzinowski, who acquired the nickname of "Chief" from chasing fire trucks as a child, has been working on his yard since 1973, when he retired after thirty years' work in a brewery; and Jim Perucca and Jimmy Green have spent nearly as much time decorating their yards.

Karin Page, the fourth yard artist, has been working on her lawn for a mere ten years, although she was involved with other arts during her earlier years: piano lessons, which were started as a child and resumed during graduate school in microbiology; jewelry-making; a purple hair/exotic clothes phase of body decoration; and the use of posters and original art to transform her sterile office cubicle in a former job into what she called a "refuge." Karin saw an aesthetic component even in the genetics lab where she worked for several years: "There's lots of things you do, like running DNA gels—it's really beautiful. Like a purple background, with a little red or orangey-red lines of DNA. It was really beautiful."

Not only does involvement in the arts stretch into the past, but people also see it reaching inevitably into the future. When I talked to her during a hiatus in her successful career in modern dance and choreography, Arielle

Thomas Newman told me that she was "contemplating having a late-life dance career as a liturgical soloist." She had recently given a dance performance at her church, and she gave another several months after we spoke.

Over the course of these people's lives, the level of involvement in the arts may fluctuate, but typically it leaves only to return, as has been the case with Celeste Lindell: "I quit [performing music] for quite a while, even though I still had all my musical gear. In fact, some of it I bought in the meantime, thinking, 'Oh, I know I'll get back into it,' because it's just, once you start, you're just gonna do it. It just doesn't seem like you ever really stop . . . I just knew I was going to keep doing it."

Before dismissing such statements as romantic hyperbole, consider Celeste's mother, Linda, who had to stop singing and playing bass with a traveling rock-'n'-roll band when she learned she had cancer. When I interviewed Linda, although she no longer had the energy to play, she could not part with her instrument: "I think about it a lot when I'm in my car and playing music that I like. I listen to the bass player and I think I'm gonna sit [at] home and start playing my bass again. But there's no real reason to, because I'm not going anywhere with it. So that's the problem and . . . well, I haven't sold [my base] yet." Linda died a year and a half after our conversation, her equipment still unsold; and at last report, Linda's bass was sitting beside the urn that holds her ashes.

Artists' commitment to their media is not only enduring; for most informants, it is quite powerful. For instance, Lawless Morgan, who has loved comic books since childhood, told me that he can "hardly wait" for each new issue of his current favorite series, a Japanese comic entitled *Yosaki Yojibo*. Equally committed to her art is Sally Von Werlhof-Uhlmann, who, a week before I interviewed her, had made a wild mushroom lasagna that requires sixteen varieties of fresh and dried mushrooms. Sally had started preparing the dish at nine o'clock in the morning and worked steadily on it through the day, finishing in the late afternoon. Jack Cox, who has worked in the television industry for thirty years, has seven televisions in his home; and Tracy Warren, another television enthusiast, recounts his morning routine: "After I shut off the alarm [clock], I walk immediately to the television closest and turn it on. (I have it preset for a certain channel.) And then I walk in [to the living room and] turn this one on the same channel. Then I . . . proceed with the daily toiletry thing."[1]

[1] Tracy Warren's having two televisions turned on simultaneously is paralleled by a story told by John Schaefer, the music director at an Episcopal cathedral: "In elementary and then high school, I had two churches at all times. I had the church where I was a member, and I had the church where I went to hear the good music."

Some might dismiss as insignificant such arts as tattoo (witness a popular bumper sticker that says, "Tattoos: Permanent Records of Temporary Insanity"), but such expressive forms are of considerable consequence to their adherents. Jim Schindelbeck, for example, spent two-and-a-half years actively looking for the right artist to tattoo the scene that now nearly covers his back.

It is not surprising that extreme dedication to the Muse can come at a price: A car enthusiast who trains paramedics told me that there is "kind of a conflict" between her profession and the fact that when her 1984 Camaro was modified to be a convertible, the shoulder strap of the seat belt had to be removed. She also conceded that she likes a car "that has a lot of pickup, because . . . if I'm in a car and I need to get into a lane or I need to be someplace, I want to be able to push on the gas and know it's going to get me there."

Another way to appreciate the role of the arts in informants' lives is to ask, What would these people's lives be like *without* their respective arts? Several told me that such a life would be inconceivable—like "living without food" (as Episcopal organist Ken Walker remarked) or without "breathing" (as silversmith Robyn Nichols said).

It is not just their own personal involvement in the arts that is important for the informants, but rather the role of the arts in the world at large. Dancer Arielle Thomas Newman told me, "Without dance, what would it be like? It would not be a society *I* would care to live in! No, it would be like that movie, *Fahrenheit 451,* and people would have these secret dance societies [laughs]." (Other informants mentioned *Fahrenheit 451* in similar contexts, suggesting that the film's apocalyptic vision reflected a prevalent fear of a world void of art.) In her remarks about singing, Kim Kircher put it most succinctly: "Without it I would die!"[2]

Of course, not everyone feels they would die without art. In fact, all four informants who watch a great deal of television expressed marked ambivalence about the medium; all now often use their televisions to watch movies, either videotaped or off the air; and all feel that most broadcast fare fails to live up to the potential that they believe television has.

One might expect that topless dancers are also ambivalent, or perhaps even thoroughly negative, about the art they practice; and indeed, each of the three I interviewed talked about how difficult the work was for them, physically, emotionally, and socially. But although they all mentioned having financial motivations for their work as dancers, they found (in varying degrees) pleasure in it as well. The specific kinds of satisfaction will be discussed in later

[2]Rev. Bo Mason also raised the issue of the artist's mortality, but in a different way: "While I'm preaching—that's the way I'd like to die. While I was delivering a sermon for God."

contexts; but for *a priori* evidence of the importance of dancing in their lives, consider the career of a woman who works under the name of "Eve" and who still danced in a topless club at age forty-one when I interviewed her. "Eve" told me that she began dancing for money at age twelve, encouraged by her mother, who was a stripper and a Playboy Bunny, and by her grandmother, who had danced on the burlesque stage. When "Eve" married her current husband, she stopped dancing but resumed after a four-year interruption. When I interviewed her, "Eve" knew she was nearing the end of her stage career and was waiting to be licensed as a nursing assistant. She hoped, however, to be able to keep dancing part-time even after she found a job in that field.[3]

MULTIPLE MEDIA

The diverse art media and sundry aesthetic formulations that coexist in America today constitute a loosely organized system of thought and practice. Proof of this premise is difficult because such a system is intangible, and nowhere are the abstract principles that constitute the system codified and written down. Some supporting evidence can be found, however, in the fact that a majority of the people I interviewed are actively involved in more than one art form. This pattern became apparent only after several of the interviews had been carried out, so I did not consistently explore the issue with every informant. Nonetheless, of the sixty-four people I interviewed, I know thirty-eight to be, or to have been in the past, actively involved in more than one art form. A few representative examples are the following:

- A painter, a gardener, a dancer, and a car enthusiast have all tried their respective hands at creative writing.
- An interior designer, a musician, a gourmet cook, and a television enthusiast have all done painting or drawing.
- Two tattoo enthusiasts, a writer, a yard artist, a gourmet chef, a silversmith, and a painter all said they get great satisfaction from music or dance.

[3]A case might be made that "Eve" is not an artist but merely an exploited sex worker, but this confuses two dimensions of analysis, the economic and the aesthetic. With regard to the former, "Eve" believes (and, significantly, the same view was expressed by both of the other topless dancers I interviewed) that the term "exploitation" should be reserved for the many dancers who, unlike themselves, dance only to support children, an unemployed boyfriend, or a drug habit, who believe they have no career options other than topless dancing, and who tolerate unwelcome sexual advances from customers or club managers. For their part, "Eve," "Frankie," and Dielle see themselves as having power over their customers and view dancing as a job that rewards hard work with substantial pay. But regardless of economic analysis, the aesthetic point is that all three of the women pride themselves as being consummate dancers—that is, as being artists.

Several people have an active interest in more than two art media. For example,

- Liz Craig, whom I interviewed about ballroom dancing, also composes and plays music and is a professional copywriter as well.
- Boyde Stone, who talked to me about his long-standing involvement with bluegrass music, also greatly enjoys dancing and has drawing experience. (Moreover, Boyde's occupation involves body decoration, in that he is a successful barber and owns a shoe repair business.)
- Roger Hurst, noteworthy for his lifelong love of cars, worked his way through college by playing in a band, and he now does writing and illustration for the newsletter of a sports car association newsletter.

Of course, some people are more eclectic than others. If involvement in multiple arts was mentioned by about 60 percent of the informants, that leaves 40 percent who did not. Some of these might have been "false negatives," where I failed to inquire about the subject, and the informant did not happen to mention it. But some individuals do focus on a single art form. One of the last people I interviewed was Donna Allen, an ordained minister, a professor of preaching at St. Paul's United Methodist Seminary, and herself a nationally known speaker in the African-American community. Here is part of our exchange:

> R.L.A.: What about other involvements with the arts? There's a whole range— drama, writing, music, dance, the visual arts. Did you have any . . .
> D.A.: No, not really. My background in the arts is rather limited . . . The joke my mother used to make was that although I used to be in the church choir, I couldn't carry a note from one end of the room to the other in a bucket.

For those who pursue more than one art medium, there appear to be no neat and simple patterns regarding the chosen media. In numerous cases, the arts are similar and seem logically related. For example, Jack Rees, a retired interior designer, has practiced needlepoint as a satisfying hobby for many years.

But in perhaps half of the cases, the relationship seems unpredictable, as demonstrated by the examples previously noted, in which visual, performing, and literary arts seem to be randomly chosen. In fact, from the vantage point of some aficionados, the very boundaries between sensory modalities are irrelevant. Two car enthusiasts, for example, told me that besides *looking* good, a superior car should have a satisfying *sound* when it is running and should *feel* good to drive. Likewise, Larry "Fats" Goldberg made many references to the olfactory and tactile senses as he regaled me with his views about the glories of food.

Of particular interest is the mixing of fine and popular arts. Of the sixty-four informants, twelve have, or have had, a serious commitment to more than one art form, at least one of which falls into the genre traditionally considered to be fine arts.[4] Of that twelve, only two confine themselves to the fine arts alone: Debra Di Blasi used to be a fine art painter and now writes experimental fiction; and besides writing poetry, Carol Mickett writes, produces, and performs serious drama. The other ten are like Lester Goldman, a fine art painter who enjoys going dancing; Maria Vasquez-Boyd, another painter, who once played in a rock 'n' roll band; and Theresa Maybrier, an interior designer who has a degree in painting and printmaking.

The case for the existence of an art and aesthetic system is strengthened even more when one moves from art activities to the conceptual framework in which art is created and appreciated. On more than a dozen occasions, informants used one art medium or genre to explain, analyze, or describe another. Here are three representative examples:

- Jan Jones compared her love of cars built in the 1960s to a parallel taste she has for styles of home decorations from the same period.
- Theresa Maybrier explained her approach to interior design by reference to the fine arts: "I think because my degree is in art and not in design, I look at things very differently. I look at a room like a three-dimensional sculpture. I analyze from one standpoint to another standpoint how things move the eye and what contributes to the overall flow of the room. When I do table-top accessories, it's like setting up a still life."
- Rev. Gene Lowry—preacher, seminary professor of homiletics, and jazz pianist—has written several books on theories of preaching, especially the role of narrative in the sermon. He told me, "My preaching really hasn't impacted my piano playing much, but my piano playing has totally impacted my preaching. I was doing narrativity at the keyboard by the age of five."

Experimental fiction writer Debra Di Blasi provided the most extended cross-media analysis. An earlier novel, *Drought,* received the Thorpe Menn Award in 1998 and was made into a prize-winning short film. When I interviewed her, she was nearing completion of another novel, which she described in terms of music:

[4]The fact that twelve people fit this pattern may seem to contradict the earlier claim that only eleven people were interviewed regarding the fine arts. The explanation is that most interviews focused on a single art form, going into it in some depth. Often, however, the person was involved in another art form. Thus, for example, Steve Cromwell, with whom I discussed popular music and record collecting, also has significant connections with the fine arts: He is a professor of art history, and at an earlier period in his life, he had a serious career as a fine art photographer.

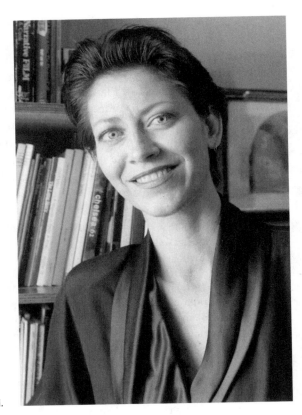

Figure 7–1 Debra Di Blasi.

I'm more interested in conveying the emotional content than the objective story, but I'm finding that I can do it by combining the elements of rhythm, the music of language, with storytelling. And remember, the original storytelling was often sung, you know? So I'm really kind of going back to the beginning, but in a more sophisticated way.

I think there's a reason why they sang those [stories], besides the fact that you can remember it a lot better. I think that's why there are mantras and why there is liturgy. I think it reaches you on a deeper level. I believe that; and I think if you can do that with literature, then you can convey a lot more about humanity, faster and deeper, than you can any other way, and that's what I'm trying to do.

Although Debra Di Blasi's degree is in painting, it is clear that the artistic idiom of music informs her thinking as a writer. (Conversely, Episcopal music director and organist Ken Walker told me, "I think of myself as a visual person . . . I suppose it was more the textures and the colors [of the organ] that first attracted me.")

Almost everyone has numerous activities and interests outside his or her occupation—hobbies, sports, family and social relations, and so on—and sometimes they serendipitously intersect. But for a person seriously involved in two or more art forms, involvement in multiple media seems to spring from deep in the person's being, providing a wellspring from which artistic production and aesthetic satisfaction flow. A man might legitimately be "a gentleman *and* a scholar," but remarks by the people I interviewed suggest that a different conjunction, or a different sense of "and," is appropriate for a woman who, for example, not only makes paintings but also produces creative writing. Rather than being a painter and a writer, she is an *artist*—who paints and writes.

ARTISTIC TALENT

Americans grow up in a culture founded on the principle that everyone is created equal, but despite the prevailing attitude of "political correctness," nearly half of the people I talked with expressed the belief that they possess artistic skills and sensibilities that substantially exceed those of most other people. The fact that talent can be a generalized ability and not just a knack for a specific medium is shown by several of the interviewees' being (or having been) involved in more than one medium. For example, yard artist Karin Page took piano lessons for many years through her childhood and again during graduate school—all before she began decorating her backyard with bowling balls. The most dramatic shift in focus may be found in Carol Mickett, who held a position as a college professor of aesthetics before she left academe to pursue a full-time career in writing and the theater.

Carol and others see themselves as talented; and talent being an ineffable quality, several validated their claim by noting either their own accomplishments or their appraisal by others, such as former teachers. (Teachers were not always considered to be the best judges of talent, however. East Coast Al Kimber, whose tattoo creations have won international competitions, said, "My [high school] art teacher told me I should take shop [laughs]. He said I'd never make a living as an artist. Course, then, he's dead and I'm alive; and I'm making a living as an artist.")

Views about talent vary from person to person, but some themes recur. Most informants, for example, talk as if talent is something one either has or does not have, with no gray area between the two. In our discussion about dance, Arielle Thomas Newman said, "I think that you either have rhythm or you don't have rhythm; and I also think you either have stage presence or you don't have stage presence." Arielle went on to say, "I don't think that those

Carol Mickett, from Philosopher to Artist

When I first met Carol Mickett, some time in the early 1990s, she was a professor: Having earned a Ph.D. in philosophy, for more than ten years she had specialized in aesthetics but also taught courses in women's studies. When I ran into Carol a couple years later, she told me she was putting together a small theater group to perform the plays she had started writing; and by the time I interviewed her in the summer of 1997, Carol had fled the university and was expanding her involvement in the arts to include poetry writing.

As she now tells the story, the arts effectively rescued Carol from academe. Looking back on her days as departmental chair, she says, "There was all this horrible politics and I was really having a hard time—getting ill—, and a friend of mine said, 'You should go take acting classes so you can learn to have fun.' So I did, and . . . I loved it—and I was good at it!"

In theater, Carol found things she had long missed. She says, "It was the first time in my life that I was supported and applauded for being myself; and the more I was me and revealed stuff, the more bonus points I got. At the university, the more you did that, the more they said, 'No, no; don't do it, don't do it!' [laughs]." Moreover, whereas academic philosophy made her feel locked into her head, acting allowed her to regain her body. Carol says that the change has been so dramatic that when she runs into friends she hasn't seen for a long time, they sometimes remark, "'What happened to you? You're so different! You're, like, glowing; you're happy!'"

Although she has a cousin who trained and toured as an opera singer and a brother who used to do some writing, Carol sees little familial precedent for her involvement in theater: "I don't come from a family that does any of this sort of stuff. I'm sort of the oddball," she says. Nonetheless, the praise she has gotten from others leads her to think she has some "natural talent" in writing and acting. However, Carol is also quick to mention the hard work required by her craft—acting and voice lessons for theater, and, for writing, "knowing the history of what's gone before and all of the technique and the language and the forms."

Besides having an inborn ability and the development of technique, Carol believes that "you have to have something inside." To name that "something" is not easy, though. As she and I talk, Carol tentatively tries "insight," "facility," "inspiration," and finally settles on "something spiri-

two things you can particularly learn"; and others concurred, although the medium in question varied, from interior design and cooking to singing and writing.

If talent cannot be taught, where does it come from? Several people claimed that it is something one has at birth, "by nature" or "by instinct."

tual" as most nearly conveying what she has in mind, concluding, "You actually are in [the world] in a special way that a lot of other people aren't . . . Some people have a way of seeing the world, being in the world, experiencing it, and with the craft they can then share it with us. There's nothing like it."

Like many writers and actors, Carol has to harness her creative ability to ensure a living income from her work. (For example, Carol hosts a weekly talk show on a community radio station but hopes that the program will be picked up by the local PBS-affiliated television station so that she can start getting paid for her work.) Nevertheless, in her description of her daily routine, Carol clearly has no regrets about leaving academe to pursue the Muse: "I get up and I walk and then I write; and I have no greater joy than that in the morning."

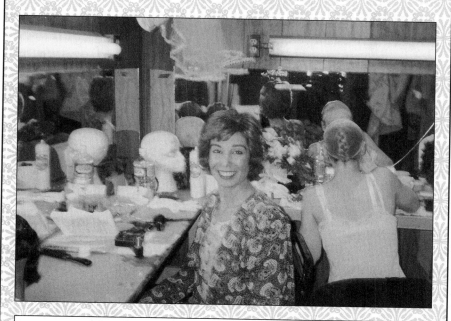

Figure 7–2 Carol Mickett, in a backstage dressing room.

Opinions tended to fall about equally into two camps, however, regarding the ultimate source of such instincts. Not everyone was asked, but of those who were, seven informants adopted a biological paradigm: Talent, they said, is in the artist's genes. The vocabulary varied from "Some stuff's just hard-wired in" (playwright/actress, Carol Mickett) to "Like, maybe there's a music gene"

(keyboardist Ted Gardner). But often the biological model was buttressed by reference to close (and sometimes not-so-close) relatives who are also talented. (A discussion about artists' families will concern us shortly.)

If genes solve the enigma of artistic talent for several people, a nearly equal number call in the supernatural. For example, Episcopal chorister Lenette Johnson said that her musical ability "is a gift that was bestowed on me from God"; and choral director Arnold Epley, when asked the origin of his talent, said somewhat more circumspectly, "Depending on how one defines, 'God,' I would say, God."

It is not surprising that the informants who are involved with religious arts would credit the realm of the divine as the origin of their special abilities; but similar explanations also were given by practitioners of secular arts, as illustrated by the following story by Theresa Maybrier about how she came to open her interior design studio:

> This store is a gift from God; and I can tell you that one very specifically. I was out of work for about a year and a half . . . I thought, "There's got to be a reason that this happened"—I have a lot of faith, anyhow. And so I started praying . . . , wanting to know what God thought I should do for the benefit of my family—the future of my family.
>
> One morning about 4 A.M. I got up and I started writing as fast as I could, and I could show you the paper. It's just incredible! I've kept it. I just kept writing like there was a person inside of me, spewing all of this information. And it was so detailed in terms of how to operate and run this business. And my husband got up about 7:30 and he said, "What have you been doing all night?"
>
> And I said, "It's a miracle," and I meant it!

Even "Frankie," who performs both topless and on the legitimate stage, attributed her special dancing and singing talents to a higher power: "I guess God gave me those gifts, or, that is, whatever you want to call it. You know, something gave me those powers." ("Frankie" also feels that insofar as she entertains her audience, either at The Club or on stage, she is returning the gift "to the world, to humanity, to your culture, to everyone who happens to be there at that moment.")

Although most informants who spoke on the subject attributed their talent to *either* God *or* genes, "Frankie's" shift from crediting her talent first to "God," and then to "something" suggests a way out of the apparent contradiction between the two explanations: Maybe *both* forces are at work. At least, that possibility was suggested by two informants. Rev. Donna Allen told me, "There's some stuff I've got that I could not learn, but that I was given [and] I would absolutely say, *God*-given." Rev. Allen, who changed her career goals

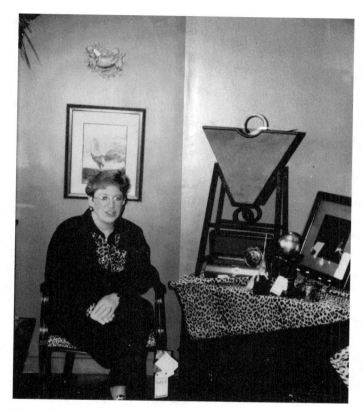

Figure 7–3 Theresa Maybrier, in her shop, Paul Harrison Interior Decorations.

by quitting the third year of medical school in order to go to seminary, later elaborated by saying, "The scientist in me feels that one day we will be able to identify the exact place on the chromosome that constructs the 'gift.' I would still call it a 'gift' . . . Regardless of how I got it, how God put it in me."

Similarly, Karin Page, the yard artist with a master's degree in microbiology and work experience in a genetics laboratory, when asked about the source of artistic talent, said, "It *is* a gift. I think your genetic makeup is a gift—from God. I mean, whatever talents [you have], you get from God. They are gifts . . . I guess some people might just call it 'lucky,' but it feels like more than that."

Whether the source is biological, supernatural, or both, the most salient pattern is that artists believe themselves to be uniquely possessed of an identifiable quality—"talent," "natural instinct," or whatever. Moreover, this

quality is of lifelong duration and has its place of origin in a realm that transcends everyday experience. The tenacity with which this view is held is seen in the fact that even art media of relatively recent invention are understood in terms of the same paradigm. For example, when I asked a television enthusiast, "Do you think there's a talent for television viewing?" her answer was, "Yeah, I do." Another person told me that excelling in television graphics "is a matter of inborn talent"—a talent, he said, that is distinguishable from a talent for making newspaper advertisements or for doing other visual art.

Two other themes regarding talent were also mentioned, albeit not as frequently as the last one. First, several people told me that for artistic success, nurturing and developing one's talents is necessary; inborn traits are not enough. Marya Jones, who has an artist's pride in her personal appearance, said, "My mom has great legs. She really does—and I got them . . . But it's my job to maintain [them]. That's why I'm down there [in my basement] on that treadmill every morning, working on it . . . It's a constant battle. It isn't easy."

Others go a step further, saying not only that talent requires nurturance but also that the person possessed of talent has a moral responsibility to actually develop it. Lenette Johnson, who described her musical ability as a gift from God, went on to say, "It's reciprocal. There's something I need to give back to that. And when I'm singing, hopefully that's what I'm doing."

Obviously, insofar as the rest of us benefit from the arts produced by talented people such as Lenette, we are fortunate that she and others feel obliged to develop and share her art.

A LIFE IN THE ARTS

Many artists have interesting stories to tell about how they were first drawn to the arts. Forty-five interviews touched on informants' first interest in the arts, the most dramatic pattern being the early age at which many of them were attracted to the arts. Almost all had a memorable involvement in one art form or another by their teens, and for more than two-thirds of the informants, the memories reach back to age ten or younger. The very earliest memories of art are remarkable indeed. Here are a few of the many:

- By age **two,** church organist Ken Walker was improvising at the keyboard; television enthusiast Michele Fricke recalls watching the circus on television; and singer/dancer Kim Kircher was staging an unscheduled evening performance for her mother and her mother's friends: One night, after being put to bed, she got up, toddled into her mother's room where she found high heels, a

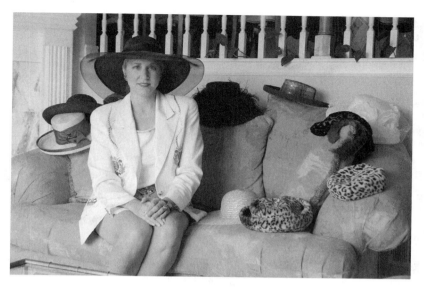

Figure 7–4 Marya Jones, with a few of her hats.

wig, and a silk scarf to dress up in, and then went to the kitchen and announced to her mother and her mother's friends, "Shut up everybody, because I'm going to sing!"

- East Coast Al Kimber was "drawing naked stick people at the age of **three.** Anatomically correct stick people! . . . I remember the beating [from my father], and he told me I was about three years old when I started doing that." (Not one to be deterred easily, Al continued to draw. By age nine he was creating a thirty-page comic book.)
- Television enthusiast Tracy Warren recalls the day his parents bought their first set when he was **four:** "The first thing that came on the screen that night was an Indian gentleman with a turban. He played the organ for fifteen minutes . . . then turned to the camera and said, 'Thank you. My name . . .' And then he said his name."
- By age **five,** Rev. Donna Allen was returning from church on Sunday mornings to perform her own sermons, imitating the oratorical technique of the Baptist minister whom she still describes as being "gifted."
- Chris Harris traces his first fascination with tattoos to age **six,** when a friend of his parents would tattoo himself at the family's kitchen table. (However, Chris says, "I didn't get my first tattoo until I was forty. And the reason for it mostly had to do with I wanted to find what I wanted to have; and I was always looking for styles that I liked.")
- Gourmet cook Sally Von Werlhof-Uhlmann tells this story from when she was **seven:** "[My mother] was a little overwhelmed by having four kids and the

regimentation of a six-o'clock dinner time, so she didn't really want us in the kitchen when she was cooking, but I'd sort of always stand on the fringes and set the table and offer to do things . . .

"Then she took up golf and was playing golf every Tuesday and Thursday, and she would get home at like five-thirty . . . So one Tuesday I made the big pitch of, 'I'll cook dinner, Mom' . . . I showed her I knew how to operate the stove; and I put the skillets on and [showed her] that I understood the oven. And I was so persistent that out of exasperation she agreed to let me do it, completely convinced that I was going to burn everything and that I would get totally frustrated and this would put an end to it. Instead, I invented a new salad dressing—which was a bacon and avocado salad dressing, which the family still uses, with fresh lemon juice and olive oil and garlic. So I was very successful at making dinner. At first, I think my mother was totally astonished and a little miffed; and then she decided it was great. So from then on it pretty much became a routine that on Tuesdays and Thursdays, I cooked dinner."

- At about the same age, the absence of parents gave car enthusiast Roger Hurst a similarly challenging opportunity: "I would get home [from school] at three or three-thirty in the afternoon, and I would have to watch myself until my parents got home at five; and so I'd pull this can of Three-in-One Oil out of the cabinet and put a few squirts of it on the linoleum on the kitchen floor. I had this race car, and I'd put the oil on so I could make it slide sideways like you would at a race; and then I'd try to get it all cleaned up before they got home. And if I didn't get it all cleaned up, I was in big trouble!"

Many of these early vignettes presage features of the adult artist's mode of work. Consider Robyn Nichols's story:

I remember in grade school, third grade I think it was, I was kept after class because I did my art and I did two other girls' art. One of them gave me her lunch money, and one of them did my math for me. And I just thought, you know, I didn't like to do math, and she didn't really like to do art. And so the teacher kept me after school and said, "Robyn, you can't draw for people . . ."

I thought, "Ok, I'll make one friend this style, and the other will be this style, and then I'll be me."

Today the silver sculpture and jewelry that Robyn creates are sold in expensive shops throughout the United States, reflecting not only her talent and lifelong commitment to visual art but also the same entrepreneurial skill she possessed in grade school.

Sometimes the precedents set in youth are more remote to current artistic practice. For example, Lester Goldman told me that when he paints in his studio today, he experiences the same meditative, isolated, introverted feeling he had as a child making model airplanes, an activity that he said was his first real art. Also, rabbit skin glue, Lester noted, makes newly stretched canvas become taut in exactly the same way that water used to tighten the

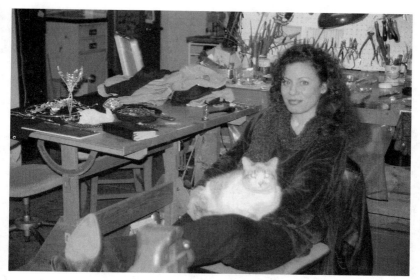

Figure 7–5 Robyn Nichols, in her silversmithing studio.

tissue paper over the balsa wood frames of his childhood model airplanes. A third aspect of model-building raised for Lester a deeper philosophical concern about the permanence of all things, art included. After completing a model as a child, he would "put glue on the plane and then I'd light it and then I'd throw it off the building so it would basically self-destruct . . . So on one level I would be very, very attentive to, you know, like making this thing and bringing it to fruition and everything, but then basically not really care that much about whether it existed forever. And a lot of things were like that."

Although commitment to the arts tends to be a lifelong proposition, several informants spoke of the changes they had gone through, dictated at times by personal circumstances. For a few, there were fluctuations in degree of involvement. For example, Steve Cromwell listened to less music in college than he had in high school, partly because of the lack of electronic equipment. (Even then, he says, there were radio programs, "like WFMT's 'Midnight Special,' which I listened to religiously.")

In other cases, the change has been in the direction of increasing refinement or sophistication. All four of the television enthusiasts, for instance, told me they are more selective in their viewing at present than they used to be. (Tracy Warren said that he has watched so much television over the years that now he sees very little programming that breaks new ground.) Similarly, in recent years Susan C. Berkowitz has abandoned macramé for knitting

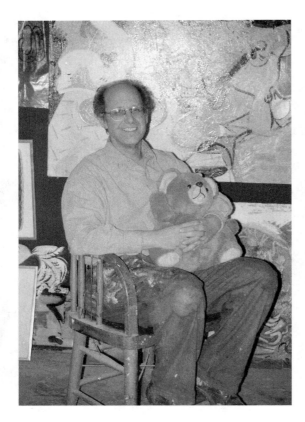

Figure 7-6 Lester Goldman, in his painting studio.

sweaters and making quilts; and Robyn Nichols's former interest in wearing jewelry has diminished as her career in designing and fabricating jewelry and sculpture has taken more and more of her time and attention. Perhaps the same dynamic accounts for a change that Lawless Morgan told me about: His "addiction," as he called it, to comic books extends over three decades; but whereas in his youth he was intrigued by the characters and the art in the comics, now he is much more interested in their plots.

The Artist's Family

The family is the seedbed in which artistic talent takes root and grows—or, at least, that is the picture that emerges from the remarks of the people I interviewed. Many relate their own "gifts" in the arts to the talents of other family members. Although the artists themselves may pursue diverse media, in many cases, their family stories focus on the same (or a closely related)

medium that they were to pursue as an adult. For example, the mother of Episcopal music director and organist Ken Walker was also a church organist; Larry "Fats" Goldberg grew up living above his father's grocery store in a family where everyone (save his father) loved to eat; and silversmith Robyn Nichols's mother and two sisters were all such good draftspersons that she was surprised to discover in later childhood that not everyone can draw.

In this setting, no reference to divine sources of talent is needed to account for emergent talent; the psychology of family dynamics seems to be sufficient. For example, dancer/choreographer Arielle Thomas Newman told me, "My dad was a jitterbug champion. I still have a trophy of his. My mom wasn't a dancer, but my dad was . . . I remember that we would dance in the living room, my dad and I." In addition, Arielle's father, and her mother too, had talent in the visual arts: "I always felt disappointed that I didn't get that talent, although I incorporate a lot of visual art into my choreography." Similarly, Arielle has a brother "who did not go into the arts at all—although he's a chef, and cooking was also really important in our family."

In some cases, the influence of the family is overt and direct. Singers Lenette Johnson and Linda Lindell both recounted childhood memories of singing with their parents; and car enthusiast Roger Hurst still recalls the noise and excitement of Kansas City's old Olympic Stadium, where he and his father would watch midget car races on warm summer nights.

However family experiences are not always straightforwardly linked to a later attraction to the arts. Another car buff, Dick Jobe, told me, "I was always fascinated by mechanical things, even when I was a kid, you know? My dad had laundromats and so he'd bring these old washing machines home and we'd rebuild the pumps on them and the motors and file the points down and do all this wild stuff." In parallel fashion, bluegrass music performer Boyde Stone, who had some success at drawing in his early adult years, recalls making sugar bells and roses with his mother, who was a professional cake decorator and the person to whom Boyde credits his talent.

In some cases, artists attribute their adult involvement in the arts to a general ambiance or style of interaction that was characteristic of their families. Amateur actress Teddy Graham says that relatives on her "father's side of the family were kind of wacky, creative kinds of people in many different kinds of ways," who would "put on fake radio shows or re-create *Moby Dick* at holiday get-togethers." Or, to cite another example, Chris Harris, who wears numerous tattoos and is a professional body piercist, described his family as having a broad interest in the surreal.

If a template for many artists' talents and skills can be found in their childhood homes, for other informants the familial relationship is more

complex. In seven cases, artists recall a total indifference toward the arts in their childhood homes; three artists were actively discouraged from pursuing their artistic interests; and two individuals, both gardeners, recall a marked childhood dislike for the arts that they later avidly pursued. If this small sample is indicative of the larger universe of artists, such uninspiring early environments seem to have no consistent effect on the type or degree of adult artistic pursuit—popular or fine art, amateur or commercial.

Several people now look back at adverse childhood experiences as being what actually brought them to the arts. Six informants see their involvement in the arts growing out of one or another form of sibling rivalry. For example, Teddy Graham, who performs in community theater, said, "I used to imitate people to get attention . . . Everybody's pretty blasé by the time the fourth kid comes along." Similar factors motivated Theresa Maybrier, one of nine children, to become interested in the arts. Her father took only the boys with him when he went fishing and hiking, but Theresa got to paint, draw, and go on photo shoots with him. In her work as an interior designer, she says that she still uses principles of visual analysis and composition that her father taught her while looking at scenes framed on the ground glass of her childhood Brownie camera.

Or consider Nancy Jenkins, who has worked as a commercial artist, who went through a creative clothes phase, and who now uses her garden as an expressive outlet:

> My family [is] really flat. They have no spark. That's what it is, it's the spark. I [wanted to be] as different from my family as possible. You know, I really didn't want to be a part of them. I just really see them as being not cool [laughs]. You know, I wanted to be cool . . .
>
> I'm not as tied up with my family now. I sorta feel like I did a "Fuck you!" with them; and they were still controlling me, in that whatever they didn't want me to do, I *would* do.

Others, although not using the arts actively to rebel against their families, nevertheless see themselves as having fundamentally different personalities from those of their relatives, referring to themselves as "kind of the odd duck" (writer/actor Carol Mickett), "sort of the oddball" (yard artist Karin Page), a "round hole in a square peg" (interior designer Jack Rees); and generally as being unlike the others in their families— "I mean, they were *normal*" (painter Maria Vasquez-Boyd).

Thus, the family of origin is typically a point of reference for artists. Far more than schools, teachers, and individual mentors, families are the substrate on which the germ of artistic genius first grows. Most often the artist replicates some of the artistic habits of family; otherwise, an artistic course

may be pursued in reaction against the family. Rarely are families insignificant in the formation of the artist.[5]

OTHER INFLUENCES

I initially wanted to interview Boyde Stone because I knew he had long played bluegrass music. In the course of the interview, however, I learned that in earlier years, Boyde also had some success in the visual arts. He told me, "*If I'd had some training* [emphasis added], I could have been good." And indeed, a few of the informants mentioned how they benefited from their formal training in the arts. For example, Jack Rees, now in his late seventies and semiretired after a successful career in interior design, went to Pratt Institute on the G.I. Bill following World War II. Now, fifty years later, when Jack talks about the many residential and commercial design projects he has carried out, one still can clearly discern the "form follows function" paradigm that was brought to Pratt by several émigré Bauhaus architects and designers who joined its faculty during the war years. A handful of other informants also gave some credit for their artistic development to schools, teachers, or childhood visits to art galleries, but most of these influences ranged from vague and nonspecific to outright negative: As noted previously, East Coast Al Kimber's high school art teacher actively discouraged him from studying art.

How can we account for the relative insignificance of formal training as a factor in leading a person to pursue the arts in later life? One possibility is that a sampling error may be present. The subject of families was mentioned often in the first interviews I conducted, and sensing this to be a fruitful area to explore, in subsequent interviews I often raised the issue myself. I did not do the same regarding art teachers, schools, and so on.

But the relatively low profile of formal art education also has something to do with the arts themselves. Although most gallery painters have earned at least bachelor degrees in the fine arts, practitioners of the popular arts are inheritors of long-standing oral traditions, where training occurs informally or by apprenticeship. Gardening, popular music and dance, and tattoo are examples.

In other media, formal education exists to "certify" the most expert practitioners; and because most of the people I interviewed fall into that category, quite a few have such credentials. To name only a few: Car enthusi-

[5]A friend who grew up in Hungary, Bela Csaki, tells the tale of two brothers, sons of an alcoholic father. One, when asked to account for his own alcoholism, replied with two words: "My father." The other son, asked to explain his total avoidance of drink, had an equally succinct answer: "My father."

Nancy Jenkins: Portrait of a Gardener

If many people come to art by following in the footsteps of their artistic parents, Nancy Jenkins did the opposite: Because the people in her family were, in her eyes, so colorless and uninteresting, she has nurtured her own creative side in an effort to be unlike them. Although she earned a degree in commercial art, when Nancy got a job in that field, the projects she worked on rarely gave her the feeling of total concentration and immersion that, in her opinion, true art should afford.

Since leaving commercial art and becoming a psychotherapist ten years ago, Nancy has looked to the popular arts to fill her need for creativity. After an early hippy phase when she was uninterested in fashion, in her twenties, she became fascinated by clothes and personal appearance and also with home decoration. Four years before I interviewed her, though, Nancy began flower gardening, and since then, most of her artistic efforts have gone into that medium. "I love having passions," she told me, "and gardening is a passion."

Nancy derives great satisfaction from the beauty that her garden displays in the summer months, and (as noted in a later chapter) she has an elaborate theory to account for that enjoyment; she also recognizes that the arts play a role in her social life. For example, she first became friends with informant Susan C. Berkowitz (who, in fact, suggested that I interview Nancy) because of their kindred tastes in clothes and accessories. It is, however, the psychological and spiritual dimensions that most inform Nancy's thinking about gardening. Working in her garden, Nancy can have the flow experiences that are so valuable to her: "I call it 'lost in the garden'... It's like, I don't know what I did, but I was there a couple hours. I'm just like literally *lost* in it. I love getting lost in things, and that's the feeling I get when I'm really creative, is feeling lost. I'm not so guarded and intellectual and controlled."

Gardening is therapeutic for Nancy, providing a place for her to purge job-related stress; but besides that, Nancy also conceptualizes her garden in metaphorical terms: "I start thinking about things living and dying and why some plants [are] more fragile... When I was turning forty last year I

asts Roger Hurst and Dick Jobe both have completed numerous automotive training programs; chef and food consultant Bonnie Winston attended the Culinary Institute of America; Jack Rees graduated cum laude in industrial design from Pratt Institute and is a past officer in the American Society of Interior Designers; and all four of the people I interviewed about the art of delivering sermons are ordained ministers.

was out in that garden and I was putting those stones in and I thought, jeez, a hundred years from now somebody's probably going to come out here and dig these up. I'll be dead. It was just this feeling of time passing."

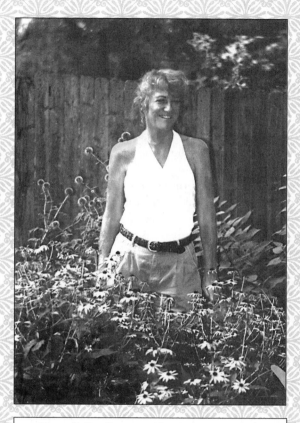

Figure 7–7 Nancy and her backyard garden.

If the other informants had wanted to do so, most could have found certificate or degree programs in their fields as well—fashion design for people interested in decorating the body, landscape architecture for the gardeners, media studies or video art programs for the television aficionados. But most did not go that route; and their decisions may reflect a deep ambivalence that Americans feel about the relationship between art and education. Proficiency

in the arts is seen as an amalgam of skill and genius, in varying proportions. At least to a certain extent, the skill component can be taught, and the various certification programs seem to focus on the practical components of art. Education, in much popular thought, means mastery of a fixed (and marketable) body of knowledge. Genius is another matter, however. If talent is inborn, as a gift from God or a quirk of genetics, and if the arts derive, at least in part, from emotions and the unconscious—as will be discussed in the next chapter—then conventional academic course work is of dubious applicability.

Friends can also affect the course of the artist's development. At age fourteen, Jim Schindelbeck was encouraged to get his first tattoo by an acquaintance who already had one; Joyce Halford was introduced to acting by a high school boyfriend ("the relationship sort of went by the wayside, but the love [of theater] was there"); and yard artist Karin Page, who had long been an amateur musician, credits her husband with fueling her current enthusiasm for the visual arts.

Even other art media sometimes play a role in attracting a person to the arts. As previously noted, Episcopal music director John Schaefer says that initially the *appearance* of the pipe organ drew him to the instrument as much as its sound; and television gave future professional dancer William Whitener a broader understanding of the possibilities of dance: "'Talent Roundup' on the *Mickey Mouse Club* was a time when kids tap-danced and performed. Darlene was dancing on *pointe*; Bobby was tap-dancing there, and then later on the *Lawrence Welk Show*, so I began to track these people as a child and imitate them."

Such stories suggest the truly capricious nature of causality in the emergence of artistic interest and ability. Sheer coincidence played a role in many informants' development as artists.

- When his mother became ill, the responsibility of fixing his and his father's lunches fell on young Steve Johnson, and he has been an avid cook ever since.
- During the Second World War, Jack Rees happened to be stationed in New Guinea just at the time when General MacArthur's headquarters needed a draftsperson, so he turned in his rifle and spent the rest of the war effectively preparing himself for his career as an interior designer.
- In junior high school, Doug Wylie's art teacher occasionally worked as an usher in a theater that staged road company productions. The teacher asked Doug whether he would be interested in substituting for the teacher one evening when he had to be out of town: "I said, 'Sure! It sounds like fun.' So I went and ushered and stayed for the show, and from that moment on I decided that that was what I wanted to do . . . and have done that ever since."

As noted earlier, the three retired yard artists present the greatest challenge for explaining the source of their interest in art. Consider this exchange among Chief Korzinowski, his close friend Katrina Oldenberg, and me:

R.L.A.: Let me ask you this: Were you ever involved in art when you were young?

C.K.: No, no. No, I don't know why. I just start[ed] picking up things . . .

R.L.A.: Do you have other family that's into collecting and decorating things?

C.K.: No. My two sisters, they don't collect nothing. I graduated from grade school in 1938 and '39; and where these [buildings that house] truck lines are now, I pulled radishes for ten cents an hour. Picked them with my hands, put rubber bands around them. Ten cents, and ten hours a day. When I started at the brewery I made ninety cents an hour . . .

R.L.A.: Have you seen any other people who decorate their yards?

C.K.: No.

R.L.A.: Magazines, books, newspapers?

C.K.: Nope.

K.O.: He don't pay attention to magazines or books. He don't look at magazines, he don't do pictures.

As we shall see later, Chief does have his reasons for making art, but responding to family, teachers, or the rest of the art world does not appear to be among them.

ART, SKILL, AND FORMALISM

Nobody whom I interviewed seemed to believe that skill is sufficient for defining art,[6] but many of them felt that skill is necessary. Just as they acknowledge their exceptional talent, they also know that they possess a consummate artistic skill and technical mastery that most nonartists lack. Reflecting on customers who have less experience and ability than he himself has, one interior designer remarked, "The world is loaded with housewives with ideas, and they can get people in more damned trouble than you can shake a stick at!"

Roger Hurst's account of how his automotive skills ultimately allowed his love of cars to grow into a thriving business is illuminating:

I started the business because I couldn't find anybody to work on my car. You know, I could take it to the local dealers and spend a hundred dollars for a

[6]Record collector Steve Cromwell told me, "I tend not to like albums where the musical facility is really what stands out because I think that if that's what it is, it doesn't fit my criteria. I want the experience, rather than admiration of someone's ability."

tune-up back in 1962, and I'd get it back and it wouldn't hardly run. And that was a lot of money, back in '62, you know? So I bought a book and began to work on it . . .

I got my car running really good, and I entered some of these rally and autocross driving contests and began to win first places because my car ran better than anybody else's, and people began to flock over and say, "My gosh, your car runs good. Who works on your car?" And I'd say, "Well, I do it." And they'd say, "Well, would you mind setting my timing, or set my carburetors," and I would and they'd offer to pay me. And I wouldn't take anything at first, and then they would come back and bring their friends, and there got to be a line there, of people waiting to have me look at their cars.

So I began to charge to slow them down, and they kept coming, and I kept charging more, and I was shortly making more in evenings and weekends than I did from Mobile Oil Company—so that's what got me into the business.

As is the case with most art-related subjects, dissenting opinions regarding artistic skill can also be heard from informants. One of the topless dancers, although she feels herself to be a talented performer, believes that most of her customers are so undiscriminating that "anybody can do it." An anecdote from yard artist Karin Page also plays on the theme of philistine taste: Her daughter "did this painting that I had up in my office, and my boss came in. He collects art, and he said, 'Who did that?' And he really liked it 'til I told him it was my daughter's, and then he didn't like it [laughs]. It was great!"

The aesthetic of formalism dominated Western fine arts for much of the twentieth century (cf. R. Anderson 1990a:216–219). This school of thought (which will be described in greater detail in Chapter Eleven) asserts that art is valuable and important because of its "formal" qualities—the painter's use of color and composition, the composer's mastery of counterpoint, the poet's choice of words to fit a rhyme scheme, and so on. Although we often associate the rise and decline of such an aesthetic with modernism in the fine arts, it has been an enduring force in the West since ancient Greece. Pythagoras and Aristotle both praised qualities such as order and symmetry; and medieval and Renaissance artists strove for harmony, proportion, and measure.

Likewise, even if the postmodern attack on "art for art's sake" has been successful in the fine arts, the age-old concern with formal qualities in art lives on in the popular arts in a widespread appreciation of technical skill. Chapter Ten will focus on several aesthetic principles that are implicit or explicit in informants' remarks, but we may get a preview here by looking at artists' feelings about the importance of skill, not so much in their own

Figure 7–8 Roger Hurst, working on a customer's race car, at Hurst Foreign Car Service.

mastery of technique but rather in the frequency with which they themselves respond to the formal qualities of art.

Some formalist remarks about the popular arts merely reflect the fact that most contemporary Americans with college educations have come in contact with academic formalism. For example, Michele Fricke had the following observations regarding three of her favorite television series:

> I think *Dharma and Greg* is an unusually well-written program. I admire the way they shape that program . . .
>
> [*The X-Files* is also] well written. I *really* love it. And it's so minimalist. You have to work a little bit to be with that show, and that makes me like it more . . .
>
> The first [episode of *Miami Vice* that] I watched, at the very end of the show, after a long shoot-out, there's this dead guy laying [on the ground], and one of the characters that's a regular has him kind of in his arms—he's an old friend [of the person] that's been killed. And the cop's partner comes behind him and puts his hand on his friend's shoulder. And I was in graduate school [in art history] at the time; and I went, "My God, that's right out of a painting!" And I ran to my textbook, and there it was. If that was accidental, I'll eat my hat.

In her references to the "shape" of *Dharma and Greg,* the "minimalism" of *The X-Files,* and the visual composition of a concluding shot from *Miami Vice,* Michele's familiarity with formalism is apparent.

Michele was not the only informant to use the language of academic formalism to discuss popular art forms. Interior designer Theresa Maybrier ("the room is very well tied together, and the proportions are as they should be") and Ed Bartoszek (who talked about the "composition" of the paintings he makes to sell at art fairs) both have degrees in painting.

The stretch is a bit further for Karin Page, who as an adult has many friends in the fine arts. Accounting for the pleasure that she gets from decorating her garden and yard with bowling balls, Karin said, "It's hard to make something round . . . There's something pleasing about it—maybe because there's something unattainable about making it perfectly round."

An appreciation of the formal qualities of artworks also comes from informants with no apparent ties to the world of fine arts:

- Regarding the evaluation of tattoos, Chris Harris said, "In art, your eye has to follow a direction; and the direction is established by the art itself. If your eye runs into dead ends, then you lose the ability to perceive the totality of what you're dealing with."
- Dick Jobe said that he likes "the forms of the cars, you know? The old classic body styles. The round cars. English sports cars I felt were especially nice because of the way they looked. Mechanically, they weren't really much; but, boy, they sure looked good, and I liked that part of it." Old cars, he continued, "just have those wonderful lines that we don't see now. Now they're all econo-boxes. And it was back in an age when they didn't just slam them together."
- Jan Jones also made several remarks that reflect her appreciation of some of the formal qualities of automobiles: "I'll have to admit, a pretty car turns my head. It really does . . . I like the color red, so I figure why not have a red car . . . I think I've always been into real striking, but classic, kinds of shapes and colors . . . When I buy a car, I take a lot of time. What I want to get is what I think is the very best color for that car. I mean, everything has to fit together."

As these remarks show, formal criteria continue to be at least as prevalent in the popular arts as they were in the fine arts during the heyday of modernism. When artists critique an art work in a medium in which they themselves are experienced, they are highly discerning in matters of technique. Skill is not everything, and artists may give it less weight than other aesthetic factors; but as with talent and experience, artists often see skill as a sine qua non for excellence.

ART AND SELF

Nearly half of the informants talked in one way or another about the intimate bond between art and self. For a dozen of them, the relationship was simple: Through art they experience their true selves. Here are three examples:

- Speaking of his artistic talents and abilities, choral director Arnold Epley said, "I believe that when I make full use of those things, I become fully who I am."
- In describing her approach to delivering sermons, Donna Allen said, "Particularly out of the West African tradition, when you are a storyteller, you embody the Word, and the Words embody you. You do not just spill them out, but they come to life. So the Word of God becomes alive because it is alive in you."
- Being possessed by one's art form is not restricted to religious contexts, however. For Larry "Fats" Goldberg, food is an all-consuming passion, as seen in this exchange:

 L."F."G.: Always, food is it. It's pizza, women, and air conditioning. Those are the only things I have . . . It's my life.

 R.L.A.: Food?

 L."F."G.: Food! It's absolutely food . . . People ask my name. It's Larry "Fats" Goldberg. But they say, "You're not fat!" Of course, but in here [gesturing toward his heart]—I'm fat.

The identity between art and self can also be turned around, subtly changing "my art is me" into "I am my art." As discussed in the pages that follow, this transformation is most common in theater, where many actors at least fleetingly feel that they actually become the character they are playing. (And not just actors feel this way. Doug Wylie prefers directing to acting because as he plans a production, "for a brief time you get to be *all* the characters.")[7]

The same experience can happen in other media, as well. William Whitener talked about the years when he was a member of Twyla Tharp's dance company, especially the peak moments of discovery and performance: "I felt I was, in those moments, married to the music and had gotten *inside* the music in my own, spontaneous kind of way."

The concept of being "married" to an artwork is carried a step further by experimental fiction writer and former painter Debra Di Blasi:

[7]Clearly, finding one's self in art is not far removed from finding an alter ego there. Michele Fricke was first attracted to the soap opera *All My Children* because the character of Tara in the soap opera was Michele's own age, "and she was having all these adventures that I was not having. I was going to college, and she was out doing all these things."

I think there's a sense of capturing something, to *own* the beauty or to *own* the object. It's like turning around the idea of the primitive fearing you'll capture their soul with a photograph. Flip that around—you're trying to capture the soul or the essence of something by drawing it. You're the camera. And it's true! You can do that . . .

The novel that I'm finishing now is really talking about this because it's talking about possessing a beautiful person. It's about ownership. The character is a painter, and she has this feeling that if she can replicate it, . . . she should own it . . .

I still paint occasionally or draw, and when I have done something particularly well, then I feel that ownership.

More than one informant noted that the identification between artist and art form means that an absence of art throws one's very existence into jeopardy. Painter Lester Goldman said, "If I don't do it, in a sense, I feel like some part of me died, you know? . . . It's not understood that there's this vitalistic center that basically has to do with [art], and it's hard to explain that. But the more years you do it, you realize that it's your core necessity."

A related, and even more frequently mentioned, idea is that the arts provide an avenue for expressing the artist's inner being. Many informants emphasized the uniqueness of the artist's self. This was particularly the case regarding decoration of the body. For example, Marya Jones has always chosen her wardrobe in part to distinguish herself from her twin sister.

Three of the tattoo enthusiasts expressed the same idea, and the richness of their commentary deserves extended attention. East Coast Al Kimber said, "Being an avid motorcyclist, I have motorcycle designs on me. That's expressing myself through one of my loves of life. I have numerous women tattooed on me. I love women—couldn't live without them. So I guess I'm expressing myself to the world through these particular tattoos."

For Jim Schindelbeck, the message was more complicated: His large back tattoo is composed of nature images, including a bear, a wolf, an eagle, a mountain, and a waterfall. Jim has strong feelings about each one. About the eagle, for example, he said, "I always wanted to do its freedom of flight . . . If you could be anything for a day, I'd be a bird. I don't care if I was a canary, you know? I'd want to fly." Jim, however, does not believe that he can always convey such feelings to others adequately in words, so he hopes that the tattoo does it for him: "It explains myself to other people in a way, I think. You know, without me really having to do it."

Because Chris Harris seemed willing to debate, I played Devil's Advocate with him about the large and intricate tattoo on his back, with interesting results:

C.H.: [My tattoo] was something that revealed what was inside and what I thought about.

R.L.A.: So why's it on areas you can't see?

C.H.: Because I don't have to see it. I know it's there. You know, if you're reflecting something that's inside, you know it's inside. You don't really have to see it; you know it's there.

R.L.A.: By that logic, you wouldn't need to have it painted on your skin.

C.H.: No. No. But you like the idea that it is. There's a little show-off in all of us, eh? . . . I was always set apart from society. I was always different than the main group. I did things differently. So it's basically a representation of the way I am . . .

R.L.A.: Your [tattoos] are about Native American stuff. How come?

C.H.: 'Cause I'm part Indian.

R.L.A.: That's right, you mentioned that.

C.H.: But on the other hand, if I were walking down the street, you wouldn't guess me as being part Indian, would you?

R.L.A.: But you're part a lot of other things, too. Maybe Scottish. But you don't wear a kilt down the street.

C.H.: No. On the other hand, I feel closer to [Indian culture], because of the representation that Indians bring to my mind, as far as living within the realms of earth.

If several informants such as Chris Harris express their own individuality through their art, two others highlighted the ways in which art links the individual with a larger cultural identity. Roger Hurst said, "Back when I was a kid, . . . your family, if they were farm people or any kind of rural people, they probably drove Fords. And if they were more urban, they probably drove Chevrolets—General Motors products. Or Chrysler. And you didn't vary because all hell would break loose in the family if you bought a different brand of car." Today, Roger said, the patterns are more complicated: "People that are into the environment, or into human rights, animal rights, you almost always find those people driving Volvos."

Similarly, painter Kim Anderson recalled this story from her childhood:

I remember, in the basement of my house there was a little room, and down there were all these neat books—by Botticelli, DaVinci, Michelangelo. Just wonderful art that I was exposed to—I know that a lot of it was about Christian stuff—biblical themes, and things like that. Images of suffering. And in my personal case, since I was a sufferer, these seemed to talk to me about my own pain and just make me feel like that was being reflected in some way, so I wasn't alone with it . . . Your self is reflected: not just your own personal self, but as you stand in your culture, you know?

Two interesting variants of the theme of art reflecting one's self emerged from the interview as well. Interior designer Theresa Maybrier said that she strives to make a home "reflect where you [the owner] are, and

where you're going." With most of her clients, she said, this is an interesting challenge. She said, that however,

> the process of doing [clients] that don't have a real specific personality or that don't have a defined desire: Those are much harder, because then not only am I creating just a beautiful space from my imagination, but I'm also, in a sense, a writer, because I'm writing a life-story for those people. That's very tricky! . . . I find that to be the most difficult part of my job. They're the jobs that pay the best because, of course, you're *doing* more.

(Silversmith Robyn Nichols said that she has had the same problem in designing jewelry for a few of her clients.)

It is not just too little personality that can be a problem in the decorative arts: The possibility of multiple personalities was mentioned by a couple of people involved in the performing arts. As discussed later, singer Linda Lindell and dancer Arielle Thomas Newman both commented on experiencing a split between the spontaneous, performing self and the conscious, critical self; and coming at the issue from a different angle, topless dancer "Frankie" said that she has to be "a chameleon, constantly changing my colors, changing my personality, outfits, and music."

But these variations aside, the fact is that many artists see their art as being intimately connected to their social identity, and that conclusion leads directly to the next topic, namely, art and the inner self.

8

Art and the Inner World

From one point of view, art belongs solely to the realm of psychology. From the creator's initial inspiration to the consumer's "Ah" of delight, one could contend that art is from, by, and for the human mind. In some media, such as painting, a material manifestation of the work occupies a place in the social and material worlds; but even then, one might argue (as did Plato) that the physical artwork is no more than a shadow cast by the ideal essence of the painting, a Form that transcends pigment and canvas, just as the music of Bach transcends the keyboard or a sonnet by Shakespeare surpasses the printed page.

Much of the material I gathered in interviewing people who are seriously involved with the arts focused on art and the inner world, leading to many compelling aesthetic concepts. As in the preceding chapter, which focused on the person of the artist, a number of persistent themes can be discerned in the several hundred psychologically and spiritually oriented passages in the interview transcripts. They are presented here under four broad headings: art and the body; the psychology of art production; art and affect; the aesthetic response; and religion and spirituality, transcendence and flow.

ART AND THE BODY

To analyze art's life in the mind, we might begin by considering the place where the mind dwells, the body. As painter Kim Anderson said to me, "My abilities are built into my body." Liz Craig, who works as an advertising

copywriter but whom I interviewed primarily with regard to her love of ball-room dancing, elaborated on this theme: "When I was growing up, I never had much encouragement to be very physical and be in my body. It was all, like, from here [gestures toward her neck] on up. They encouraged my intel-lectual side a lot, and as I got older I discovered that I needed physical move-ment . . . We don't really live in our minds; we just like to hang out there to solve problems."

Obviously, some arts engage the body more than others. Three women with white-collar jobs told me that a primary reason they are avid gardeners is the physical labor that their gardens demand. (Nancy Jenkins said, "I love that feeling of hard work, and you're sweating and you're dirty and I've got dirt under my fingernails.") Informants involved with music and theater also re-marked on the extent to which their bodies were engaged by the arts. But even fine art painting, which may seem primarily cerebral to a nonpainter, can yield the same satisfaction. Maria Vasquez-Boyd said, "Physically applying the paint and just kind of digging into the surface [is what] I'm *really* attracted

Figure 8–1 Maria Vasquez-Boyd, in her studio.

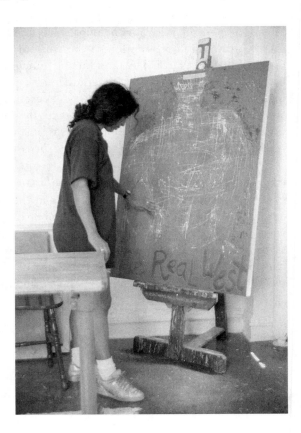

to. I just have too much energy, I think . . . Making art, large scale, you know, really helps kind of pull that out of me."

If several informants talked in general terms about the relationship between art and the body, an even larger number focused on a particular aspect of the relationship, namely the sensuousness (and, in some instances, the eroticism) of making art.

The stimulation that many of the arts provide to the senses is axiomatic, but some informants were especially graphic in their accounts of the *multisensory* pleasures of the arts and in the vividness of their sensory response. Consider the following examples:

- Gardener Nick Rivard said, "You smell a tomato plant and it's like, it almost happens over night: your plants go from little plants to all [of] the sudden big-stemmed, buxom, lush growth . . . It's as much the color as anything in the garden. It's really pretty awesome." After Nick had rhapsodized about the beauty of the vegetables in his garden, I pointed out that at no time during our interview had he mentioned the attractiveness of flowers (which Nick also grows) and the way that they can beautify the home. Nick cleared his throat and said, "I never cared about that much. [It's] not to make the house beautiful. It's more for me to enjoy the flowers . . . I can enjoy *Home and Garden* kinds of shows, but I never really tried to do that . . . I never cared much about weeds in the yard."
- Food enthusiast Bonnie Winston told me, "I'm a very sensual person and things of the senses appeal to me, [as does] being in a kitchen, where it's warm and smells good and all of that . . . Food captures all the senses. I mean, there isn't a one that isn't involved . . . I'm a very, very visual person; I think food is beautiful. I mean, when I go to a market, a farmers' market or something, I come home and I set up all these little still lifes in my kitchen. It pleases me to no end . . . I'm a sensory junky, really."
- Painter Lester Goldman remarked, "See, I don't just depend on my eyes or my hands or my ears or things like that. I basically believe that after [a] while you use all your senses in order to form [art]. And that's why it's so complex, what kind of images you get, because it's not just your eye. And so there's all these other things. Like colors have sounds to them; marks have density, they have touch. There's a visceral sense of the world itself."

These comments, and others like them, once more call into question the strict boundaries between media that conventional accounts of the arts rely upon. But this questioning creates a dilemma. For example, I have referred to Lester Goldman as a "painter," and painting is the quintessential visual art. However, Lester's own testimony reveals how wide of the mark such a designation is. I see no preferable alternative, however. Lester has sometimes incorporated sculpture, music, and performance into his work,

but in the passage quoted here, he is referring specifically to painting; so to say that when he applies paint to canvas, he is a "multimedia artist" is even more misleading. Perhaps all we can do is to resign ourselves to the imprecision of language, especially the words that are meant to demarcate boundaries between one art medium and another—that, and to be sensitive to as many sensory modalities as possible when we talk and write about art. Insofar as we adopt such an approach, we follow the practice of many artists themselves.

Several informants narrowed the subject of sensuousness by positing a connection between the arts and sexuality or eroticism. On the simplest level, some people acknowledged that the arts can enhance sexual attraction. Thus, Jim Schindelbeck said that when he got his tattoo, his girlfriend liked it so much that she got one of her own. (For his part, Jim says of women who get tattoos "all over their arms—to me, that's unsexy. But there are certain women [who] get them in certain places, and they're *very* sexy.")

Art can also be a means to sexual ends. For example, when I asked Jimmy Green, who was in his early seventies when I talked with him, why he had decorated his yard with cast concrete sculptures and had painted pithy remarks (primarily about Black Power) on one side of his house, he repeatedly said, "Because it sets me apart from the average Negro," or some variant thereof. On one occasion, however, he gave an additional reason: He also likes the fact that "girls" like to come and look at his yard. Some, he said, even come inside his house; and although the remark was delivered with clearly sexual innuendo, Jimmy declined to discuss what went on in his house.

On a similar note, Dick Jobe talked about the American institution of "cruzin' your baby in your car," and he recounted a story about once taking a new girlfriend for a ride in his restored MG convertible: "She was all over me, just because she was so caught up in the thrill of being in a cool old car, you know, driving around in the country—and it moved her! I loved that girl!" [Laughs.] Showing that he was aware that such tales could easily be dismissed as male fantasy or folklore, Dick continued: "You always hear these guys talk about their Ferrarris, and women just can't stay out of them, you know? I think there's something to that!" For his part, Dick believes that Italians design "the sexiest cars . . . They're like ultra-modern, ultra-sleek, ultra-sexy."

The sex appeal of some art media is proverbial in our culture. "Frankie" told me that she believes that most men in the audience have erections when she dances topless; and "Eve" believes that sometimes she has brought men to orgasm through her topless performances. Such claims entail conjecture, but this diminishes when the subject shifts to the sexual arousal that all three of

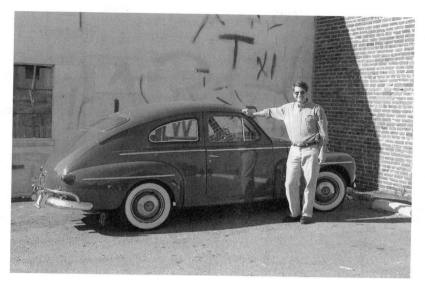

Figure 8–2 Dick Jobe, with his restored, bright red Volvo.

the topless dancers sometimes experience when they dance. "Frankie" made this distinction:

> It's not just standing up in a convertible and going, "WAAAAA!" [gestures as if opening her blouse], which I did yesterday—you know, just kidding around. No, I was not sexually aroused; I was more humored by it than anything else.
>
> But you know, then there are other times, you know, you'll undo your blouse a couple of times and see the look on somebody's face. And that is, you know, very sexually stimulating.

Dielle Alexandre said that she too occasionally experienced "a touch" of arousal while dancing, sometimes while watching herself in the mirror when the club was nearly empty, or else when the audience was full of cheering, applauding men.

Whereas Dielle felt that only a few dancers have the same experience, "Eve" was of the opinion that all do, and she repeatedly emphasized that exhibitionism, with concomitant sexual arousal, is a major reason she dances. ("Eve" said that twice in her career, she herself reached orgasm while performing.)

Not only are topless dancers sometimes aroused during their performances, but I was even more surprised[1] when several informants told me of

[1]Standard accounts of paraphilias (e.g., Stoller 1976) claim that exhibitionism—that is, sexual exposure, accompanied by sexual arousal—occurs only among males.

having erotic feelings from media that most people do not consider to be intrinsically sexual. Three of the people involved with theater did so. Actor Joyce Halford put it this way:

> You're having relationships with other people on the stage, some of which are sexual, just by the nature of American writing. You know, [drama is about] the human experience, and sexuality is certainly a big part of that. So there's that. There's also almost a flirtatious thing going on with the audience, because you're bringing them to a certain point; and you don't give it all to them. You hold some things back; you make them wait; you have a certain dance that you're doing to elicit certain responses, and I suppose there's a sexual element to that.

Music and food were also alluded to in sexual terms, but so were nonperforming arts. Poet and playwright Carol Mickett cited Audre Lorde, who, she said,

> wrote about this a lot, and I completely agree with her, that when you're really being creative, it's incredibly erotic. I think that those are my most erotic states, when I am really in the midst of it. And I guess I describe it as erotic in the same way as making love is erotic—you get so lost in it, you know, when it's really working. Like, nothing else is there; and when I'm actually creating things, it's exactly like that. It's the same abandon, you know? I think that describes the state the best way for me. My body just gets charged! Sometimes it's sorta, I go, "Whoa! What's that about?!" [Laughs.] But it's a very erotic experience. I've heard other people say that, too. Filled with energy. There's nothing like it.

Maria Vasquez-Boyd brings us full circle by merging multisensory experience with the eroticism she finds in painting. Earlier in the interview, Maria had said that when she played in a rock 'n' roll band, it had been "just like sex," so I asked if she experienced similar feelings while painting. She responded,

> Oh, God! It's the same. It's very much the same. It's not just the subject matter . . . it's just the viscosity of the oil paint and the linseed oil. The smell. You know, it just kind of—the paint will just sort of drip down, if I let it . . .
> Sometimes, too, when I'm working and I get so caught up in it and I'm really, really working hard, I find myself out of breath—"pant, pant"—and it's like, OK, I'm ready for my cigarette [laughs]! It feels that way! (And there are times when it doesn't, and that's OK too.)

Kim Anderson, also a painter, agreed: "When I really *feel* colors and shapes, and especially when I put down certain lines, I can feel sexual energy flowing through me like pure power."

In all, more than a third of the informants talked about the sensuous or sensual gratifications that art can provide. A few others ally art and the body, but in different terms. Three people (two gardeners and one chef) linked art with nurturance; and three others (two gardeners and one yard artist) talked about their respective art forms as simply ways of keeping themselves busy. (Of these three, two are retired, and the other is a schoolteacher who spends some of her time in the summer working on her garden.) These observations, along with the additional comments previously cited about sensuality, show just how intimate is the marriage between art and the human body.

ART AND AFFECT

Since the days of ancient Greece, Westerners have recognized art's power to move human emotions profoundly. Plato feared the madness that the muse could unlock, but Aristotle applauded the therapeutic value of catharsis. Meanwhile, as the philosophers explicated their theories, members of Greek Dionysian cults relished the altered states of consciousness that they could evoke through dance and music, wine and revelry. Similarly, nearly all of the people I interviewed spoke at one time or another about art's effects on emotions. A few emphasized the toll that the arts could take; many others treasure the intense concentration of "flow" experience; and still other passages in the interview transcripts dwell on the emotional cauldron of psychic freedom and spontaneity in which creativity and artistic discovery are forged. The following pages will look at each of these topics in turn.

Cooking is a passion for Steve Johnson, currently in his kitchen at home, and formerly when he was co-owner of "Food for Thought," a small Kansas City restaurant that offered customers a creative menu in a relaxed atmosphere. During our discussion, Steve talked at length about the many kinds of satisfaction he derived from preparing food, but when I asked whether he would go back into the restaurant business, he recalled the negative aspects of the work: "It's a pain. It's long hours. You have to worry about it . . . I don't miss the simple hard work. People don't realize how hard it is. It's the kind of hard work that grinds on you."

In these remarks, Steve echoed several other informants who felt that, to adapt a cliché, true art is to conceal the labor that goes into making art, whether it is mastering a musical instrument or repertoire, writing fiction or sermons, judging beauty pageants, or doing the physical exercise needed to have the body of a successful topless dancer: "Eve," for example, believes that prostitutes are too lazy to do the work required of dancers; and other

informants also prided themselves on their self-discipline. Ed Bartoszek works in his studio from 8 A.M. to 5 P.M., five days a week, in order to produce the six hundred paintings he sells at art fairs each year; and Bonnie Winston, Sally Von Werlhof-Uhlmann, and Larry "Fats" Goldberg all exercise regularly in order to control their weight and still be able to indulge their love of good food.

There were other complaints among the dozen informants who commented on art's psychologically onerous aspects. Two mentioned feelings of extreme frustration when the creative process goes awry; one fashion enthusiast admitted that her selection of clothes is limited by considerations of comfort; and Ted Gardner remarked that although he loves to play music and takes pride in his ability, these very things make him highly vulnerable to the criticisms of others.

Of all the informants, perhaps the greatest ambivalence toward art was expressed by Larry "Fats" Goldberg. Sixty-three years old when I spoke to him, he talked about his career as a gourmand: "It's my life," he said, and he recounted anecdotes such as the following to support his claim: "One time in college, I was about 280 [pounds]. It was snowing, and there was this place that had doughnuts. I didn't have a car, so I was begging [a housemate], down on my knees; and he was a good guy and he took me down and got a dozen. I said that I had to get it!"

"Fats's" weight eventually reached 320 pounds, but he was haunted by a warning given him by a doctor when he was a child ("Larry, if you don't lose weight, you're going to die"), so for nearly forty years, he has observed a strict diet that he calls "controlled cheating." The regimen (about which Larry "Fats" has published two books) allows him to eat anything he wants on Mondays and Thursdays, but during the rest of the week he restricts himself to fruit and chicken. Since beginning the diet, he has kept his weight at 160 pounds. "It's better than being dead," he observed to me wryly, but he still acknowledges the dark side of his passion for food: "It's like a junky, to eat like that . . . It's like a disease."

If "Fats" and a few others decry the emotional hardships associated with art, a larger number of informants positively revel in the difficulties that their arts inherently present. Although I rarely introduced the term myself, more than a third volunteered that they are drawn to their respective art forms because they enjoy the "challenge" it represents. Consider these examples:

- Norman Snyder has many types of flowers and shrubs in his garden, but he is most proud of those, including many of his 160 varieties of hosta, that other gardeners cannot grow in the Kansas City area. Norman is active in several garden clubs, and he is pleased by the praise he gets for his accomplishments,

Figure 8-3 "Before" and "after" photos of Larry "Fats" Goldberg.

but his goal is not to outdo others. Rather, he strives to meet the challenges presented by the plants themselves.[2]

- After many years of working in community theater, Doug Wylie said, "I came to discover that what is *good* theater is the theater that has the most difficult struggle."
- Experimental writer Debra Di Blasi told me, "There's nothing that can replace the satisfaction of having done something remarkably well . . . It's like wanting to climb Mt. Everest, except it's art. I mean, how far can you push yourself? How far can you go and succeed?"

Although a love of artistic challenge might be part of the popular stereotype of the fine artist, the people I talked to who are involved in the popular arts are just as likely to become emotionally caught up in their art of choice. Car buff Dick Jobe addressed this issue explicitly:

I think that most people, when they look at cars and they look at automotive people that work on cars, you know, they get this vision of some grubby guy in coveralls that doesn't have very many teeth and smokes like a chimney and, you know, can't speak very well. And, yeah, there's a lot of those kinds of people out there. But there's also a lot of other people out there who are just unbelievably intelligent, and *unbelievably lost* [emphasis added] in what they're

[2]Challenge is not the only motivating factor for Norman's gardening. He said that if he had to choose between planting a beautiful, easy plant and a less beautiful but more challenging one, he would select the former. On the other hand, he said, most challenging plants are beautiful!

doing. Those are the people that I like to hang around with because they're the ones that can really do it.

An interesting variation on this theme emerged from my discussions with people about tattoos and pain. At one extreme was East Coast Al Kimber, himself a professional tattooist, but also the wearer of several large tattoos. He conceded, "It's a definite nuisance to get a tattoo" but continued that "it's never bothered me that much." By contrast, Jim Schindelbeck and Dielle Alexandre admitted that getting a tattoo could be a painful process, especially on some parts of the body, such as inside the elbow; but they did not view the pain in a negative light. Jim said, "I think, if you're going to do it, you gotta go through it. I mean, people tell me, take Valium, take muscle relaxants—blah, blah. And I don't do it. It's a weird feeling. It's almost like, it hurts good."

I asked Dielle, if it were possible to be tattooed painlessly, would she do it? She answered emphatically, "No!" and explained that

> the price is not just money . . . Someone has to be able to go through the pain to have it. So it is a symbol of a toughness or a dedication or whatever . . .
>
> Or like, if I meet somebody and find out they did it on painkillers, my attitude of that person would just be, "Ugh!" I'd be almost sickened! . . .
>
> Personally, I'm glad I went through the pain because when I'm sitting there, there's a certain idea, "That which does not kill me will serve only to make me stronger." And by going through that process and being able to do it, there's just a, "Wow, I did it!" I look in the mirror and I'm like, "Yeah, I can take it!"

The fourth tattooed person I interviewed, Chris Harris, largely dismissed the significance of pain in tattoo, as did East Coast Al, but Chris added an interesting aside from his experience as a professional piercist: Some individuals, he said, "really, really like that rush they get during that period [of piercing]. I've had a couple [customers] that had multiple piercings and tore them out on a weekly basis, just so they could get repierced."

Chris emphasized that the proportion of such people is extremely small—in his memory, only three among the thousands of people he has pierced. Chris believes that such people are seeking "badges of honor," rather than anything artistic. Given the comments of other artists I talked to, however, those three would seem to differ in degree, rather than in kind, from gentle Jim Perucca, who festoons the trees of his yard with stuffed animals and who remarks about the squirrels and birds that he knows will pull out the stuffing to build their own nests, "That's the way I like things; the challenge is good"; or from writer Lou Sondern, who after talking about the travails of wrestling with the "mystery underneath words," said, "That, I think, is maybe what draws us into [writing]. You just want to suffer for suffering's sake."

THE AESTHETIC RESPONSE

The theorists of formalism long extolled the way in which "significant form" can elicit an "aesthetic response," that is, a feeling of being totally engaged by an art-work's aesthetic qualities (as opposed to its practical qualities, such as its subject matter, its monetary value, and so on). Although modernists took for granted the primacy of the aesthetic response and used it as the touchstone for distinguishing art from non-art, I have argued that its existence and cross-cultural distribution cannot be taken for granted but are empirical questions that are deserving of study. In *Calliope's Sisters,* I examined nine non-Western aesthetic traditions, and I found that only one of them, early India, recognized even an approximate equivalent to the aesthetic response posited by formalists (R. Anderson 1990, esp. pp. 276–278; see also R. Anderson 1989:12–17).

What about the broad spectrum of art in America? In previous passages, I talked about some of the extra-artistic emotional states that art can evoke, such as art's relationship to sensuality and the challenges that accompany the creative process. But what of emotions that are intrinsic to art, feelings that can be described only as a relish for art itself? Several of the people I interviewed simply said that art is "fun," "enjoyable," or "entertaining"; others said that it gives them pleasure, makes them happy, or energizes them. Stronger feelings were commonly noted, as well. Bluegrass player Boyde Stone, for example, described the escalation of emotions in terms of speed: "One [tempo will] put you in a mild mood; [another] one will put you in a little bit in-between mood; and fast music: I can clean house real good [laughs]!"

Several others described a heightened emotional response: Speaking of the feelings he experienced on his first visit to England's Ely Cathedral, Epis-copal music director John Schaefer said, "You're driving along and suddenly this big, massive thing appears out of the ground, and you think, 'Wow.' Then you go inside, and you go 'Wow' all over again"; and summing up her feelings about dance performance, Arielle Thomas Newman said, "There's such a rush! Nothing that I've found can replace that rush." As Denis Dutton has observed (personal communication), such remarks suggest that some peo-ple, on some occasions, do distinguish the aesthetic response from evoked re-sponses that are cognitive ("What is it?"), practical ("How can it be used?"), or personal ("What personal reveries does it trigger?"). So regardless of the the-oretical problems that, in my opinion, rule out treating the aesthetic affect as a definitive trait of art, it does sometimes figure powerfully in some people's experience and deserves additional study.

In some contexts, such strong reactions can be thought of as a common currency in the realm of the aesthetic, transferred from person to person and often used to measure the value of artistic performance. As such, they play a

role in aesthetic socialization. For example, when I asked choral director Arnold Epley about his earliest memory of being affected by the arts, he told this story:

> I remember at an early age, at nine or eleven, my father took me to . . . hear a Metropolitan Opera B-level singer in recital in Alabama. He was on tour, grinding out one more concert in a high school auditorium . . . He was a good singer, but not a great singer; but at the end of his program (my father and I were sitting up in the balcony) he sang "Danny Boy," and I was suddenly aware that my father was weeping, and I think it dawned on me that music was powerful.

The currency of emotion also passes between the producers and consumers of art. Three informants involved in the performing arts said that reciprocity may occur whereby feelings generated on the stage pass out to audience members, who in turn give it back again to the performers, thereby reinforcing the performer's initial emotional states.

The more common situation, however, occurs when the artist experiences a deep emotional identification with some component of art itself. For example, all four of the theater people I interviewed described ways in which they "become" the stage characters they portray. Teddy Graham said, "You kinda lose yourself and you can be someone different." Teddy qualified her remark by saying, "I never *totally* lose myself in a role," but Carol Mickett and Joyce Halford posited a deep identification between actor and role. Carol said,

> One of the things that happens when you perform is that you become these other characters, but the other characters are part of you. I mean, it's not like you "act" like someone else. You discover those things in you that you don't normally let out, because you don't want to be, you know, evil or angry or racist or any of those sorts of things. Well, in plays you have to have those characters, so you get to be that. You get permission to, like, be that character, be that person.

Such unification of artist and artwork is not confined to drama. A writer, a dancer, two musicians, and two preachers said similar things. For instance, Rev. Bo Mason said, "When I do a sermon, when I pick out the text, I've got to get into that text. If it's a character, I've got to get into that character's mind, and then I go from there."

This theme, like several others discussed here, has a potentially dark side, too. Later in my conversation with Rev. Mason, I asked whether there was also a possibility that, in his idiom, the Devil could use artistry to bring harm and evil into the world. He responded, "If you stick to what the Bible is

saying to you, which is scriptural, I don't think the Devil will try to come in and try to disrupt what you are going to say on behalf of God."

Other informants were less sanguine than Rev. Mason. Choral director Arnold Epley agreed that "negative emotions can be stirred up by the musical experience," noting that martial and patriotic music can "light the fires of horrible aggression." On an individual level, Joe Egle spoke of having known four different auto mechanics, each intelligent and talented, but each heir to various personal problems, ranging from alcoholism to suicide. But whether positive or negative, many of the informants agree that the arts can profoundly affect a person's feelings.

Uses of the Unconscious

The psychology of art is not, of course, limited to conscious thoughts and feelings. A dozen informants made some sort of reference to the realm of the unconscious, and half of them clearly distinguished it from consciousness, or else utilized a similar dichotomy, such as "right brain" versus "left brain." For example, Arielle Thomas Newman said that during a performance, she has a sense of being split into two entities, the dancer and what she calls The Grand Observer; preacher Gene Lowry spoke of including both "discursive" and "nondiscursive" material in his sermons; and painter Kim Anderson said that experiencing art "transcends the rational . . . ; it's from the unconscious and has that kind of pull." The idea that the conscious and the unconscious are distinct (but interrelated) forms of mental functioning is the basis for a strategy used by gourmet cook Sally Von Werlhof-Uhlmann: She described cooking as being "completely meditative," but she also said, "Any time I have something that I really need to think out, [cooking helps me] think through a problem and really come up with numerous solutions." The creative component of art-making, however, does not seem to benefit from excessive conscious thought: Several informants concur with musician Ted Gardner's remark that "I just try not to think too hard about it, because if you think too hard about it, you try too hard and it doesn't work."

Despite its important contribution to the artistic process, informants provided no clear and comprehensive picture of the unconscious. Two alluded to its nonverbal qualities ("It's *below* words," said writer Lou Sondern); and two others, both musicians, portrayed it as residing in their hands ("Your fingers know, even though your mind doesn't," said Linda Lindell). Whatever the precise role of the unconscious in art, however, informants view it in a highly positive light, a place where several of the informants said they very much like to go, calling it an "escape" (six people), a "refuge" (three people), a "haven," or a "sanctuary."

Also, the unconscious is a very private realm. Art wears its public face in social settings, but the solitary dimension of art should not be ignored. Even a medium such as tattoo, which may be thought of as a public statement about the wearer, can have a personal dimension. Chris Harris told me, "Maybe nobody else sees [your tattoo] but you know it's there. The 'secret garden' concept . . . Only people that you want to let in can see it." East Coast Al Kimber elaborated on Chris's comment:[3]

> People may think they know you based on your clothes, but they *don't* know you because there are aspects of your life that you're keeping hidden from them . . . I think we all want to have things about ourselves that other people don't know. We only let people have a little bit of us. We don't give ourselves entirely to people, because once we do, the real pain comes out. Our personas get hurt, and that's the real pain in life.

I shall return somewhat later to the concepts of transcendence and "flow" experience, which are the best developed themes to emerge from the subterranean realm under discussion here; but two other topics, therapy and psychic freedom, should be dealt with first.

Although I seldom raised the question myself, more than a quarter of the informants volunteered that art can have a therapeutic effect on the human psyche. The kinds of comfort associated with art are quite varied:

- Yard artist Karin Page said that while she was working on her master's degree in biochemistry, she "was taking a [piano] performing class, and that drove my [professor] crazy, because she just wanted me to do science. [It] drove her crazy, but it made me *sane!*" [Laughs.]
- Black preacher Rev. Wallace Hartsfield told me, "Just the worship itself is a very liberating experience. It's a *healing* experience. We tend to go to church because we meet each other there; and we deal with each other's pain there. And we go, often times, because we want to feel better."
- Gardener Nancy Jenkins, a psychotherapist, said, "I feel like I take all this energy from people, and [the garden] is a place where nothing is demanded of me. I just sort of put it back in the ground, and it feels like I release something."

[3] I interviewed Chris Harris at East Coast Al's tattoo studio, and Al was working at his nearby desk as Chris and I talked. Al remained quiet most of the time, and after this interjection, he said apologetically, "But I didn't mean to jump in." The only other interviews at which others were present were those with topless dancers Dielle Alexandre and "Frankie," who invited their respective boyfriends to join us; Bill Desmone, whose partner and fellow-gardener Tony Ryan is also involved in Bill's garden; and Chief Korzinowski, whose close friend Katrina Oldenberg accompanies Chief on many of his expeditions in search of antique farm equipment and tools to place in his yard. In every case, the additional person added numerous useful clarifications to the informants' own remarks.

• Painter Kim Anderson spoke of her insight that "art is a very good way to get in touch with the unconscious." Art, she feels, involves "not just the philosophy of your conscious mind, but your entire being, including your body [and] your unconscious." Kim very strongly believes that "taking visual information from the unconscious can inform and heal the conscious mind." As an example, she described a dream in which she looked into a mirror and saw "a powerful, impassive, black-skinned woman with huge waves of hair—like the hair of a sheep." As she created a painting of the feeling of the image, which she described as a "Great Mother archetype," Kim began to get over the agoraphobia that she had experienced previously.

Thus, art can be, and often is, an extremely valuable source of sanity, psychological healing, stress release, or inner balance. Also, for two informants, art provided protection from very concrete threats: As children, art gave them a safe haven from dangerous environments. One of them told me, "My father was alcoholic and he was abusive, and so I think that, you know, I learned at a young age that there were some places you could go (which would probably be the dance studio) where you were safe."

Freedom in the Arts

In contemporary popular thought, artists are creative, free spirits; and to a limited extent, the people I interviewed fit this stereotype. Three people expressed a dislike of repetition ("I can hardly bear to make the same thing twice," said food consultant Bonnie Winston), and seven others extolled the virtues of freedom of artistic expression. Their remarks, however, allow us to go beyond the clichés of popular culture, moving the locus of freedom from the artist's personality to actual artistic practice. Among all sixty-four informants, only the tattoo artist East Coast Al Kimber dwelled on his generalized penchant for nonconforming behavior. For others, the common theme was that art itself provides a much-prized venue for freedom. Doug Wylie said that one reason he enjoys directing plays is that "you have complete freedom"; craft fair painter Ed Bartoszek said that he was first drawn to art because of "the freedom to do whatever you want . . . I can do anything [in art] and it won't be wrong"; and Liz Craig said of ballroom dancing, "Once you get past the basics and don't have to worry about your feet every moment, it's freedom. It's almost like flying."

Some informants have intriguing theories about the value of freedom in their respective art forms. Actor Carol Mickett said, "In the terms of actually doing the play, I'm not being immoral if I kill somebody, or if I, you know, cheat on my husband . . . You get to dress up [in] other people's clothes, so there is a freedom in that regard. There's no consequence to your actions."

Rev. Wallace Hartsfield posited a different role for freedom, holding that a well-delivered sermon is liberating both for his congregation, and also for himself when he "finally comes to realize that this is the word from the Lord that's coming through me . . . I think it is at that point that the *preacher* becomes liberated—from himself, from his ego, or whatever it is; and I think that is when the Holy Spirit is manifested."

For his part, William Whitener emphasized that freedom in a dance performance comes only through discipline and mastery of technique. He said that during rehearsal,

> the options have been explored, and the performance can then happen with a sense of free will and daring . . .
>
> In the [Twyla] Tharp troupe we had some group work that appeared to be very dangerous; and it was only because we worked as intensely as we did that we were able to achieve that and genuinely shock audiences with the level of daring. But we knew exactly what we were doing, just like any high-wire act . . . The movement had the look of pure abandon—free and spontaneous.[4]

Although their theories differ in detail, the remarks by Carol Mickett, Rev. Hartsfield, and William Whitener (and other informants, as well) reflect a widespread belief that through art, one can experience a degree of freedom not found elsewhere in life.

RELIGION AND SPIRITUALITY, TRANSCENDENCE AND FLOW

In many cultures, art and religion are bound together in function and form. Art and religion often address the same human needs and use similar psychological strategies: Religion distinguishes the sacred from the profane, just as art separates the aesthetically affecting from the sensuously mundane; and both establish their power by means of culturally encoded traditions, handed down from generation to generation by means of emotionally charged socialization of the young (cf. Anderson 1989:45).

As Brent Staples (1998) has shown (and the cynicism of many intellectuals notwithstanding), most Americans have deep commitments to religion and spirituality, so that it is not surprising that a majority of the people I interviewed had something to say about those topics. Individuals whose arts are overtly religious—preachers and church musicians—had interesting observations, such as citations of biblical precedents for using the arts to make church services more effective. In addition, a few informants whose arts are not

[4]Gardener Nancy Jenkens said nearly the same thing: She is free to do what she likes in her garden, but only as long as she has *control* over her garden.

sacred in any obvious way provided religious interpretations of their works. For example, yard artist Jim Perucca, who identified himself as a Catholic and born-again Christian, said,

> I love God, and He loves me . . . Even in this artwork (if you want to call it that, kinetic art display, art in motion) I seek His guidance and direction in a lot of things. I think, "Well, how do I do this," or something. I just kinda talk back and forth . . . If He doesn't like it, He can blow it all down.
>
> When I work outdoors here, nibbling on these different things, trying to make something a little nicer, I give praise to God constantly. Early morning and late at night—I pray constantly.

Jim Perucca's religion also informs some of the subject matter of his work. For example, of the innumerable stuffed toys that decorate his lawn he associated a small lamb with Christ, the "Lamb of God." During our interview, as we sat surrounded by the decorations that fill his front yard, Jim drew my attention to a stuffed toy clown with a missing leg, a victim of a squirrel or bird:

> J.P.: Some people might think I should take it down and throw it away, but it's still of interest the way it is, I think. [Laughs.]
> R.L.A.: Can you say why?
> J.P.: Well, it's just, while it was a lot prettier when I first put it out, [now] the weather has faded it and deteriorated it. It's just kind of like the life process we go through. Everything is kind of changing and metamorphosing, you might say. It's the way life is. It's real life, you know, seems to me . . . We're all getting older; and even from childhood on, we never know when our last day on earth is going to be.

If several believers related art to orthodox religious ideas, an equal number made allusions that reflect the popularity of New Age beliefs in contemporary America, especially within the creative community. Thus, various informants spoke of dancers having auras, of fairies, of angels, and of an overrepresentation among artists of people born under the astrological sign of Leo.

The nondogmatic attitude of the informants is perhaps best demonstrated by the willingness of believers to postulate an equivalence between the essence of sacred and secular art forms, as revealed by these examples:

- Episcopal music director John Schaefer, with no prompting from me, mentioned the music of Ned Rorem, who, he said, "states quite firmly that he is not a believer, and yet he writes choral music for the church that is really wonderful, beautiful; and if we didn't know that he wasn't a believer, we would think that he was. I don't know that anyone can explain exactly how that works."
- Rev. Donna Allen said that "there's no separation between sacred and secular [although that notion] still looms within the Black church." In her own work as a seminary professor of preaching, Rev. Allen told me, "I'm [currently] reading a number of German playwrights in order to develop some methodology

Jim Perucca, A Man and His Yard

In 1962, Jim Perucca, then age thirty-five, looked at a hole in the stump of a tree while visiting his parents' house in suburban Kansas City and decided it would be more interesting if he positioned a concrete frog in it. Some time later, the gravel driveway to the house was modified to accommodate the newly widened street, yielding many large stones, and Jim saw an opportunity to further decorate the yard by building rock gardens. Jim moved back into the house himself in 1970, in part to care for his parents, but also because his own recent divorce left him without a home of his own, and the yard became the logical site for the installation of several wagon wheels that he had accumulated over the years.

Jim's decoration of the yard became more ambitious after he retired from his job in sales: He started attaching stuffed children's toys, glass bottles, ceramic plates, metal pots and pans, pieces of mirrors, and a dizzying array of other small objects to the wagon wheels, to the trees, and finally to ropes and lines that he strung between the trees. At some point, Jim decided to add even more color and movement to the scene by tying on strips of ribbon that would flutter in the near-constant Kansas breeze.

I met Jim in 1996, when he was sixty-nine years old and still working in his yard every day—adding, adjusting, and fixing, but rarely removing anything from the display that now reaches across the wide expanse in front of his house, into the yard and driveway along its right side (where the concrete frog still sits in the old tree trunk), and spills into the backyard, where it shares space with several old Cadillac automobiles. Always busy but never in a hurry, Jim described himself to me as always "kinda nibblin' at things" in his yard.

Jim has long enjoyed the visual arts; Renoir is a favorite, because of his rich use of color. (Jim has tried his hand at pastels, and for a while he used acrylics to paint on glass to create the effect of stained glass.) However, although he has read widely about the fine arts, in decorating his yard over the years, he has followed his own muse. He says, "I've studied kinetic art, and I understand there's some pretty elaborate displays throughout the world. I've seen pictures of some which were very expensive and elaborate stainless steel kinds of things, that would be museum quality. But I have never seen anything like this. There's nothing like this in all the world."

Jim's claim to originality is justified. For example, when Jim incorporates colored glass bottles into his display, he always places them upside down. As we talked, I wondered aloud whether he was intentionally following the tradition of "bottle trees" made by many folk artists, especially in the American South, but Jim said that he did it for his own purposes:

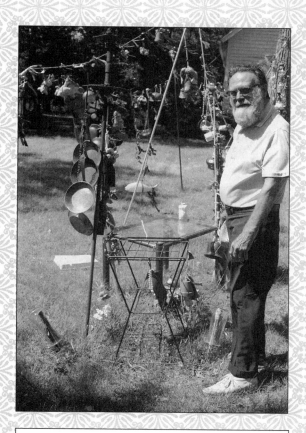

Figures 8–4 A small part of Jim's side yard.

When he positioned the bottles upright, they would fill with water in the winter, the water would freeze, and the glass would break. Turning them upside down, he discovered, prevented the problem.

Jim has no telephone (and is grateful for the consequent quiet solitude), but he is always pleased when people drop by to see his yard. Even if he received no recognition for his work, however, Jim values his creative efforts in their own right. He looks on the constant attention that the yard demands as a compelling hobby—and one with no negative side effects: "I used to drink beer a lot. That's a hobby that can be very enjoyable, but it can also cause you a lot of problems. And so I quit smoking and drinking and kinda . . . got into something like this. This still costs money, like any

(continued on next page)

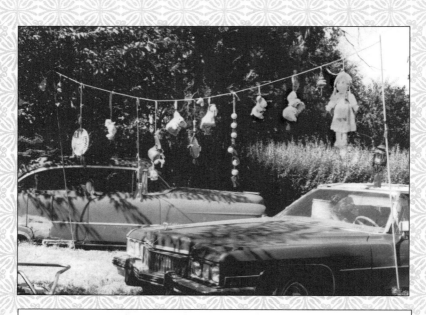

Figure 8–5 Jim's backyard.

of those other hobbies, and sometimes quite a bit, but I enjoy it very much." Jim does like to keep busy, saying that sometimes Jesus "gets aggravated by the worrisome man's hands."

But besides the process, Jim also values the product. The afternoon I first went to his house, after I described my own work and explained why I wanted to talk with him about his yard, he offered me a chair under a shade tree in his front yard and said, "I get a big joy out of just sitting here and watching the action going on. If you had to electrify this thing, it would take thousands of motors to put these things in motion. But I think it's so interesting [in the wind]. And it can't get boring—unless you're just a completely bored person." A bored person, Jim Perucca certainly is not.

for teaching preaching. I'm finding that those [writers] that are in the traditional art forms in many ways have a better grasp of how to teach those art forms than we do in preaching."

• Lenette Johnson, a paid member of the choir of Grace and Holy Trinity [Episcopal] Cathedral, said to me that on rare occasions while singing sacred music, "when it goes really well, there's this feeling (and I don't know how to describe it), you just know in your heart and soul that you've almost reached heaven." Lenette sings in musical theater, too, and she told me that "the spirit"

can also be present in that secular setting. Moreover, Lenette works as a third-grade music teacher, and she told me, "With my third-grade choir I make a big deal out of singing with spirit; not just singing the notes, but really putting your whole self into it—and I think that's very important."

Thus, once more the boundaries that are so useful for analytic discussion—in this case, those used to distinguish sacred from secular art—appear to be permeable in the real world.

For some informants, the arts are a means to a religious end. Perhaps Larry "Fats" Goldberg was exaggerating when (referring to the "controlled cheating" diet that allows him to eat whatever he wants two days a week) he said, "Monday and Thursday, it's heaven. I'm going there. I can eat, so I'm fine!" I believe that there is a significant element of literalness, however, in the following excerpts from interviews:

- Susan C. Berkowitz, who uses some of her artistic talent to decorate her house, told me, "I guess my home is my temple. It's a place where I feel really safe. I feel good when I've been away and I come back. I feel that way in church, too."
- Five of the eight gardeners I interviewed (as well as Karin Page, whose yard is decorated not only with bowling balls but also with flowering plants and a small fountain) spoke of deriving distinctly religious feelings from their gardens. Donna Hobbs said, "I probably feel a lot more spiritual there [gestures toward her garden] than I would be sitting there [gestures toward a neighborhood church], surrounded by a bunch of people that I may think are pretty hypocritical." [Laughs.]
- Jane Overesch, in her early seventies when I interviewed her, told me, "I don't go to church, because I hate church. I'm a believer because of the garden. You couldn't be a gardener and not believe in something. You know how big a petunia seed is? A seed the size of a pinhead, and it's absolutely amazing that [it can grow and bloom]." Similarly, Gail Owens told me that she (like Nick Rivard, mentioned earlier) especially enjoys gardening on Sunday mornings—"And I was brought up 'churchy'!"

In the examples cited thus far, the arts might be seen as an accoutrement to, or substitute for, religious belief; but for a much larger number of informants, art is more than that. A recurrent theme is that artworks have spiritual (or magical or supernatural) qualities unto themselves. Again, however, the extent to which such animistic ideas are meant to be taken literally is not easy to determine. For instance, music director Ken Walker said to me that the church organ "plays the breath of the congregation." This could be dismissed as metaphor, except that in another context, Ken spoke of the pipe organ's "mystery," remarking that "the sense of power and the sound that gets under you is often something that [congregants] don't really see or understand."

Similarly, Maria Vasquez-Boyd said that she feels that as she creates a painting, a "spiritualized Being" comes to reside in it. Again, the literalness of

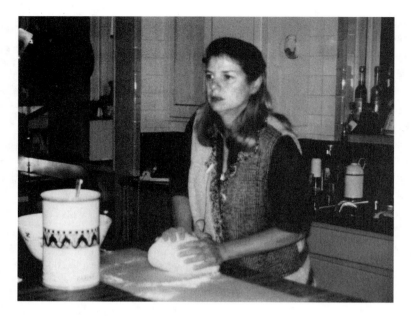

Figure 8–6 Sally Von Werlhof-Uhlmann, kneading bread dough in her kitchen.

Maria's statement is confirmed when juxtaposed with her comment that when she is painting, "I'm just in another place, and I feel like I'm in connection with the Great Spirit . . . It's a concentration with the brush in your hand and colors, an expression of that meditation with the greater Being."

Furthermore, the spirits that dwell in art are not necessarily passive. Because this notion is contrary to popular belief about the lifelessness of supposedly inanimate objects, I cite the following extended list of examples:

- Lou Sondern, Michael Christie, and Linda Lindell, all writers, spoke of the ways in which stories create themselves and fictional characters take on lives of their own.
- Chefs Sally Von Werlhof-Uhlmann and Steve Johnson both spoke of good food and ingredients as being alive. As I talked with Sally in her kitchen, she was starting a batch of sourdough bread, and at one point she remarked, "It talks to you. It tells what's going on. So, like this bread has told me it's been kneaded enough. It feels exactly the way it should feel, which is airy, elastic—and alive."[5]

[5]Sally's vitalistic theory of food is well developed. She told me, "Everything has a life force, and so when you're eating, you're eating to keep alive. What you're doing is, you're taking a life force and you're putting it inside yourself to keep alive. So it's really a very sacred process. And you can either eat food that is truly alive, that is truly nourishing, or you can eat really dead food." Later she remarked that the aliveness of food "plays into the whole weight issue, [in] that the more dead a food is, the more it tends to stick around in your body."

- Robyn Nichols sometimes works in gold, and because of its high monetary value, "You work out the design first, to avoid mistakes." But in her metier, silver-smithing, Robyn said that designs "just sort of evolve....It just sorta comes to life." Later, referring to the plant themes, such as ginkgo tree leaves, that she often incorporates in her work, Robyn said, "I want to preserve that growth, that flow, and so I portray it in botanicals. How I design or manipulate the metal gives the entire piece movement, allowing the reflective qualities of silver to dance through the piece. It's almost preserving the life, the breath, the force, the whatever; and I'm using nature, I think, as an example, trying to capture that spirit." (When pressed on the matter, Robyn conceded, "I don't think there's a spirit that lives on in the piece. I think I give it breath; and it's my interpretation.")
- As for the performing arts, with the perennial impossibility of, in Yeats' phrase, distinguishing the dancer from the dance (a paradox that embodies the previously mentioned equivalence between artwork and artist), both dancers and actors spoke of performances "coming alive." Looking back on her career as a dancer, Arielle Thomas Newman conceptualized this phenomenon in very clear terms: "What I enjoyed was psychically sending my energy out to the audience and making a contact from my energetic persona to theirs via my focus." Arielle has long believed that such energy can be seen as an auric field around the dancers, and for her 1978 master's choreographic thesis at UCLA, entitled *Energy as a Creative Focus in Dance*, two auric field readers were able, she said, to ascertain the images she had previously given the dancers to "work with when they were dancing."

- It is not surprising that two of the preachers I interviewed explicitly described their sermons as containing supernatural power. Rev. Donna Allen said that as a preacher, "you're almost losing yourself and being used to create this preached Word, which becomes alive . . . You need to be able to yield to . . . the Holy Spirit." For his part, Rev. Bo Mason told me that in preparing for a sermon, "sometimes you can just open up your Bible and there's a text. And, hey, that will preach!" When I commented that his use of words made it sound as if the text itself would actually do the preaching, he quickly responded, "Yes! Right, right!" Rev. Mason also described the occasional sermon when one experiences "the anointing coming on; and I think God puts words in your mind that he wants you to speak . . . Usually it's a joyous feeling. Maybe tears will start coming. Like the old preachers say, the Holy Spirit is visiting you at that time."

In each of these instances, to one degree or another, informants are finding qualities in art that transcend the normal and everyday and that seem to give art the capacity to act on its own. (And as we shall see, artists themselves can experience equally transcendent states by means of art.)

In a previous section, "The Aesthetic Response," I described ways in which informants said that the arts affect their overt emotions; but as a large proportion of the informants confirmed, reactions to art can run far deeper

Arielle Thomas Newman: A Life of Dance

Arielle Thomas Newman looks back on a lifetime of modern dance performance and choreography. At age forty-five, she still recalls the time when, as a six-year-old, she convinced her brother to perform her own interpretation of the "Arabian" solo from *The Nutcracker* in the family living room. Three years later, Arielle's school went to a professional production of *Show Boat* and she vowed, "I want to do this!" (So total was her conviction, she says, that she had trouble grasping how other young people could be undecided about what they were going to do when they grew up.)

Dancing, however, is a physical art form; and no matter how committed the spirit, the body does not necessarily cooperate, a fact that Arielle knows too well. A childhood battle with rheumatic fever led the family doctor to bar her from pursuing any strenuous activity, including dance. Finally, by age fourteen, Arielle recovered and was able to begin dance class, paying for it with the allowance money she earned by helping to clean house every Saturday morning. Soon, though, she realized that to make any progress, she needed to add a second dance class—one that met on Saturday mornings!

Looking back on the crisis, Arielle says, "I argued with my mom and it was a power struggle . . . I just had to become strong and say, 'I really want to do this. I'll do my housework, but I'll do it afterwards, when I come home.'"

Although her parents had many avocational interests in the arts, they had misgivings about Arielle's pursuit of a career in modern dance. Again, however, she remained steadfast, and reflecting now on her successful career, she says, "I proved them wrong, because I've made my living off it—a good living off of it . . . I think my parents were really proud of me and my accomplishments. I performed at the Sydney Opera House, in Australia. My mother was very pleased."

Arielle admits that she enjoys being onstage and the focus of people's attention, but although "the applause was fine, that wasn't it. What I enjoyed," she says, "was psychically sending my energy out to the audience." In another context, Arielle remarks, "When I'm performing, there's an intensity there that goes beyond just wanting to get the step right. There's a communion, if you will, that I'm aiming for—between the audience and myself as a performer . . . There's a flowing of communication that's going back and forth between the performer and the audience, but it's all done on a nonverbal level."

Just as rheumatic fever had temporarily kept the young dancer from following her muse, when she was forty-three, Arielle suffered a dance-related back injury that again restricted her mobility. Since then she has

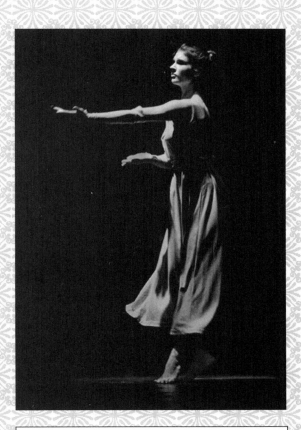

Figure 8–7 Arielle in a dance performance, age nineteen.

continued to choreograph and has become the regular dance critic for the *Kansas City Star* newspaper, and she continues to give yoga classes.

Her own performance, however, has not ended but has evolved in a direction that Arielle now feels was predictable and inevitable, namely, to link dance with her long-standing metaphysical interests. As a member of the church of Religious Science, she has performed short dance pieces that she feels have been very successful. (After one of them, she says, "People were crying in the sanctuary, and I knew that my intent had really reached them.")

Beauty (as the adage goes) may be eternal, but the capacity to dance with beauty does not necessarily have the same longevity—or, at

(continued on next page)

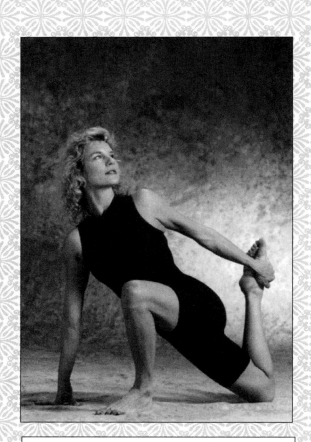

Figure 8–8 Arielle in 1998.

least, many Americans believe so. (Old people are considered consummate dancers in certain societies in Southeast Asia, Arctic North America, and West Africa.) Whether because of audience preferences for the appearance of youth or because most human bodies cannot long survive the rigorous physical demands of professional dance, virtually all dancers can expect career changes by middle age. In facing that challenge, Arielle Thomas Newman is now showing the same determination that she demonstrated in her youth.

than just having transient feelings. If a few informants attributed spiritual qualities to art, many more spoke of being moved by the arts into a powerfully sacralized state.

In some instances, this state was described in the idiom of the supernatural. Describing his feelings when his band was performing at its best, musician Ted Gardner spoke of "the *magic* [emphasis added] moment: I throw down my crutches and I'm walking and I'm enjoying my surroundings and how it's making me feel. It's a triumph. Triumph of music over people." Karin Page told me that although her decorated yard is not overtly religious, she does associate it with "religious experience." When I asked for clarification, her response was, "Ooooh—do I get some spiritual buzz out of it? Well yeah!" She continued by saying that during the years when she had been employed by an insurance company, after coming home from work, she would "go out in my yard and it would *rejuvenate my soul* [emphasis added]. It would!"

Nearly half of the informants talked about an experience that would seem to be cognate to those just described by Ted Gardner and Karin Page,

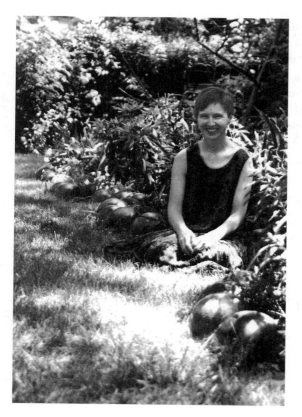

Figure 8–9 Karin Page, with a few of the many bowling balls that decorate her backyard.

but they did so in language that derived from the domain of psychology rather than religion. The term "flow" was used by several informants, revealing the degree that the general reading public has taken up that concept, which has been extensively developed in the psychological literature by Mihaly Csikszentmihalyi but which he initially derived from comments by his own informants, including artists. Csikszentmihalyi (1975:38–47) identified several characteristics of flow experiences, such as a feeling of being totally focused on, and in control of, the task at hand and, conversely, a loss of awareness of everything else, including both external stimuli and self-consciousness.[6]

The remarks of several informants are highly congruent with Csikszentmihalyi's model of flow. For one thing, they portray it as being a thoroughly desirable experience. Dancer "Frankie" said that under the right conditions (a "really big crowd, and they're working the smoke [machine] and the lights, and, you know, the whole rigmarole"), her identity as a dancer "completely takes over, you know? The [real me is] kind of just shoved totally out . . . Oh, I *love* it when it happens!"

Flow was described not only as being something positive but also as a spiritually higher sort of experience. Liz Craig spoke of experiencing "transcendence" through writing, dancing, and composing music; Carol Mickett referred to writing and acting as "something spiritual"; and Lenette Johnson said that on rare occasions, she has felt "the Divinity" while singing choral music. Renée Lindberg, speaking of club dancing, described "a state of grace . . . [a] transcendental, peaceful, 'in the moment' [feeling]—you know, where you feel like there's purpose and there's reason [and] that we're some sort of an instrument for a higher Being." Several others described heightened energy levels and spoke of becoming so engrossed that they seemed to lose themselves.

For a person experiencing flow, the sense of time can be distorted, a phenomenon mentioned by two writers, two musicians, a chef, and a gardener. Car enthusiast Dick Jobe said that he can lose track of time when he's driving. Also, he continued, when he is working on cars,

> it really happens a lot, where I just get completely lost in my work and, you know, it will be seven o'clock at night and it feels like three in the afternoon, you know? You're into it.
>
> You can have something on a transmission where you have lots of little bitty pieces that have to go back together again; and just everything is going along real smoothly and you're just in another world. I think my buddies, when I get like that, say, "Oh—don't mind him. He's just in tranny-land." I've heard that several times; and it's a place I like to go, because that's when you

[6]In Csikszentmihalyi's account, flow experiences are not limited to transcendental spiritual experiences. I address informants' references to flow here in the context of religion and spirituality because most informants couched their accounts in those terms.

do your best work, when you're completely removed from your sur-
roundings.

For most people, rebuilding automobile transmissions admittedly would
seem to have few of the recognition criteria of art. It is significant, however,
that for Dick, the artistry of automobiles is not confined to the outward ap-
pearance of cars but includes both the form and the design of some automo-
tive parts. Later during the interview, Dick said, "if you don't look at it as a
transmission but look at it just as what it is, . . . it's unbelievably nice. [Once]
I made a table out of an old transmission housing, just because it looked so
nice."

The fact that Dick Jobe's friends say he's in "tranny land" is representa-
tive of a final feature of flow in art: Although nearly half of the informants
talked about it in one form or another, they are no better than academic psy-
chologists in actually describing it in detail. They spoke of being "in the
groove," of being "completely absorbed" or "totally focused," of experiencing
a "stab of joy," and of feeling "adrenalin" or a "rush." Perhaps the most de-
scriptive accounts came from writers, who resorted to similes: Liz Craig re-
marked, "It's almost like flying"; and Debra Di Blasi said, "It's like—have you
ever eaten crème brûlée? It's a dessert. It's incredible—it's got all this butter,
eggs, and stuff in it. Great dessert. That's what writing's like. It's like one of
those fine, fine moments that's to be savored."

A recurrent theme in the interviews was the role of religion and spiritu-
ality, transcendence and flow, in artistic practice. Clearly, this association is
extremely important for many people who are seriously involved with the
arts in America today. At the same time, however, the relationship must be
kept in perspective.

For example, I used in passing the term *animism* (narrowly defined as a
belief in spirit beings) when talking about informants' comments that suggest
that artworks are alive or that they embody autonomous spirits; and I do not
doubt that on some level, that characterization would be acceptable to some
members of the art community. On the other hand, I believe it would be an
exaggeration to equate such ideas with, say, the feelings that traditional Aus-
tralian Aborigines have about *tjurungas*. These ritual objects are flat, oval, or
circular slabs of wood or stone, from two inches to eighteen feet in length,
often bearing complex painted and incised patterns (Berndt and Berndt
1964:367). For the groups that make them, *tjurungas* are believed to be the
residences of supernatural spirits, spirits whose reality is, if anything, greater
than that of the empirical world of land, rocks, and trees that make up the
natural environment. The spirits that inhabit *tjurungas* are so real that to touch
one (for example, during a coming-of-age ceremony) is to be in direct,

physical contact with the realm of the supernatural. The existence of the spirits is so manifestly accepted in traditional Aboriginal culture that *tjurungas* are the only objects that are not destroyed or left to disintegrate after their ritual use. I believe that the literalism of Aboriginal beliefs about *tjurungas* is greater than that of most or all of the Americans I interviewed about art.

For example, Jim Schindelbeck told me about his first tattoo, gotten when he was eighteen years old:

> I already had my ears pierced, you know; and I was into rock-n-roll, and all the rock stars had the tattoos, you know, and all that. So I thought, well, I'll have to go ahead and, you know, proceed into that. If I'm going to be a rock star, well this is what you've gotta do. Then, all the sudden you realize—God, it doesn't work out that way, you know? I've got a tattoo, I've got a guitar; why ain't I a rock star yet! [Laughs.]

But although Jim now chuckles at the idea of his first tattoo's having magical potency, he does profess a deep spiritual bond with the Native American subject matter of the design that he has since had tattooed on his back. ("It sounds funny to actually say these things, you know, but I mean, to me, I feel like I should have [lived] back then.")

Similarly, painter Lester Goldman told me, "I actually have a great skepticism of critical theory based on spiritual values in art"; and he continued later, "I'm uncomfortable saying it's a spiritual scenario." Lester concluded, however, by saying, "I would rather describe it as losing my self-consciousness."

Furthermore, for individuals who do admit to experiencing art on a spiritual level, such a reaction is not always present. For example, Episcopal music director John Schaefer, who told me stories of sometimes being completely swept away by music, confessed that during most Sunday morning services, he is responsible for so many practical details that he is "not caught up in the movement of the liturgy the same way a worshipper would be."

For still others, art's potential link to the supernatural seems to be completely unrealized. Quite a few informants volunteered nothing whatsoever on any of the topics just discussed; and insofar as I developed an understanding of informants' approaches to art (and to life), I would guess that about a quarter of them have absolutely no religious, spiritual, or transcendental associations with their respective art forms. These qualifications aside, however, religion and spirituality, transcendence and flow, play a significant role in art for many contemporary Americans.

9

Art and Society

Although I began the last chapter by asserting that "art belongs solely to the realm of psychology," I included the qualification "from one point of view." From a broader perspective, art inevitably is situated in a social context. As noted previously, artists often reflect the early and ongoing influences of family, friends, and teachers; and as we shall see, few adult artists are oblivious to the social, economic, and cultural milieus in which they exist. Moreover, and as several informants remarked, art and society can mirror each other in ways both superficial and profound.

Contrary to common stereotypes about alienated, antisocial, apolitical, or ivory-tower-residing artists, the people I interviewed frequently placed themselves and their work in larger social frameworks. In this chapter, we shall look at diverse ways that art and artists relate to the social world around them.

ARTISTS AND OTHERS

Although I did not systematically raise the issue myself, nearly half of the informants mentioned ways in which the arts foster relationships between people. For arts that usually occur in a social setting, such as dancing and singing, eating and decoration of the body, this finding is hardly surprising; but even here, informants offered fresh insights. Consider, for example, the wide range

of ways in which tattoos can bring people together. East Coast Al Kimber talked about a long-standing friendship he has with another accomplished tattoo artist who lives elsewhere; Chris Harris and Jim Schindelbeck both emphasized the powerful attachment that can develop between a person receiving an elaborate tattoo and the artist who creates the tattoo. (Chris said, "You bond with them to a certain extent—you have to. You're giving trust to somebody!") Dielle Alexandre, for her part, described the ways that her tattoo influences her relations with other people:

> If someone's tattooed it's like, automatically they can come and ask me about mine or vice versa . . . [On the other hand] if anyone is so against my tattoos that they don't even want to meet me, then I don't want to meet them, because I'm interested in meeting open-minded people . . . If they have tattoos, its definitely an unspoken feeling of, like, a brotherhood.

There are resonant notes regarding the less social art forms as well. Thus, although several informants spoke of their gardens as being havens, places where they can escape the stresses of the world, most also see in gardening a good basis for establishing friendships. For example, gardener Jane Overesch and her husband used to be active birdwatchers, but with very different social consequences. "Birders," she said, "are so competitive. They want to get the bird, but they don't want you to get it. It was just awful. But gardeners, on the other hand, they're just dying to tell you where they got this plant, and how they grew it, and what to do about it. Nobody holds back information, and you always have something to talk about."

Nancy Jenkins made a related point, contrasting the garden in her front yard to the one behind her house. As we sat on a deck overlooking her back garden, Nancy said, "Gardening in the front is [for] when I'm in a more social mood. I end up talking to a lot of people. I really love that because I never really knew my neighbors before. Since I started gardening, I know my neighbors. The guy across the street's a gardener, and he gives me stuff all the time, and I give him stuff . . . If I'm in sort of a more . . . contemplative mood I come back here and work." (Echoing a belief expressed by several others, Nancy also said that "if you find someone at a party that's a gardener, you've got conversation for hours!")

Even television, a medium often thought to be inimical to social interaction, is seen in a different light by the four television enthusiasts whom I interviewed. Two noted that one evening's programs often provide grist for the next morning's small talk at their respective jobs; and three of them, two of whom live alone, said they think of the television as a welcome social presence in their homes. Tracy Warren put it this way: "It is as personal as having

somebody in your home."[1] (As we shall see, television also plays a role in the social life of the family.)

Not only do the arts foster social relationships in general, but the informants also noted two specific kinds of associations that are especially promoted by the arts. Four talked about ways in which art helps establish or maintain sexual bonds. For example, one reason Steve Cromwell often went to street dances during his teenage years in the 1950s was, by his own admission, "to meet women"; moreover, "that's where I would take women to impress them."

Dielle Alexandre's previously quoted remark about feeling a tacit "brotherhood" with other tattooed people introduces a second kind of social relationship, namely, the family. Three informants—a singer, a dancer, and an actor—used the metaphor of the family to describe the warm feelings they had for fellow artists,[2] and gardener Loretta Rivard turned the metaphor around in expressing her fondness for certain flowers, such as four-o'clocks, that bring back memories of her mother, who grew them when Loretta was a child. (This case also illustrates the power of art: When she was young, Loretta, like some other currently avid gardeners, saw gardening as an onerous chore that she would have avoided if she could.)

For several others, art's role in strengthening family bonds is actual, not metaphorical. I have already mentioned several informants for whom the arts and early family experiences were intimately related, and others could be added to the list.[3] Even television, the frequent whipping boy of media critics, fits this pattern. Several decades after the fact, both Michele Fricke and Tracy Warren still fondly recall specific television programs that their respective families would watch each week—in Tracy's case, accompanied by "two huge brown grocery bags" full of popcorn that his father would make for the occasion.

[1] Tracy's remark also reflects, of course, the previously mentioned idea that inanimate artworks are sometimes thought of as being living, sentient beings.

[2] On the other hand, another actor dates her first adult involvement with theater to the years when her children were young and she was a stay-at-home mother. It was, she said, "kind of a way of making sure [her husband] had time with the kids and I [got] out of the house."

[3] Previously noted examples of the mutual growth of familial relationships and artistic development are the following: Roger Hurst's going to midget car races with his dad, Arielle Thomas Newman's dancing with her father, Theresa Maybrier's learning photography and formal visual composition from her father, Teddy Graham's telling jokes and doing imitations for her family, and Lenette Johnson's and Linda Lindell's singing with their parents. Also, Nick Rivard fondly recalls gardening with his mother, and Jack Rees has similar memories of learning woodworking with his cabinetmaker grandfather and learning about fabrics from his milliner mother.

Probably one reason that the arts weld social and familial bonds so firmly is the like-mindedness of the individuals involved, a phenomenon that eight informants commented on. For example,

- Lester Goldman, who has a successful career as a painter, said, "I started out in commercial art [but] everyone that was at all intelligent or interesting or curious was always in painting or sculpture, so I just couldn't take it, so I went over there."
- Graphic artist Jack Cox said, "There's sort of a rapport between people who do this kind of work. Larry [a Disney cartoonist, who lives in California] and I are the very best of friends. We can go two or three years and not see each other, and [then] pick it right up where we were the last time; and I find that true with most of the people I work with."
- Conversely, an absence of like-mindedness can threaten social relationships. Sally Von Werlhof-Uhlmann loves having dinner parties for people who enjoy her gourmet meals, but, she said, "There have been people that I have dropped as friends because they're allergic to garlic or ginger, which, to me, are very important ingredients. How," she asked, "can I ever have them over to eat?"

Understandably, people who share the artist's perspective and knowledge are also the most appreciated sources of praise. For example, few people fail to remark on the beauty of Norman Snyder's garden, but he was extraordinarily pleased when a former writer for *The New Yorker* told him that it was one of the best gardens in the United States. Similarly, reflecting on her years of playing in a touring rock 'n' roll band, Linda Lindell said, "There's almost always somebody who can tell [how well the band is performing], and you're playing really for that somebody. For everyone else, you're just playing for them to have a good time. Keeping the beat, so they can dance and go hit on the chicks, I guess."

On the other hand, as Linda's daughter Celeste says of her experience with her own band, "It's nice to get whatever recognition you can." For many people, art can be highly satisfying even in the absence of praise, but for several informants, praise is highly appreciated. In a later context, Celeste added, "Of course, the acclaim of others—that's probably what you're really going for"; but her addendum is significant: ". . . and the satisfaction that you didn't make very many mistakes—that you sounded good."[4]

[4]Csikszentmihalyi (1977) coined the term *autotelic* to refer to activities that are demanding but that yield the actor little or nothing in the way of external rewards. An example from my interview data would be as follows: After hearing him describe with pride a particularly skillful wiring arrangement he had just made on the engine of a sports car, I asked Roger Hurst if he would still get satisfaction, even if nobody ever looked under the hood. His response was immediate and emphatic: "Yes! Yes! Oh, absolutely!"

MONEY, STATUS, AND COMMERCE

The marketplace is a major site of interaction between people who are in-
volved with art and those who are not, but there was a strong consensus
among informants that financial gain is not the central motivation for making
art. For example, Ken Walker described quitting a non-art-related office job
that "nearly drove me to suicide" to pursue a career in music, despite conse-
quent vagaries of income. Today he feels "fortunate and blessed" to have a
full-time position as music director in a well-established church. Similarly,
silversmith Robyn Nichols laughingly told me that she knows that her purpose
in life is "not to have a big house and fancy cars." Emphasizing the fact that her
work is prompted by a love of art rather than money, she continued, "If
someone gave me a million dollars, I can't imagine ever stopping what I do!"[5]

Only craft fair painter Ed Bartoszek mentioned money as a motivation
for making art ("This was about the quickest way to get income"), but even

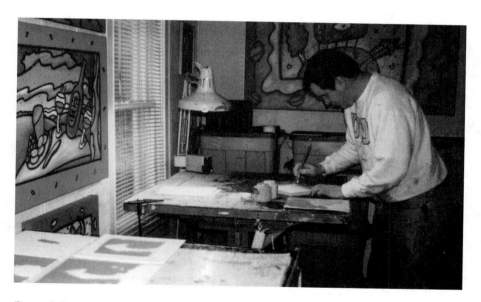

Figure 9–1 Ed Bartoszek, working in his studio on a series of similar paintings.

[5]Needless to say, this attitude is not necessarily shared by people who are not artists.
Karin Page studied piano as a child and loved music so much that she wanted to pursue it in
college. Her parents, however, dissuaded her on practical grounds, so she went into science
instead. Only as an adult has she been free to pursue the arts—music and the decoration of
her yard—despite the fact that they are not financially rewarding.

Ed puts artistic integrity before profit: Near the end of our conversation, I mentioned that some people associate art with truth, and he replied with this anecdote: "I guess one thing I do to be truthful is, like: this painting. A couple came in the other day, and they said, 'Well, we like this.' And to me, it's not done. And to be truthful, I would not sell it to them, because I know that it's not complete."

Informants expressed similar views about the money that goes into art-works. Among the small number who mentioned the matter, all said that expensive items, although sometimes desirable, are not necessary. For example, after Sally Von Werlhof-Uhlmann described her elaborate wild mushroom lasagna dish, I asked whether she thought that successful dinners require exotic and costly ingredients. Her answer was emphatic: "Oh heavens, no! No. I mean, a meal of properly prepared brown rice, with a few different kinds of vegetables stir-fried and served on the side, and a grilled chicken breast that's put over a barbecue grill is absolutely delicious and fabulous."

Although fine art painter Kim Anderson said, "I wouldn't do [art] for money," noting the limitations on artistic freedom that can accompany patronage (a phenomenon to be discussed in the following pages), a few commercial artists expressed pride at having made money with their art. Nicely confirming this pattern were two artists who use their monetary success in one art medium to subsidize their work in other media that have less commercial potential. For example, "Frankie" admits that the primary reason she dances topless is "so that I can pursue my artistic, my *real* artistic, dreams and goals," namely singing and dancing on the legitimate stage. (Shortly before I interviewed her, "Frankie" had spent most of a year in Nashville making a CD recording, all paid for by dancing at The Club, and especially by a wealthy patron of The Club who "never expected anything in return other than a copy of the CD, and a hug, and maybe listening to him ramble on about things that he needed to talk about—you know, such as a therapist, in a way.")

If informants generally downplay the importance of money in art, they know very well the monetary significance of art in American society. Silversmith Robyn Nichols, classic car enthusiast and dealer Joe Egle, and interior designer Jack Rees all acknowledged the extent to which their work provides symbols of elevated social status for their wealthy customers. For his part, Jack Rees waxed cynical on the matter: "There are women who are simply not capable of putting this [design] together, yet they want the badge of a handsome house; and they're usually affluent enough that they can afford to hire the professional." Jack, semiretired when I interviewed him, went on to quote a New York designer friend who told him, "Every night when I go to bed I pray that the people with money will get taste, and the people with taste will get money."

But other informants broadened this perspective, showing that in addition to the ever-present information about economic class that art communicates, other dimensions of identity are conveyed as well. Robyn Nichols sees subtle distinctions among the wearers of exclusive, handmade silver jewelry: "There are people who would never wear my work: It's too fluid for them. But there are people you'll see with heavy geometric shapes all over them[selves], and I think that says 'this is who I am.'" Robyn went on to speak of people who wear "a [piece by] David Yerman, for instance, . . . they're kind of the people that live in the same place, they do the same thing. Not to say it's not good classical design. It's *safe* classical design." Robyn concluded, "When I wore [other artists' jewelry], I wanted unique pieces. That was *my* thing. I felt that I wanted to say I was different."

Robyn is not alone in believing that whereas some people may lose their individuality via art, they themselves use art to express their own uniqueness. Speaking of a very different sort of body decoration but making a similar claim, East Coast Al Kimber said that "a third of the people need tattoos to help them go somewhere, and the rest are maybe just pack-following"; and I heard parallel claims from a few other informants as well.

Looking at art in the marketplace raises the related issue of art as the basis of employment, an issue that is relevant to about half of the informants. For a few, making money by creating art seems to come naturally (recall Robyn Nichols's story about doing a fellow third-grader's art assignments in return for her lunch money). Larry "Fats" Goldberg's omnivorous appetite was not adversely affected by his opening a chain of pizza parlors; and John Schaefer even said that paying salaries to the eight core members of his church choir has a positive effect on the ensemble, giving the group "a sense of direction."

But for himself, John is well aware that employment in the arts is a mixed blessing. When our conversation turned to that subject, he lamented the hectic pace of rehearsals and performances that leaves him with little time for reflection, and he resolved, "Maybe that's a goal for the year ahead."

Nearly half of the informants with backgrounds that included having had an income from the arts share John's ambivalence. Like John, some of them commented on the pressure and practical demands that accompany their chosen work. Robyn Nichols gave this testimony: "It's so hard when you run a business. You have employees; and right now I'm everything—I'm the janitor, I'm the bookkeeper, I'm the manager." Like John Schaefer, Robyn expressed a need to change her situation, and mused about perhaps establishing a workshop in the silver-working town of Taxco, Mexico, where traditional craft workers could execute her jewelry designs. In a tone of desperation,

Robyn continued, "I realize that my needs as an individual are to pull out what's in here [gestures toward her heart], not just make a product that somebody's going to wear. It's nice to see my work on people, but now I know that I need to express myself—through this [gestures toward a non-functional piece]. I mean, I may even change mediums—I don't know."

Other informants, all speaking from firsthand experience, expressed a range of discontents about the business of making art. When I interviewed Joyce Halford, she speculated about the joys of working in community theater, in contrast to television, which she viewed as being "very commercial. It's all ratings"; and Jack Cox, who has done graphics for a television station for more than thirty years, confirmed Joyce's view. Jack, whose college degree was in painting, told me, "I'd like to try 'fine art' again . . . something without a formula, something that you could do for your own enjoyment, you know, rather than a project that has been dictated to you. I'm just tired of that." (Jack was quick, however, to qualify his remarks: "Now that isn't saying that when you get a project dictated to you that you don't have to be imaginative, or that it isn't fun when you get into it, because it is.")

Weighing the relative merits of doing art as a job, versus doing art (in Jack's phrase) "for your own enjoyment" is difficult because of popular stereotypes about the drudgery of wage labor versus the supposed idyllic freedom of responding to the Muse. Therefore, informants such as Jack Cox, who have done both, are particularly interesting, and from all of them comes the same refrain. Liz Craig, who works as a copywriter but has also done creative writing, is representative: "Almost any writing project that I get into, if I can make myself start it, I can make myself get into a state of flow . . . When I was working on the novel and other sort of creative things like poetry or whatever, I obviously enjoyed that a little bit more."

Of course, Liz Craig, Jack Cox, and most of the other informants who contributed on the subject, were discussing activities that actually differ with regard to *two* variables—commercial versus noncommercial art and fine versus popular art. Therefore, Sally Von Werlhof-Uhlmann's experience merits special attention because it deals with two popular art forms, fashion design and cuisine.

By the time she was a teenager, Sally told me, she realized she could be financially successful at either one. Moreover, she resolved that, whatever she did, she would retire by age forty. While attending Antioch College, in Yellow Springs, Ohio, Sally rented a pre–Civil War farmhouse and began fixing dinners for sixteen to twenty-four people: "I just set a menu and I didn't say ahead of time what I was making and it was a set fee and then you got to eat."

But Sally had also always made clothing ("I was one of the original San Francisco hippies, and I made stage clothing for a lot of the rock 'n' roll

bands"), so in addition to earning money for college by preparing dinners for other students, she also designed custom clothing, had local farm women sew the garments, and sold them in a dress shop called The Purple Rabbit that she opened in Yellow Springs.

The quasi-restaurant experience was illuminating for Sally, as she explained:

> I realized that if I had a restaurant and people felt they could complain or say, "I don't like beets—what else do you have," that I would just get very irritated; and I would be stymied, trying to figure out, what can I really make? Because if I'm going to make a profit, I've only got X number of dollars, and I can't really add this special, wonderful ingredient: It's too expensive. The whole money issue would get too tied into it; and if it became a job, the passion for it would die.

The garment business was less problematic for Sally. She lived in Europe for several years, studied regional styles of clothing, and developed a line of high-end, custom designs that did, in fact, allow her to retire a few years ago at age forty; but it also gave her her fill of sewing, as one of her anecdotes reveals: Sally said that on the evening before our conversation, her husband

> was getting ready to go to New York, and it's cold in New York, and he pulls out this beautiful Armani coat, and he says, "There's a button missing," and he just kind of looks at me—and he knows I'm not going to sew on that button.
>
> I just simply (when I gave up the garment industry) said "I'm never sewing another thing. I don't care what it is, I'm not doing it. I'm finished with that."
>
> And somewhere in my mind I knew that if I took food on as a profession, that I would get to that point of just saying, "I can't stand it any more!"

Other informants told me of similar experiences. Susan C. Berkowitz, for whom personal appearance had always been an avenue of personal expression, does not get as much satisfaction out of working with her own hair now that she owns a beauty salon. On the other hand, changing from professional architectural illustrator to craft fair artist, Ed Bartoszek revels in the artistic freedom he now has. (In his current medium, he said, "You can make the grass purple, and you're not going to do anything wrong.")

Again, facile stereotypes must be avoided. Although Ed Bartoszek enjoys his license to paint grass any color he pleases, he does not describe architectural illustration as being unsatisfying. He told me, "There's a *lot* of fulfillment in that." Nevertheless, the collective opinion of the people I interviewed gives one message, loud and clear: The muse feels constrained to some degree when she enters the marketplace.

ART, POLITICS, AND MORALITY

Although a few informants portrayed art in purely apolitical (or even antipolitical) terms, more than a quarter of them acknowledged art's role in the realms of politics, morality, and ethics.

For some, the political dimension of art is highly personal. "Frankie" delights in the power that she exercises over the male customers at The Club; Lester Goldman told me that a series of paintings entitled *Cabala Ball* helped him to work through his thoughts and feeling about the Holocaust; and Tracy Warren described how in the 1970s a particular episode of the television series *Mash* transformed his previous political apathy into activism.

Several others think in more systemic terms. All three of the black preachers I talked to said that they feel a responsibility to address important social issues. For Rev. Donna Allen, it is not only sermons but *all* art that is political: "I don't know how you have nonpolitical art. I have seen pieces that persons have shown me and they'll say, 'This is abstract art; this is nonpolitical.' And I say, 'OK, talk to me about the artist.' And no the sooner than they begin to talk about the artist and the context and what the artist was saying . . . and I say, 'Right, real nonpolitical!'"

In the course of my interview with Rev. Bo Mason I mentioned being struck by a remark he had made during the preceding Sunday's sermon that Christ is in everyone. Christ has many faces, he had asserted, and pointing to a stained glass window behind the pulpit, he had said to his congregation something like, "See, up there He has a black face and nappy hair just like you and me!" When I mentioned this during the interview Rev. Mason replied by quoting an aphorism that an older Black preacher had once told him: "Preaching isn't preaching, unless you're teaching."

Besides the black preachers, other informants hope to affect the world through their arts:

- William Whitener told me that he thinks of dance as providing a model for "respect for an individual's space." He continued, "I think in my dream of a perfect world, that is the key to the end of war, to renewed respect for each other . . . When we see outbursts of violence it's often where someone feels their space has been invaded [or] another person's too close, threatening them in some way; and I think that all goes back to a spacial awareness."
- Writer Michael Christie told me, "I would like to be able to change some people's minds"—especially, he said, "about the ideas of property and wealth and the distribution of wealth."
- I asked Debra Di Blasi what she hoped to accomplish by means of the complex emotional messages she conveys through her fiction, and she answered with a laugh, "To change people! To enlighten [them], I think." Referring to this

remark later in our conversation, she said, "I was sort of joking, but not really. What I'm trying to do is to hopefully, even for a split second, have somebody take that mask off and look at themselves in the mirror for who they really are; because I think it's the greatest epiphany sometimes . . . I think the lies we tell ourselves are dangerous, and I think they're dangerous to society as a whole. I think that's why we have so much sickness—and I mean sickness like, for example, the fanatics on the religious right, who, there's always somebody they're blaming."

For several informants, the emphasis was less on politics and more on morality and ethics. Lee Berkowitz and Michele Fricke both commented on the extent to which television programs convey moral precepts. About soap operas, Michele said, "Eventually, the bad guys get what's coming to them. It may take years [laughs] . . . When you finally get to see it happen, Hah! Thank you! And it makes me feel good. I think, 'There's justice in this world.'" In another context, Michele characterized soap operas as "little morality plays," and said, "One of the clearest messages soap operas send is that wealth doesn't bring happiness, because all of the people have money—and they're all miserable. And the more money they have, the more miserable they are!"

East Coast Al Kimber, always able to surprise me with his views on tattoo art, volunteered that "I'm very much into the ethics of business. People say you can't have high morals and ethics and tattoo . . . but I believe there's ethics to this." For Al, tattoo artists have a responsibility not only to use sanitary procedures but also to be honest with customers and to act in what they believe to be the customer's best interest. He said, "I won't put a tattoo on a place on their body where it will deter them from having employment—whether they want it or not. That's integrity. I have integrity."

The most extended discussion of ethics, morals, and art came from comic book fan and dealer Lawless Morgan. He pointed out that in order to bear the seal that signifies compliance with the Comics Code, "good has to win" at the conclusion of the story.[6]

One of Lawless's favorite comics as a child was *The Incredible Hulk,* in which the highly intelligent Dr. Bruce Banner, through no fault of his own, becomes a monstrous pariah, inexplicably pursued by the Army. (The series became even more appealing to Lawless when he saw the very first issue of *The Incredible Hulk* and confirmed the rumor that he had heard that his hero, who was green in subsequent issues, had initially been black, like Lawless

[6]Rule 6 of "General Standards Part A" of the Comics Code Authority states, "In every instance good shall triumph over evil and the criminal punished for his misdeeds" (Daniels 1971).

Rev. Bo Mason: A Man of Words

Rev. Bo Mason's position at St. James United Methodist Church in Kansas City, Missouri, brings him more work and pastoral responsibilities than is usual for an assistant minister to a large urban congregation because the principal minister at St. James, Rev. Emmanuel Cleaver, is often away from the church fulfilling his duties as mayor of Kansas City. But hard work in a public setting is nothing new for Rev. Mason: In his early years, he played professional baseball with the Kansas City Monarchs; and after integration of the National League, he played for the Philadelphia Phillies. Following retirement from baseball and a second career as regional sales representative for the Goodyear Tire and Rubber Company, Mason followed a long-felt calling to the ministry and was ordained in the United Methodist Church fourteen years before I spoke with him.

Rev. Mason acknowledges a God-given talent in baseball ("Nobody ever taught me to play"); but he is less certain of the source of his public-speaking abilities, even though he won oratory contests from the eighth grade onward and continues to travel widely and to speak frequently for the Negro Leagues Baseball Museum. Perhaps Rev. Mason's uncertainty about his artistic talent comes from the great amount of focused effort that he puts into preparing sermons. He carries note cards with him throughout the week, jotting down ideas relevant to the subject of the sermon he will give on Sunday morning; and then on Friday evening, he begins actually writing the sermon, a job that may not be finished until three o'clock Sunday morning.

After all the planning, however, Rev. Mason says, "Sometimes you use half of it ... When you are anointed, nothing on the manuscript matters." The reference to "anointing" reveals the deep and complex psychological dimension of Rev. Mason's approach to preaching. He says that during the preparation of the sermon, "when I pick out the text, I've got to get into that text." Then, he says, on some Sunday mornings "I feel that I'm not doing the preaching, but Christ is doing the preaching through me—because I've studied His word," a remark that reflects Rev. Mason's conception of the interplay between inspiration and reason in his art.

In some respects, however, Rev. Mason has a thoroughly cerebral approach to his work, fastidiously shaping the beginning, middle, and concluding portions of his sermons to meet the expectations of his congregation and consciously adopting a rhythmic, call-and-response style of delivery to draw his listeners into the feeling and substance of his chosen text. So accomplished is his art (and he readily acknowledges, "All preachers are artists") that when he preaches to white congregations, Rev. Mason changes his style considerably.

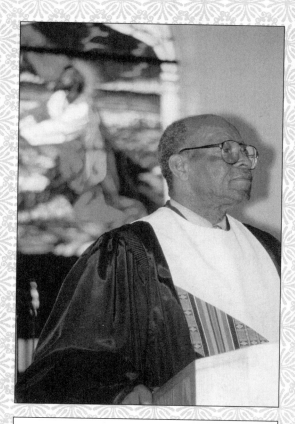

Figure 9–2 Rev. Mason at the pulpit.

As noted later in this chapter, Rev. Mason has well-developed views about the black minister as storyteller and as teacher; and Robert Farris Thompson has pointed out (1976) that African-American preachers such as Rev. Mason are contemporary representatives of a tradition of the "man of words" that reaches back to pre-Colonial West African cultures. But analysis and history aside, Rev. Mason is a consummate oratorical artist. On the Sunday morning that I attended the service at St. James, Rev. Mason spoke to a rapt congregation that filled the pews.

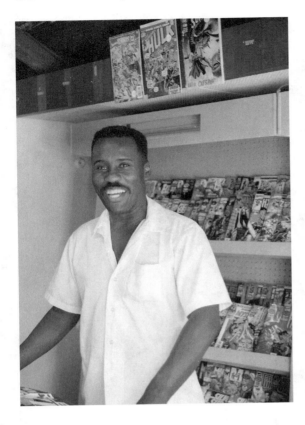

Figure 9-3 Lawless Morgan, in his shop, Lawless Times.

himself.) The Hulk's stoicism in the face of injustice was a lesson for Lawless in his youth: "I felt like I had my own little personal Hulk inside me, you know? We all get mad and angry sometimes, but we try to control that." Lawless even took classes in Latin and physics and enrolled in a six-year medical program, hoping one day to be a physician, just like the Hulk's alter ego, Dr. Bruce Banner.[7]

Lawless also said that he learned from the comic book character Superman "that *anything* is possible," an attitude that "inspired me to go on, you know, and try to get this business together; and it's inspired me to know more, because I didn't know about computers before I developed the store."

The moral effects of Lawless's predilection for comic books is long-lasting indeed, as illustrated by this exchange about his childhood:

[7]Lawless eventually realized that his desire to emulate Dr. Bruce Banner was not great enough to justify seeking a career in medicine, so he became a career Army man.

L.M.: I had a Super Boy comic. It's funny, because even to this day you keep thinking that you want to do things in a certain kind of way. You're not going to become a super hero, but you can feel the influence that you want to do the right thing, you know? You know, you keep thinking, what would your hero do? Your hero would always do the right thing.

R.L.A.: How old were you when you had the Super Boy comic?

L.M.: Ah, gosh, I had to be around six years old.

R.L.A.: May I ask how old you are now?

L.M.: Oh, I'm forty-one . . .

R.L.A.: So that was, what, thirty-five years ago?

L.M.: Yeah.

Lawless's stories are especially interesting, of course, because unlike preachers' sermons, comic books are not commonly thought of as instruments of moral instruction, something of which Lawless has long been aware. When Lawless was young, a neighborhood child who wanted to be Superman "actually jumped off the second floor porch [and] broke his arm." As a result, Lawless grew up hearing constant warnings, such as "You can't read these comics and stuff. It's nothing but junk, and we don't want you jumping off of a roof."

Today, Lawless does not completely dismiss such warnings of danger. Even though he likes to have his own eight-year-old son Alex visit his store and to read comics, he said, "I always tell him, 'Remember, son, this is fantasy. This is not real. We cannot really fly. We do not have powers. We cannot turn green and big.'"

Lawless's ambivalence about arts' potential to be a force for both good and harm was echoed by a few other informants. Television graphics artist Jack Cox was typical in telling me that he believes that parents should take responsibility for their children's moral education, but also in admitting that "you kind of get a cynical attitude in working around [televised violence] because you see horror every day," and he related an anecdote about station employees eagerly watching videotapes of crime scenes that were too gruesome to be broadcast.

ART'S EFFECT ON OTHERS

In the previous section, I briefly touched on informants' claims that the arts can, in Michael Christie's phrase, "change some people's minds." Statements about the beneficial social and health effects of art were occasionally quite specific and narrow, as in "Eve's" theory that sex workers, including topless dancers such as herself, effectively reduce men's chances of getting prostate

cancer, an illness that she believes can be caused by too infrequent ejaculation.[8]

A few such idiosyncratic theories aside, informants often saw art as doing the same thing for others as it does for artists themselves. Several said, for example, that the arts can powerfully affect people's moods. The performing arts, they observed, can make audience members feel like laughing, crying, or dancing. For example, Karin Page said that the bowling balls in her backyard not only make her happy but also often bring chuckles to other people who see them for the first time.

Because of the decorative style of his work, I explicitly asked craft fair painter Ed Bartoszek if his customers were affected by his work. His response was affirmative: "I've had people buy the cat ones and they say, 'Well, I look at him every morning and smile.'"

Similarly, if art can have a spiritual power over artists, it can affect the spirituality of others as well. Such, of course, is the whole point of religious art, as affirmed by several of the church-affiliated informants. Thus, when Rev. Bo Mason spoke with me, he emphasized the importance of presenting his sermons as stories. Using a story himself to make his point, he said, "I read in one book where this new preacher was coming into a black community, and no one had ever heard him; and one of the parishioners asked the other one, 'Can he tell The Story?' So, you know, usually my sermons are in a story form."

I pressed Rev. Mason on the issue, asking, "What's the value of putting extra effort into presenting the sermon as a story? I mean, you can do it in different ways." When he answered that God's word itself is a story, I continued, "It's almost blasphemous to put it this way, but why would God give his message in the form of a story?" Rev. Mason answered thoughtfully, "I think people can understand a story. You know, if you tell it in a story-like form, they will remember. You know, you can get off on some high theology and stuff like that, [but] in the black church, that doesn't work. I think preaching the gospel, you preach the gospel. You don't preach theology."

Similar ideas were articulated in nonreligious contexts, as well. For example, Kim Anderson said that she believes that art "shows us our symbols, and we have to have them . . . Having art that reflects our symbolism is so absolutely [necessary]. We just have to have it. I mean, it's a record of where our souls are."

[8]A medical reference book says that there is "no good evidence for *the common notion* [emphasis added] that more frequent sexual activity can help cure prostate inflammation" (Anonymous 1993:743). "Frankie" had a different theory about the social function of topless dancing: "There would be men cheating on their wives all over the place; a lot more than they [already] are. I've got so many customers who just say, 'I don't want to cheat on my wife, but she's boring me to tears!'"

Other informants who spoke of art's effects on others shifted the focus from the spiritual to the moral and the ethical. Carol Mickett said, "I think if you are really moved by a piece of theater, it stays with you . . . Because it's so heightened, you take it with you. I think it really influences how you live and how you interact with people." Joyce Halford expressed similar views, explaining one reason why, for her, the medium of theater is so important:

J.H.: There are some plays, like a lot of David Mammet's work, that I love just because he's so thought-provoking . . .

R.L.A.: About what kinds of things? . . .

J.H.: About everything. About politics, about relationships, about how society works or doesn't work, about what's fair and what's not fair, about religion . . . [and] spirituality.

R.L.A.: Do you get more than you'd get if you picked up the *New York Times* and spend a couple hours with it?

J.H.: Yeah, because it's not just black and white, you know? There are grey areas in plays—or at least, there should be in good ones—where you can think and you can draw your own conclusions and you can say, "OK, where's this person going?" So I like plays that I'm going to get something out of on an intellectual or spiritual level.

True to Joyce Halford's questing impulse, political dogmatism was largely absent from informants' remarks. The people I interviewed were not politically unaware. Issues of gender, race, and ethnicity did come up occasionally,[9] but the only straightforwardly political perspective was given by Rev. Donna Allen, who complained that when some white scholars write about black preaching, they focus "on what black preaching looks like and sounds like. It doesn't deal with the content." She continued,

I think there are a couple reasons for that. One is because the content of black preaching, both historically and contemporary, deals blatantly with racism. So if you're repeatedly attacking white racism and capitalism and sexism and oppression, then white scholars, who are a majority of the scholars, are not prone to write about that. And so they reduce black preaching to that which is most palatable, namely . . . some sort of performance. It's most palatable to say, "Dance or sing for me; amuse me," rather than to deal with the content.[10]

[9]For example, Linda Lindell told me that one reason she became a professional musician was that she liked the challenge of breaking into what she characterized as "a skinny-white-boy-with-long-hair person's business." On the other hand, Maria Vasquez-Boyd said that although her Hispanic heritage had once been apparent in her paintings, by the time that I interviewed her, she had become "annoyed at the whole notion of 'Is it Chicano art' or 'These are her Latino roots.'"

[10]Lacking Rev. Allen's command of the homiletic literature, I can only assume her analysis is correct. As a white scholar who is guilty in a sense of doing what she describes, my own defense is to second a remark made by Rev. Wallace Hartsfield following a sermon delivered by a young black assistant minister in his church: "There's a lot of power in telling a good story" and unequivocally to state my agreement with the political and social messages I heard in sermons in black churches while gathering information for this book.

Three of the television fans I interviewed talked about how much they have learned about the world from watching television,[11] and conversely, fifteen informants remarked on the extent to which they, as artists, have a responsibility to educate others. In taking this position, however, they adopted two different lines of reasoning. About half hope to educate the general public about their own art medium. For example, talking about food, Bonnie Winston said to me, "I love introducing people to new things that are beautiful and [that have] interesting new tastes and flavors. I mean, that's great!" When I mentioned the missionary zeal of her remarks, she replied that at one time she had actually used "missionary" to describe herself on her résumé. She continued, "If I can expand people's horizons and let them know there's more [to eat] than fried chicken and macaroni and cheese . . . I've done them a favor. They might even live longer to enjoy what they eat!"

The other group of informants talked about lessons learned from art that transcend the arts themselves. Some ideas were vague and programmatic, but others were quite concrete. Lawless Morgan talked about how comic books are used in other countries to teach children reading skills; and Lenette Johnson expressed her view that rap music, although variable in quality, accurately describes social conditions in communities that all Americans should know about.

Amateur actor Teddy Graham commented that "Shakespeare in the Park" is a "pretty good history-teaching tool," and her remark opens a topic that several informants touched on in one way or another, namely, art's potential to transcend, interrupt, or otherwise alter the flow of time. This phenomenon has already briefly come up in several preceding contexts, such as Loretta Rivard's associating four-o'clock flowers with memories of her mother. Several other gardeners have similar recollections, but those that Jane Overesch shared with me, as we sat in the cool shade behind her house overlooking her extensive flower gardens through which several peacocks roamed, is perhaps the most vivid:

> Smelling a lilac reminds me of my childhood because we had lilacs and my mother always had a great big bouquet of them, and you can remember

[11]Of the three viewers, Michele Fricke's insights about television's educational function were the most complex. She does see television as giving valuable information about what the viewing public thinks or wants to see, but she is skeptical of commercial television's efforts to be educational. Michele is an art historian by profession, and one of her areas of expertise is ancient art, so she was excited when she learned that The Learning Channel was going to broadcast "The Great Pharaohs." She was disappointed, however, when she saw the actual program "because so much of it was not accurate . . . It's too romantic. They go for the glamorous and the most sensational version of things." Lee Berkowitz was even more dubious, expressing his opinion that local news programs "fabricate reality."

fragrances so well. You can remember what lilies of the valley smell like, and all of those flowers we did have in our garden at home. And as a child, we had a vacant lot across the street and I used to sit over there by the hour picking violets in the spring.

Jane went on to say, "It's almost the same thing as hearing music that you like," and in this observation, too, she was not alone: Ted Gardner told me, "I view music as a time line, a calendar . . . I hear a song, I instantly think of a period of time." One actor and two tattoo enthusiasts made comparable comments.

If art can transcend time for the artist, it does the same for nonartists as well, as reflected in Teddy Graham's remark that "Shakespeare in the Park" can bring Elizabethan England to contemporary America. The best example of this transcendental element comes from Chief Korzinowski. Previously I quoted the exchange that I had with Chief in which he denied being motivated to decorate his yard by anything he had read or seen. Noticing two small statuettes of the Virgin Mary, I continued to probe for his motivations and so asked Chief whether religion played a role in his yard art, to which his friend Katrina Oldenberg replied, "There's no religious messages," with Chief adding, "I'm Catholic, but no."

During our rambling, two-hour conversation, two motivations for Chief's work did come up repeatedly, however: First, he gets great personal

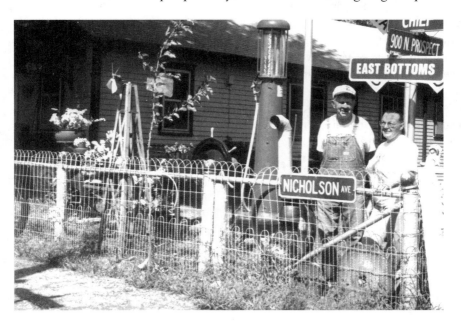

Figure 9–4 Chief Korzinowski, with his friend, Katrina Oldenberg.

enjoyment out of making things with his hands, especially when he plays with ideas. (Chief chuckled when he pointed high in a tree to a birdhouse that he had made from an old portable hospital urinal.) The second theme in Chief's remarks was the satisfaction he gets from educating people, especially young people, about things of the past. Most of the artifacts that decorate his yard are antique tools and old farm implements. Chief is amazed at how little today's youths know about subjects that previously were common knowledge, as shown in this story that Chief and Katrina collaborated in telling:

C.K.: You've got to hear this: We went to a farm show out in the country.
K.O.: Megan, my daughter, was sixteen.
C.K.: And we're walking in the field, and there was cow shit there. Her daughter asked her, "What was that?" [Laughs.]
K.O.: Yeah, I told her it was cow manure; and she says, "Mom, what's cow manure?" [and I said] "cow shit!"
C.K.: [Laughs.] [She] didn't know that!
K.O.: Children don't know. And he thinks it's important they should.

Katrina, speaking with Chief's nodding assent, continued, "There's a lot of children in this world that has not seen a lot of this stuff; and when they come by, they really appreciate things." Later she added, "It makes him feel like he's contributing to the society in one way or another—without, you know, charging. They get to see things they never seen before."

For his own part, Chief genuinely likes the old items he collects: On nearby properties, he has stored an amazing quantity of items that he calls "junk"—ancient, nonfunctional trucks and, again, an array of old tools and farm implements. That inventory, however, stands in contrast to the special pieces that he has painted and installed in the yard around his house. Whether the latter is "art" in Chief's mind is a question that we shall take up in the following pages; but for now, it is clear that through his work, Chief hopes to make the past come alive in the present, and in so doing, to make a positive contribution to society.

10

Vernacular Aesthetics

As the foregoing four chapters attest, the sixty-four artists and art aficionados whom I interviewed have much to say about their personal histories of being significantly engaged by the arts, issues of the artistic mind and spirit, and the placement of art and artist in contemporary society. However, about ten percent of their remarks were more theoretical, dealing with the nature of art in abstract terms: definitions of *art,* the relationship of art to truth and to beauty, and so on. Taken together, these remarks constitute a system of vernacular aesthetics, a philosophy of art as articulated not by professional philosophers but by women and men who are intimately and intensely involved with diverse American arts.

ATTEMPTS TO DEFINE ART

Several informants commented on art's refractory nature. Painter Kim Anderson told me that art "transcends what people can say about it; it transcends language." Other informants were equally pessimistic about efforts to "explain" the arts: Using a surprising figure of speech, preacher and homiletics professor Gene Lowry said, "most great preachers don't know what the devil they're doing"; and when I asked Karin Page why she decorates her yard with bowling balls, she hesitantly explored several motivations but gave up in frustration: "I don't know, there's something, uhm, attractive about the

roundness. I don't know—I can't explain it." Finally Karin resorted to using a term from her former field of biology: "It's really hard to *dissect*."

Art may be "really hard to dissect" (and Karin was the only informant who explicitly denied being an artist), but others were willing to try to define art, sometimes without being asked to do so. Recall my exchange with Chris Harris, quoted at the beginning of Chapter Six. After remarking that "I can't really think of anything that doesn't have an artistic value," he narrowed his definition, agreeing that "Everything *can be* artistic," and continuing, "It's the approach that's more important than anything else."

On one point there was unanimity: Art can be distinguished from nonart. (East Coast Al Kimber stated the matter plainly: "Anybody can do a tattoo, but not all people can take and make a tattoo into what's an art form.") Beyond that fundamental agreement, however, opinions differ among informants as to the defining feature of art. As usual, however, some recurrent themes are discernible.

In their attempts to identify art's definitive trait or traits, several informants emphasized the source of the artwork, focusing especially on the creator's imagination, expressiveness, and skill, as seen in this quotation from musician Ted Gardner: "To me, anything that you strive to do well and take pride in can be considered an art . . . OK, I'm going to say imagination." Like Chris Harris, who equated art with "imagination and mechanical ability," Ted was completely catholic with regard to art media. (Ted said, "I'm sure there are people who really know about computers and can look at a bunch of code and say, 'The guy that wrote this is just an artist. This is just beautiful.'")

Three other informants took a different approach to defining art by emphasizing features intrinsic to the artwork itself, such as its sensuous qualities. For example, Bonnie Winston told me that one factor that raises food to the level of art is its visual beauty. Bonnie also said that artful food must have "integrity," and when I asked what that term meant when applied to food, she said that it was "just simply respecting it for what it is and treating it accordingly. Yeah, so I think some of the food we have experienced in recent years that has been so overworked and, you know, distorted, by combining ingredients that in and of themselves might be interesting [and that] have no right to be in each other's company. That lacks integrity for me." (Michele Fricke seemed to have the same idea in mind when she told me, "I think if it's an *honest* [emphasis added] endeavor, then it can be art in whatever medium.")

Remarks contained in some of the interviews suggest that money can jeopardize the honesty and integrity in art. For example, Dielle Alexandre

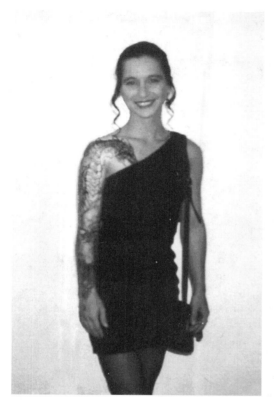

Figure 10–1 Dielle Alexandre and her dragon tattoo.

had stopped dancing at The Club six months before I interviewed her. When I asked her whether, in retrospect, she thought that topless dancing was an art, her answer in the affirmative was illuminating in its supporting explanation:

> Believe it or not, I even miss that part of it. There's a very big difference between dancing on stage, dancing a lap dance or a private dance, or dancing for tips. Ok, couch dance is a one-on-one. They tip you ten or twenty dollars to actually sit on their lap and wiggle around and that kind of thing . . . It's not an art, it's a, you know, I would go into dance mode. Do this four beats, turn around, do this one four beats . . .
>
> And then on stage, that's where there's really two types of dancing, you know. You dance in front of the dollar that he's set on the table or to get him to give a dollar, OK?
>
> Well, the one type of dancing that I think is more of an art form is when you're on stage and you don't care about the audience. You know, either there's a bunch of bachelor parties that aren't tipping . . . or just guys around

that aren't tipping, or when there's nobody there. Actually, there was a lot of times I really preferred to . . . just dance, be sexy, feel good.

The sullying effect of money was also noted by Linda Lindell. Most of our conversation focused on her work in a touring rock 'n' roll band, but Linda also had extensive experience in the creative department of an advertising agency. I asked Linda whether she thought her work as a copywriter involved art. Here is her answer:

> Sometimes. When I was at the big agency, the only creativity that came my way was when they would do charitable things— fund raisers, and so forth . . . When the lights came on and people were fumbling for their handkerchieves, that's gratifying, because you know [that] you touched them, and something good would happen. But generally it's, "Come on in and check out our prices on plastic dinnerware." It's not a whole lot of challenge there, and the work load in those big places is humongous.

Some of the issues mentioned by Linda in this passage will engage us in the following section, when we compare and contrast fine art and popular art; but what is of interest here is the marked difference between her feelings about writing advertising copy for commercial versus charitable causes.

My interview with yard artist Chief Korzinowski and his friend Katrina Oldenberg produced another definition of art that depended on the presence or absence of the profit motive. Chief and Katrina told me about the time when city officials tried to make Chief erect an eight-foot-high fence around his yard, claiming that his display of painted antique farm implements and tools was nothing but "junk."

Chief was extremely upset about the threat, and Katrina took up the battle for him, contacting a state senator and a district attorney. During our conversation, Chief reminded Katrina of her strategy: "You told them this was 'art,' and they left us alone!" Katrina finished the story:

> I said, "Now is there anything wrong with this yard?" I said, "Is it hurting anybody?"
>
> And they said, "No, it isn't hurting anybody." They said, "*He's not selling it, is he?*" [Emphasis added.]
>
> I said, "No, he's not." I said, "He's putting it there for his pleasure, something that he likes to do . . ."
>
> So they said, "Fine. Put an eight-foot fence up in the yard over there [across the street, where Chief stores undecorated items] to where kids can't get in there."

Thus, although government officials probably had their own nuanced conceptions of what *art* refers to, the deciding question in this case was whether or not the items were being displayed in order to make money.

POPULAR ARTS AND FINE ARTS

Some people have long claimed that art untainted by the marketplace is more nearly pure, more truly artistic than commercial art (art sold in galleries excluded!).[1] One common line of attack by critics of the popular arts is simply to dismiss them as not being art in the first place. The people I talked with who are primarily involved with the popular arts remain unconvinced, however: The several who addressed the issue had no reservations about using the word *art* to refer to their medium, be it television, tattoo, or topless dancing. For example, Michele Fricke, an art historian by profession, told me, "I don't have any trouble acknowledging that there is art in television."

On the other hand, I did hear statements that reflect an awareness of the gulf that sometimes separates fine and popular arts. Ed Bartoszek, for example, told me that when people at art fairs ask him to characterize his paintings, he replies that they are "contemporary" or "pop." Ed is not displeased when his work is compared with that of Peter Max or Keith Haring, but Ed conceded that he is unlike "the people the NEA is after, or the people that are doing the urine in the glass"— presumably a reference to Andres Serrano's controversial photograph *Piss Christ.*

In another context, however, Ed also recognized the symbiotic relationship between his paintings and fine art paintings, which often serve as starting points for his work. Ed showed me a small print of a neoclassical painting and then pointed to one of his own acrylics: "This is my take on it. I don't know how old this painting is, but these are old masterpieces. I've taken this guy's composition, that was done a hundred (or three hundred) years ago, and I've put my twist on it."

Ed's comment paralleled remarks by several other informants who discussed their own popular art media in terms that are used more commonly to talk about the fine arts, as these examples illustrate:

- Dick Jobe described the mechanical challenge of replacing a Volvo's engine with a much larger V-8 engine. He said, "One guy I saw who'd done it, his motor mount brackets looked like a piece of *sculpture* [emphasis added]. I mean, they were perfect." Dick continued, "There's not a heck of a lot of difference between that person and my friend, Stretch, up the street, that's a sculptor . . . A guy who's working on his car, it's something he's thinking about that he knows will fit what he needs, as opposed to Stretch, who just

[1]Gans's *Popular Culture and High Culture* (1974) includes a seminal overview of such critiques, as well as Gans's rebuttal.

thinks about something that's really whacked out. But besides that, they're going through all the same motions. It's the same deal, you know?"

- I explicitly asked Rev. Donna Allen whether she thought of preaching as an art form, and she answered affirmatively, pointing out the importance of rhythm and rhetoric, imagery and allusion (all, of course, stylistic staples of the poet), as well as what she referred to as "that other mystery that often comes with what we call an art form, that creative part, that allows me comfortably to say, 'Yes, it's an art.'"
- Larry "Fats" Goldberg was emphatic in defending food as a possible art form ("Oh, sure! God, yes!"), but when I asked him to defend his position, he emphasized the visual, rather than the gustatory, dimension of food: "You want everything in it's place. That's pretty; that's good. Looking at a [barbecue] rib is pretty; it's as good to me as anything is."
- During my interview with Steve Cromwell, we focused primarily on his love of popular music, but as an art historian specializing in American art since 1945, Steve made an interesting critical leap between popular art and fine art. He said that his basic criterion for evaluating music "is my lower body. If I'm listening to a tune and I want to stop what I'm doing and I want to turn it up and I want to get out of my chair and I want to scream and bounce and dance, that's a good tune." Likewise in painting, Steve said, his own personal favorites prompt the same response. Thus, "Edward Kienholtz is probably one of my favorite artists, who I never tire of. Ever. When I see a Kienholtz I think about things like loneliness. I think about things about definitions of men and women. I think about things like death. Those are lower body things to think about."

Although people involved in media such as cars, food, and popular music are confident in proclaiming them to be arts, in some interviews, there was a hint of ill will between the fine art and the popular art communities. For a view of the fray from the latter group, recall, for example, the previously mentioned scorn that Karin Page had for her former boss, who dismissed a painting when he learned that it was by Karin's young daughter. Or this: When I asked Steve Cromwell whether he himself had ever played music, he told me about playing in his high school band, going on to say, "I at one time considered a career in music as a performer. I was pretty good, basically, but I realized I'd have to convince people to let the euphonium into the symphony."

On the other hand, informants aligned with the fine arts were occasionally disdainful of the popular arts. Choral music director Arnold Epley derided the genre called "contemporary Christian" music as "the cheapest level of self-indulgence" and snorted at what he called "the Gospel according to Amy Grant." Experimental fiction writer Debra Di Blasi strongly defended some popular artists, such as the rock musician Nick Cave, but she did admit to there being limits to her aesthetic pluralism: "Sofa paintings. Anybody who mass-produces paintings to hang over other people's couches— they're not very creative."

People involved with the popular arts and the fine arts concur, however, in their hope that their arts are accessible to others. In the first camp, writer Michael Christie said, "I've got a story to tell, and I want people to read it"; and community theater director and actor Doug Wylie told me that he constantly worries "about the audience, and what they're going to take away from the play [and] making sure that what *you* think the play is all about is what *they* think as they leave." Similarly for the fine arts, Carol Mickett said (speaking of poetry), "You need to communicate to the reader"; and painter Lester Goldman told me that he is increasingly asking "questions like, 'How's the work being received, where's it going, what's its conduit, what's its exposure?'"

Lester Goldman's remark leads to a final definitional issue regarding art: Recall the story that was told in Chapter Seven, about Lester's building model airplanes as a child, only to watch them literally go up in flames when he launched them from his building's roof. Several other informants share Lester's view that the *process* of creating art is at least as significant as the finished *product*. Four gardeners said explicitly that producing beautiful flowers and plants is only a small part of the reason they dig, sow, weed, and otherwise labor in their garden plots: The activity of working in their gardens is also extremely valuable.

Doug Wylie elaborated on the theme, as it applies to community theater:

> I have the most fun in rehearsal, where you go through the process of making discoveries. You try things and you find out what works and what doesn't work, so you start that process of creating, building, and finding some thread that kind of weaves everything [together] and allows the characters and the words to make sense and start to take on an emotional state of their own.[2] That's really where I find the most satisfaction, in the rehearsal process.

(Doug acknowledged that not all theater people have the same priorities. Although some prefer rehearsals, he said that others derive more satisfaction from the actual performance of the play.)

ART AND TRUTH

Remarking on the adage "Beauty is truth, truth beauty" that the poet John Keats found on his famous Grecian urn, W. H. Auden has argued (1989) that, "art arises out of our desire for both beauty and truth and our knowledge that they are not identical." The people I interviewed reflected the dilemma that

[2]In this reference to words' taking on "an emotional state of their own," we see yet another case of the anthropomorphizing of an artwork.

Auden identified. On the one hand, of the several informants who offered substantive comments on the subject, about half talked about art's capacity to convey a true picture of reality, as these accounts illustrate:

- Chris Harris expressed particular pride in the realism of the face of a Native American tattooed on his arm. "A lot of artists depict American Indians as modified Caucasians," he said, "and they never look right."
- Joe Egle told me that unlike many other classic car buffs, rather than preferring a perfectly restored car, he is partial to one that has its "original leather, original paint, original carpet. You know *exactly* how that car was when it was produced new . . . When it's got the original, you know what it looked like in 1919, or whenever it came out. Somehow that sort of places you seriously back in 1919. You can see the Highland Park Plant in Michigan, where they cranked these things out."
- Painter Kim Anderson said, "I recently did a painting, and when I looked at it when it was finished, I wept because what it had done was express more than what I was conscious of having put into it . . . It was bigger than me." To further illustrate her point, Kim said of a Van Gogh painting, "It's beautiful— because it's psychologically true."

On the other hand, a few informants emphasized art's capacity to *mis*-represent reality. This was particularly the case with television aficionados. Lee Berkowitz, for example, argued that television creates an "American mythology" and said, "I don't think I can watch TV without having a theory of fiction."

In addition to the claims for and against art's veracity relative to the rest of the world, three informants discussed truth intrinsic to the artwork itself. Carol Mickett best articulated this position when she described her own goals: "I might start out writing from my experience, but often I change it if the poem will be better a different way or with a different word. That's what poets do . . . The poem's about the integrity of the line and the language of the line and the world of the poem. The world of the poem is different from my life." This idea, with its implicit formalism, is not confined to the fine arts, as proven by the previously quoted remark by Bonnie Winston about the integrity of food.

The most commonly heard opinion, however, was a decided ambivalence about art's power to portray reality truthfully. Thus, Boyde Stone laughingly remarked, "When I was going through my divorce, the theme song was 'She Got the Gold Mine and I Got the Shaft'"! Later in our conversation, however, Boyde said that he seldom knows the words to the songs he plays on guitar. ("Lots of people analyze songs to get something out of it for themselves. Shit, I'm mixed up enough without trying to find out!")

Even the cynic Lee Berkowitz conceded that for anyone who adopts an anthropological perspective, television provides a true picture of the American public by revealing their tastes and interests. But Lee took his argument one step further: "Most television dramas are cop shows [and] the number of violent acts on TV is a little out of synch with what goes on out in the real world. [Laughs.] However, it does feed on people's paranoia and *becomes* the reality of their perception of the everyday world . . . It's a *fabricated* reality for viewers."

The slippery relationship between art and truth is the source of art's metaphoric capacity, a function commented on by several informants. For example, Liz Craig portrayed ballroom dancing as "a kind of a metaphor for real harmony. When you see ballroom dancing couples in competition," she said, "it's so perfect, a metaphor for how we all wish our relationships were." Ballet director William Whitener made a somewhat different case: "The artist is dealing in metaphor, and different people will react differently because you are, then, engaged in your own imagination and [you] go along for the ride. Each audience member will have a different reaction—and that may be intended by the creator."

ART, UTILITY, AND BEAUTY

Chapter Nine discussed a wide range of social functions of art, and several of the creative people I interviewed gave me additional theories, ranging from Roger Hurst's belief that short men are overrepresented among car buffs because "a good-looking car or a fast car is an equalizer for somebody that has any sort of low self-esteem problem," to Sally Von Werlhoff-Uhlmann's assertion that "bread is really what united civilization."

Such claims, of course, fly in the face of the long-standing idea that art is definitively nonutilitarian, a concept that was expressed by several informants.[3] For example, when I asked Joe Egle what it is that makes the MG-TC, a classic sports car, into a work of art, he answered, "Well, I guess part of it is the impractical part of it. A long hood: That's not a utilitarian thing." Similarly, Susan C. Berkowitz told me with a laugh that most things in her home "are useless. They don't do anything!"—except that, she added, "they bring me pleasure." Also, Episcopal music director Ken Walker said, "I have some friends who think that art should be used for a good cause. And I think, you

[3]Elsewhere (R. Anderson 1989:12–14) I have argued against using nonutility as a defining feature of art because even if the arts do nothing but give psychological gratification to those who make and use them, that alone is an important and a valuable function.

don't *use* art. I mean, art is a part of being." Later, calling on the Bible to justify his position, Ken recalled a parable about "the extravagant waste of the woman who gave ointment on Jesus' feet and the disciples were outraged at it. I think that's an example of where the inexplicable extravagance of art is a necessity."

But even when art serves no materially useful purpose, it can yield the experience of beauty, as many of the informants attested. Whether the medium was paintings or automobiles, music or tattoos, beauty was to some extent a concern of many of the people I interviewed. For example, both Jane Overesch and Donna Hobbs told me that they had little interest in planting vegetables or herbs in their gardens because most such plants lack visual beauty.

However, the relationship between beauty and art in informants' minds is complex. For one thing, the applicability of the word *beauty* seems somehow contingent on the medium in question. None of the four preachers I interviewed spoke of "beautiful" sermons; and the four people with whom I discussed tattoos showed some reluctance to apply the word for that particular art form. East Coast Al Kimber told me, "There are some really dynamite tattooists out there, and some people wearing some extraordinarily beautiful work." But this exchange ensued later regarding the effect of wearing tattoos:

R.L.A.: We talked a little about beauty. Some of your tattoos, you feel, are very well done?

E.C.A.K.: Do they add to my overall looks? They definitely add to my overall looks. Whether or not it makes me "beautiful" is another story.

R.L.A.: Or handsome.

E.C.A.K.: Handsome's alright. I don't know. Beauty's a skin-deep thing, and so's a tattoo. Many cultures did tattooing as a rite of passage and to beautify the body—especially the women.

Chris Harris also was more comfortable describing his tattoos as "handsome," rather than "beautiful."

Such remarks suggest that besides the art medium, gender may also be a factor in the use of the word *beauty,* but the picture is far from simple. Speaking of her tattoo, Dielle Alexandre said, "Overall, it doesn't mean that much to me that it's beautiful . . . The fact that it's beautiful is just, you know, the cherry on top." Moreover, all four car buffs (three of whom were male) used *beautiful* repeatedly to describe various aspects of automobiles, including the sounds of their engines.

Three informants made efforts to explain the fundamental nature of beauty, but I see only a weak and implicit consensus among them. Gardener Nancy Jenkins conceived of beauty as having been produced by "something

bigger than us . . . I mean, you go out and there's wildflowers; and, you know, you go to certain areas that are untouched that still have beauty in them." Robyn Nichols said that she sees beauty in nature and that she tries to capture it in the silver jewelry she designs, claiming that "beauty is something that has action with it, even mystery; action to the point of taking your breath from you. Beauty has something the soul yearns to possess . . . [There is] something going on in the piece—like, it is alive." For her part, Kim Anderson said the following of a medieval painting: "The utter, complete beauty of it . . . [It is] beautiful in a way that other things are not beautiful. They're beautiful in the way that trees are not beautiful." Perhaps the common denominator for these three women is their view of beauty as transcending the quotidian world.

When she spoke of beauty, Robyn Nichols also acknowledged that "what I find to be beautiful may not even be acknowledged by others as beauty," and other informants remarked on the tendency of beauty to take on different guises, from time to time and place to place. Three of the preachers contrasted the black and the white styles of delivering sermons; two car buffs noted the evolution of car body design over the years; and Boyde Stone (admitting "I sound like my dad thirty years ago") said, "The rock 'n' roll of today doesn't appeal to me very much. It's noise."

CONCLUSION

One limitation of these chapters is obvious: Their findings rest on interviews with a relatively small group of people, and although the individuals who shared their insights with me represent a wide range of art forms, many other media that thrive in America today are unrepresented. It is, however, a problem that future research may address. Such work will surely shed light on problems that remain puzzling, such as the significance of television enthusiasts' apparent ambivalence about the role of TV in their lives. Theoretical issues cry out for attention, as well. For example, more than once during the preceding analysis it was clear that the traditional analytic categories, which were developed over the centuries for use in the fine arts, are often inadequate when applied to the popular arts.

But despite such limitations and although every human being is unique, I believe that several important themes can be clearly discerned in this material, foremost among which is that art is extremely important in the lives of many Americans. Spanning an astonishingly wide range of fine and popular art media, pursued on either an amateur or a professional basis, comprising both committed producers and serious consumers of art, occurring everywhere

from the middle of the mainstream to the edge of American society the arts really do matter in many people's lives.

This conclusion is supported by several motifs that recur in the preceding pages: The people I talked with have a substantial current commitment to the arts in terms of effort, time, and resources; and far from being an ephemeral infatuation, their dedication to the arts reaches back many years, often to childhood. For most informants, the arts are a major component of self-identity, often closely linked to familial background and spiritual life.

Also, a fairly consistent picture emerges of the very nature of the arts themselves: The arts represent (at least for the most part) a positive force in the world; they may be pursued by solitary individuals, but usually they have a distinctly social dimension; and although they are affected by factors of reason and commerce, they are more powerfully influenced by the ineffable forces of the psyche.

All of which is not to say that total consensus prevails. As we shall see in the final chapter, differing views about the arts can be seen as an indication of the philosophical nature of vernacular aesthetics. Nevertheless, the extent to which agreement on aesthetic issues is to be found in America is, I feel, remarkable, given the diversity of our nation.

11

Calliope in America

Fieldwork has always been the wellspring of cultural anthropology. Theoretical paradigms have come and gone, but a fascination with what people do and say, what they think and feel, has remained constant. The previous chapters record the results of several excursions into the culture of American art, a land that even though it is close at hand and often studied in piecemeal fashion, has not previously received a broad, anthropological description. Although the domain is too vast and diverse to be dealt with exhaustively in a single book, we have uncovered several salient features of American art.

Chapters Two and Three show the omnipresence of art in the lives of most Americans. If, as I believe, the three vignettes in Chapter Two are typical of American homes and businesses, then there is an enormous amount of art in our day-to-day environments. Such a conclusion is, of course, contingent on the definition of *art* that is adopted; but throughout that chapter—as, indeed, throughout the book—I have assiduously applied the definition that was developed in Chapter One, namely, that things are art insofar as they possess most or all of the following traits: They are the result of human production; they are created through exceptional physical, conceptual, or imaginative skill in a public medium, with the intention of provoking a sensuous effect; and they share stylistic conventions with other works from the same time and place.

Subsequent chapters revealed not only that art is present in great quantity in contemporary America but also that for at least some occasions and

certain people, art is extremely important. Chapter Three demonstrated that although weddings *could* be conducted with little or no art, the vast majority of people seem to agree with informant Kim Crenshaw's view that art, and lots of it, is necessary for a "real ceremony." And if weddings (and funerals and Christmas and Hanukkah celebrations) require enormous amounts of art, for the individuals who provided information for Chapters Six through Ten, art is a significant and meaningful component of their existence. Art tends to be a life-long personal commitment, a preeminent component of their inner world, and a major factor in their social lives.

I undertook the project that led to *Calliope's Sisters* (1990a) because I suspected that anywhere a great deal of art is made, there must be good reason to make it, justifying the effort and resources that art production typically requires. My expectation turned out to be true for all nine of the non-Western societies that I discussed in the book, and I presented the indigenous paradigms that account for art's existence as so many "philosophies of art" or "aesthetics systems."[1]

But what about contemporary America? Admittedly, the Western fine arts have been subjected to prolonged and extensive analysis, but is there an

[1] By and large there was a positive response to *Calliope's Sisters,* but Jacques Maquet (1991) took me to task for describing such material as "aesthetic" in societies that have neither explicit, indigenous paradigms of art, nor native aestheticians to articulate them.

In a rejoinder (1992) I defended my project, but I relied more on reasoned argument than empirical evidence. For example, I suggested an analogy with linguistics: It is not uncommon for a people to have neither a word that translates directly into our term *language,* nor an explicitly stated set of principles that we would recognize as a grammar. Despite those lacunae, few linguists would hesitate to say that such a population has language, one grounded in a discoverable set of grammatical rules. Or, to cite an example I learned of after the previous remark was published: Fromkin and Rodman (1998:431) observe that "some languages have no native word to mean 'sexual intercourse.'" Presumably, such peoples are not threatened by extinction because they are unaware of the act that they are reluctant to name.

Denis Dutton (1997), citing Julius Moravcsik (1991; 1992), has shed useful light on this ticklish issue by pointing out that the task of determining the meaning of *art* is different from that of studying non-Western art. Resolving the former would be necessary before one could say whether or not things such as the drawings made by gorillas in zoos are "really art." Such resolution is not, however, necessary for studying non-Western art traditions inasmuch as they easily meet the criteria conventionally associated with *art.* Developing his own analogy with language, Dutton writes, "The discovery, if such a thing were possible, that any of the marginal cases, music or birdsong, is or is not a language could no more disprove that Urdu is a language than the discovery that atoms are mostly empty space disproved that a blacksmith's anvil is solid" (Dutton 1997:2).

In any case, the data reported in previous chapters of this book, along with the reasoned arguments of this chapter, conclusively show, I believe, that there can indeed be "aesthetics without aestheticians."

aesthetic of popular art? Does mass culture contain within it a theoretical and systematic rationale for the art forms of the people? As Chapters Five through Ten have shown, statements about the nature of popular art are not hard to find in contemporary America. Many song lyrics contain such comments, and people who are avidly involved with the arts express them again and again. But do such statements constitute a full-blown aesthetic system? In this chapter, I argue that they do, first, by showing the ways in which contemporary American vernacular aesthetics addresses the same sorts of fundamental issues that Western aestheticians have long argued about with regard to the fine arts; and second, by showing how the many aesthetic principles uncovered in Chapters Five through Ten, when taken together, possess the hallmarks we generally associate with aesthetic systems per se.

FINE ART THEORY AND POPULAR ART PRACTICE: FOUR AESTHETIC PARADIGMS[2]

Tatarkiewicz's monumental three-volume *History of Aesthetics* (1970a, b; 1974) records a vast panoply of ideas about Western art, from pre-Socratic and early Hebrew thinkers down to the modern era. Although most Western aestheticians have attempted to formulate ultimate and universal truths regarding art, a few writers[3] have systematized these paradigms; and the consensus among them is that the major Western philosophies of art generally fall into four broad but well-defined categories that may be briefly summarized thus[4]:

- **Mimetic paradigms** focus on the ways that art portrays things in the world around us, representing them either literally or else by capturing them in an idealized or essentialized form.
- **Instrumental paradigms** emphasize the belief that art can make the world a better place. Religious art, with its goal of enhancing the spiritual condition of the audience, constitutes the most common type of instrumental art, but political art also has an instrumental goal.
- **Emotionalist paradigms** dwell on neither the material nor the social world but on the psychological realm of inner experience and the feelings of the individual. Emphasis may be on the artist's expression of emotion, on the cathartic purging of audience members' emotions, or on the creative process.

[2]In programatic form, much of this section first appeared in R. Anderson 1990b.

[3]Notably, Abrams (1953), Stolnitz (1960), and Pepper (1945).

[4]For a more complete account of the four traditions of Western aesthetics, see R. Anderson 1990a:199–220.

- **Formalist paradigms** do not deal with the material, social, or psychological realms, but rather with the artwork itself. Art is conceived to be a masterful manipulation of an artistic medium, capable of producing a definitively arresting response in the aesthetically attuned audience member.

Several qualifications must be made regarding this fourfold typology. First, although specific Western aesthetic *paradigms* tend to fall into one of four categories, actual *people* and individual *artworks* cannot be so classified: A person inevitably uses different aesthetic criteria for varied artworks; and often a particular work may be responded to from more than one aesthetic perspective. Second, although the four traditions may be clearly distinguished from each other for purposes of analysis, in reality they sometimes overlap or are complementary in their concerns. (Postmodernism, to take a recent example, included ideas from all four aesthetic traditions.) Third, Western standards of art *criticism* (cf., e.g., Guerin et al., 1998) are more numerous and varied than Western art *philosophies*, which deal with the ultimate nature or purpose of art. Finally, these four broad paradigms by no means exhaust the possibilities; as shown at length in the book *Calliope's Sisters*, many other aesthetic principles are found in non-Western cultures.

Contemporary surveys of aesthetics (e.g., Feagin and Maynard 1997; Fisher 1993; Ross 1994; and Sheppard 1987) typically draw their supporting examples from the fine arts, and we usually think of the art theories of such philosophers as Plato and Aristotle, Arthur Danto and George Dickie, as addressing issues that are pertinent to the fine arts. Recall, however, that with the exception of formalism, Western aesthetic paradigms were conceived before a clear distinction between popular and fine arts had come into existence. Thus, we should not be surprised that such paradigms work as well for the popular arts as for the fine arts. Let us examine each of the four broad aesthetic models more carefully and see how each applies to the popular arts.[5]

The Mimetic Aesthetic

The aesthetic principle of mimesis calls for an artwork to portray some tangible subject matter. This idea is as enduring in the Western tradition as it is absent from most of the rest of the world's cultures. Visual artists from Praxiteles through Michelangelo and Constable to Richard Estes, and writers from Sophocles through Chaucer and Dickens to Tom Wolfe have all mar-

[5]Popular culture theorists Cawelti (1971), Madden (1973), and Doherty (1988) have decried the absence of a vernacular aesthetic. However, all three authors use *aesthetic* in a more normative sense than I do, calling for fellow scholars to enunciate critical standards to which the popular arts should conform, rather than documenting the implicit philosophies that inform vernacular art.

shaled their considerable talents to create works that convey to the viewer or reader what their subjects are "really" like. (The mimetic impulse has been less influential in music and dance, although some examples do exist, such as Beethoven's *Pastorale Symphony* and Tchaikovsky's ballet *Swan Lake.*)

In the modern era, the aesthetic of mimesis was largely supplanted in most sectors of the fine arts by Romanticism, and Formalist theorists have given it even shorter shrift. But if mimesis is less important today in the fine arts, it remains a powerful force in popular art. Mimesis is implicated every time a movie is praised because it "tells it as it is," whether its subject is family relations, politics, or any number of other topical themes. Likewise, the success of many popular singers and songwriters, from Woody Guthrie to the creators of the most recent permutations of rap, rests on the mimetic capacity of song lyrics to represent the world around us.

Or consider the quintessential American popular art medium, television. To take just one theme, *The Honeymooners*, *All in the Family*, *Married— With Children*, and *The Simpsons* all have portrayed working-class family life in America; and they are only latter-day incarnations of a tradition that reaches back at least to nineteenth-century live theater.[6] Granted, such dramas give stereotypical accounts of their subject, but as far back as ancient Greece, some mimetic artists have often forsaken literal reality in favor of idealized reality on grounds that such a technique conveys the essence of the subject matter. (Thus, Praxiteles' *Discus Thrower* is more perfect than any mortal athlete.)

The preceding chapters contain many cases of popular art's being valued for its ability to represent the world around us.

- In Chapter Two, photographs were notably present in the homes of Kim Anderson and Carmen Tamayo, as well as in Dick Jobe's garage; and several landscape and genre paintings adorned Carmen's walls. In each of these instances of art (and, for some of the photos, quasi-art), the goal is the representation of concrete subject matter.
- Recall that for the average wedding, over $900 is spent on wedding photos. Again, such artistic records of weddings are valued because they provide a lasting documentation of the wedding itself.
- Thirteen lyrical passages that provided the data for Chapter Five remarked on art's capacity for verisimilitude; for example, in "Swollen Pockets," rappers Phase n' Rhythm say, "I speak the truth . . . I'm not a baker, but I roll the dough."

[6]Although the plots of yesteryear's melodramas may seem fantastic to us today, in their day they were fairly realistic. Nye observes, "Many of the situations presented in the melodrama often reflected real problems quite familiar to their audiences. Drunkenness and gambling caused untold sorrow in nineteenth century homes; country girls and boys did go wrong in the city" (Nye 1970:160).

- In Chapter Ten's account of "Art and Truth," three informants were quoted regarding the high value that they place on art's ability to realistically portray the things of the world.

Instances of art whose popularity (in both senses of the word) is based, at least in part, on its being representational could be multiplied ad infinitum, but a different sort of evidence for the applicability of mimetic aesthetics to popular art is found in the criticisms that come from mass culture and that are directed at modern fine art: When a person who is not an aficionado of fine art wonders how Picasso can be considered "great" despite his portrait subjects having grossly misplaced eyes and noses; when the same individual questions the sanity of anyone who would spend tens of millions of dollars for the seemingly phantasmagorical images of Van Gogh; or (and even more to the point) when an abstract painting by Mark Rothko is dismissed outright because it does not depict anything tangible at all, the power of the aesthetic of mimesis in popular thought is revealed beyond a doubt.[7]

The frequently heard observation that "art reflects society" identifies an objective feature of art; but to a certain extent, the remark merely codifies one of the principles that informs much of the general public's conception of art in Western civilization: We have long believed that art can portray the things we see in the social and material world around us; and by duplicating and validating our significant perceptions, art, both popular and fine, plays an important role in our lives.

Instrumental Aesthetics

As with the fine arts, some popular art is not inspired primarily, or even at all, by the mimetic impulse. Fashion in clothes, popular dance, and residential architecture are only occasionally meant to be representational. But rather than being void of any abstract rationale, they simply respond to other muses.

One such impetus is instrumental in nature, calling for art to earn its keep through its beneficial effects on society. Aristotle conjectured that Athenian drama might enhance the stability of the state by providing a safe venue for the purging of pent-up emotions and hostilities; sacred art, especially during the Middle Ages but also before and after, has been made largely to heighten the religiosity of individuals and the community; and the practitioners of neoclassicism had a similarly uplifting goal in mind.

[7]The cartoonist Al Capp is often remembered for his quip that "abstract art is a product of the untalented, sold by the unprincipled, to the utterly bewildered" (Capp 1963), confirming Suzi Gablik's observation (1984:14) that "in modern society, art breeds mistrust."

The belief that art should improve those exposed to it has been a potent force not only in the fine arts but in some forms of popular art as well. For example, eighteenth-century broadside verse initiated an enduring tradition whereby popular poetry was expected to teach and to inform (Nye 1970:90). Similarly, although high-culture critics predicted that the novel would debase public morals, in fact, many novels have had the opposite goal. For example, Nye says that the nineteenth-century domestic novel used "sex, sentiment, and religion" to convey thoroughly moral messages, namely, "that conventional sexual morality was best, that deviation from it was dangerous, that immorality was punished by terrifying results" (Nye 1970:26). Obviously, not all popular literature is intended to elevate the reader, but from *Ben Hur* (a fabulously successful early best-seller) through the popular Horatio Alger stories and Little Orphan Annie to the contemporary plethora of inspirational and self-help books that perennially appear on best-seller lists[8]—all lie comfortably within the tradition of popular literature created to elevate the reader.

Music, too, has often been a medium through which individuals have tried to improve, indeed save, the world. John Wesley used hymns to win and retain converts to Methodism, and the tradition continues to thrive in hymns and gospel music today. Also, as Denisoff's *Sing a Song of Social Significance* (1972) clearly shows, the use of music to express protest and propaganda, a tradition that grew out of a religious framework, has been an enduring feature of American popular culture, and it continues to thrive in reggae, rap, and some other popular music styles.

Although some popular art creators and performers have straightforwardly admitted their intention to use art to influence society in ways that they view as desirable, there is an enormous quantity of popular art that only covertly and implicitly expresses and validates the values of the status quo—thus presumably making those exposed to it into better citizens; and I see no effective way to establish the exact extent to which a particular popular art form is propaganda for the Establishment. But again there is another sort of evidence for the presence of aesthetic instrumentalism in contemporary mass culture. In the same way that philistine criticism of abstract art ("It doesn't *look like* anything") corroborates the pervasive assumption that art should represent things in our perceived world, recurring concerns about the "wholesomeness" of particular popular art forms confirm the general, though usually

[8]So strong is the self-improvement impulse that the June 28, 1998, *New York Times Book Review* listed as a "New and Noteworthy" paperback a volume entitled *How Proust Can Change Your Life,* by Alain de Botton, which was described in these terms: "A clever nine-step program drawing lessons from the life and literature of Marcel Proust shows how *Remembrance of Things Past* can make you a better person" (Anonymous 1998:28).

tacit, belief that art should indeed be decent, if not actually elevating (cf. Gans 1974).

But criticisms of some forms of popular art also spring from mass culture itself. For example, when he was vice president of the United States, Spiro Agnew claimed that music by the Beatles, the Byrds, and Jefferson Airplane would "sap our national strength unless we move hard and fast to bring it under control" (Denisoff 1972:ix). In expressing an opinion shared by many Americans, Agnew was revealing the aesthetic premise that art should have a beneficial effect on those who are exposed to it. Art that does otherwise, he felt, should be brought "under control" forthwith. The same belief, of course, underlies the censure of "slasher" movies by some portions of the public; it has motivated citizen groups to call for the removal of countless books (most perennially, *Catcher in the Rye*) from public school classrooms and libraries; this belief provoked congressional attacks on the National Endowment for the Arts in the wake of the NEA's sponsorship of work by Robert Mapplethorpe and Andres Serrano; and it has prompted some women's rights advocates to seek a total ban on pornography. All of these actions reveal the potency of the instrumental aesthetic.

The instrumental aesthetic may also be seen at several junctures in the preceding chapters:

- Among the many artworks noted in Carmen's house were three wall plaques bearing homely prayers ("Thank you, Lord, for everything"), as well as a palm leaf ornament that Carmen brought home from mass on the previous Palm Sunday.
- Much of the traditional symbolism found in weddings carries a religious or moral message, from the common use of a religious structure as a setting for the wedding, to the bride's white gown, symbolizing her supposed virginity.
- As documented in Chapter Five, many lyrics, from both sacred and secular songs, equate art with the supernatural, and other lyrics claim that the arts are valuable because they can lead to good health or mental well-being.
- People who are seriously involved in the arts, including the informants for Chapters Six through Ten, also provide testimony that the instrumental aesthetic is alive and well in the popular arts. Television buffs become better informed by watching news and educational programs; and as Michele Fricke observed, soap operas can be seen as modern morality plays. Chapter Nine's section entitled "Art, Politics, and Morality" catalogs the ways in which art fulfills an edifying function for informants, ranging from the personal and idiosyncratic (e.g., Tracy Warren's being moved to political activism by seeing episodes of *Mash* and Lawless Morgan gaining personal fortitude in his youth by finding role models in his comic book heroes, The Incredible Hulk and Superboy), through the educational (recall the lesson that Chief Korzinowski and Katrina Oldenberg taught her daughter about cow manure), to the public and institutional (such as black preachers' using their rhetorical skills to convey both political and spiritual messages to their congregations).

Art as Emotional Expression

A third enduring muse in Western civilization is concerned with the powerful feelings that the arts can provoke. From Aristotle's discussion of *katharsis* to the Romantic artists' calls for feeling and emotion in the creation and appreciation of art, Western civilization has long valued art's passionate side.[9]

Although the best-known arguments regarding this issue have focused on the fine arts, the principle has been embraced also by the population at large for application to many of the popular arts. Obviously, some popular art gains wide, even enthusiastic, acceptance because of its effective capacity to make people laugh (as in comedy movies) or cry (as in television soap operas); to be held in a state of suspenseful tension (as by murder mysteries); to experience erotic arousal (as by the figure photography in *Playboy* and *Playgirl* magazines); to wonder at awesome spectacle (as at the circus); or to have other strong emotions.

Unlike mimetic and instrumental aesthetic principles, both of which are substantially the same whether applied to fine or to popular art, the emotionalist aesthetic as developed in the modern era for application to the fine arts is different in two ways from the emotionalist aesthetic that is utilized in mass culture for making, appreciating, and evaluating popular art. For one thing, it is acceptable for the popular arts to provoke a broader range of emotions than generally occurs in the fine arts. The fine arts are expected to elicit only "refined" responses in those who experience them. Pathos, for example, is permissible in "the cinema," whereas both pathos *and* bathos occur in "movies"— and in ineptly made art films.

Second, when the fine arts are lauded for the emotions they evoke, the goal is typically *strong* feelings—Goethe's account of Young Werther's sorrows, or, as the playwright Peter Weiss has the Marquis de Sade say in his play *Marat/Sade,* "no Marat, no small emotions please" (Weiss 1965:26). Certainly the popular arts often prompt powerful feelings—indeed, sometimes stronger than those roused by the fine arts, if we contrast, say, the affective responses experienced by many symphony concert goers to those that young people can feel during a popular music concert. But in addition to such peak experiences, it is also acceptable for popular art to stir far more moderate

[9]So pervasive is the emotionalist aesthetic in Western culture that one might assume it to be a human universal. Cross-cultural studies show this not to be the case, however. Traditional Navajo aesthetics, for example, focus on art's beauty, and Navajos assume that art should make one happy. But far from seeking the heights of art-induced ecstacy, Navajos told David McAllester (1954:83) that, for example, a person who experiences an odd or a dizzy feeling on hearing the music of the Sing known as *Enemy Way* is thought to be ill and in need of having the ceremony performed over himself or herself.

feelings: Popular music includes not only the bacchanal of the rock concert but also the "elevator music" of Muzak. And, of course, it could hardly be otherwise inasmuch as popular art so pervades day-to-day life that it cannot *always* be ecstacy-inducing.

On the other hand, fine art and popular art probably differ more in the *ideal* of high emotional involvement than in practice: Whether its creators like it or not, classical music is often heard as "background" music, and powerfully affecting paintings sometimes appear as posters that unobtrusively decorate the walls of living spaces, or even serve as graphic fodder for advertising. For that matter, although some popular art inspires high passion, much of it provides a sensuous enhancement of mundane existence, having no greater affective consequence than to make life generally more pleasant.

Popular art's capacity to stir human feelings, either great or small, was evident frequently in the preceding chapters:

- The living and working environments described in Chapter Two are filled with the "decorative arts." Of the more than two hundred items mentioned, many are purely ornamental. Be they architectural details, items of personal adornment, or home or business furnishings, all exist only to make the setting more pleasing. Even the jar of hard candy on the counter at Dick Jobe's garage exists to give customers a small gustatory treat.
- For weddings, romance and joy are the prevailing emotions (at least in theory!); and many of the artistic accoutrements of weddings (music, flowers, clothes, food) exist to enhance that effect. (Recall Kim Crenshaw's aversion to being married in "just a cold, sterile office" by a justice of the peace.)
- A major theme (with many variations) of American song lyrics details the ways in which the arts can stir emotions. Lyrics proclaim that the performing and visual arts can kindle affection, romance, and sexual arousal; and a wide range of nonromantic feelings, from the blues to patriotism, can also be spawned by the arts.
- The artists and serious art consumers of Chapters Six through Ten also attest to the wide range of feelings that art can evoke. For some of these people, too, sexual arousal can be prompted by art, but the most powerful psychological consequence of art for several of them is the transcendent state that has been called the "flow" experience. From topless dancers and auto mechanics to poets and painters, the informants in Chapter Eight effectively illustrate how strongly the arts can affect people—and how much the experience is valued by many people.

Art, Form, and Skill

Formalism is the fourth aesthetic tradition that has been used to justify, explain, and evaluate fine art. This approach emphasizes art's formal qualities—the visual artist's use of color and composition; the composer's use of

counterpoint or the sonata form; or the poet's use of rhythm or assonance. At the core of formalism is the assertion that successful artists manipulate such techniques so masterfully that they can evoke an aesthetic response in those who understand their media and are in a receptive frame of mind.

Some traces of formalism may be found in popular thinking about the arts. For example, most children learn that "stripes and plaids don't go together" and that such colors as red and pink "clash" when juxtaposed. Less hypothetically, in Chapter Three's account of "wedding arts," we heard from a bride-to-be who recoiled at the thought of men in a wedding party being variously dressed in black, brown, and blue suits. Also, many Americans expect poems to have lines that rhyme; musicians typically want their instruments to be in tune before they play; graphic designers are masterful creators of images that utilize effective composition to produce valuable corporate logos (recall Dick Jobe's being barred from using Volvo's official logo); and good cinematographers have remarkable senses of color. Furthermore, in the section of Chapter Seven entitled "Art, Skill, and Formalism," we heard informants as they commented on the formal dimensions of popular artworks, such as the compositional form of tattoos.

But formalism can be thought of as a rarified subcategory of a much broader aesthetic focus on artistic virtuosity, a concern that has a wide and enduring presence in the popular arts. Go to any craft fair and find the perennial ceramicist throwing pots, and you probably will hear him or her being complimented for being able to control the clay on the wheel, making it rise into a tall, narrow vessel or flare out to form a delicate dish; then eavesdrop at the stall of a "wildlife artist," and again you will hear praise for the person's exceptional ability to render animal figures. Visit the music tent, and you can listen to people agreeing on how the fiddle player "sure can make it talk." Presumably, each of us non-performers has sung in the shower at one time or another, and our own paltry efforts make us appreciate the gulf between ourselves and the singers we hear on stage.

The lyrics of Chapter Five and the informants of Chapters Six through Ten acknowledge the special skills possessed by artists; but in natural settings, the appreciation of popular artists' exceptional skills is made explicit in only a few situations, as when a less-than-competent artist is criticized or when prizes are given to artworks—a blue ribbon, perhaps, for the best watercolor drawing entered in the local county fair. But far from negating the importance of the principle, I believe that such practices confirm the extent to which we take for granted the fact that most of the things that are commonly considered to be art are, in fact, skillfully produced.

As noted previously, the four aesthetic traditions that have been outlined do not by any means exhaust the possibilities for philosophies of art found

round the world. Moreover, some factors that are inarguably important in Western art are not included in the quartet of principles that, tacitly or overtly, constitute the core of Western aesthetics. For example, both the fine arts and the popular arts are strongly influenced by commercial considerations; however, money does not seem to be associated in the public mind with art's existence as art. Thus, although such popular arts as network television, Hollywood movies, and rock music are obviously big business, as we saw in Chapter Nine, the making of money is not thought to be either an exclusive or a definitive feature of art. To the contrary, the public attitude seems to vacillate between wonderment that the arts can engender huge fortunes, and mortification at the decadence that such wealth sometimes subsidizes.

Aesthetic Pluralism

On reflection, it may be predictable that the fine arts and the popular arts derive from the same theoretical foundations. Without underestimating the considerable social, economic, and political boundaries that have traditionally separated the elite stratum of society from the rest of the population, and with no disrespect for the consummate talents and heroic achievements of fine artists, it should come as no surprise that the aesthetic underpinnings of the realms of the fine arts and the popular arts overlap. Consider these facts:

- The fine arts and the popular arts are often consumed by the same individuals. Even the most devoted of opera buffs cannot avoid hearing some popular music, and they may positively enjoy some genres of it—not country and western or "easy listening," perhaps, but maybe jazz or Broadway musicals.
- The producers of fine arts and popular arts may be the same individuals. A few, like Graham Greene, are notably successful in both the fine and the popular arts, but many others are earnest hobbyists in artistic areas far afield from their specialization.
- Art forms themselves sometimes migrate between the fine and the popular arts: The elevation of Shakespeare's plays from popular entertainment to serious drama exemplifies one direction of movement; but Leonard Bernstein's use of *Romeo and Juliet* as the basis of *West Side Story* represents the opposite.[10]

[10]Of course, the translation from one idiom to another may drastically alter the meaning of an artwork, as has been the case with Pop Art and more recent experiments with appropriated images. The same misunderstanding, willful or otherwise, occurs, of course, when members of Western culture "appreciate" non-Western art for largely ethnocentric reasons. Clifford Geertz (1983:119) has aptly observed that "most people . . . see African sculpture as bush Picasso and hear Javanese music as noisy Debussy."

(Also, as noted previously, the distinction between fine and popular art is relatively recent.)

From these observations, it is apparent that American civilization is not artistically pluralistic in quite the way that some analysts have supposed. Both the high culture critics of popular art, as well as Gans (1974), who offers rebuttals for most of their criticisms, assume that the fine arts and the popular arts are distinctly different species of endeavor. I, however, am arguing that despite noteworthy stylistic and sociological differences, the two types of art derive from the same theoretical foundation. Even the various "taste cultures" that Gans identifies within various segments of the larger population share the same basic aesthetic assumptions. Each of the four aesthetic traditions is, however, open-ended enough to permit notable differences in actual art production. For example, the mimetic muse moves many popular artists to portray "reality"; however, an artist who is creating within the context of working-class black culture is likely to perceive a different reality from that of someone who is comfortably situated in middle-class white youth culture; and both of them see things differently than do representatives of the various ethnic subcultures. As a consequence, each of these taste cultures produces and consumes distinctly different art forms—hence the enormous richness and diversity of Western popular culture, including as it does, in music alone, blues, techno, and polka, and scores of genres in between.

But if high, middle, and low levels of society respond to the same aesthetic factors, every part of society has varying ideas about what art is and should do. Thus, George Boas's essay "*Mona Lisa* and the History of Taste" (1963 [orig 1940]) charts the successive opinions held by experts regarding Leonardo's painting over the course of several hundred years, as the dominant mimetic assumptions of the Renaissance were replaced by the ethical emphasis of the instrumental neoclassicists, which in turn was supplanted by the emotionalist paradigm of the Romantic period.

Such conflicts of judgment occur not only historically but also today, and this inclination is particularly interesting in the popular arts. For example, a situation might arise in which "splatter movie" fans extol their favorite film because it is so exciting (that is, because of its excellent—for them, at least—fulfillment of the emotionalist aesthetic), whereas critics of the same movie, using the instrumental aesthetic, worry that the film is leading to the moral decay of American youth. Of course, the four traditions may act in concert with each other: Some viewers of the television program *Lassie*, for example, presumably loved it because they found it simultaneously realistic, uplifting, heartwarming, and well acted (especially by that darned dog!), thus

successively invoking mimetic, instrumental, emotionalist, and formalist aesthetics.[11]

AMERICAN VERNACULAR AESTHETICS

As the previous section shows, American popular art rests on a fourfold aesthetic foundation, one that it shares with the fine arts. An important difference between the fine and the popular arts, however, lies in degree of specialization. On the one hand, the fine arts tend to be the domain of artists who are full-time practitioners. The competent performance of a Rachmaninoff piano concerto requires a lifetime of dedicated keyboard practice, and Kant's *Critique of Judgment* is comparably demanding of its author and its readers.

By contrast, the technical challenges of the popular arts are, with notable exceptions, somewhat lower; and likewise, there have been no full-time aestheticians to take their measure. What is it that justifies calling the four implicit philosophies[12] of mimesis, instrumentalism, emotionalism, and formalism an "aesthetic system"? The answer, I maintain, is its possession of the traits that typify *any* intellectual construct that could plausibly be called a philosophy of art: First, central theoretical issues regarding art are addressed; second, the style of discourse in which these issues are treated is characterized by debate and argumentation; and third, ideas are not presented piecemeal but are logically integrated to form a more or less articulated intellectual system. The following sections will argue that all three of these traits are present in American vernacular aesthetics.

The Concerns of Aesthetics

Every systematic survey of Western aesthetics is unique, but in addition to surveying the substantive aesthetic paradigms of mimesis, instrumentalism, and so on, most touch on a small number of core themes. One inevitable task is to grapple with the issues surrounding a **definition of art.**

Likewise, the issue of definitions arose repeatedly in the preceding chapters. As among full-time philosophers, no unified consensus emerged; and likewise, several informants in Chapter Ten remarked on the illusive nature

[11]Since we are treating art as something made by humans, perhaps Lassie's acting does not count. Or as Carolyn Ingalls has pointed out (personal communication), the definition of *art* could be broadened to include work by any intelligent being, opening the door to the possibility of art being made not only by the clever Lassie, but also by any aliens smart enough to travel to Earth.

[12]Clyde Kluckhohn (1949) coined the phrase *implicit philosophy* in his discussion of Navajo religion and worldview.

of *art*.[13] On the other hand (and again paralleling academic aestheticians), this difficulty did not deter informants from proffering tentative definitions of *art* and from distinguishing (albeit often tacitly) art from nonart. For some informants, the criterion that sets art apart is the artist's creativity (and attendant freedom), expressiveness, or skill; for others, formal qualities of the artwork itself are more important.

Philosophers since Aristotle have not only been concerned about the boundary between art and nonart but also have debated the relationship *between* the arts. Likewise, some American song lyrics discuss genealogical relationships between artworks and art media. Moreover, informants interviewed for Chapters Six through Ten made distinctions between fine arts and popular arts, accepting such things as tattoos and ballroom dancing as being in some sense of the word art, but simultaneously distinguishing them from, say, gallery painting and ballet.

In addition to issues of definitions and boundaries, the previous chapters noted several **intrinsic qualities of the popular arts** that parallel standard discussions of the fine arts. Numerous song lyrics associate art with some aspect of the supernatural, either equating art with supernatural places or beings, or else portraying art as a vehicle through which the supernatural affects the world. In a related fashion, quite a few informants associate art with religion and spirituality, transcendence and flow. Both the lyrics of Chapter Five and the informants of Chapters Six through Ten acknowledged art's characteristic capacity to affect people and the world; and they attributed this power to art's ability to convey truth, to its intimate relationship with nature (including the artist's body), and (perhaps cynically with respect to the fine arts) to its sponsorship by a socioeconomic elite.

Besides definitions, another topic that standard treatments of aesthetics texts address is **the artist.** Artistic creativity typically gets some attention, as does the question of the artist's intentions. Also dealt with are the issues of self-expression and the emotions associated with artistic production.

Again, the data of previous chapters are rich with references to these same topics: Chapter Six's informants had much to say regarding artists' high degree of involvement in the arts, their inborn talent, their families and the larger web of social and political relations they are part of, the identification they make between themselves and their chosen art media, and their use of the unconscious in their production of art. The lyrics analyzed in Chapter Five mention some of the same issues; and in addition, they have things to say

[13]To observe that art is difficult or impossible to define does not necessarily make one antiphilosophical. As noted previously, one of the most influential aesthetic arguments of the twentieth century (Weitz 1957) did exactly the same thing.

about the artist's stereotypical role in society and about art as work. These premises about the artist lead to a third, and closely related, topic—**the audience.** Usually the consumer parallels the producer, so, for example, art evokes the same array of emotional responses in artists and audience member alike.

A final topic touched on by most broad surveys of aesthetics concerns **the role of the arts in the world at large,** especially the ways in which the arts address questions of ethics and morals, truth and meaning, language and communication. Both song lyrics and people who are seriously engaged by the arts comment on art's power to convey the truth and to transform reality. Also, both sources of data address issues of value—not only about the worth of art itself, but also the ways in which art can make the world a better place. Finally, when diverse arts embody long-standing traditions (for example, in weddings), when photographs convey memories of bygone times, or even when well-composed designs are used in advertising, art's ability to transfer information from one time and place to another becomes apparent. (Previous chapters have *not* provided a great deal of information regarding the interpretation, evaluation and criticism of art—a topic that some surveys of aesthetic give attention to. It is interesting that these same issues seldom receive explicit treatment in non-Western cultures as well. [Cf. R. Anderson 1990a.])

Style of Discourse[14]

Students in beginning philosophy classes are often told that the word *philosophy* is derived from the Greek words for "love of *wisdom,*" but they soon discover that "love of *argumentation*" is a more accurate characterization of the discipline. When philosophers take up a topic for consideration, they typically debate it from all possible angles, and the Sisyphean process of disputation often seems to be the chief goal, rather than arriving at final answers to life's great questions.

The philosophers who specialize in art are no different. Plato and Aristotle disagreed about whether art conveyed falsehood or truth and about whether the State was harmed or helped by the presence of artists, and these debates and others continue today. John A. Fisher begins his introductory book on aesthetics by observing, "Art is as challenging to understand and evaluate today as it was in ancient Greek times. Indeed, the issues are much more complex for us" (Fisher 1993:iii). That view is seconded by Marcia Muelder Eaton, who concludes her concise overview of Western aesthetics with the remark, "The questions that Socrates asked at the beginning of this book are

[14]This section draws on ideas that first appeared in R. Anderson 1996.

still with us. Several others have been raised along the way" (Eaton 1988:145).

The same spirit of unresolvable debate is apparent in the vernacular aesthetic system that Chapters Five through Ten tapped into. The argumentative style of discourse that typifies philosophy occurs in numerous contexts but is most apparent in the recurrent contrasts between the positive and negative values of the arts. Consider, for example, just how many polarities were encountered among the song lyrics discussed in Chapter Five:

- The arts occur in heaven, with its singing angels and celestial beauty, but also in hell, where the Devil is a good dancer, a snazzy dresser, and a fiery fiddle player.
- Although several songs claim that personal beauty can lead to romantic bliss, others warn that it can also seduce the unsuspecting into destructive relationships.
- Art, some lyrics assert, can define reality, whereas other songs observe that art can also create a false reality.
- Performing artists love their audiences and attendant fame, but the artists also feel vulnerable to them.
- Whereas some music brings "soul" to the listener, the likes of "honky-tonk" music can put one's soul in jeopardy.

A comparable dialectic appeared in the remarks of the people whom I quoted throughout Chapters Six through Ten:

- Several individuals described the feeling of satisfaction they experience when they are engaged by art, whereas a few others noted how burdensome the muse can be. Steve Johnson, speaking of restaurant cooking, summed up this position by saying, "It's a pain."
- Some people reported that art can engender positive emotions in those who experience it, but others observed that negative responses also can be produced—to the point of igniting the "fires of horrible aggression," as Arnold Epley put it.
- Although the arts can convey moral and ethical lessons, they can also bring harm: Recall Lawless Morgan, who as a child, aspired to imitate his hero Dr. Banner (that is, The Incredible Hulk) but who was also warned against risking life and limb by trying to fly like Superman.
- Informants pointed out that art has an uncanny ability to depict truth and reality, but that art can also deceive and misrepresent reality.
- Many informants were encouraged as children to develop their artistic abilities by their families, but a few pursued the muse *in spite of* indifference, or outright opposition, from others.
- For some informants, art offers spiritual transcendence; for others, it does nothing of the kind. (And the differences seem to have little to do with the medium or with whether fine or popular art is involved.)

- For several people who were interviewed, art is a means through which one's individuality may be expressed; but it is equally a means through which a person gains identification with an enveloping social group.

Surely with this finding we have uncovered a fundamental feature of Western aesthetics, namely, our deep *ambivalence* about art. As noted, the roots of the debate can be found among the ancient Greek philosophers; and certainly the biblical injunction against the worshiping of graven images (accompanied by urgings to sing God's praise) bespeaks similar intellectual misgivings among early Jewish thinkers. Given the historical depth of this debate, it is little wonder that the contemporary Western world has such mixed attitudes about the arts. On the one hand, we revel in the popular arts while we simultaneously fear the damage that they may bring to individuals and to society at large; and we equate the fine arts with the best that our civilization produces, while damning its patrons as elitist snobs and its producers as effete decadents. Such ambivalence is, I believe, an artifact of culture, not a necessary feature of art itself. (The aesthetic systems of other cultures are complex and nuanced, but they do not, so far as I know, share our concerns about art's darker potential.)

The important point, however, is not the substance of the debate but rather the very *existence* of debate. Philosophical systems are characterized by the confrontation of fundamentally opposing ideas, and such a dialectic is as pervasive in vernacular aesthetics as it is in the canon of theories that focus on the fine arts.

Aesthetic Integration

Another trait that characterizes aesthetic systems is conceptual integration. When a professional aesthetician propounds a philosophy of art, it is not "a thing of threads and patches" but rather an articulated system of thought. An author may rhetorically argue both sides of a case, but we expect some degree of coherence between the first and the last chapter of the resultant book. Unlike the proverbial camel, the philosophy should not seem to be designed by committee.

Identifying conceptual integration is no easy matter. For one thing, it must not be confused with tautology. From the outset, I have defined *art* as referring to those things that possess most or all of a short list of traits, such as being made with the intention of stimulating the senses in a particularly acute fashion. Having done that, it comes as no surprise here at the end of the book to realize that most of the things discussed through the preceding chapters are, in fact, sensuous in nature.

Integration cannot even be equated with *the absence of contradiction.* In fact, as we have just seen, the data at hand demonstrate a consistent opposition in which art is alternately characterized as being good, true, and so on, versus being a burdensome hindrance to goodness, truth, and the like. This is, however, a *systematic* contradiction, a consistent dialectic that runs through much discussion about the arts, both at the present time and far back into the history of Western thought. In fact, I see such a persistent pattern as being evidence *in favor* of vernacular aesthetics constituting an integrated system. The alternative, after all, is an arbitrary jumble of aesthetic propositions, each exhibiting no logical consistency with the others—something like throwing together numerous randomly selected aesthetic principles from so many different non-Western societies.

That the positive/negative dialectic is an integrating theme in Western aesthetics is supported by the fact that it comes to light in so many different contexts—in song lyrics and in informant's remarks, with regard to the fine arts as well as the popular arts; from visual, performing, and literary art forms; from both amateurs and professionals; and from art creators as well as art consumers.

Other aesthetic premises indicative of conceptual integration also recur in preceding chapters, as seen in the previous sections of this chapter:

- The four paradigms of mimetic, instrumental, emotionalist, and formalist aesthetics are at least as applicable to the popular arts as to the fine arts, and each one has influenced numerous art media, styles, and so on.
- An acknowledgment of art's capacity to touch human feelings, sometimes with great force, comes from all quarters of the art community, as does a tendency to attribute art's power to the belief that art conveys the truth and that it sometimes elevates people to a transcendent state.
- The "portrait of the artist" that emerges from these pages is relatively consistent, be it of a fine art author (for whom James Joyce coined the phrase) or a committed flower gardener. As Karen Field has also shown, Americans generally agree that artists are different from most other people in several respects, including having the challenge presented to them by the arts themselves and rising to this challenge by having "access to insights and inspirations outside the realm of normal human experience" (Field 1993:400).

In addition to these integrating themes, Chapter Six noted two other kinds of evidence for the systemic nature of vernacular aesthetics. First, several informants are involved in more than one art medium; and they have no trouble moving between arts as different as painting and writing, playing jazz piano and delivering sermons, or playing music and decorating lawns. Second, many informants found it convenient to talk about one art medium by making analogies to other media. Also, as noted in Chapter Three, Americans expect the diverse arts that occur in weddings to be stylistically integrated with each other.

Although the broad sweep of American aesthetics shows clear signs of being an integrated system, it is by no means a *simple* system. This characteristic, however, is predictable in a complex society where the existence of the written word allows the aesthetic premises of the past to survive into the present day. Early nineteenth-century Japanese art, for example, showed the influence of Shintoism, Esoteric Buddhism, Amida Buddhism, Zen Buddhism, and, to a limited extent, Confucianism (R. Anderson 1990a:173–198); and since the end of the Tokugawa period in 1867, many Western notions about art and culture have been added to the mix. This complex heritage notwithstanding, however, a fundamental integrity is evident in traditional Japanese art.

The coherence of American popular art and vernacular aesthetics is, I feel, equally apparent, and this quality applies as much to popular art as to the fine arts. In these final pages, I have adduced both reason and data to support the position that the popular arts rest on a set of principles that address the issues conventionally assigned to aesthetics, doing so in a way that is as coherent and logically integrated as any other system of thought that we dignify with the label, *aesthetics*.

A final trait common to aesthetic systems is that, on sympathetic perusal, they are often convincing. Picking up any of the standard texts on Western aesthetics and reading it with an open mind, a person typically finishes the work with a sense of having received one or more genuine insights into the arts. Perhaps the reader cannot honestly embrace the entire argument, but some parts of it probably ring true.

For me, at least, the same reaction is prompted by reflecting on the aesthetic principles that have emerged during the course of this study: Many of them feel existentially valid to me.[15] Obviously, of the traits that I have attributed to aesthetic discourse, this is the weakest, not only because it is based on my own subjective response but also because it is predictable that I, as a native of the culture in question—Western mass culture—would experience a flash of recognition as many of the principles revealed themselves overtly. Nevertheless, I am certainly not the only American who can relate to many of the principles of vernacular aesthetics that have been described. Others, like myself, *do* feel that the arts have great power to do good or ill, that they have the capacity profoundly to move one's emotions, and that they can both conceal (and, one hopes, more often) convey the Truth.

[15]Although this study attempts to describe only American art and aesthetics, it is noteworthy that American popular arts are also popular in much of the rest of the contemporary world. It will be interesting to look for foreign sources of American notions about art and to find out whether American vernacular aesthetics are being exported to other countries, along with Hollywood movies, rock 'n' roll, designer jeans, and so on.

References Cited

Abiodun, Rowland
 1987 Verbal and Visual Metaphors: Mythical Allusion in Yoruba Ritualistic Art of *Or'i*. Word Image 3(3):252–270.

Abrams, Meyer Howard
 1953 The Mirror and the Lamp. New York: W. W. Norton.

Alland, Alexander, Jr.
 1983 Playing with Form: Children Draw in Six Cultures. New York: Columbia University Press.

Anderson, John
 1990 Dressed in Peace. Texas Monthly, December 1990, pp. 110–111.

Anderson, Richard L.
 1979 Art in Primitive Societies. Englewood Cliffs, New Jersey: Prentice Hall.
 1989 Art in Small-Scale Societies. Second edition of Anderson (1979). Englewood Cliffs, New Jersey: Prentice Hall.
 1990a Calliope's Sisters: A Comparative Study of Philosophies of Art. Englewood Cliffs, New Jersey: Prentice Hall.
 1990b Popular Art and Aesthetic Theory: Why the Muse Is Unembarrassed. Journal of Aesthetic Education 24(4):33–46.
 1992 Commentary: Do Other Cultures Have "*Art*"? American Anthropologist 94:926–929.
 1993 Art That Really Matters. *In* Richard L. Anderson and Karen L. Field, eds., Art in Small-Scale Societies: Contemporary Readings. Englewood Cliffs, New Jersey: Prentice Hall. Pp. 445–542.

1996 Vernacular Aesthetics: An Anthropologist Looks at Popular Art. Paper read at the 26th annual meetings of the Popular Culture Association, March 26, 1996, Las Vegas, Nevada.

Anderson, Richard L., and Karen L. Field, eds.
1993 Art in Small-Scale Societies: Contemporary Readings. Englewood Cliffs, New Jersey: Prentice Hall.

Anonymous
1990 Marriage Today: Facts and Figures. Unpublished readers' survey, Formal Wedding Survey, Bride's Magazine.
1991a Modern Bride Facts. Unpublished readers' survey, "Modern Bride Consumer Council Study," Modern Bride Magazine.
1991b Planning That Fabulous Night. Harper's Magazine, June 1991, pp. 35–42.
1992a Selecting Your Music. Modern Bride Magazine, February, 1992, p. 466.
1992b Musical Notes. Bride's Magazine, February, 1992, p. 250.
1992c Untitled advertising copy. Bride's Magazine, February, 1992, p. 31.
1992d Gift Registry Checklist. Modern Bride Magazine, February, 1992, pp. 231–2.
1992e Your Wedding Dress . . . Defined. Bride's Magazine, February, 1992, p. 1038.
1992f Guide to Buying Your Dream Dress. Modern Bride Magazine, February, 1992, pp. 526, 530.
1992g What to Wear. Modern Bride Magazine, February, 1992, p. 440.
1992h Tips for Toasters. Modern Bride Magazine, February, 1992, p. 376b.
1992i Starring Role. Bride's Magazine, February, 1992, pp. 810–813.
1993 The Columbia University College of Physicians and Surgeons Complete Home Medical Guide. Revised edition. Mount Vernon, New York: Consumers Union
1998 New and Noteworthy. New York Times Book Review, June 28, 1998, p. 28.

Auden, W. H.
1989 The Dyer's Hand and Other Essays. New York: Vintage Books.

Barker, Roger Garlock, and Herbert P. Wright, with others
1951 One Boy's Day: A Specimen Record of Behavior. New York: Harper & Brothers.

Becker, Howard S.
1982 Art World. Berkeley: University of California Press.

Berliner, Paul F.
1978 The Soul of Mbira: Music and Traditions of the Shona People of Zimbabwe. Berkeley: University of California Press.

Berndt, Ronald
1976 Love Songs of Arnhem Land. Chicago: University of Chicago Press.

Berndt, Ronald, and Catherine H. Berndt
1964 The World of the First Australians. Chicago: University of Chicago Press.

Birket-Smith, Kaj
1933 The Chugach Eskimo. Copenhagen: Nationalmuseets Skrifter, Etnografisk Raekhe, 6 København, Nationalmuseets Publikationsfond.

Bleich, Susan, Dolf Zillmann, and James Weaver
 1991 Enjoyment and Consumption of Defiant Rock Music as a Function of Ado-
 lescent Rebelliousness. Journal of Broadcasting and Electronic Media
 35(3):351–366.
Boas, George
 1963 [orig. 1940] The Mona Lisa in the History of Taste. In Marvin Levich, ed.,
 Aesthetics and the Philosophy of Criticism. New York: Random House.
 Pp. 576–594.
Bridges, John, and R. Serge Denisoff
 1986 Changing Courtship Patterns in the Popular Song: Horton and Carey Re-
 visited. Popular Music and Society 10(3):29–45.
Brown, Michael F.
 1996 On Resisting Resistance. American Anthropologist 98(4):729–749.
Capp, Al
 1963 Quoted in National Observer. Silver Spring, Maryland, July 1, 1963.
Carey, James T.
 1968 The College Drug Scene. Englewood Cliffs, New Jersey: Prentice Hall.
 1969 The Ideology of Autonomy in Popular Lyrics: A Content Analysis. Psychia-
 try 32:150–164.
Carroll, Nöel
 1986 Art and Interaction. Journal of Aesthetics and Art Criticism 45(1):57–68.
Cawelti, John G.
 1971 Notes Toward an Aesthetic of Popular Culture. Journal of Popular Cul-
 ture, 5(1):255–268.
Chandler, C. R., H. Paul Chalfant, and Craig P. Chalfant
 1984 Cheaters Sometimes Win: Sexual Infidelity in Country Music. In Ray B.
 Browne, ed., Forbidden Fruits: Taboos and Tabooism in Culture. Bowling
 Green, Ohio: Bowling Green University Popular Press. Pp. 133–144.
Charsley, Simon M.
 1987a Interpretation and Custom: The Case of the Wedding Cake. Man
 22(1):93–110.
 1987b What Does a Wedding Cake Mean? New Society 81(1279):11–14.
Chesebro, J. W., J. E. Nachman, A. Yannelli, and D. A. Foulger
 1986 Popular Music as a Mode of Communication: 1955–1982. Critical Studies
 in Mass Communication 2:150–164.
Child, I. L.
 1962 Personal Preferences as an Expression of Aesthetic Sensitivity. Journal of
 Personality 30:496–512.
Clifford, James
 1988 The Predicament of Culture: Twentieth-Century Ethnography, Literature,
 and Art. Cambridge, Massachusetts: Harvard University Press.
Cole, R.
 1971 Top Songs in the Sixties: A Content Analysis of Popular Lyrics. American
 Behavioral Scientist 14:389–400.

Cook, Anthony
 1990 The $60,000 Wedding. Money Magazine 19(5):118–132.
Csikszentmihalyi, Mihalyi
 1975 Beyond Boredom and Anxiety. San Francisco: Jossey-Bass.
D'Andrade, Roy G.
 1995 The development of cognitive anthropology. Cambridge: Cambridge University Press.
Daniels, Les
 1971 Comix: A History of Comic Books in America. New York: Outerbridge and Deinstfrey.
David, Nicholas, Judy Sterner, and Kodzo Gavira
 1988 Why Pots Are Decorated. Current Anthropology 29(3):365–389.
Davis, Nancy
 1992 Choosing the Best Photographer. *Modern Bride* Magazine, February, 1992, pp. 594, 598.
Davis, Stephen
 1991 Definitions of Art. Ithaca, New York: Cornell University Press.
Dawson, Jim, and Steve Propes
 1992 What Was the First Rock 'N' Roll Record? Boston: Faber and Faber.
d'Azevedo, Warren L.
 1958 A Structural Approach to Esthetics: Toward a Definition of Art in Anthropology. American Anthropologist 60(4):702–14.
DeBeaugrande, Robert
 1985 Poetry and the Ordinary Reader: A Study of Immediate Responses. Empirical Studies of the Arts 3(1):1–22.
Denisoff, Serge
 1972 Sing a Song of Social Significance. Bowling Green, Kentucky: Bowling Green University Popular Press.
Denisoff, R. Serge, and Mark Levine
 1972 Brainwashing or Background Noise: The Popular Protest Song. In R. Serge Denisoff and Richard A. Peterson, eds., The Sounds of Social Change: Studies in Popular Culture. Chicago: Rand McNally. Pp. 213–221.
Dickie, George
 1964 The Myth of Aesthetic Attitude. American Philosophical Quarterly 1(1):56–65.
 1974 Art and the Aesthetic. Ithaca, New York: Cornell University Press.
Dissanayake, Ellen
 1992 Homo Aestheticus. New York: Free Press.
Doherty, Thomas
 1988 Toward—and Away from—an Aesthetic of Popular Culture. Journal of Aesthetic Education 22(4):32–43.
Dutton, Denis
 1997 Aesthetic Universalism and Analogy. Paper read at the annual meetings of the American Society for Aesthetics, Santa Fe, New Mexico, October 1997.

1998 But They Don't Have Our Concept of Art. Paper read at the annual meetings of the African Studies Association, New Orleans, Louisiana.

Eaton, Marcia Muelder
1988 Basic Issues in Aesthetics. Belmont, California: Wadsworth Publishing Co.

Faris, James C.
1972 Nuba Personal Art. Toronto: University of Toronto Press.

Feagin, Susan L., and Patrick Maynard, eds.
1997 Aesthetics. New York: Oxford University Press.

Fernandez, James W.
1965 Symbolic Consensus in a Fang Reformative Cult. American Anthropologist 67:902–929.

Field, Karen L.
1979 Doing What I Love: The Socializtion of the Artist in the United States. Volumes I and II. Stanford University: Ph.D. Dissertation.
1993 Artists in Liberia and the United States: A Comparative View. In Richard L. Anderson and Karen L. Field, eds., Art in Small-Scale Societies: Contemporary Readings. Englewood Cliffs, New Jersey: Prentice Hall. Orig. in Journal of Modern African Studies 20(4):713–730 [1982].

Fisher, John A.
1993 Reflecting on Art. Mountain View, California: Mayfield.

Forrest, John
1988 Lord I'm Coming Home: Everyday Aesthetics in Tidewater North Carolina. Ithaca, New York: Cornell University Press.

Freilich, Morris, ed.
1989 The Relevance of Culture. Westport, Connecticut: Bergin and Garvey.

Frith, Simon
1981 Sound Effects: Youth, Leisure, and the Politics of Rock and Roll. New York: Pantheon.

Fromkin, Victoria, and Robert Rodman
1998 An Introduction to Language. Sixth edition. Orlando, Florida: Harcourt Brace.

Gablik, Suzi
1984 Has Modernism Failed? New York: Thames and Hudson.

Gage, Diane
1991 Weddings: Big Dreams on Small Budgets. Good Housekeeping. Vol. 212(6):118–139, 207–213.

Gallie, W. B.
1964 Philosophy and the Historical Understanding. London: Chatto and Windus.

Gans, Herbert J.
1974 Popular Culture and High Culture: An Analysis and Evaluation of Taste. New York: Basic Books.

Gardner, Howard
1980 Artful Scribbles: The Significance of Children's Drawings. New York: Basic Books.

Geary, Christraud M.
 1988 Images from Bamum: German Colonial Photography at the Court of King Njoya. Washington, D.C.: Smithsonian Institution Press.
Geertz, Clifford
 1973 The Interpretation of Cultures. New York: Basic Books.
 1983 Local Knowledge: Further Essays in Interpretive Anthropology. New York: Basic Books.
Glaser, Barney, and Anselm Strauss
 1967 The Discovery of Grounded Theory. Chicago: Aldine.
Goffman, Irving
 1974 Gender Advertisements. New York: Harper & Row.
Goodnow, Jacqueline J.
 1979 Children Drawing. Cambridge, Massachusetts: Harvard University Press.
Graves, Leslie
 1998 Transgressive Traditions and Art Definitions. Journal of Aesthetics and Art Criticism 56:232–258.
Guerin, Wilfred L., Earle Labor, Lee Morgan, and Heanne C. Reesman,
 1998 A Handbook to Critical Approaches to Literature. Fourth Edition. New York: Oxford University Press.
Halle, David
 1993 Inside Culture: Art and Class in the American Home. Chicago: University of Chicago Press.
Hanna, Judith Lynn
 1998 Dance and "Art." Anthropology Newsletter, February 1998, p. 32.
Hansen, Christine Hall, and Ranald D. Hansen
 1991 Schematic Information Processing of Heavy Metal Lyrics. Communication Research 18(3):373–411.
Hardin, Kris
 1988 Aesthetics and the Cultural Whole: A Study of Kono Dance Occasions. Empirical Studies of the Arts 6(1):35–57.
 1991 Review of Calliope's Sisters: A Comparative Study of Philosophies of Art. Journal of Anthropological Research 47(1):116–121.
Harris, James F.
 1993 Philosophy at 33-1/3: Themes of Classic Rock Music. Chicago: Open Court.
Hatfield, Elain, and Susan Sprecher
 1986 Mirror, Mirror: The Importance of Looks in Everyday Life. Albany, New York: State University of New York Press.
Hayes, E. Nelson, and Tanya Hayes, eds.
 1970 Claude Lévi Strauss: The Anthropologist as Hero. Cambridge, Massachusetts: The M.I.T. Press.
Hickey, Dave
 1997 Air Guitar: Essays on Art & Democracy. Los Angeles: Art Issues Press.
Horton, Robin
 1957 The Dialogue of Courtship in Popular Songs. American Journal of Sociology 62:569–578.

Hospers, John, ed.
 1969 Introductory Readings in Aesthetics. New York: The Free Press.
Hrdlicka, Ales
 1975 The Anthropology of Kodiak Island. New York: AMS Press.
Jenness, Diamond
 1946 Material Culture of the Copper Eskimo. Canadian Arctic Expedition 1913–18, Vol. 16. Ottawa: King's Printer.
Katz, Jennifer
 1992 Did You Know? Bride's Magazine, February, 1992, p. 782.
Keesing, Roger M.
 1982 Kwaio Religion. New York: Columbia University Press.
Kellog, Rhoda
 1969 Analyzing Children's Art. Palo Alto, California: National Press Books.
Kemp, Jim
 1987 American Vernacular: Regional Influences in Architecture and Interior Design. New York: Viking.
Kennick, W. E.
 1958 Does Traditional Aesthetics Rest on a Mistake? Mind 67(267):317–334.
Kimple, Inga Lycan
 1992 Writing Your Own Vows. Bride's Magazine, February, 1992, p. 648.
Kirby, P. R.
 1936 The Musical Practice of the ǂami and ǂkhomani Bushmen. Bantu Studies 10:373–431.
Kluckhohn, Clyde
 1949 The Philosophy of the Navajo Indians. In F.S.C. Northrop, ed., Ideological Differences and World Order. New Haven: Yale University Press. Pp. 356–384.
Kroeber, A. L. and C. Kluckhohn
 1952 Culture: A Critical Review of Concepts and Definitions, Papers of the Peabody Museum of American Archaeology and Ethnology, Harvard University, Vol. 47.
León-Portilla, Miguel
 1963 Aztec Thought and Culture: A Study of the Ancient Nahuatl Mind. Trans. by Jack Emory. Norman: University of Oklahoma Press.
 1966 Pre-Hispanic Thought. In Mario de la Cueva et al., Major Trends in Mexican Philosophy. Notre Dame: Univesity of Notre Dame Press. Pp. 2–56.
 1971 Philosophy in Ancient Mexico. In Robert Wauchope, ed., Handbook of Middle American Indians, Vol. 10. Austin: University of Texas Press. Pp. 447-451.
Lévi-Strauss, Claude
 1967 The Structural Study of Myth. In Claude Lévi-Strauss, Structural Anthropology. Garden City, New York: Doubleday. Pp. 202–228.
Lewis, G.
 1980 Day of Shining Red: An Essay on Understanding Ritual. Cambridge: Cambridge University Press.

Lewis, Oscar
 1951 Life in a Mexican Village: Tepoztlán Restudied. Urbana: University of Illinois Press.
 1959 Five Families. New York: New American Library.
 1965 La Vida. New York: Vintage Books.
Lull, James
 1982 Popular Music: Resistance to New Wave. Communication Research 32: 121–131.
 1987 Listeners' Communicative Uses of Popular Music. *In* James Lull, ed., Popular Music and Communication. Newbury Park, California: Sage. Pp. 140–173.
Madden, David
 1973 The Necessity for an Aesthetic of Popular Culture. Journal of Popular Culture 7(1):1–13.
Maquet, Jacques
 1986 The Aesthetic Experience. New Haven: Yale University Press.
 1991 Review of Calliope's Sisters: A Comparative Study of Philosophies of Art, by Richard L. Anderson. American Anthropologist 93:967–968.
Marsh, Dave
 1993 Louie Louie. Westport, Connecticut.: Hyperion.
McAllester, David
 1954 Enemy Way Music. Cambridge, Massachusetts: Peabody Museum.
McDannell, Colleen
 1995 Material Christianity: Religion and Popular Culture in America. New Haven: Yale University Press.
McManus, Kevin
 1991 Keeping Funeral Costs in Line. Changing Times, vol. 45, June, 1991, pp. 87–90.
Meldgaard, Jorgen
 1960 Eskimo Sculpture. London: Methuen.
Merriam Webster's Collegiate Dictionary, tenth edition.
 1993 Springfield, Massachusetts: Merriam-Webster.
Miner, Horace
 1956 Body Ritual Among the Nacirema. American Anthropologist 58:503–507.
Moravcsik, Julius
 1991 Art and "Art." Midwest Studies in Philosophy. Vol. 16: 125–132.
 1992 Why Philosophy of Art in a Cross-cultural Perspective? Journal of Aesthetics and Art Criticism. Vol. 50:233–249.
Nelson, Edward
 1899 The Eskimo about Bering Strait. Washington, D.C.: 18th Annual Report—Bureau of American Ethnology.
Nettl, Bruno
 1983 The Study of Ethnomusicology: Twenty-Nine Issues and Concepts. Urbana: University of Illinois Press.

Nye, Russel
 1970 The Unembarrassed Muse: The Popular Arts in America. New York: Dial
 Press.
O'Meara, J. Tim
 1989 Anthropology as Empirical Science. American Anthropologist 91(2):
 354–369.
Pepper, Steven C.
 1945 The Basis of Criticism in the Arts. Cambridge, Massachusetts: Harvard
 University Press.
Pittenger, Robert E., Charles F. Hockett, and John J. Danehy
 1960 The First Five Minutes. Ithaca, New York: Paul Marineau.
Plattner, Stuart
 1996 High Art Down Home: An Economic Ethnography of a Local Art Market.
 Chicago: University of Chicago Press.
Powell, Rachel
 1991 It's One Party Even the Recession Can't Spoil. New York Times, Sunday,
 June 23, 1991. P. F10.
Rasmussen, Knut
 1932 Intellectual Culture of the Copper Eskimos. Fifth Thule, Vol. 9. New
 York: AMS Press.
Ray, Dorothy Jean
 1977 Eskimo Art: Tradition and Innovation in North Alaska. Seattle: University
 of Washington Press.
Roberts, J. M.
 1965 Zuni Daily Life. Behavior Science Reprints. New Haven, Connecticut.:
 HRAF Press. (Orig., 1956 Zuni Daily Activities. Laboratory of Anthropol-
 ogy, University of Nebraska, Notebook 3, Monograph 2.)
Robinson, John P., and Paul M. Hirsch
 1972 Teenage Response to Rock and Roll Protest Songs. In R. Serge Denisoff
 and Richard A. Peterson, eds., The Sounds of Social Change: Studies in
 Popular Culture. Chicago: Rand McNally. Pp. 222–231.
Rosenbaum, Jill, and Lorraine Prinsky
 1987 Sex, Violence and Rock 'n' Roll: Youths' Perceptions of Popular Music.
 Popular Music and Society 11(2):79–89.
Ross, Stephen David, ed.
 1994 Art and Its Significance: An Anthology of Aesthetic Theory. Third edition.
 Albany: State University of New York Press.
Ruby, Jay, ed.
 1982 A Crack in the Mirror: Reflexive Perspectives in Anthropology. Philadel-
 phia: University of Pennsylvania Press.
Sartwell, Crispin
 1995 The Art of Living: Aesthetics of the Ordinary in World Spiritual Tradi-
 tions. Albany: State University of New York Press.

Seltzer, Shirley
 1976 Quo Vadis, Baby?: Changing Adolescent Values as Reflected in the Lyrics of Popular Music. Adolescence 11:419–429.
Selzer, Richard
 1979 Confessions of a Knife. New York: Simon and Schuster.
Sheppard, Anne
 1987 Aesthetics: An Introduction to the Philosophy of Art. New York: Oxford University Press.
Shister, Neil
 1998 Queen for a Day. Boston Review. October, 1998.
Shusterman, Richard
 1997 The End of Aesthetic Experience. Journal of Aesthetic and Art Criticism 55(1):32–47.
Shweder, Richard A., and Robert Levine, eds.
 1984 Culture Theory: Essays on Mind, Self, and Emotion. Cambridge: Cambridge University Press.
Staples, Brent
 1998 One Nation, After All: What Middle-Class Americans Really Think About: God, Country, Family, Racism, Welfare, Immigration, Homosexuality, Work, the Right, the Left, and Each Other. New York: Viking.
Stoller, Robert
 1976 Sexual Deviations. In Frank A. Beach, ed., Human Sexuality in Four Perspectives. Baltimore: The Johns Hopkins University Press. Pp. 190–214.
Stolnitz, Jerome
 1960 Aesthetics and Philosophy of Art Criticism: A Critical Introduction. Boston: Houghton Mifflin.
 1965 Aesthetics. New York: Macmillan.
Strauss, Anselm, and Juliet Corbin
 1990 Basics of Qualitative Research: Grounded Theory Procedures and Techniques. Newbury Park, California: Sage Publications.
Strong, Bryan, and Christine DeVault
 1994 Human Sexuality. Mountain View, California: Mayfield.
Tatarkiewicz, Wladyslaw
 1970a History of Aesthetics. Volume I: Ancient Aesthetics, ed. J. Harrell, trans. Adam and Ann Czerniawski. Warsaw: Polish Scientific Publishers.
 1970b History of Aesthetics, Volume II: Medieval Aesthetics. Ed. C. Barrett, trans. R. M. Montgomery. Warsaw: Polish Scientific Publishers.
 1974 History of Aesthetics, Volume II. Modern Aesthetics. Ed. D. Petsch, trans. Chester Kisiel and John F. Besemeres. The Hague: Mouton.
Taylor, Charles
 1979 Interpretation and the Sciences of Man. In Interpretive Social Science: A Reader. Paul Rabinow and W. M. Sullivan, eds. Pp. 25–71. Berkeley: University of California Press.

Thompson, Robert Farris
 1973 Yoruba Artistic Criticism. *In* Warren L. d'Azevedo, ed., The Traditional
 Artist in African Societies. Bloomington: Indiana University Press. Pp.
 19–61.
 1976 Black Gods and Kings. Bloomington: Indiana University Press.
Tyler, Stephen A.
 1986 Post-Modern Ethnography: From Document of the Occult to Occult Doc-
 ument. *In* Writing Culture: The Poetics and Politics of Ethnography.
 James Clifford and George E. Marcuse, eds. Pp. 122–140. Berkeley: Uni-
 versity of California Press.
Tylor, Edward B.
 1958 [orig. 1871], Primitive Culture. New York: Harper.
Van Gannep, A.
 1961 The Rites of Passage. Trans. M. B. Vizedom and G. L. Chaffee. Chicago:
 University of Chicago Press.
Weiss, Peter
 1965 The Persecution and Assassination of Jean-Paul Marat as Performed by the
 Inmates of the Asylum of Charenton Under the Direction of the Marquis
 de Sade. New York: Atheneum
Weitz, Morris
 1957 The Role of Theory in Aesthetics. Journal of Aesthetics and Art Criticism
 15(1):27–35.
Williams, Raymond
 1958 Culture and Society, 1780–1950. New York: Columbia University Press.
 1976 Keywords: A Vocabulary of Culture and Society. New York: Oxford Uni-
 versity Press.
Wise, Debra
 1991 The High Cost of Getting Married. Glamour Magazine. Vol. 89(5):
 189–190. (May 1991).
Witherspoon, Gary
 1977 Language and Art in the Navajo Universe. Ann Arbor: University of Michi-
 gan Press.
Zullow, Harold M.
 1991 Pessimistic Rumination in Popular Songs and Newsmagazines Predict Eco-
 nomic Recession via Decreased Consumer Optimism and Spending. Jour-
 nal of Economic Psychology 12(3):501–526.

Index